Van Gogh in Saint-Rémy and Auvers

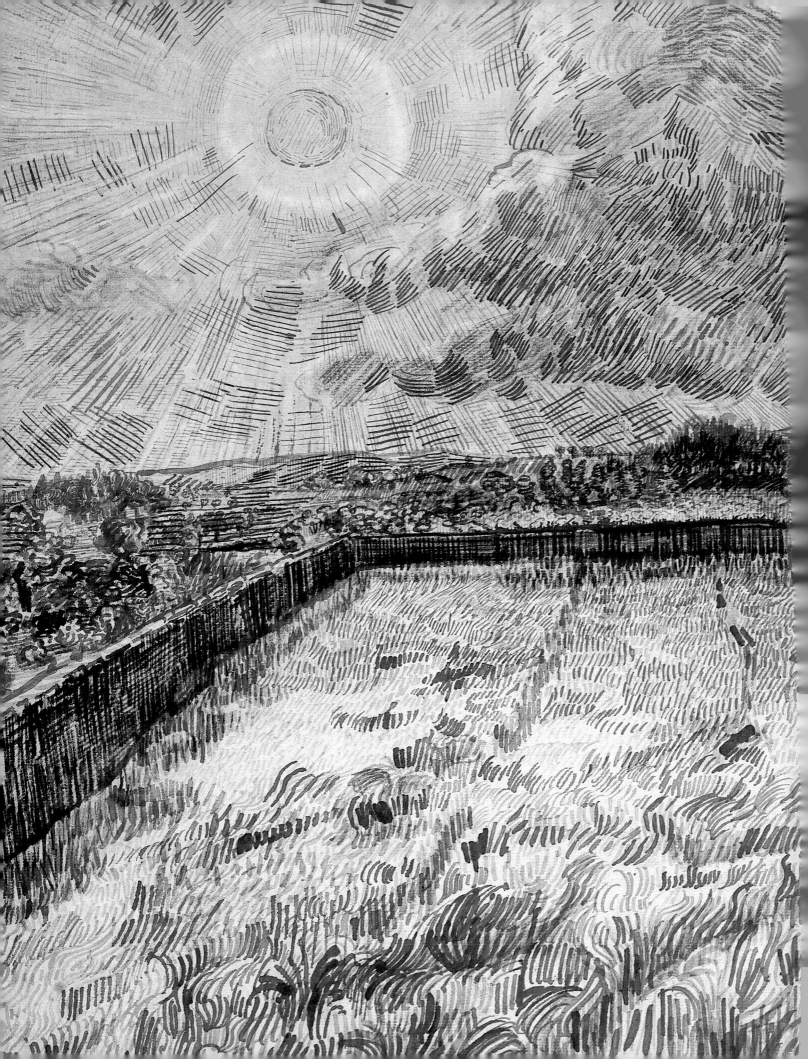

VAN GOGH IN SAINT-RÉMY AND AUVERS

RONALD PICKVANCE

THE METROPOLITAN MUSEUM OF ART
HARRY N. ABRAMS, INC., PUBLISHERS

Published in conjunction with the exhibition *Van Gogh in Saint-Rémy and Auvers*, held at The Metropolitan Museum of Art, New York, 25 November 1986 – 22 March 1987.

Excerpts from the letters of Vincent van Gogh are reprinted from *The Complete Letters of Vincent van Gogh*, 3 vols. (Boston, 1958), by permission of New York Graphic Society Books/Little, Brown and Company (Boston).

This exhibition has been made possible by

E F Hutton & Company
The Florence J. Gould Foundation
Robert Wood Johnson, Jr. Charitable Trust

An indemnity has been granted by the Federal Council on the Arts and the Humanities.

Library of Congress Cataloguing in Publication Data

Pickvance, Ronald.
 Van Gogh in Saint-Rémy and Auvers.

 Exhibition catalogue
 Bibliography: pp. 323–25
 1. Gogh, Vincent van, 1853–1890—Exhibitions.
2. Gogh, Vincent van, 1853–1890—Homes and haunts—France—Saint-Rémy-de-Provence—Exhibitions. 3. Gogh, Vincent van, 1853–1890—Homes and haunts—France—Auvers-sur-Oise—Exhibitions. 4. Painters—Netherlands—Exhibitions. 5. Saint-Rémy-de-Provence (France) in art—Exhibitions. 6. Auvers-sur-Oise (France) in art—Exhibitions. I. Metropolitan Museum of Art (New York, N.Y.) II. Title.

ND653.G7A4 1986 659.9492 86–21871
ISBN 0–87099–475–1 (clothbound) ISBN 0–87099–477–8 (paperbound)
ISBN 0–8109–1734–3 (trade clothbound)

Published by
The Metropolitan Museum of Art, New York
Bradford D. Kelleher, Publisher
John P. O'Neill, Editor in Chief
Emily Walter, Editor
Gerald Pryor, Designer
Henry von Brachel, Production Manager
Maps drawn by Kathleen Borowik

Type set in Sabon and Univers 55 by Cardinal Type Service, New York
Printed on 130 gsm Gardamatt Brillante, manufactured by Cartiere del Garda
Printed and bound in Italy by Amilcare Pizzi, S.p.A.

Reproductions are by permission of the owners of the original works or documents, who supplied color transparencies and black-and-white photographs, or by permission of the photographers, as noted.

Cover/jacket
Front: *Road with Cypress and Star* (cat. 55). Rijksmuseum Kröller-Müller, Otterlo
Back: *Self-Portrait* (cat. 22). Collection Mrs. John Hay Whitney

Frontispiece: *Wheat Field with Sun and Cloud* (cat. 39).
Rijksmuseum Kröller-Müller, Otterlo

CONTENTS

DIRECTOR'S FOREWORD

The exhibition *Van Gogh in Arles,* held at The Metropolitan Museum of Art in 1984, was conceived as a single project that would afford the opportunity to participate in van Gogh's artistic journey during an extraordinarily focused and prolific period in the development of his art.

During the course of that exhibition's organization, and in conversation with Guest Curator Ronald Pickvance, it became clear that it would be highly desirable to mount an exhibition of the paintings and drawings which van Gogh executed during his last fifteen months, a turbulent but productive period that he spent in Saint-Rémy and in Auvers. Indeed, it seemed that the value of the first exhibition—also concentrated on a fifteen-month period—and its contribution to our knowledge of van Gogh would be considerably extended if the artist's final year were to be given the same scholarly scrutiny.

I might mention here that the Metropolitan's van Gogh projects have inspired an exhibition to be organized in France by the Réunion des Musées Nationaux Français, quite logically on the subject of van Gogh's years in Paris. Thus we will, in effect, have presented two volumes of a trilogy that may one day be a quartet, completed by yet another volume, devoted to the work of van Gogh during his early days as an artist in Holland.

Both exhibitions, *Van Gogh in Arles* and *Van Gogh in Saint-Rémy and Auvers,* enable us to focus on two astoundingly fertile and remarkably self-contained periods in van Gogh's career. Self-contained in that the artist, so closely bound to and in touch with his surroundings, created a body of work that has striking local cohesion; and self-contained in that the work so dramatically reflects and illuminates an individual and very personal vision.

Van Gogh arrived in Saint-Rémy in May 1889. There he voluntarily committed himself to an asylum, originally built as a monastery in the twelfth and thirteenth centuries. Initially, he depicted the interior environment, recreating for himself his room, a vestibule, the vaulted corridors of the old building. He also painted the asylum grounds, the park, and the walled field. Later he ventured beyond the asylum walls, his horizons extending to the surrounding landscape. He made copies after prints sent to him by his brother Theo. He copied the work of, among others, Delacroix, Daumier, and Millet. Progressively, his range of subjects began to expand. His most famous new motif was the cypress, whose sinuous black-green form became for him almost an obsession. He ascribed to it the beauty of the Egyptian obelisk, and in painting it he applied the colors in thick strokes of rich impasto.

Both in Saint-Rémy and in Auvers, as earlier in Arles, van Gogh painted portraits, village streets, fields, and orchards. Then, in the last weeks of his life, his horizons widened yet again in a poignant and resonant crescendo. The paintings he executed in Auvers are his largest works, symbolic vistas on horizontal canvases of double-square format, nearly a meter in width. They form a dazzling coda to his life's work, as they do to the present exhibition.

Van Gogh suffered from what has been most commonly diagnosed as an epileptic disorder. His pictures, however, were painted during interludes of intellectual clarity; they are no less intense for that. Indeed, they sometimes convey a sense of such disquiet and anguish that we may be tempted to see in them an expression of madness. But a careful study of the work and a close reading of the letters bring forth, to the contrary, the image of a man of fiery temperament and enormous sensitivity, of an artist who was profoundly analytical and introspective, yet who expressed himself with a degree of force and concentration rarely encountered.

In Saint-Rémy and in Auvers, van Gogh returned to earlier motifs. In his incredibly rich transmutations of images, his endlessly inventive variants of familiar themes and subjects, we are reminded of such epic works as Bach's *The Well-Tempered Clavier.* Indeed, the exhibition could be described as an exploration of the deliberateness and lucidity of van Gogh's approach to his work during a time of great emotional crisis, one which this exhibition allows us to follow almost day by day. It is through this sharp focus that we find ourselves looking over his shoulder, as it were, peering closer than ever before into the artist's mind and heart.

The selection of paintings and drawings and the writing of the catalogue is the work of Ronald Pickvance, to whom I am enormously grateful for assuming the responsibility of organizing the exhibition, and whose detailed and eminently readable text should prove invaluable to all students in the field.

At the Metropolitan Museum, my special thanks are

due to Susan Alyson Stein for the intelligent and meticulous implementation of this project; to Gary Tinterow, who gave to it the benefit of his knowledge and enthusiasm; and to Emily Walter, for her skill and judiciousness in editing the text.

The generosity of many devoted collectors, some of whom have chosen to remain anonymous, has ensured the success of the exhibition. We thank them for sharing with us the works in their possession, as we thank also the scores of American and foreign museums that are represented here. In particular, we acknowledge with pride and pleasure, for a second time, the extraordinary contributions of museums in Holland, notably the Rijksmuseum Vincent van Gogh and the Vincent van Gogh Foundation, Amsterdam, and the Rijksmuseum Kröller-Müller, Otterlo.

In the same spirit of mutually enriching cultural exchange, I am happy to record that The Metropolitan Museum of Art is sending a reciprocal exhibition of thirty nineteenth-century French paintings to the Rijksmuseum Vincent van Gogh, Amsterdam, in the spring of 1987.

The exhibition has been made possible by generous grants from E F Hutton & Company, The Florence J. Gould Foundation, and the Robert Wood Johnson, Jr. Charitable Trust.

An indemnity has been granted by the Federal Council on the Arts and the Humanities.

Philippe de Montebello

ACKNOWLEDGMENTS

Van Gogh in Saint-Rémy and Auvers is the logical sequel to *Van Gogh in Arles,* held at the Metropolitan Museum in 1984. As with the latter exhibition, this one is the result of the enormous goodwill and generous cooperation of many individuals and institutions. Philippe de Montebello, Director of The Metropolitan Museum of Art, has been wholeheartedly supportive, and patient beyond measure, during the entire genesis of the exhibition. I owe him an incalculable debt. Sir John Pope-Hennessy, Consultative Chairman; Katharine Baetjer, Curator and Administrator; and Gary Tinterow, Assistant Curator, of the Department of European Paintings, have once again provided invaluable advice and professional expertise throughout. I should especially like to single out Mr. Tinterow, who has been particularly helpful and supportive. Many other colleagues at the Metropolitan Museum have contributed, in a variety of ways, to the successful realization of this exhibition: James Pilgrim, Deputy Director; Mahrukh Tarapor, Special Assistant to the Director for Exhibitions; Ashton Hawkins, Vice President, Secretary, and Counsel; Emily K. Rafferty, Vice President for Development; Richard R. Morsches, Vice President for Operations; Linda M. Sylling, Assistant Manager for Operations; Bradford D. Kelleher, Vice President and Publisher; John P. O'Neill, Editor in Chief and General Manager of Publications; Henry von Brachel, Production Manager, Editorial Department; John Buchanan, Registrar; Jeffrey L. Daly, Chief Designer, Design Department; John Brealey, Chairman, and Gisela U. Helmkampf, Conservator, Paintings Conservation; Helen Otis, Conservator, Paper Conservation. Further thanks are due to Zachary R. Leonard, who provided able research and editorial assistance, and Anne M. P. Norton, who cheerfully and efficiently executed a host of administrative tasks. I am deeply indebted to the designer of the catalogue, Gerald Pryor, and to the designer of the exhibition, Roy G. Campbell.

No van Gogh exhibition could possibly achieve any measure of comprehensiveness without the sympathetic collaboration of the Vincent van Gogh Foundation and the Rijksmuseum Vincent van Gogh in Amsterdam. I am profoundly grateful to Johan van Gogh, Chairman of the Vincent van Gogh Foundation, for so generously agreeing to the loan of such a significant number of paintings and drawings. I am equally grateful to his sister, Mrs. Til Cramer van Gogh, for innumerable kindnesses. Dr. Ronald de Leeuw, Director of the Rijksmuseum Vincent van Gogh, has given the exhibition his full and enthusiastic support. As always, I have received unstinting advice and assistance from Han van Crimpen, Curator, and Fieke Pabst, Research Assistant, Documentation, of the Rijksmuseum Vincent van Gogh: without them, the documentary part of this catalogue would be immeasurably poorer. I am deeply in the debt of Dr. R. W. D. Oxenaar, Director, and Johannes van der Wolk, Research Curator, of the Rijksmuseum Kröller-Müller, Otterlo, for invaluable help and advice, and for allowing such important works in their care to travel to New York. In The Hague, Martha Op de Coul of the Rijksbureau voor Kunsthistorische Documentatie has been as unfailingly helpful as ever, and Annet Tellegen has continued our long-standing discussion of van Gogh problems.

In Saint-Rémy-de-Provence, the Mayor, Henri Richaud, and his Secretary-General, Alain Quinsac, have kindly given me access to their archives. I have benefited greatly from conversations with Marcel Bonnet, Président de l'Escolo dis Aupiho. I owe a very special debt to Jean, Maguy, and Didier Delrieux. It is entirely fitting that they—the family of Dr. Edgar Leroy (1883–1965)—should maintain the intimate knowledge of this region of Provence, its history, topography, and customs, as well as an abiding curiosity in van Goghiana, all of which were so apparent in the many writings of Dr. Leroy (see Selected Bibliography). On my visits to Provence they have been ever generous and hospitable. In addition, Jean Delrieux's photographic skills have been utilized in this catalogue.

In Auvers, the Mayor, Serge Caffin (whose grandfather signed van Gogh's death certificate), and Daniel Lainé, Maire-Adjoint, Chargé des Affaires Culturelles, have very kindly allowed me full access to their archives. Jacques Truffot and Madame Millon, of the Syndicat d'Initiative, have patiently answered my many queries. Daniel Raskin has enthusiastically responded to persistent questioning about the family of Charles-François Daubigny, and has also accompanied me *sur les traces de*

van Gogh. Monsieur and Madame Vandenbroucke, the owners of Dr. Gachet's house for the past twenty years, have warmly welcomed me to that famous house and garden. In Paris, Anne Roquebert, Librarian of the Musée d'Orsay, has been especially resourceful and efficient in leading me to relevant material and in providing photographs and photocopies.

Two friends in New York again shared with me their infinite knowledge of van Gogh. John Rewald, as magnanimous as ever, has placed at my disposal his unique collection of photographs of Saint-Rémy and Auvers taken in the mid-1930s, four of which are reproduced in this catalogue. Artemis Karagheusian, so thoroughly conversant with the letters of van Gogh, has freely exchanged opinions about them.

Sally and Wynn Kramarsky have dispensed extraordinarily warm hospitality on so many occasions. Marianne, Maria, and Walter Feilchenfeldt have continued to provide the well-mixed cocktail of friendship, hospitality, and advice. Drs. Paul and Magrit Hahnloser have also been exceptionally generous hosts.

My debt to many scholars is enormous. In particular, I should like to record my special gratitude to Jan Hulsker, John Rewald, Mark Roskill, Meyer Schapiro, and Bogomila Welsh-Ovcharov.

The exhibition has been generously supported by collectors and public institutions in the United States and abroad. To each of the lenders I extend our immense gratitude. Were it not for the special efforts made by Dr. Christian Geelhaar, Director, Kunstmuseum Basel; Dr. Rudolf Staechelin, President of the Rudolf Staechelin Family Foundation; Dr. Siegfried Salzmann, Director, Kunsthalle Bremen; and Mr. Robert Yassin, Director, and Mrs. Robert W. Greenleaf, Co-Chairman of the Museum Fine Arts Committee, Indianapolis Museum of Art, particular loans of great importance would not otherwise have been available. For their invaluable assistance in our loan negotiations, I wish to thank William R. Acquavella, Acquavella Galleries, New York; Dr. Felix A. Baumann, Kunsthaus Zürich; Harry A. Brooks and Ay-Whang Hsia, Wildenstein and Co., New York; Christopher J. Burge, Christie, Manson and Woods International, New York; Eugene V. Thaw, E. V. Thaw and Co., New York; and David Nash and Sharon Schultz, Sotheby's, New York.

Added thanks are due to colleagues who helpfully provided documentation, interceded in locating works, or exchanged ideas: Haruo Arikawa, Alan Bowness, Françoise Cachin, Lili Couvée-Jampoller, Desmond Corcoran, France Daguet, Roland Dorn, Caroline Godfroy, Dr. J. M. Joosten, Geneviève Lacambre, Ellen Lee, Nancy Little, Alice Mauron, Alain Mothe, William McNaught, and Arleen Pancza-Graham.

As with *Van Gogh in Arles,* three indispensable people have worked unremittingly to bring the project to fruition. Emily Walter, Editor, has guided the manuscript through its various metamorphoses with skill, sensitivity, and vision, and maintained through sheer dedication a close working relationship that bridged the Atlantic. Susan Alyson Stein, Research Associate, has coordinated the complex organization of the exhibition, maintaining delicate negotiations with extraordinary diplomacy, and smoothly guiding this endeavor through its various stages, from inception to completion.

Für G.R.P., enormous bouquets of sunflowers, Vincent's symbol of gratitude.

Ronald Pickvance

LENDERS TO THE EXHIBITION

AUSTRIA

Vienna Österreichische Galerie 78

BRAZIL

São Paulo Museu de Arte de São Paulo 48, 54

CZECHOSLOVAKIA

Prague Národní Galerie 10

FEDERAL REPUBLIC OF GERMANY

Bremen Kunsthalle Bremen 9
Essen Museum Folkwang 33
Munich Staatliche Graphische Sammlung 38

FINLAND

Helsinki Ateneumin Taidemuseo 71

GREAT BRITAIN

London The Trustees of the Tate Gallery 4, 74, 82
Manchester Whitworth Art Gallery, University of Manchester 77

JAPAN

Hiroshima Hiroshima Museum of Art 89

THE NETHERLANDS

Amsterdam Rijksmuseum Vincent van Gogh (Vincent van Gogh Foundation) 2, 3, 5, 7, 21, 27, 43, 49, 51, 56, 57, 58, 80, 83, 85, 88
The Hague Rijksdienst Beeldende Kunst 66
Otterlo Rijksmuseum Kröller-Müller 11, 34, 39, 42, 50, 55

SWEDEN

Göteborg Göteborgs Konstmuseum 41

SWITZERLAND

Basel Oeffentliche Kunstsammlung, Kunstmuseum Basel 81
 Rudolf Staechelin Foundation, on extended loan to the Oeffentliche Kunstsammlung Basel 84
Solothurn Kunstmuseum Solothurn 24
Zurich Kunsthaus Zürich 72; on loan 8

UNITED STATES OF AMERICA

Brooklyn The Brooklyn Museum 18
Chicago The Art Institute of Chicago 19, 47, 76
Cincinnati Cincinnati Art Museum 79
Cleveland The Cleveland Museum of Art 44
Dallas Dallas Museum of Art 86
Detroit Detroit Institute of Arts 70
Indianapolis Indianapolis Museum of Art 28
Kansas City The Nelson-Atkins Museum of Art 12
Minneapolis The Minneapolis Institute of Arts 40
New York The Metropolitan Museum of Art 15, 46, 52
 The Museum of Modern Art 6, 14
 The Pierpont Morgan Library 17
 Solomon R. Guggenheim Museum 20
Philadelphia Philadelphia Museum of Art 29
Pittsburgh Museum of Art, Carnegie Institute 73
Portland The Joan Whitney Payson Gallery of Art, Westbrook College 1
Saint Louis The Saint Louis Art Museum 60, 64
San Antonio Marion Koogler McNay Art Museum 75
Toledo The Toledo Museum of Art 63
Washington, D.C. The Phillips Collection 45, 65

PRIVATE COLLECTIONS

The Armand Hammer Collection 32
Governor W. Averell and Pamela C. Harriman 53
Joseph H. Hazen 69
Josefowitz Collection 61
Elizabeth Taylor 36
Mrs. John Hay Whitney 13, 22

ANONYMOUS LENDERS

16, 23, 25, 26, 30, 31, 35, 37, 59, 62, 67, 68, 87 (and see Zurich 8)

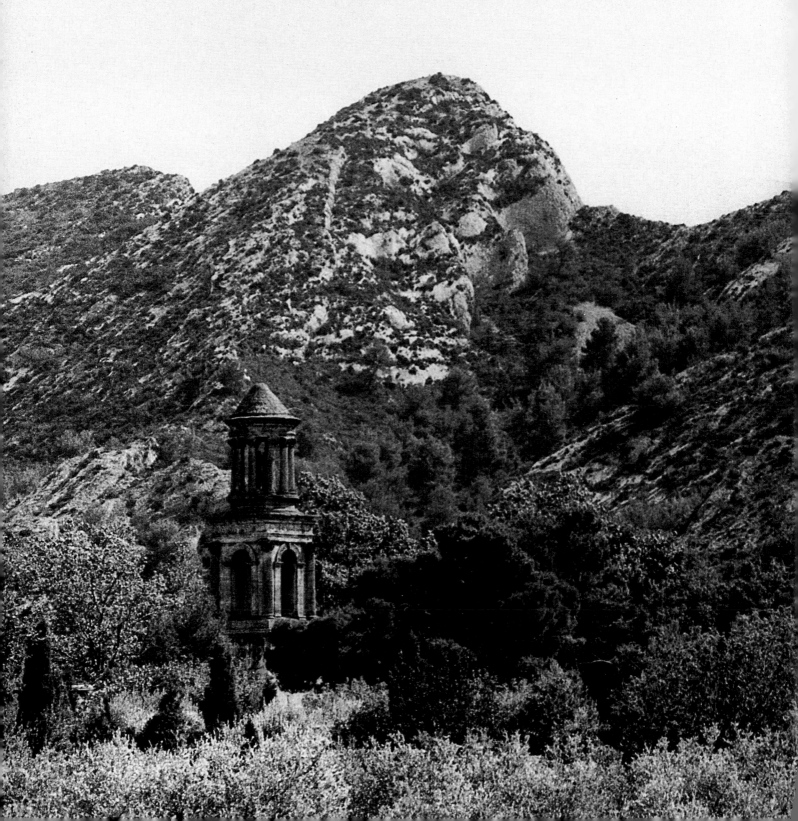

VAN GOGH IN

SAINT-RÉMY AND AUVERS

The range of the Alpilles, Saint-Rémy-de-Provence, 1976.
From the left: Entrance to the asylum of Saint-Paul-de- Mausole;
Mont Gaussier; Trabuc's house; and the cenotaph of Julius,
remains of Glanum, 2nd century B.C.–3rd century A.D.
Photograph by Jean Delrieux

VAN GOGH IN SAINT-RÉMY
AND AUVERS

Van Gogh's artistic odyssey lasted ten years. The final fifteen months of his life were spent in a private asylum in Saint-Rémy-de-Provence, in the South of France, and in the small village of Auvers-sur-Oise, some twenty miles northwest of Paris, where he committed suicide in late July 1890. Like Raphael, Caravaggio, Watteau, and Toulouse-Lautrec, he died at the age of thirty-seven.

In van Gogh's case, there was what has been seen as a preordained progression from asylum (with the implied assumption of madness) to suicide, which has fueled the myth of the mad genius. But whatever the illness may have been—and some form of epilepsy seems the most probable, whether exacerbated by absinthe, glaucoma, Digitalis poisoning, or syphilis—the fact is that it did not directly affect his work. His paintings are neither graphs of his so-called madness nor primarily indicators of his mental state. Between his breakdowns at the asylum he had long periods of absolute lucidity, when he was completely master of himself and his art.

That his mind was informed and imaginative, interpretive and highly analytical can be seen in the way he assessed his own work. From Saint-Rémy he sent seven batches of paintings to his brother Theo in Paris (see Appendix II). At one level, this periodic chore was undertaken primarily to thank Theo for his unfailing financial and moral support. But it also provided a series of progress reports on recently completed work, demanding selection in the first place and then commentary and exegesis. Van Gogh categorized his paintings with care, referring to individual works as studies or pictures, as paintings from nature or studio repetitions, as part of a series or as independent entities. He described handling, color, and design in

terms that respond far more to internal artistic necessity than to psychological quirks or medical abnormalities; he conceived of process, purpose, and function with a quite deliberate and almost programmatic intent. He provided a degree of multifaceted analysis a small fraction of which would bring Cézanne, Seurat, or Toulouse-Lautrec so much closer to us.

The selection of works for the present exhibition attempts to reflect not only van Gogh's own categorizations but also the choices he himself might have made. Emphasis has been placed on seeing his work as an entity made up of defined groups and series that are organically connected. This counters the tendency to remove individual pictures from their context and subject them to intensive scrutiny in an attempt to grasp their sources, symbolism, and ultimate meaning. The *Starry Night* (cat. 14), for example, is seen together with its pendant, *Olive Trees with the Alpilles in the Background* (cat. 13), and related to other landscapes painted in Saint-Rémy in June 1889. *Crows Over the Wheat Field* (cat. 85) also has its pendant, *Wheat Field Under Clouded Sky* (cat. 83), and they are considered in the catalogue as an integral part of a larger complex of thirteen canvases of the distinctive double-square format that were painted in Auvers in June and July 1890.

This highlighting of pairs, groups, and series of paintings has meant that a strictly chronological order has not been followed—in the grouping of the four autumn landscapes of the walled wheat field (cat. 27–30), for example, or the four autumn views of the asylum garden (cat. 31–34). Compared to van Gogh's practice in Arles, the dialogue between painting and drawing is less continuous. The majority of the large independent drawings, views taken in the asylum garden (cat. 2–4), were made during the first weeks of acclimatization in Saint-Rémy; and from Auvers, no more than a handful of such drawings exist (cat. 56, 57, 76, 77). Drawings done after paintings, so marked a feature of van Gogh's Arles period, are fewer. There were none from Auvers, and just twelve—admittedly large—were sent to Theo from Saint-Rémy, ten in July 1889 (see cat. 16–19) and two in December (see cat. 38).

Van Gogh, like many artists and writers in exile, had an intensely heightened sense of place. The longer he stayed in Provence, the more he strove to capture its atmosphere and essence. And the longer he stayed, the more he felt he could achieve this in series paintings devoted to individual motifs. "My God!" he wrote to his friend Émile Bernard, "It is a very bad sort of country here; everything in it is difficult to do with regard to disentangling its inner character and to avoid making it a vaguely apprehended thing instead of the true soil of Provence" (B20). And to Theo he expressed the hope that when he eventually left Saint-Rémy, his work would form "at best a sort of whole, 'Impressions of Provence'" (LT609).

Cypress trees, olive orchards, mountains—these were the three motifs van Gogh wanted most to capture in series. He never completed the cypresses or the mountains to his highly exacting standards, but he did succeed with the olives. He began with three summer paintings (cat. 11–13) whose stylistic and coloristic forebears include Monet, Gauguin, and Bernard. After prolonged observation, he undertook an autumn series that eventually comprised eight large paintings, of which four are in the exhibition (cat. 40–43).

Writing from Auvers to the Dutch art critic J. J. Isaäcson, he explained what he was attempting to do: "The effect of daylight, of the sky, makes it possible to extract an infinity of subjects from the olive trees. Now I, on my part, sought contrasting effects in the foliage, changing with the hues of the sky. At times the whole is a pure all-pervading blue, namely when the tree bears its pale flowers, and big blue flies, emerald rose beetles and cicadas in great numbers are hovering around it. Then, as the bronzed leaves are getting riper in tone, the sky is brilliant and radiant with green and orange, or, more often even, in autumn, when the leaves acquire something of the violet tinges of the ripe fig, the violet effect will manifest itself vividly through the contrasts, with the large sun taking on a white tint within a halo of clear and pale citron yellow. At times, after a shower, I have also seen the whole sky colored pink and bright orange, which gives an exquisite value and coloring to the silvery gray green" (LT614a).

Ironically, however, posterity has tended to ignore the paintings of olive orchards as a series, perhaps because the autumn sequence in particular contradicts so much of what is thought to represent van Gogh's late style. Instead of violently impetuous brushstrokes, thick impasto, and turbulent compositions, they display a remarkably lucid and unified brushstroke system, a consistently harmonious surface, carefully planned compositions, and a pervasive mood of contained serenity.

In Saint-Rémy, van Gogh's color scale was more muted; the "high yellow note" of his dazzling Arles palette was abandoned. He began using ochers again, and contemplated returning to the more somber palette of the North (that is, of his Dutch period). Elsewhere he wrote: "What I dream of in my best moments is not so much striking color effects as once more the half tones," influenced, he affirmed, by the pictures of Delacroix that he and Gauguin had seen in the Bruyas collection at Montpellier in December 1888. His interest waned in the compositional and coloristic devices he once so admired in Japanese woodblock prints.

Time of day, weather, season, as well as composition, viewpoint, color, and morphology of brushstroke, are modified from canvas to canvas in the four versions of the walled wheat field painted between early September and mid-November 1889 (cat. 27–30). Two of them, the *Reaper* (cat. 27) and *Enclosed Field with Peasant* (cat. 28), were seen as pendants by van Gogh, the one, he felt, too hastily conceived in thick impasto, all in yellow, the other painted calmly, over several days, in the complementary contrast of violet. The two should hang together, he instructed Theo. The two are hung together in this exhibition.

Van Gogh painted relatively few still lifes in Saint-Rémy and Auvers. During his last days in the South, however, he made a quartet of flower still lifes (see cat. 51–53). Formalistic color exercises, whose essential unity fuses in a supremely economical treatment that presages the work of Matisse, these too were probably conceived as a group, one in which variations of color are played off one another within the framework of complementary vertical and horizontal formats.

Van Gogh's brand of Post-Impressionism was overtly heterodox, broader in its admirations and admitted influences than Cézanne's, Gauguin's, or Seurat's. He carried a heavy artistic burden that included seventeenth-century Dutch painting

and the Barbizon school, Meissonier and Monticelli, European realist illustrations and stylized Japanese woodblock prints; he wanted somehow to combine past and present, North and South, Rembrandt and Delacroix, Europe and the Far East. In his portrait of Trabuc (cat. 24) he used only images of the past, wood engravings and etchings in black and white. But when he painted Dr. Gachet (cat. 62), he described at length in a letter to his sister Wil (quoted in cat. 62) his conception of the "modern portrait," of color, of the future, creating an ideological base as well as a practical exemplar for Fauvist and Expressionist portraiture. Portraits were surprisingly few in Saint-Rémy and Auvers. This was one reason van Gogh chose to make so many painted copies after such artists as Delacroix, Millet, Daumier, Rembrandt, and Gauguin (see cat. 37, 46–48). Even self-portraits number only three; all were executed in fairly close succession during August and September 1889. In his last self-portrait (cat. 25), peasantlike and beardless, he again blended past and present, summoning memories of his boyhood in Brabant, yet creating a "modern" image.

After his Provençal sojourn, van Gogh saw the Northern landscape with a sharpened and heightened vision. In Auvers there was a conscious change in his pictorial language. In his landscapes whites, blues, violets, and soft greens dominate. In his portraits, by contrast, he used the harsher primary colors and was ready to impose his color theories on his sitters (see cat. 68, 81). There was, too, a certain unevenness and impetuosity of brushstroke, a simplifying of the composition, and, above all, a change in format to the double-square canvas.

Van Gogh lived in Auvers for only seventy days, during which time he painted some seventy canvases. Only half are documented in the letters, and a chronological sequence is not easily proposed, especially for the last month of his life, when letters are scarce. While he led a restricted and isolated existence in Saint-Rémy, van Gogh was able in Auvers to wander freely, to choose his own motifs, and to paint whenever he wanted to. His most deliberate artistic decision was to adopt a double-square canvas (19⅝ x 39½ in.). Thirteen such canvases were painted: twelve landscapes and one portrait. A single-square canvas (19⅝ x 19⅝ in.) was used for six others: four portraits, one landscape, and one still life. Van Gogh himself said nothing about why he began using these unusual formats. Begun in mid-June 1890, the paintings were probably envisaged as a series to be hung and exhibited together, a continuation of van Gogh's ideas on decoration that had so obsessed him in the Yellow House in Arles. The single squares were not available for the present exhibition, but, miraculously, eleven of the double squares have come to New York and are shown here together for the first time.

EXPLANATORY NOTE

The catalogue is divided into two sections, Saint-Rémy-de-Provence and Auvers-sur-Oise. A detailed illustrated chronology opens each section.

Dating

Dates in the chronologies and of the works themselves are based largely on van Gogh's letters. Some changes have been made in the dating and ordering of many of van Gogh's letters from those previously proposed. For a complete list incorporating these changes, see Appendix I.

Titles

Van Gogh rarely gave consistent titles to his paintings and drawings. Only one painting from the Saint-Rémy–Auvers period is inscribed with a title: "le jardin de Daubigny" (cat. 89). Titles in J.-B. de la Faille, *The Works of Vincent van Gogh: His Paintings and Drawings*, New York, 1970, have been modified in the interest of simplicity.

Dimensions

Dimensions are given in inches and centimeters. Height precedes width.

Abbreviations

LT	Letter to his brother Theodorus (Theo)
W	Letter to his sister Wilhelmina (Wil)
B	Letter to Émile Bernard
T	Letter from Theo
H	de la Faille 1939
F	de la Faille 1970
JH	Hulsker 1980
GAC	Cooper 1983

See Selected Bibliography for full references.

Provenances and Exhibitions

Former owners of works in the catalogue and previous exhibitions in which these works have appeared have not been provided. These can be found in de la Faille 1970.

References to the Literature

These are confined as much as possible to catalogues raisonnés and to the published letters of van Gogh and Gauguin. Related works are cited by their de la Faille (F) catalogue number; a list of these works and their present owners is provided in Appendix IV.

SAINT-RÉMY

Wheat Field with Rising Sun (cat. 30), detail

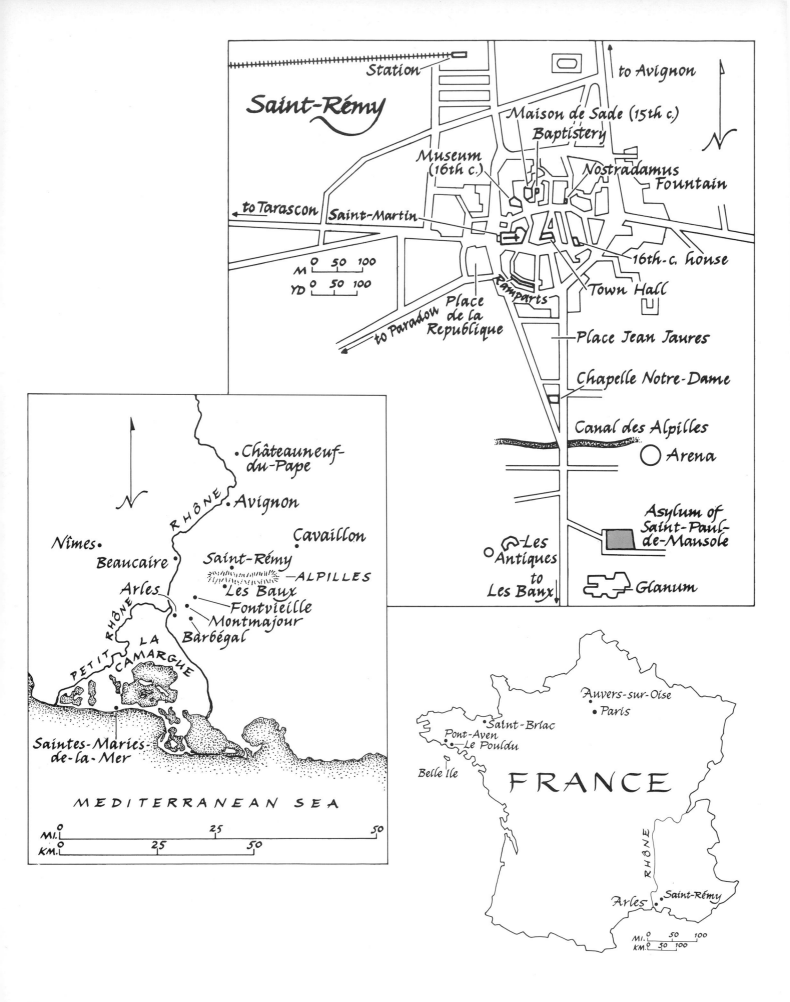

Saint-Rémy

Station

to Avignon

Maison de Sade (15th c.)
Baptistery

Museum
(16th c.)

Nostradamus
Fountain

to Tarascon Saint-Martin

16th-c. house

M 0 50 100

YD 0 50 100

Town Hall

to Paradou Place
de la
République

Ramparts

Place Jean Jaurès

Chapelle Notre-Dame

Canal des Alpilles

Arena

Asylum of
Saint-Paul-
de-Mausole

Les
Antiques
to
Les Baux

Glanum

N

Châteauneuf-
du-Pape

Avignon

RHÔNE

Cavaillon

Nîmes

Beaucaire

Saint-Rémy

ALPILLES

Arles

Les Baux

Fontvieille

Montmajour

PETIT RHÔNE

LA
CAMARGUE

Bàrbégal

Saintes-Maries-
de-la-Mer

MEDITERRANEAN SEA

MI. 0 25 50
KM. 0 25 50

Auvers-sur-Oise

Paris

Saint-Brïac

Pont-Aven

Le Pouldu

Belle Île

FRANCE

RHÔNE

Arles Saint-Rémy

MI. 0 50 100
KM. 0 50 100

SAINT-RÉMY-DE-PROVENCE

In 1890, Augustus J. C. Hare, inveterate English travel writer, published the guidebook *South-Eastern France*. He described Saint-Rémy as "a place well worth seeing." "It takes its name," he wrote, "from the bishop of Reims, who is supposed to have wrought a miraculous cure here in [the year] 500 on his way to Avignon with Clovis. The church tower was built in 1330 [*sic*] by John XXII." But of the town itself Hare said nothing, concentrating, as all visitors did, on the ruins of Glanum, "about 2 k. from the station…[on] the Plateau des Antiquités. Here, close together, with the picturesque peaks of the Alpines rising behind them, stand the principal remains of the Gallo-Roman town of Glanum Livii, consisting of an Arch of Triumph and a Tomb."

After the obligatory account and illustration of these Roman remains, Hare continued: "Not far from the ruins is the former Priory of S. Paul de Mausole (now a lunatic asylum), with an XI. c. church [*sic*] and a romanesque cloister."

Two years later, Mary Robinson Darmesteter, an Englishwoman married to a Frenchman, provided a contrasting view of Saint-Rémy in an essay entitled "Impressions of Provence" that she wrote for the English periodical *Contemporary Review.* "We fell in love with St. Rémy; we stayed there for a week, in the Hôtel du Cheval Blanc, where the long, dark, convent-like corridors and the cypress-screens behind the house give one already, as it were, a waft of Italy. St. Rémy is a delightful little place. All its streets are avenues of great zebra-trunked, century-old plane-trees, garlanded in April with quaint little hanging balls, or else of wych-elms, gay with pinkish-buff blossoms, and yet so knarled and hollow that they might almost be those famous elms which Sully planted about the towns of France. La Ville Verte the people call it, and never was name better chosen….The town has shrunk within its ancient girdle, and has filled out its space with gardens, with orchards, with hay-meadows. The gardens of St. Rémy are the fortune of the place, and owe to their happy situation behind the range of the Alpines an earlier harvest of flowers and fruit than elsewhere, even in the sunny South. In the roomy inn-garden we wondered at the luxuriance of the spring, as we sat in the shadow of the blossoming Guelder-rose bush, or picked great trails of rose and syringa. We gathered our first dish of strawberries on the 23rd of April. There are but two openings at St. Rémy—miller or market-gardener; the two prettiest trades, suitable to this greenest, most pastoral of cities.

"St. Rémy is but gently raised above the plains; still low enough to nestle among the white-flowered hawthorn hedges by the runnels bordered with flowers. But, scarce two miles beyond, there rise the scarred, fantastic, sun-baked crags of the Alpille Mountains—the Alpines in modern guide-book parlance. These are true southern hills, barren and elegant, grey, lilac, blue, pink even, or purple against the

sky; but never green. Walk thither along the upward road till, at the mountains' feet, you come to a round knoll of fine turf, fringed with stone-pines, under every tree a marble sarcophagus for a seat. Hence the view is beautiful across the wide blue valley to the snow-streaked pyramid of Mont Ventoux. But you will turn your back upon the view, for, placed on the middle of this grassy mound, is the pride of St. Rémy, the Antiquities, sole relic of the prosperous town of Glanum Livii. Nowhere in Provence have we seen so beautiful a setting to monuments so perfect in their small proportions as the Triumphal Arch and the Mausoleum."

Madame Darmesteter said nothing about the asylum of Saint-Paul-de-Mausole.

CHRONOLOGY

Saint-Rémy, 8 May 1889 – 20 May 1890

Wednesday 8 May

Van Gogh leaves Arles, where he had been living since 20 February 1888, by train, accompanied by the Reverend Frédéric Salles, pastor of the Reformed Protestant Church in Arles, for the asylum of Saint-Paul-de-Mausole in Saint-Rémy-de-Provence, some fifteen miles to the northeast. On 10 May the pastor writes to van Gogh's brother Theo (Theodorus van Gogh, 1857–1891) in Paris: "Our trip to Saint-Rémy was accomplished under excellent conditions. M. Vincent was perfectly calm and explained his case himself to the director, as a man who is fully aware of his situation. He remained with me until my departure, and when I took leave of him he thanked me profusely and seemed somewhat moved at the thought of the completely new life he was going to lead in that establishment. Let us hope that his stay will be truly beneficial for him and that soon he will be regarded as capable to resume his complete freedom of movement. M. Peyron assured me that he will receive all the kindness and care which his condition demands" (Hulsker, "Vincent's Stay in the Hospitals at Arles and St.-Rémy," pp. 35–36).

Dr. Théophile-Zacharie-Auguste Peyron (1827–1895), director of the asylum since 1874, was described by van Gogh as "a little gouty man—several years a widower,

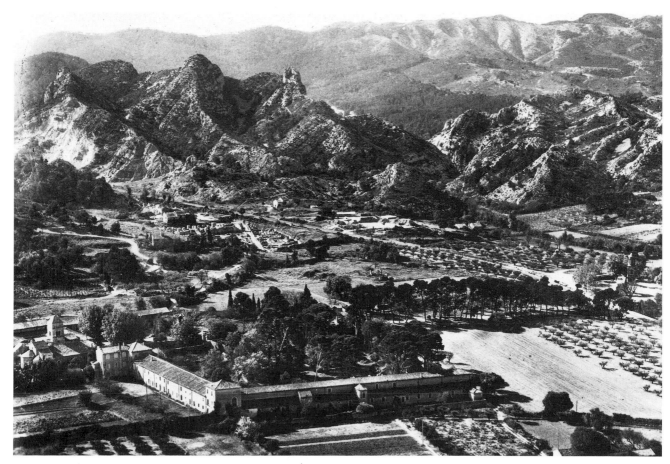

Aerial view of the asylum of Saint-Paul-de-Mausole with the Alpilles in the background. Postcard, c. 1940s. Collection Jean Delrieux

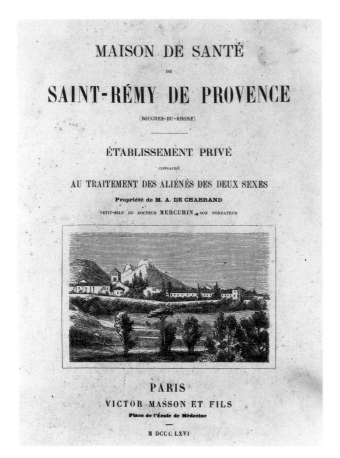

Title page of a prospectus for the asylum of Saint-Paul-de-Mausole, 1866. Rijksmuseum Vincent van Gogh (Vincent van Gogh Foundation), Amsterdam

Admission register. Archives of the asylum of Saint-Paul-de-Mausole, Saint-Rémy-de-Provence

with very black spectacles. As the institution is rather dull, the man seems to get no great amusement out of his job, and besides he has enough to live on" (LT593).

Thursday 9 May

In the register of the voluntarily interned Dr. Peyron observes, twenty-four hours after van Gogh's arrival, that, "having been treated in the hospital [in Arles, the patient] is suffering from acute mania with hallucinations of sight and hearing which have caused him to mutilate himself by cutting off his right ear. At present he seems to have recovered his reason, but he does not feel that he possesses the strength and the courage to live independently and has voluntarily asked to be admitted to this institution. As a result of the preceding it is my opinion that M. van Gogh is subject to epileptic fits at very infrequent intervals, and that it is advisable to keep him under prolonged observation in this establishment."

Van Gogh receives encouraging letters (T7, T8) from Theo and his wife, Jo (Johanna Gesina van Gogh-Bonger, 1862–1925). "I don't look upon your going to Saint-Rémy as a *retreat,* as you say, but simply as a temporary rest cure in order that you may come back after a short time

with renewed strength," Theo tells his brother. He refers to paintings at the Paris Salon, among them "two absinthe drinkers and the portrait of two young girls in white…perhaps the best portrait in the Salon," both by Jean-François Raffaëlli (1850–1924). "Otherwise, there is very little of interest in the whole bazaar." For her part, Jo describes their new apartment at 8 Cité Pigalle, in Montmartre, and how Vincent's pictures are hung there. The large *Harvest (Blue Cart)* (F412), from Arles, hangs over the piano in the drawing room. "The dining room is also full of [paintings], but Theo is still dissatisfied with the arrangement, and every Sunday morning is spent hanging the pictures in other places and rearranging everything." She tells of visits by various artists: "Last night, for instance, there was quite a reunion. Pissarro [Camille Pissarro, 1830–1903] and his son [Lucien Pissarro, 1863–1944], Isaäcson [Joseph Jacob Isaäcson, 1858–1942] and young Nibbrig [Ferdinand Hart Nibbrig, 1866–1915]…and my brother [Andries Bonger, 1861–1934]." She and Theo have been married three weeks.

Friday 10 May

The Reverend Salles writes to Theo about the journey to Saint-Rémy.

Van Gogh writes his first letter from the asylum to Theo and Jo (LT591). (The week's delay may be due to his knowing that the Reverend Salles had already written to Theo.) Seeing the "madmen and lunatics in this menagerie" is helping him to lose "the vague dread, the fear of the thing," he tells his brother. Dr. Peyron thinks that van Gogh had some sort of epileptic attack in Arles. Van Gogh has started work on two motifs taken from the garden, some violet irises (cat. 1) and a lilac bush (cat. 1, fig. 1).

Writing separately to Jo, he contrasts Paris and the country, Delacroix (as the essential Parisian) and Millet, contrasts that will recur often in his letters. For him and for Theo, "Paris is certainly already something like a graveyard where many artists have perished whom we once knew directly or indirectly." When he is busy in the garden, the other patients come to watch him quietly and discreetly. "Quite near here there are some little mountains, gray and blue, and at their foot some very, very green cornfields and pines."

Thursday 16–Monday 20 May

Van Gogh continues working in the asylum garden.

Tuesday 21 May

Theo replies to Vincent's letter (T9). He hopes the stay in Saint-Rémy will be only an interlude. It may be possible to find someone who would accommodate him, yet allow him his liberty: "If you didn't have such a dread of going back to Paris or its environs, I myself would try to find a boardinghouse of this kind." He asks about the treatment Vincent is receiving, about the food and the other patients, and whether he has yet seen anything of the countryside.

The consignment of pictures from Arles arrived some days ago in good condition. Theo is especially impressed with *La Berceuse* and the *Portrait of Roulin* (F432). They have "vigor" and "in the course of time they will become very beautiful by reason of the settling of the layers of paint, and they will undoubtedly be appreciated someday."

Photograph of Theo van Gogh. Rijksmuseum Vincent van Gogh (Vincent van Gogh Foundation), Amsterdam

Photograph of Johanna Gesina van Gogh-Bonger. Rijksmuseum Vincent van Gogh (Vincent van Gogh Foundation), Amsterdam

The French pictures at both the Salon and the Paris World's Fair (L'Exposition Universelle Internationale de 1889) he thinks are weak. By contrast, the Dutch school "cuts a very good figure": in particular, two watercolors by Jan Hendrik Weissenbruch (1824–1903), whom van Gogh had known at The Hague in 1882–83. Theo recently saw Paul Gauguin (1848–1903), who is now sculpting; he plans to go to Pont-Aven in Brittany shortly to join the Dutch artist Jacob Meijer de Haan (1852–1895). The Salon des Indépendants will take place soon; Theo asks Vincent which canvases (up to four) he would like to show.

Still working in the garden, van Gogh draws "a very big, rather rare night moth, called the death's-head [F1523], its coloring of amazing distinction, black, gray, cloudy white tinged with carmine or vaguely shading off into olive green; it is very big. I had to kill it to paint it [F610], and it was a pity, the beastie was so beautiful" (LT592).

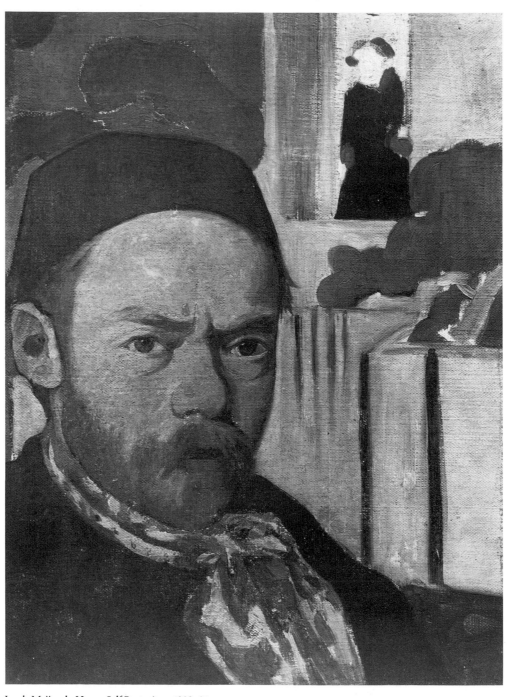

Jacob Meijer de Haan. *Self-Portrait,* c. 1889–91.
Oil on canvas, 12¾ x 9⅝ in. (32.4 x 24.5 cm.).
Collection Mr. and Mrs. Arthur G. Altschul

Wednesday 22 May

Theo's letter arrives. His questions about Vincent's health and the asylum and his comments on the artistic scene in Paris prompt a seven-page letter (LT592), embellished with sketches. Vincent responds to the news of Weissenbruch and to Theo's comments on *La Berceuse*. Included is a sketch of the picture flanked by two canvases of sunflowers, making a triptych, so that "the yellow and orange tones of the head will gain in brilliance by the proximity of the yellow wings." He asks Theo to give one version of *La Berceuse* to Gauguin and another to Émile Bernard (1868–1941).

He has finished a new size 30 canvas—still of the garden—of ivy-covered tree trunks, with periwinkle, a stone bench, and a bush of pale roses (F609). "Since I have been here, the deserted garden, planted with large pines beneath which the grass grows tall and unkempt and mixed with various weeds, has sufficed for my work, and

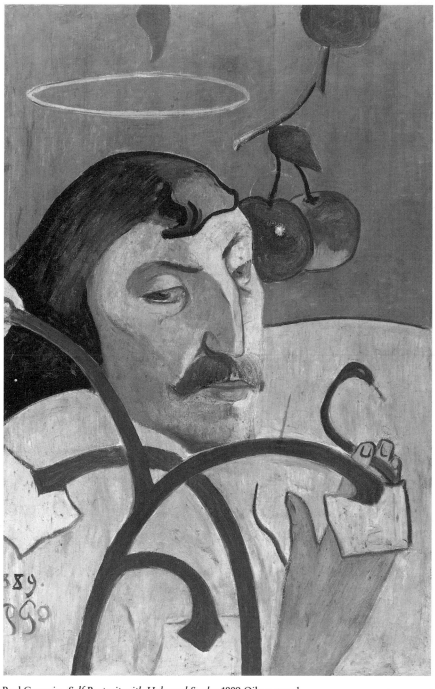

Paul Gauguin. *Self-Portrait with Halo and Snake,* 1889. Oil on wood, 31¼ x 20¼ in. (79.2 x 51.3 cm.). National Gallery of Art, Washington, D.C. Chester Dale Collection

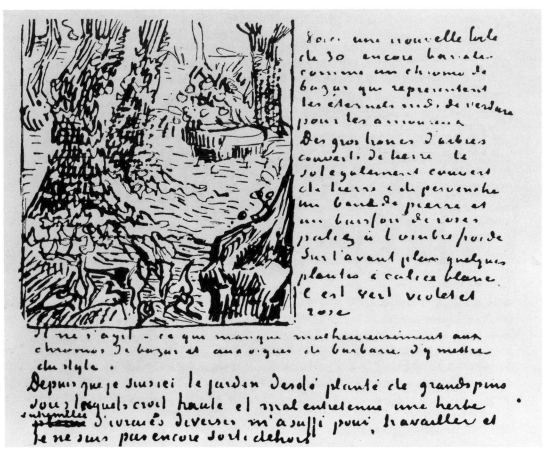

Sketch of *Trees with Ivy* (LT592).
Present location unknown

I have not yet gone outside. However, the country round Saint-Rémy is very beautiful and little by little I shall probably widen my field of endeavor."

He describes his room: "A little room with greenish gray paper with two curtains of sea green with a design of very pale roses, brightened by slight touches of blood red. These curtains, probably the relics of some rich and ruined deceased, are very pretty in design. A very worn armchair probably comes from the same source; it is upholstered in tapestry splashed over like a Diaz [Narcisse Virgile Diaz de la Peña, 1807/8–1876] or a Monticelli [Adolphe Monticelli, 1824–1886], with brown, red, pink, white, cream, black, forget-me-not blue and bottle green. Through the iron-barred window I see a square field of wheat in an enclosure, a perspective like van Goyen [1596–1656], above which I see the morning sun rising in all its glory. Besides this one—as there are more than thirty empty rooms—I have another one to work in.

"The food is so-so. Naturally it tastes rather moldy, as in a cockroach-infested restaurant in Paris or in a boarding-house. As these poor souls do absolutely nothing (not a

book, nothing to distract them but a game of bowls and a game of checkers), they have no daily distraction other than to stuff themselves with chickpeas, beans, lentils, and other groceries and merchandise from the colonies in fixed quantities and at regular hours....

"The *fear* of madness is leaving me to a great extent, as I see at close quarters those who are affected by it in the same way as I may very easily be in the future." He recalls his former aversion to "madmen," and how harrowing the thought used to be that so many painters had ended thus. Here, he tells Theo, there is much self-help among the patients, some of whom howl or rave continually; the most serious cases, however, are in a separate ward. He takes a two-hour bath twice a week, and his "stomach is infinitely better" than it was a year ago at Arles. He intends to go on quietly, and may have a better idea of his future by the end of a year. The idea of a fresh start may return, but at the moment returning to Paris or going anywhere else has absolutely no attraction for him. His work will save him from the extreme enervation from which the others suffer.

He is working on four canvases of the garden (cat. 1;

cat. 1, fig. 1; cat. 2, fig. 3; F734) and two or three drawings. Yesterday he drew and painted the death's-head moth. He thinks the damaged *Bedroom* (F484) should be relined in Paris by someone whose address Gauguin should have. He encloses an order for paints, and provides a searching analysis of his condition: "I gather from others that during their attacks they have also heard strange sounds and voices as I did, and that in their eyes too things seemed to be changing. And that lessens the horror that I retained at first of the attack I have had, and which, when it comes on you unawares, cannot but frighten you beyond measure.... Most epileptics bite their tongue and injure themselves. Rey [Dr. Félix Rey, 1867–1932, van Gogh's doctor and friend from Arles] told me that he had seen a case where someone had mutilated his own ear, as I did, and I think I heard a doctor here say, when he came to see me with the director, that he also had seen it before....There is someone here who has been shouting and talking like me *all the time* for a fortnight; he thinks he hears voices and words in the echoes of the corridors, probably because the nerves of the ear are diseased and too sensitive, and in my case it was my sight as well as my hearing, which according to what Rey told me one day is usual in the beginning of epilepsy."

Thursday 23 May

No doubt disturbed by receiving Vincent's letter, Theo writes to Dr. Peyron to obtain a reassuring professional opinion about his brother's health. (The letter is lost.)

Saturday 25 May

Dr. Peyron, writing his observations ("Certificat de Quinzaine") in the asylum register, notes that van Gogh "has shown a noticeable improvement in his state, but must be kept in the establishment to continue his treatment."

Sunday 26 May

Dr. Peyron replies to Theo's letter of 23 May: "I am pleased to tell you that since his entry into this house M. Vincent is completely calm and that he finds that his health is improving day by day. At first he was subject to painful nightmares which upset him, but he reports that these bad dreams tend to disappear and become less and less intense, so that now he has a more peaceful and restoring sleep; he also eats with better appetite. To sum up: Since his arrival here there has been a slight improvement in his condition which makes him hope for a complete recovery.

"He spends the whole day drawing in the park here, but as I find him entirely tranquil I have promised to let him go out in order to find scenery outside this establishment.

"You ask for my opinion regarding the probable cause of his illness. I must tell you that for the time being I will not make any prognosis, but I fear that it may be serious as I have every reason to believe that the attack which he has had is the result of a state of epilepsy and if this should be confirmed one should be concerned for the future.

"I hope to go to Paris in the course of June. It will be an honor to come and see you and talk to you about your patient better than one can do by letter" (Hulsker, "Vincent's Stay in the Hospitals at Arles and St.-Rémy," pp. 39–40).

c. Sunday 2 June

Vincent writes to Theo (LT593) after a lapse of some eleven days, although he is aware of Theo's letter to Dr. Peyron, and of Peyron's reply—"he tells me nothing and I ask him nothing, which is simplest." He asks for paintbrushes to be sent; the weather is fine; his health is good. He tells Theo he is becoming more skeptical about Impressionism, believing more than ever in the "eternal youth" of the school of Eugène Delacroix (1798–1863), Jean-François Millet (1814–1875), Théodore Rousseau (1812–1867), Jules Dupré (1811–1889), and Charles-François Daubigny (1817–1878), as much as in that of the present. "This morning I saw the country from my window a long time before sunrise, with nothing but the morning star, which looked very big. Daubigny and Rousseau have done just that, expressing all that it has of intimacy, all that vast peace and majesty, but at the same time adding a feeling so individual, so heartbreaking."

He has been at the asylum almost a month, but so far has seen only the garden and what he can look at through his window. When he receives the canvas and paints he plans to go outside the asylum grounds and explore the countryside. Indeed, "since it is just the season when there is an abundance of flowers and consequently color effects, it would perhaps be wise to send me another five meters of canvas." He asks Theo if he has read the new novel by Guy de Maupassant, *Fort comme la mort* (1889). And suggests that the *Starry Night Over the Rhône* (cat. 14, fig. 11) and a "landscape with yellow vegetation" (now lost) might be shown together at the Salon des Indépendants.

Gauguin probably leaves for Pont-Aven (T10).

Sunday 9 June

Dr. Peyron writes to Theo, acknowledging that he has received the money order for van Gogh's board and lodg-

ing (presumably for the next month) and confirming the arrival of "canvas, brushes, paints, etc., which he has been awaiting impatiently." Dr. Peyron continues, "Your patient is feeling better and finds that he improves every day; for some days now, he goes out of the asylum to look for views in the open country. Since he has been here he has not been wasting his time. He has done several paintings which he intends to send to you" (Hulsker, "Vincent's Stay in the Hospitals at Arles and St.-Rémy," p. 40).

It is probable that Vincent also writes to Theo this same day (LT594). He thanks him for the canvas, colors, brushes, tobacco, and chocolate; tells him that for some days he has been working outside the grounds of the asylum, especially on two landscapes—size 30 canvases —of views taken in the hills (cat. 8, fig. 8; cat. 9).

He has not received a letter from Theo since 21 May.

He has read an article on the Paris World's Fair and has become fascinated by an Egyptian house designed by the architect Jules Garnier (1847–1889). He has also read an announcement of the exhibition to be held at the Grand Café des Beaux-Arts, a café on the Champ de Mars, just opposite the official art section of the Fair and owned by an Italian named Volpini. Included in the exhibition will be the work of Gauguin, Bernard, and Louis Anquetin (1861–1932), among others.

He went once, still accompanied, to the village: "The mere sight of people and things had such an effect on me that I thought I was going to faint and I felt very ill."

He sends a second order for paints to Theo because he

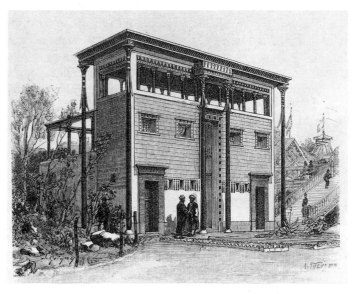

The Egyptian house. Reproduced in *Le Monde Illustré*, 25 May 1889

Poster for the Volpini café exhibition.
Rewald, *Post-Impressionism*, p. 259

"wants to do better pictures than before" and is "tempted to begin again with the simpler colors, the ochers for instance."

Sunday 16 June

In the morning, while some canvases are drying in the sun, Vincent writes his first letter (W12) since his arrival in Saint-Rémy to his sister Wil (Wilhelmina Jacoba van Gogh, 1862–1941). Reporting on the completion of two landscapes—one of an olive orchard (cat. 12), the other of a wheat field (cat. 10)—he also describes another landscape of a wheat field that he had completed earlier (F611). He compares the local peasantry and the pattern of cultivation with their Dutch counterparts. "The people of this country work a good deal less than the peasants at home; one hardly sees any cattle, and the fields make a much more deserted impression than those in our country.... The farms here would produce three times as much as they do now if they were well kept, and the whole land too if it were sufficiently manured." He jokingly dilates on the theme of love as a bacillus. Theo has not written for almost a month, but "last week he sent me a consignment of paints and canvas."

As if telepathically, Theo writes his first letter to Vincent since 21 May (T10). He admits having been remiss, "but I have not been able to formulate my thoughts." He continues to discuss the last consignment of Arles paintings —vigorous in color but tortured in form through striving for the symbolic. "How your brain must have labored, and how you have risked everything to the very limit, where vertigo is inevitable!" He advises Vincent "not to venture into the mysterious regions" for the sake of his recovery. Somewhat sarcastically, Theo comments on the Volpini café exhibition (which he compares to entering

the World's Fair "by the back stairs"). The other day (6 June), a painting of the Angel Raphael, called the Angel Gabriel by Theo and Vincent and at that time attributed to Rembrandt (present location unknown), was sold at auction in Paris. Gauguin left for Pont-Aven two weeks ago, "so he has not seen your pictures." But Isaäcson has seen them and is very impressed. Theo will return the *Bedroom* (F482), enabling Vincent to make a copy of it and then send it back to Paris to be relined.

c. Tuesday 18 June

Vincent replies to Theo (LT595), thanking him for "yesterday's letter" (T10). He is well, having lived soberly for six months; but he insists that work, far from wearing him out (as Theo had feared), actually helps by occupying and distracting him. He is also less critical than Theo of Gauguin's and Bernard's part in organizing the Volpini café exhibition: "Neither...is an artist who could ever look as if he were trying to get into a universal exhibition by the back stairs." And he recalls his own two efforts at organizing exhibitions in Parisian cafés in 1887. He has finished "a landscape with olive trees [cat. 13] and a new study of a starry sky [cat. 14]." And, even without seeing their latest canvases, he feels that these two studies are parallel in feeling to those by Gauguin and Bernard. He has no more white paint. And he asks Theo to have the damaged *Bedroom* relined *before* sending it. He wants to read Shakespeare again, and asks Theo to send a cheap edition, such as *Dick's Shilling Shakespeare*. He is dispatching a roll of drawings, two of Arles (F1467, F1468), the rest of Saint-Rémy—*Fields* (F1543) and *Olives* (F1555), and "other hasty studies made in the garden."

Once again, he reassures Theo about his work: "Do not fear that I should ever of my own will risk myself on some dizzy heights.... With the number of precautions I am now taking, I am not likely to relapse, and I hope that the attacks will not begin again."

Tuesday 25 June

Vincent writes to Theo (LT596). He encloses an order for paints replacing the one in his letter of about 9 June (LT594). In glorious weather, he now has twelve size 30 canvases in progress, including two of cypresses (cat. 15; cat. 19, fig. 15). He has received—probably from one of his sisters—Édouard Rod's novel *Le Sens de la vie* (1889). He has also reread *Zadig ou la destinée* (1748) by Voltaire. He has finished a wheat field (cat. 27, fig. 28), "very yellow and very light, perhaps the lightest canvas I have done." In his letter he includes a quick sketch of one of the cypress paintings, and promises to send drawings of both cypress paintings together with two other drawings. He also hopes to send some new drawings next week. Provoked by Theo's reference to the painting of the "Angel

Photograph of Wilhelmina Jacoba van Gogh. Rijksmuseum Vincent van Gogh (Vincent van Gogh Foundation), Amsterdam

Photograph of Anna Cornelia Carbentus van Gogh. Rijksmuseum Vincent van Gogh (Vincent van Gogh Foundation), Amsterdam

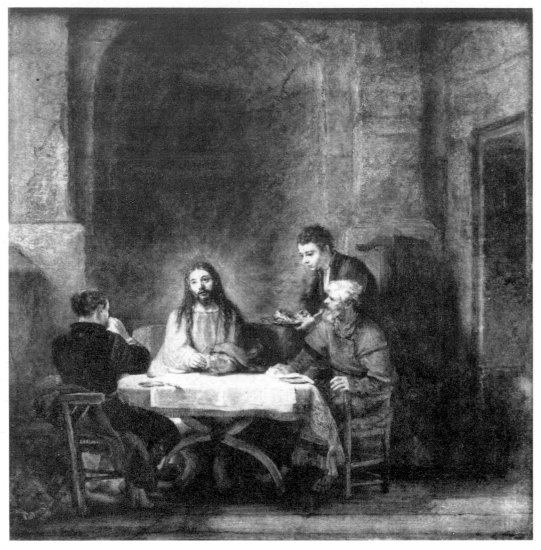

Rembrandt van Rijn. *Christ at Emmaus*, 1648 (Bredius 578).
Oil on panel, 26¾ x 25⅝ in. (68 x 65 cm.). Musée du Louvre, Paris

Gabriel," he discusses Rembrandt, suggesting that his brother send a print (or photograph?) after the *Christ at Emmaus* to the Reverend Salles.

Monday 1 July

In Paris the sale is held of the Secrétan collection, which includes Millet's *The Angelus* (1855–57; Musée d'Orsay, Paris).

Tuesday 2 July

Vincent writes to Theo (LT597), enclosing a letter he has received from his mother (Anna Cornelia Carbentus van Gogh, 1819–1907) which, having been written by a woman of seventy years, has greatly impressed him with its firm, clear handwriting and "inner serenity and calm contentment," brought about, he thinks, by Theo's mar-

riage. He thanks his brother for the package of paints and the Shakespeare—he is reading the history plays *Richard II, Henry IV,* and *Henry V.* He intends to dispatch some ten or so drawings today, all done from the canvases he is working on (see cat. 16–19). The latest is the *Reaper* (cat. 27, fig. 28); he also has a *Wheat Field with Cypresses* (F717). He is anxious to visit Arles, especially to collect the canvases left there to dry.

Clearly moved by his mother's letter, Vincent writes to her after a lapse of seven months (LT598). He repeats—and embellishes upon—what he has just written to Theo about her firm handwriting, her "youthfulness," her happiness at Theo's marriage. He also sympathetically shares her sadness at the imminent departure (in mid-August) of her youngest son, Cor (Cornelis Vincent van Gogh, 1867–1900), for the Transvaal. Knowing her love of nature, he describes how he has been painting in the wheat

Lithograph after Jean-François Millet, *The Angelus*. Rijksmuseum
Vincent van Gogh (Vincent van Gogh Foundation), Amsterdam

fields "during the hottest part of the day, without being unduly troubled by it. But sometimes one notices that the sun is rather powerful, as the grain gets yellow very soon. . . . Here there are very beautiful fields with olive trees, which are silvery gray in leaf, like pollard willows. The hills are full of thyme and other aromatic plants. But one never sees those moss-covered roofs on the barns or cottages as at home, nor the old coppices, nor spurry, nor beech hedges with their white tangled old stems. Nor the real heather, nor the birches which were so beautiful in Nuenen."

He writes a third letter—to his sister Wil (W13), thanking her for Rod's novel and telling her he has just sent Theo a dozen drawings after canvases he is working on. He tells her too that Gauguin and others have organized an exhibition at Volpini's café, and that yesterday (at the Secrétan sale) more than half a million francs were paid for

Millet's *The Angelus*. Shakespeare continues to absorb him; since writing to Theo earlier in the day, he has finished *Henry V* and begun *Henry VI*.

Friday 5 July

Jo writes to Vincent (T11), announcing that she is expecting a child next February: he will, she is quite certain, be "a pretty little boy"; they will call him Vincent. She confesses that at first she was unhappy with the news, thinking that because she and Theo are not in the best of health the child might be weak. But the doctor has been very reassuring. She goes on to describe something of their way of life. Theo always lunches at home. Often in the evening they have visitors —Isaäcson or de Haan or the Pissarros. "In general we are very tired at night, and we go to bed early, but notwithstanding this I think Theo is looking far from

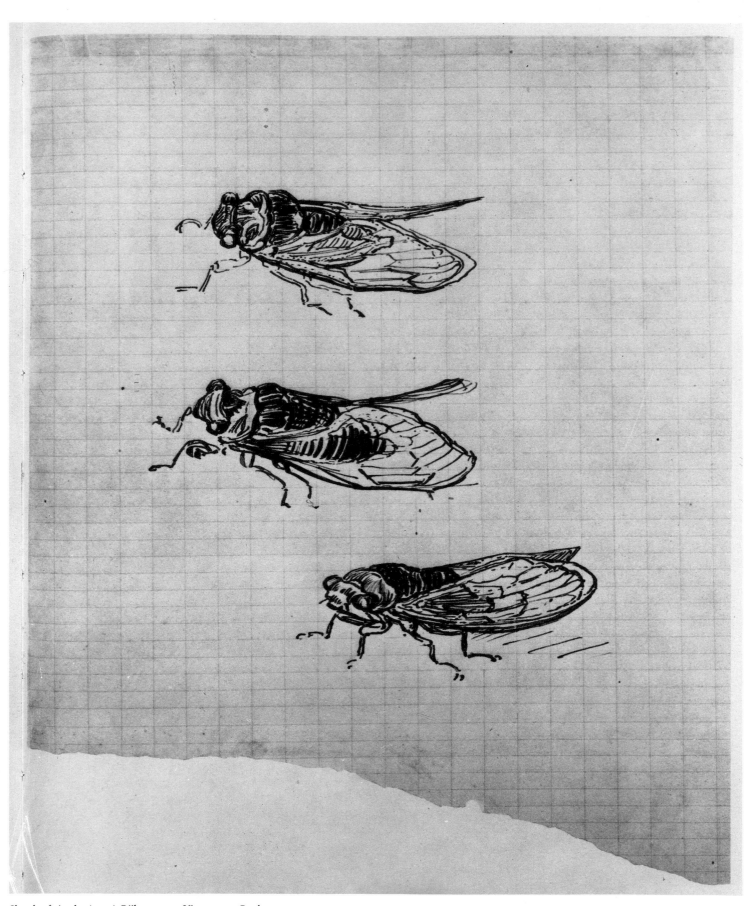

Sketch of cicadas (LT603). Rijksmuseum Vincent van Gogh
(Vincent van Gogh Foundation), Amsterdam

well, but that Secrétan sale caused him a lot of fatigue, and besides, the heat is so overwhelming!"

Van Gogh reads *Measure for Measure* and *Henry VIII*.

Saturday 6 July

Vincent replies to Jo's letter (LT599), welcoming the news of her pregnancy ("remember that Roulin's child came to them smiling and very healthy when the parents were in straits"), and reassuring her about Theo's health ("like mine, too, more changeable and uneven than feeble").

This morning he talked with Dr. Peyron, who confirmed what he himself already felt—that he must wait a year before thinking himself cured, "since the least little thing might bring on another attack." Dr. Peyron has offered to store his furniture at the asylum (it is at present at the Ginoux's café in Arles), "so that we should not be paying double." Tomorrow he hopes to visit Arles. For six months, he explains to Jo, he has lived soberly and frugally. In the past he drank too much. His present deliberate sobriety suggests to him painting in gray, in contrast to painting in color. "I am going to paint more in gray, in fact."

Reading Shakespeare makes him hope that he may read Homer at last. He compares the decline of the South with that of the North: "Outside the cicadas are singing fit to burst, a harsh screeching, ten times stronger than that of the crickets, and the scorched grass takes on lovely tones of old gold. And the beautiful towns of the South are in the same state as our dead towns along the Zuider Zee that were once so bustling. Yet in the decline and decadence of things, the cicadas dear to the good Socrates abide. And here certainly they still sing in ancient Greek."

Vincent closes his letter by reaffirming his joy at the news of Jo's pregnancy.

Sunday 7 July

Accompanied by the head attendant from the asylum, van Gogh visits Arles, mainly to collect his paintings. He also wants to discuss the fate of his furniture with the Ginoux, and to see the Reverend Salles, Dr. Rey, and his former charwoman. Unfortunately, the pastor is on vacation for two months and Dr. Rey is not to be found at the hospital. He ends up spending the day "with my former neighbors, such as my old charwoman and some others" (LT600).

Monday 8–Saturday 13 July

Having brought back some eight canvases from Arles, van Gogh is now able to review them before sending them to Paris. "Having kept back a big study of an orchard which had given me great difficulty [F511] . . . I set myself to work it over again from memory [F512], and I have found the way to express the harmony of the tones more strongly" (LT603). As well as concerning himself with his Arles pictures, he works on three new subjects taken in and around the asylum grounds. These are a new study of ivy-covered tree trunks (F746), a "view of mountains with a dark hut at the bottom among some olive trees [cat. 20]," and a "moonrise over a wheat field, now with stacks [F735]."

c. Sunday 14 July

Vincent writes three letters—one to Theo (LT600) which he sends off, and one to Gauguin (the letter is lost) which he encloses with a second letter to Theo (LT603). In his first letter to his brother, he reports on his visit to Arles and alerts him that he will be sending the next day a roll of eleven canvases, four that are pictures (two of Arles, two of Saint-Rémy) and seven that are "more studies from nature than subjects for pictures" (four of Arles, three of Saint-Rémy). The next package, to follow soon, will comprise mostly wheat fields and olive orchards. He has received the second parcel of canvas and paints.

"What a business, the Secrétan sale [this is the first time he mentions the sale to Theo]. I am always pleased that the Millets hold their own. But I should very much like to see more good reproductions of Millet, so as to reach the people. His work is sublime, especially considered as a whole, and it will become more and more difficult to get an idea of it when the pictures are dispersed."

Van Gogh's letter to Gauguin is the first to his artist friend since his arrival in Saint-Rémy. He chooses this moment to write for several reasons: he feels calmer, he can report on his trip to Arles, he can discuss the Volpini café exhibition, and he can talk of his own work. He includes in the letter a sketch of the *Reaper* (cat. 27, fig. 28) which he is busy with just now.

In his second letter to Theo (LT603), he explains why he has just written to Gauguin. He is also eager to know Theo's feelings as a future father. He reports on two paintings in progress (F735, F746). His recovery, he thinks, must be "slow and patient," and he hopes for sufficient strength to face the coming winter, especially as he must occupy himself with retouching many of last year's studies from Arles. He asks Theo if the two packages of drawings have arrived, and encloses a sketch of cicadas described in an earlier letter (LT599). He recalls their memories of the old Dutch heaths, contrasting them with his brother's life in Paris—"exile and stranger and poor man that you are." "The circumstances of living in a state so far removed from our youthful conceptions of an artist's life must make us brothers in spite of everything,

as we are in so many ways companions in fate." Theo's health, strength, and happiness will be regained as he experiences fatherhood. It was anxiety about Jo's pregnancy—and not, as Vincent had imagined, worry on his account—that was "the cause of your comparatively long silence."

c. Monday 15 July

Van Gogh sends the roll of eleven canvases to Paris.

Tuesday 16 July

Theo responds after a month's silence (T12): "I have been absolutely unable to write sooner, for the heat has been overwhelming, and I felt so weak that everything made me feel extremely tired. Now I have almost recovered from it—for good, I hope."

He thanks Vincent for his several letters, and also for the drawings. He prefers those done from nature to those done after paintings, which "give the impression of having been made in a fury."

The last consignment from Arles has been seen by artists and friends—the Pissarros, Julien (Père) Tanguy (1825–1894), the Norwegian painter Erik Theodor Werenskiold (1855–1938), and Octave Maus (1856–1919), secretary of Les XX (Les Vingt), a group of avant-garde artists in Brussels. "[Maus] came to ask me whether you would be willing to send work for their next exhibition. There is plenty of time for it. . . . I told him that I did not suppose you would have any objections. . . . In general people like the night effect [cat. 14, fig. 11] and the sunflowers [F454, F456]. I have put one of the sunflower pieces in our dining room over the mantelpiece. It has the effect of a piece of cloth with satin and gold embroidery; it is magnificent."

Theo has given up the apartment at 54 Rue Lepic as of 15 July and has rented a small room at Tanguy's to store his brother's pictures. De Haan was recently in Paris, but has now rejoined Gauguin in Brittany, leaving his friend Isaäcson "all at sea." Gauguin wrote last week (GAC14, c. 10 or 11 July), asking for Vincent's address. He is writing for Le Moderniste, a periodical edited by G.-Albert Aurier (1865–1892), a copy of which Theo is sending.

Theo is sorry to hear that Vincent missed seeing the Reverend Salles and Dr. Rey in Arles, but he himself has had a letter from Salles (the letter is lost). Before receiving Vincent's letter (LT596) suggesting that Salles be sent a print of Rembrandt's Christ at Emmaus, Theo had already sent him a lithograph after Millet's The Angelus.

Jo's parents are coming to Paris next week.

Theo encloses a money order for 100 francs: "Since you did not see M. Salles, it is possible you need something."

It is probably on this day that van Gogh is struck down by "a new attack" that "came on me in the fields when I was busy painting . . . on a windy day. . . . I finished [the painting, cat. 21] in spite of it" (LT601). This first attack in Saint-Rémy lasts some five weeks. Dr. Peyron does not inform Theo immediately. Believing his brother still to be well, Theo writes on Monday 29 July (T13), a little uneasy at not having had a reply to his letter of 16 July. He confirms that he has received the last consignment of paintings, which he likes very much, and that Dr. Peyron, in a recent letter (now lost; probably of mid-July), reported that van Gogh's condition was satisfactory. Theo himself "looks like a corpse," but a visit to Dr. Louis Rivet has put a stop to his cough.

c. Thursday 1 August

Still unaware of Vincent's condition, Theo sends a telegram, which produces a response (also lost) from Dr. Peyron, who admits that van Gogh has been ill for a day or two, but is already recovering a little.

Sunday 4 August

Theo sends a short encouraging note (T14) to Vincent, written in Dutch rather than French, presumably to keep the contents private. He reports on Dr. Peyron's letter; tells Vincent that "our little guest room . . . was inaugurated the other day by Jo's mother," and is always available for him; and that "my cough is entirely gone now, thanks to Rivet's remedies." He reassures Vincent: "In your last letter [LT603] you wrote me that we were brothers for more than one reason. This is what I feel too, and though my heart is not as sensitive as yours, I can enter at times into your feeling of being smothered by so many thoughts that cannot be resolved. Never lose courage, and remember how much I need you."

Friday 16 August

Jo writes a short letter, also in Dutch (T15). She thanks Vincent for his letter (now lost) to Cor, which was handed to him this morning when he arrived in Paris en route to Southampton and the Transvaal. Theo, she reports, "was just a little bit disappointed that there was not a single little word for him; do write him soon—if only one tiny word—we are so anxious to hear from you personally to know how you are, and we hope from the bottom of our hearts that you will be feeling better soon."

Thursday 22 August

Vincent writes a short letter (LT601) in pencil to Theo, answering Jo's letter of 16 August. Distressed by the return of another attack, his head is very "disordered." He asks Theo to write to Dr. Peyron, explaining that

"working on my pictures is almost a necessity for my recovery, for these days without anything to do, and without being able to go to the room they had allotted me to do my painting in, are almost unbearable." (Presumably Dr. Peyron is reluctant to allow him to begin painting again, since he had eaten his poisonous paints during his attack.)

Roulin has written a letter (dated 19 August) from Marseilles. So has Gauguin—"a kind letter [now lost], always a little vague and obscure, but after all I must say that I think they are right to have an exhibition [at Volpini's] among themselves." A catalogue of the exhibition has been sent to him (probably by Gauguin).

"For many days *my mind has been absolutely wandering*, as in Arles, quite as much if not worse, and presumably the attacks will come back again in the future—it is *abominable*. For four days I have not been able to eat because of a swollen throat."

He is pleased that his consignment of landscape paintings, sent in early July, has arrived (T13). He thanks Theo for sending an etching after Rembrandt's painting of the "Angel Gabriel" (auctioned in Paris on 6 June), and asks him to send one to Gauguin. He also acknowledges receiving the "very interesting" catalogue of the important exhibition of the work of Claude Monet (1840–1926) and Auguste Rodin (1840–1917) at the Galerie Georges Petit in Paris.

Mother and Wil have written a "very nice letter."

Friday 23 August

Theo and Jo receive Vincent's penciled letter, which Jo discusses in a letter she is writing to Wil (Hulsker, "What Theo Really Thought of Vincent," p. 19).

Saturday 24 August

Theo adds a paragraph to Jo's letter to Wil: "News about Vincent these days was bad again. . . . He seems to have had a complete relapse. Fortunately we got a letter from him yesterday in which he speaks highly of his treatment and the doctor, but he feels deeply the misery of not being certain of his condition."

Yet there is no evidence that Jo and Theo write to Vincent or to Dr. Peyron, even though Vincent had asked his brother to do so. Perhaps relieved to receive the penciled note, they are content to wait for another letter.

During the next days, there is no further news of van Gogh. His weakened mental and physical state, not helped by his swollen throat, the disturbing dreams he continues to have, and the consequent confinement to his room, where he is forbidden to paint, greatly increase his

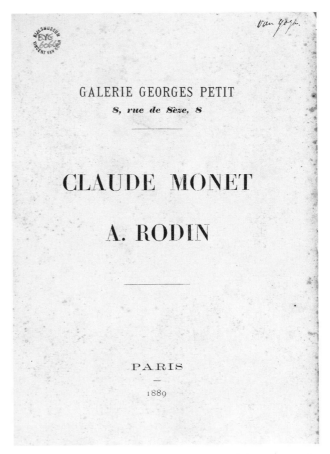

Title page of the catalogue of the Monet–Rodin exhibition, Galerie Georges Petit, Paris, 1889

dejection. It seems probable that he does not "get up" until about 28 August, when he begins working on a self-portrait (cat. 22). (His own evidence is conflicting here. He writes in LT602: "Yesterday, I began to work a little again" on a landscape (cat. 23); but in LT604 he refers to the *Self-Portrait*: "I began [it] the day I got up.")

c. Friday 30 August

Vincent tells Theo (LT602) he is feeling better, and that yesterday he began to work a little again "on a thing that I see from my window [cat. 23]." "Work distracts me infinitely better than anything else. . . . There are some beautiful things to be done. The vineyards, and the fields of olives." He hopes he will soon be allowed outside the grounds of the asylum and "into the mountains to paint the whole day."

He is in a bad humor. He has little confidence in the management of the asylum; it is expensive; he is now afraid of the other patients; and he might, if he gets better, return to Paris or go to Brittany. However, he is grateful for Dr. Peyron's kindness.

He must try to write to Mother and Wil, who will soon be moving from Breda to Leiden. Wil has asked him to

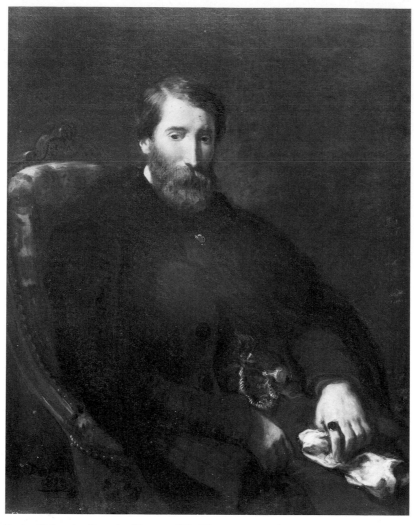

Eugène Delacroix. *Portrait of Bruyas*, 1853. Oil on canvas, 45⅝ x 35 in.
(116 x 89 cm.). Musée Fabre, Montpellier. Photograph by Claude O'Sughrue

send Mother a painting (for her seventieth birthday), and he will add another for his sister Lies (Elisabeth Huberta van Gogh, 1859–1936), who has nothing by him.

He has read the Monet–Rodin catalogue but disagrees with the author of the preface, the art critic Octave Mirbeau (1850–1917), who denigrates Jean-Louis-Ernst Meissonier (1815–1891) and has scant regard for Rousseau. He recalls artists he admired in his younger days, especially Karl Bodmer (1809–1893), not just for his color but as a man who "knew the whole forest of Fontainebleau," and Gustave Brion (1824–1877), the Alsace-born painter who illustrated Victor Hugo's *Les Misérables* (1862) "in a way not yet surpassed," making "no blunders about his characters." Recalling the Bruyas collection at Montpellier, Vincent is still moved by some portraits of Bruyas where "his face is so heartbroken and obviously frustrated" when he thinks of "what he tried to be to artists."

He is pleased that Dr. Rivet has cured Theo's cough (T13,

T14). As for himself, "The trouble I had in my throat is beginning to disappear; I still eat with some difficulty, but after all it has got better."

On the last page of this letter, Dr. Peyron adds some reassuring words (LT602a): "[Vincent] has quite recovered from his crisis, . . . he has completely regained his lucidity of mind, and . . . he has resumed painting just as he used to do. His thoughts of suicide have disappeared; only disturbing dreams remain, but they tend to disappear too, and their intensity is less great. His appetite has returned, and he has resumed his usual mode of life."

c. Monday 2 September

Having promised in his previous letter to write again soon, van Gogh begins another letter to his brother (LT604). During his illness, four letters had arrived from Theo and Jo (T12–T15). He now responds to the letter of 16 July (T12). He notes that Theo has rented a room at Tanguy's to store some of his paintings; he is happy to partici-

pate in the next exhibition of Les XX in Brussels, "though I feel my inferiority beside so many of the Belgians, who have tremendous talent."

He is working in his room "at full speed; it does me good and drives away, I think, these abnormal ideas." He has redone the canvas of his bedroom (F482), which must be properly relined sooner or later. He is busy on two self-portraits, one (cat. 22) begun the day he "got up": "I was thin and pale as a ghost. It is dark violet blue and the head whitish with yellow hair, so it has a color effect"; the other (cat. 22, fig. 19), begun since, is "three-quarter length on a light background." He is also busy "touching up the studies of this summer—altogether I am working from morning to night."

LT604. Rijksmuseum Vincent van Gogh (Vincent van Gogh Foundation), Amsterdam

This letter is interrupted and continued "little by little in the intervals when I am tired of painting." Taking up his letter once more, he tells Theo he has been working again on the same *Reaper* (cat. 27, fig. 28) that he began in late June, and that he intends to do it again on a new canvas (cat. 27).

After a further interruption, he returns to his letter (page four): "I am working like one actually possessed; more than ever I am in a dumb fury of work. And I think that this will help cure me." He might exhibit the *Reaper* and the *Self-Portrait* (cat. 22, fig. 19) with Les XX. Already it is September, winter is approaching; he hopes to continue working very hard until Christmas and see if he has another attack then. He is thinking of returning to the North, but not yet. "To leave now, when I judge a new attack next winter probable, that is to say in three months, would perhaps be too risky."

He is anxious to venture outdoors again: "It is six weeks since I put a foot outside, even in the garden; next week, however, when I shall have finished the canvases I'm working on, I'm going to try."

c. Tuesday 3 September

He begins work on a portrait of Trabuc (now lost), the head attendant at the asylum, and so apparently does not continue his letter.

The opening in Paris, on 3 September, of the fifth exhibition of the Société des Artistes Indépendants, where van Gogh is represented by *Starry Night Over the Rhône* (cat. 14, fig. 11) and *Irises* (cat. 1).

c. Wednesday 4 September

He takes up his letter once again (page five), describing yesterday's work on the portrait of Trabuc, of which he hopes to do a duplicate for Theo.

Some days ago he read in *Le Figaro* "the story of a Russian writer [Dostoevsky] who suffered all his life from a nervous disease which he finally died of, and which brought on terrible attacks from time to time." The only cure for such an illness, he thinks, is to work unremittingly. He hopes the *Self-Portrait,* which he has just finished, will reassure Theo and "will tell you better than my letter how I am." He completes the copy of the *Reaper* (cat. 27), and he promises Theo twelve size 30 canvases by the end of the month, "but they will nearly all be the same picture twice over, the study and the final picture [*l'étude et le tableau définitif*]."

Referring to a character in the Goncourts' novel *Manette Salomon* (1867) who says, "What will last is the landscape painters," van Gogh insists that portraiture is just as important as landscape, if not more so. "The desire I have to make portraits these days is terribly intense; indeed, Gau-

Cover of the catalogue of the fifth exhibition of the Société des Artistes Indépendants. Paris, September 1889

guin and I talked about this and other analogous questions until our nerves were so strained there wasn't a spark of vital warmth left in us." And he again recalls receiving a letter from Gauguin (see 22 August), and wonders what "good work" is being done in Brittany.

Theo is asked to send 10 meters of canvas and a supply of paints and brushes.

The *Reaper* is finished.

c. Thursday 5 September

Having already written an eight-page letter at intervals over three days, van Gogh now adds a twenty-four line postscript on both sides of a separate half sheet. He stresses that he would like to do the *Reaper* again for his mother—"If not, I will paint her another picture for her birthday [10 September]." Again he reminds Theo to send canvas as soon as possible, as he wants to make other duplicates for his two sisters (Lies and Wil), and he expects to have three versions each of the *Reaper,* as well as of the *Bedroom,* the *Olives,* and the *Wheat Field and Cypresses.* He adds that he will even make *four,* "for then I have still another person for whom I will do one too [his little nephew?]....I am taking the best from the twelve subjects

so that the things they are going to get will be really a little studied and chosen."

At last, van Gogh signs this protracted letter and puts it in an envelope. In the afternoon, he continues working on the Trabuc portrait, "which is getting on."

He then sees Dr. Peyron for the first time in six days. He therefore reopens his letter, adding two additional pages, telling Theo of his talk with Dr. Peyron, who plans to visit Paris during September. He also recalls, yet again, his visit with Gauguin to Montpellier in December 1888, when he was especially struck by the "halftones" in Delacroix's paintings. "It is time," he concludes, "I sent this letter off at last—I could tell you in two pages what it contains, that is to say, nothing new, but then I haven't time to do it again."

He begins a letter to his mother and Wil, but he "has not the brains to finish it" (LT605).

In Paris, Theo responds (T16) to Vincent's letter of about 30 August. He likes "the view from your window—which you give a sketch of [cat. 23]," and he takes up the brothers' familiar refrain, the contrast of city and country, citing the work of Bodmer and Théodore Rousseau, the latter of whose pictures he had seen at the Paris World's Fair. He gives Vincent news of Pissarro—of the fine rustic quality of his recent work, of the death of his mother, and of an eye operation he has recently undergone. He talks too of the Dutch artist Weissenbruch and of the batch of canvases Gauguin has sent from Brittany, which in general he likes less than last year's batch, with the exception of *La Belle Angèle* (1889; Musée d'Orsay, Paris). The Salon des

Paul Gauguin. *La Belle Angèle,* 1889. Oil on canvas, 36¼ x 28¾ in. (92.1 x 73 cm.). Musée d'Orsay, Paris

Lithograph by Celestin Nanteuil after Eugène Delacroix, *Pietà*.
The New York Public Library. Prints Division

Pietà (after Delacroix) (F630). Oil on canvas, 28¾ x 24 in.
(73 x 60.5 cm.). Rijksmuseum Vincent van Gogh
(Vincent van Gogh Foundation), Amsterdam

Indépendants, where Vincent's *Irises* (cat. 1) and *Starry Night Over the Rhône* (cat. 14, fig. 11) are hung, has opened. Each artist was permitted to hang only two works. Theo mentions those by Henri de Toulouse-Lautrec (1864–1901), Georges Seurat (1859–1891), Paul Signac (1863–1935), and Louis Hayet (1864–1940). He assures his brother that he is now in good health and hardly coughing anymore; Jo too is well, and Mother has heard from Cor.

Friday 6 September

Vincent receives Theo's letter of 5 September. The fact that it is Theo's first letter since his recovery—and also an unusually long and informative one—clearly stimulates an immediate response (LT605), evidently written in one sitting, with no sign of interruptions. It is concerned with South versus North; with the question of staying on in Saint-Rémy or returning to the North—to Paris or its environs, or even to Pont-Aven. His total, day-long commitment to painting makes him "eat like two now, work hard, limit relations with the other patients for fear of a relapse....I am now trying to recover like a man who meant to commit suicide and, finding the water too cold, tries to regain the bank." Despite all the advantages of the South—the purer light, the correspondences with Japan, the stronger sun, the colors of the prism—he has "a terrible desire...to see my friends again and to see the Northern countryside again."

His attacks, he feels, "tend to take an absurd religious turn," induced perhaps "by living in these old cloisters so many months, both in the Arles hospital and here." He is frustrated by the nuns who administer the asylum, yet he accepts that religious thoughts, when he is suffering, sometimes bring him great consolation. During his recent attack the lithograph of Delacroix's *Pietà* was ruined by falling into some oil. Disturbed by this, he has been busy making a copy of it (F630). The portrait of Trabuc is finished, and he has done a duplicate for Theo (cat. 24).

Yesterday, when he saw Dr. Peyron for the first time in six days, he asked the doctor point blank, "'Since you are going to Paris, what would you say if I suggested that you should be kind enough to take me with you?' He replied evasively—it was too sudden, he must write to you first."

In his urge to return to the North, van Gogh proposes that Camille Pissarro might allow him to stay with his family at Eragny-sur-Epte, a village some twenty-five miles north of Paris. Otherwise, he might be able to stay with another artist, perhaps Victor Vignon (1847–1909) or Auguste Jouve (b. 1846) in Paris.

He again asks Theo to send quickly the canvas he requested in his previous letter, as well as an additional ten tubes of zinc white. He talks of Gauguin ("still hoping to do his portrait"), of Delacroix, of portraits, of Eugène

Wood engraving by Jacques-Adrien Lavieille after Jean-François Millet, *Labors of the Field*. Rijksmuseum Vincent van Gogh (Vincent van Gogh Foundation), Amsterdam

Fromentin (1820–1876) ("the first to establish a link between Rembrandt and the Midi, between Potter [Paulus Potter, 1625–1654] and what he saw himself"), and of his wish to make duplicates of some of his Arles canvases.

It is now almost two months since he has been in the open air. "I tried in vain to force myself to go downstairs." He confesses to his brother: "From the first day I refused to take the stale and slightly spoiled food, eating only bread and a little soup. After the last attack, M. Peyron gave me some wine and meat, which I accepted willingly the first days, but he didn't want to make an exception to the rule for long, and he is right to accept the ordinary rules of the establishment." Dr. Peyron plans to visit Paris soon and will talk with Theo then.

Saturday 7–Thursday 19 September

After three extremely long and informative letters, van Gogh draws breath, shuts himself up in his studio, and writes no more letters until 19 September. (He even fails to send greetings to his mother on her seventieth birthday on 10 September.) The detailed commentary he gave on his painting activity during the last days of August and the early days of September is therefore lost. Retrospectively, from three letters he writes on 19 September, it seems probable that he continues working on duplicates of his summer canvases, such as *Wheat Field with Cypresses* (F615); and, more certainly, he begins his series of ten painted copies after *Labors of the Field*, a set of ten black-and-white wood engravings made after Millet's paintings by Jacques-Adrien Lavieille (1818–1862). It cannot be firmly established which seven canvases of the ten are completed during these days, nor in what order he does them.

He completes a portrait of Madame Trabuc from life (now lost), which he presents to the sitter, and makes a duplicate for Theo (cat. 24, fig. 24). He works on a reduced copy of the *Reaper* (F619) for his mother, and possibly a *Pietà* for Wil (F757); probably receives a letter from Wil (see LT607, W14); and still refuses to go outdoors, even into the garden. There is no evidence that he sees Dr. Peyron during this time.

Wednesday 18 September

Theo writes to Vincent (T17). He apologizes for his delay in answering and explains that he has been trying to contact Camille Pissarro about the possibility of Vincent's staying with the Pissarros at Eragny. He hopes to see Pissarro when he is next in Paris, but feels there is little chance of Vincent's going to live with them (de Haan had hoped to do the same last year, but this had not materialized). Jouve has no room in his apartment.

Theo advises his brother to eat more, especially meat, both to strengthen himself and to try to banish those "dark thoughts"; insists that he should stay under the supervision of a doctor; wonders why he stays locked up indoors instead of going out into the fresh air ("a sedentary life won't do for you at all"); and asks that Vincent *"give a categorical answer"* to the question of going to a sanatorium in or near Paris for the winter, and then returning to the country to paint in the spring.

Thursday 19 September

After many attempts and delays, van Gogh writes to his mother (LT606), sending belated congratulations on her seventieth birthday and promising a picture shortly (the *Reaper,* F619). He thinks it right that after Cor's departure for South Africa she and Wil should leave Breda and move to Leiden. Reassuring her about his health, he explains that he is "working from morning to night almost without interruption, day after day," locking himself in his studio to avoid distraction. "As often as I have the chance, I work at portraits, which I myself sometimes think are better and more serious than the rest of my work." He is thinking of moving back to Paris or its vicinity, having a great longing to be near his friends and to work in the North— and, of course, to see Theo again and to meet Jo.

He also writes to Wil (W14), his first letter to her since his recovery. He has made two attempts to answer her letters, but without success. Telling her of his copy after Delacroix's *Pietà* (F757) and his copies after Millet's *Labors of the Field,* he explains: "I don't especially like to see my own pictures in my bedroom, which is why I copied one picture by Delacroix and some others by Millet." He reports too on his portrait of Madame Trabuc, which he finished the other day, and on his two self-portraits. He is contemplating sending some canvases to her and Mother, "probably a field of wheat and an olive orchard, together with that copy after Delacroix."

The weather is marvelous, but he has not left his room for two months. "Since my illness, when I am in the fields I am overwhelmed by a feeling of loneliness to such a horrible extent that I shy away from going out. But this will change all the same as time goes on. Only when I stand painting before my easel do I feel somewhat alive."

Toward the end of his letter, he tells Wil that he has "this very moment" received a letter from Theo. This is Theo's letter of 18 September. Vincent replies immediately (LT607). Emphasizing that his wish to leave the South and return to the North is prompted above all by the attacks he has had, such as a superstitious man might have "in a fit of religious exaltation," he is nonetheless calm enough to wait in the South and see if he has another attack in the winter. But, he says, the moment he writes "I want to go away from here," Theo must act without delay.

He reports on his copies after Delacroix's *Pietà* and Millet's *Labors of the Field,* as well as the two portraits of Madame Trabuc. He is working on a copy of Millet's *Sheepshearers* (F634) "in a color scheme ranging from lilac to yellow," and intends to send Theo a *Self-Portrait* (cat. 22, fig. 19) and nine other paintings, to which he will add a study of flowers.

Friday 20–Friday 27 September

Dr. Peyron visits Theo in Paris.

Van Gogh is busy on small canvases for his mother and Wil, reduced copies of some of his summer paintings and of the *Bedroom* (cat. 25, fig. 26).

Saturday 28 September

Vincent writes to Theo (LT608), primarily to describe the contents of the roll of canvases he is sending. The four or five smaller canvases destined for Mother and Wil are drying and will be dispatched soon. He needs more paints, as he is eager to capture the lovely autumn effects, especially of the olive trees.

Dr. Peyron has returned from Paris "and talked to me about having seen you and said that doubtless your letter would give me all the details of the conversation he had with you. And that in any case the result was that it would be wise to stay on here for a while. Which, being my own opinion too, goes without saying. Nevertheless, if an attack returns, I persist in wanting to try a change of climate and returning to the North, even as a last resort."

Sunday 29 September- Friday 4 October

By now, van Gogh has overcome his fears about venturing outdoors. He is already observing—if not actually painting—the olive trees. But his first descriptions of *plein-air* painting are not of olive trees. "Among others, a mulberry tree all yellow on stony ground, outlined against the blue of the sky [F637], in which study I hope you will see that I am on Monticelli's track." Also "a study of two yellowing poplars against a background of mountains [F638]."

Saturday 5 October

Vincent receives a letter from Theo dated 4 October (T18), acknowledging receipt of the last consignment of work. Theo writes that the Dutch artist and art critic J. J. Isaäcson would like to do an article on Vincent's work for the Dutch periodical *De Portefeuille*. He promises to include some of Isaäcson's articles when he sends the reproductions after Millet that Vincent has requested.

During his recent visit to Paris, Dr. Peyron told Theo that he did not believe that Vincent was mad: the crises, he said, are of an epileptic nature, the last one in July having been provoked by the trip to Arles.

Theo has talked with Pissarro, who has recommended someone at Auvers "who is a doctor and does painting in his spare time. He tells me the gentleman in question has been in contact with all the impressionists. He thinks that you might possibly stay with him. He has to look him up, and will talk about the matter." The unnamed doctor is Paul-Ferdinand Gachet (1828–1909).

Bernard is coming tomorrow to look at Vincent's pictures.

Van Gogh replies immediately (LT609). He recapitulates on the paintings completed during the last week; expresses great surprise that Isaäcson wishes to write about his work, and, in fact, strongly wants to discourage him from doing so; is grateful to hear that Dr. Peyron has discussed his condition so sympathetically, but did not suspect that he "believed in any connection between my previous journey [to Arles] and the attack that closely followed it." Nevertheless, he is already thinking of again visiting Arles: "There are some people there [the Ginoux] whom I felt, and again feel, the need of seeing." He now thinks he will be staying on in Saint-Rémy until the spring.

His first mention of Auvers is in response to Camille Pissarro's recommendation of Dr. Gachet. "What you say of Auvers is...a very pleasant prospect.... If I come north, even supposing that there is no room at this doctor's house, it is probable that after your recommendation and old Pissarro's he would find me board either with a family or quite simply at an inn. The main thing is to know the doctor, so that in case of an attack I do not fall into the hands of the police and get carried off to an asylum by force. And I assure you that the North will interest me like a new country."

He feels behind in his correspondence, especially letters to Isaäcson, Gauguin, and Bernard; he would like to see what Gauguin and Bernard have brought (or sent) back from Brittany; and he has seen "very beautiful subjects for tomorrow—in the mountains."

Sunday 6- Friday 11 October

Van Gogh continues working out of doors, both on the asylum grounds and beyond, and probably begins writing letters to Gauguin, Isaäcson, and Bernard.

Saturday 12 October

Vincent tells Theo (LT610) of the completion, during the last week or so, of five landscapes: *Enclosed Field with Peasant* (cat. 28), *Entrance to a Quarry* (cat. 35), two views of the asylum garden (cat. 31, 32), and the *Ravine* (F662). He has also completed a painted copy of *Husband at Sea* by Virginie Demont-Breton (1859–1935), almost all in violet (F644). He would like to do more studies of the Alpilles, including some at sunset, but he is not allowed out at that hour. He hopes to make a long trip into the mountains to look for suitable motifs. He has no canvas, and hopes Theo will send some soon.

"I am feeling well just now. I think M. Peyron is right when he says that I am not strictly speaking mad, for my mind is absolutely normal in the intervals, and even more so than before. But during the attacks it is terrible—and then I lose consciousness of everything. But that spurs me on to work and to seriousness, like a miner who is always in danger makes haste in what he does." He encloses three letters—to Isaäcson, Bernard, and Gauguin—for Theo to send on. Only the one to Bernard (B20) survives. It was sparked off by Theo's news that Bernard, recently arrived from Brittany, was coming on Saturday 5 October to see Vincent's recent consignment of summer canvases. "I am hardly in the right mind for writing a letter, but I feel an aching void because I am no longer informed at all of what Gauguin, you, and others are doing." He has another dozen studies that will probably be more to Bernard's liking than these summer canvases. He will send them to Theo in November. Among them are *Entrance to a Quarry* (cat. 35) and *Enclosed Field with Peasant* (cat. 28), both of which he describes.

He wants very much to capture the essence of the olive trees—"silver against a soil of orange and violet hues, under the large white sun"—something neither he nor any other painter has yet done.

He asks Bernard to send him "a colored sketch of the primitive Egyptian house" on view at the Paris World's Fair.

He is working on a large canvas of a ravine (F662).

Sunday 13–Saturday 19 October

No letters survive from this week, a hiatus following the intense activity in both painting and letter writing during

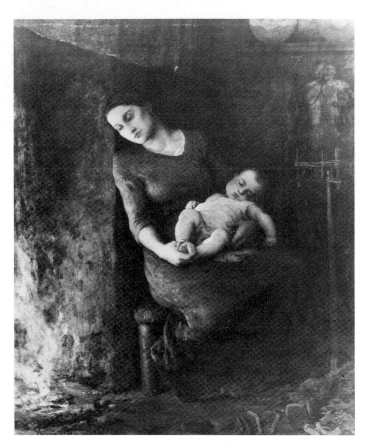

Virginie Demont-Breton. *Husband at Sea*, 1889. Oil on canvas.
Present location unknown

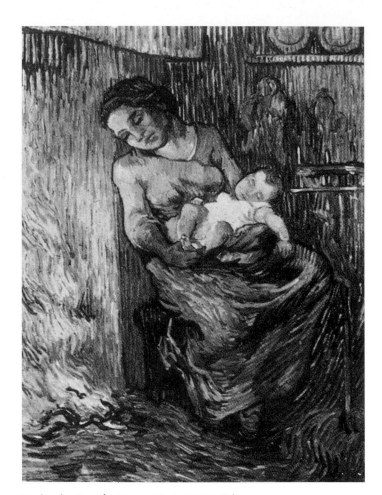

Husband at Sea (after Demont-Breton) (F644). Oil on canvas,
26 x 20⅛ in. (66 x 51 cm.). Private collection, Philadelphia

the preceding days. Without canvas and very low on
paints, van Gogh is prevented from painting out of doors
and hence continuing his series of autumn effects. In-
stead, he takes "long walks in all directions across the
country" (LT611). And with the few paints he has left, he
reworks a large study of the fever ward at the Arles hospi-
tal (F646), probably puts the finishing touches to the set of
reduced copies destined for his mother and Wil, and
works on a portrait of one of the patients in the asylum
(F703). On occasions such as this, his practice, especially in
Arles, was to do a series of drawings; but he never refers to
any drawing activity during this period.

c. Sunday 20 October

Van Gogh writes letters to his mother (LT612) and to Wil
(W15). He thanks his mother for the news of Cor's voyage
to South Africa, which reminds him of what Gauguin
had told him about his voyages to Panama and Brazil.
And now, Isaäcson too intends to go to the Transvaal.
The small canvases painted especially for Mother and
Wil are now ready to be sent. Autumn is beautiful: he

wants to paint vineyards, but there are so few in Saint-
Rémy. Commenting on the high prices paid for the work
of dead painters (he is thinking particularly of Millet's
The Angelus), he tells his mother: "It is a kind of tulip
trade, under which the living painters suffer rather than
gain any benefit." He is working on a portrait of one of
the patients (F703): "It is curious that after one has been
with them for some time and got used to them, one does
not think of them as being mad anymore."

In his letter to Wil (W15) he lists again the painted studies
intended for them; suggests that two Dutch cousins, as
well as Margot Begemann, whom he had known in
Nuenen, might like to have examples of his work; and he
provides an interpretation of the *Bedroom* (cat. 25, fig.
26). He reports that Dr. Peyron saw Theo in Paris and
"told him that he *did not* consider me a lunatic, but that
the crises I have are of an epileptic nature. Consequently
alcohol is also not the cause, though it must be under-
stood that it does me no good either." He describes in
some detail his reworking of the painting of the fever
ward at Arles, and reveals that his reading of an article

on Dostoevsky induced him to rework it. Finally, he wishes Wil success in the house move from Breda to Leiden.

Tuesday 22 October

Theo writes his first letter to his brother in eighteen days (T19). He talks of several visitors to his apartment coming to see Vincent's work. Among them are the son of the Dutch artist Isaac Israëls; Jan Pieter Veth (1864–1925), a Dutch portrait painter and writer for the periodical *Nieuwe Gids*; and the Belgian Neo-Impressionist artist Théodore van Rysselberghe (1862–1926), a member of Les XX in Brussels, who "also saw everything there is at Tanguy's, and your pictures seem to interest him quite a lot."

Theo himself prefers those paintings of "true things," which have a stronger basis in reality, such as the "irises [cat. 1]" and "the underbrush with the ivy [cat. 2, fig. 3]," to "the village in the moonlight [cat. 14], or the mountains [F622]," where "the search for some style is prejudicial to the true sentiment of things." A similar preoccupation—although with more reminiscences of Japanese and Egyptian art—characterizes the pictures in Gauguin's last consignment from Brittany. Theo praises Armand Guillaumin's (1841–1927) summer paintings of the Auvergne: "He contents himself with what he has found."

Pissarro has returned to Eragny, and Theo hopes he will contact Dr. Gachet.

"Jo is quite well; she is getting considerably bigger, and feels life already, but this does not give her too unpleasant a sensation."

Vincent receives a package from Theo containing canvas, reproductions after Millet, and some of Isaäcson's articles from *De Portefeuille*. (He had received a package of paints earlier.)

The Hospital in Arles (F646). Oil on canvas, 29⅛ x 36¼ in. (74 x 92 cm.). Oskar Reinhart Collection "Am Romerholz," Winterthur

Wednesday 23 October

Theo's letter of 22 October arrives and Vincent answers immediately (LT611). He thanks him for the canvas and paints, the reproductions after Millet, and the Isaäcson articles. In one of these, of 19 August 1889, Isaäcson wrote: "Who interprets for us in forms and colors the mighty life, the great life once more becoming aware of itself in this nineteenth century? One I know, a solitary pioneer, he stands alone struggling in the deep night, his name, Vincent, is for posterity." And he added in a footnote: "About this remarkable hero—he is a Dutchman—I hope to be able to say something later."

Having read this, Vincent responds: "No need to tell you that I think what he says of me in a note extremely exaggerated, and that's another reason why I should prefer him to say nothing about me."

He has already begun to work from the Millet reproductions—"I began *Men Digging* [F648] this morning on a size 30 canvas"—and has worked on a study of the fever ward at the Arles hospital.

Thursday 24–Thursday 31 October

Continuing to work from the Millet reproductions, he finishes *La Veillée* (F647), and is completing *Men Digging* and *End of the Day* (F649), all size 30 canvases, as well as the *Sower* (cat. 37) in a smaller size. These he considers "translations" rather than copies. In addition, he has three other canvases in progress: a "rain effect [cat. 29] ...an evening effect with some big pines [cat. 33]...and one of falling leaves [F651]." He also completes for Dr. Peyron a view of the asylum with a big pine tree (cat. 32, fig. 30).

c. Saturday 2 November

Vincent writes to Theo (LT613), enclosing an order for paints that includes more ochers than of late. He reports on the work he has been doing during the last week or so. He is searching for style, "a more virile, spontaneous drawing. I can't help it if that makes me more like Bernard or Gauguin."

He hopes to send a package in a little while (including *La Veillée*, which he would like Jo to see), but the paintings are drying very badly because of the dampness of the studio. "Here there is hardly any cellar or foundation to the houses, and you feel the damp more than in the North." Wil and Mother will by now have moved from Breda to Leiden. He will add six canvases for them to the next package.

Wood engraving by Jacques-Adrien Lavieille after Jean-François Millet, *La Veillée.* Rijksmuseum Vincent van Gogh (Vincent van Gogh Foundation), Amsterdam

As for his health, he is "very well—except for a great depression sometimes, but I am feeling well, much better than last winter, and even better than when I came here, and still better than in Paris.... Fortunately, those abominable nightmares have stopped tormenting me. I hope to go to Arles one of these days."

Sunday 3–Saturday 16 November

During this period van Gogh spends two days in Arles. He sees the Reverend Salles and the Ginoux, whom he pays for storing his furniture. He buys a stock of paints, as was his practice on earlier visits. No one showed any antipathy toward him, he reports later (LT614). On the contrary, "they were very friendly, and even welcomed me." He will have to wait and see if this journey will provoke another attack. "I almost dare to hope it won't."

He receives letters from Isaäcson and Bernard responding to his letters of about 12 October sent on to them by Theo. Both letters are lost, but something of Bernard's letter can be gathered from van Gogh's remarks in letters to Theo (especially LT614). Bernard complains of many things: even with all his talent, all his work, and all his sobriety, he is unhappy. His home is often hell for him; he is harassed by his parents. He talks of an exchange of pictures with van Gogh, thinking particularly of *La Berceuse*. And he promises to send photographs of his recent biblical compositions.

Gauguin also replies to van Gogh's letter (GAC37), but sends it to Theo, who delays forwarding it to Saint-Rémy until 16 November.

Van Gogh begins working on *Wheat Field with Rising Sun* (cat. 30), and is still occupied with his "translations"

La Veillée (after Millet) (F647). Oil on canvas, 28½ x 36¼ in. (72.5 x 92 cm.). Rijksmuseum Vincent van Gogh (Vincent van Gogh Foundation), Amsterdam

Paul Gauguin. Sketch of *Soyez Amoureuses et Vous Serez Heureuses* (GAC37). Rijksmuseum Vincent van Gogh (Vincent van Gogh Foundation), Amsterdam

after Millet. He observes women picking and gathering the olives, but as he cannot get a model he does not begin any painting of them.

Saturday 16 November

Theo writes to Vincent (T20), his first letter since 22 October. He encloses Gauguin's letter (GAC37). The wood relief *Soyez Amoureuses et Vous Serez Heureuses* (1889; Museum of Fine Arts, Boston) has arrived in Paris. Theo is delighted with it, and Vincent too "would undoubtedly love it." Theo visited Bernard this week and saw his recent work. "He has made much progress. His drawing is less definite, but it is there for all that. There is more suppleness in his stroke. There is a more direct influence of the Primitives in him."

Octave Maus, secretary of Les XX, has written to Vincent (addressing the letter to Theo), asking him to participate in their forthcoming exhibition in Brussels. Theo, too, has received a letter from Maus repeating the invitation and giving a list of the other invited artists, among whom are Puvis de Chavannes, Cézanne, Forain, Signac, Lucien Pissarro, Renoir, Sisley, and Toulouse-Lautrec.

"Pissarro wrote me that his wife and he have been looking around the country for a boardinghouse for you, but he tells me he thinks it will be better for you to go to stay with that doctor in Auvers. He will have to go to him very soon."

Sunday 17 November

Vincent receives Theo's letter, and responds immediately (LT614). He lists the six paintings that he would like to exhibit with Les XX and tells of letters he has received from Bernard, Gauguin, and Isaäcson. Gauguin's (GAC37) is "a very nice letter," in which he "talks with enthusiasm about de Haan and their simple life by the edge of the sea." In it, Gauguin refers to a letter that Isaäcson has written to de Haan, saying that van Gogh's recent canvases are "really something wholly artistic and more imaginative than the others." Gauguin talks at length of his own work, of his ideas and intentions, of the poor reception of his recent work in Paris. He describes and illustrates his *Christ in the Garden of Olives* (1889; Norton Gallery, West Palm Beach, Fla.), as well as his wood relief *Soyez Amoureuses*, which he has been working on for two months. He also writes that he and de Haan can get models easily at Le Pouldu.

Isaäcson's letter is lost, and van Gogh gives no indication of its contents. "[It] gave me much pleasure" is all that he says. It must, however, have praised his recent paintings, seen at Theo's; and it must have contained references to the articles in *De Portefeuille*. Van Gogh's reply is enclosed with his letter to Theo: "My thoughts begin to link up a little more calmly, but as you will see from it, I do not know if I must continue to paint or let painting alone." However, "you must read the letter to Isaäcson; it complements this one [to you]." (The letter to Isaäcson is lost.)

He describes his recent two-day visit to Arles. His health is fine; he would like to go to Paris in the spring, "for this life here is terribly stupefying, and in the end I shall lose my energy.... My stay here is very wearisome because of its monotony, and because the company of all these unfortunates, who do absolutely nothing all day long, is enervating."

Wednesday 20 November

Van Gogh writes to Maus (LT614b), accepting his invitation to exhibit with Les XX and listing the six size 30 canvases he would like to submit. Although he acknowledges that they take up more space than is permitted, he hopes that Maus will find space to hang them, as together they make "a somewhat varied color effect."

c. Friday 22 November

Bernard's six photographs showing his recent biblical compositions probably arrive. These prompt van Gogh to write to both Bernard and Gauguin. His letter to Gauguin (a long letter, according to GAC36) is lost. But among other things he denounces Gauguin's painting *Christ in the Garden of Olives,* "with nothing really observed," when one's duty is "thinking, not dreaming." He himself is working in the olive orchards, from nature, rather than producing "mannered" studio abstractions.

He also reprimands Bernard in his long reply (B21). He is harshly critical of the six biblical compositions, photographs of which he has before him. He insists that one must "seek after the possible, the logical, the true," that one must work from nature and the model, rather than produce "abstractions." He is particularly dismissive of "that nightmare of a 'Christ in the Garden of Olives'; good Lord, I mourn over it, and so with the present letter I ask you again, roaring my loudest, and calling you all kinds of names with the full power of my lungs—to be so kind as to become your own self again a little." He himself is working in the olive groves on five size 30 canvases, preferring to "gather new vigor in reality, without any preconceived plan or Parisian prejudice." Yet he is very discontented with this year's work, "but perhaps it will prove to be a solid foundation for next year. I have let myself be saturated with the air of the little mountains and the orchards; this much gained, I shall wait and see. My ambition is limited to a few clods of earth, sprouting wheat, an olive grove, a cypress—the last, for instance, by no means easy to do."

He describes at length two canvases he is at work on: a view of the park of the asylum (cat. 33, fig. 31) and the sun rising above a field of young wheat (cat. 30). The impression of anguish he achieves in the first, he writes, "without aiming straight at the historic Garden of Gethsemane"; and in the second he produces a consoling and gentle motif without portraying "the characters of the Sermon on the Mount." He thanks Bernard for sending a description of the Egyptian house at the Paris World's Fair, a sketch of which he had requested in October.

Tuesday 26 November

Vincent thanks Theo for sending a package of paints and a woolen waistcoat (LT615). The arrival of the paints was timely, because those he brought back from Arles are almost finished.

This month he has been busy in the olive groves; he has already produced five size 30 canvases, which, together with the three studies that Theo already has (cat. 11–13), constitute an "attack" on the problem. This is partly to refute the biblical pictures by Bernard and Gauguin (which, he tells Theo, he has also done in letters to both

Émile Bernard. *Christ in the Garden of Olives,* 1889.
Oil on canvas. Present location unknown

Wood engraving after Jean-François Millet, *Men Digging.* Rijksmuseum
Vincent van Gogh (Vincent van Gogh Foundation), Amsterdam

Men Digging (after Millet) (F648). Oil on canvas, 28¼ x 36¼ in.
(72 x 92 cm.). Stedelijk Museum, Amsterdam

of them), and partly to try to capture the essence of the olive tree, which, like the cypress, has rarely been captured in paint.

He needs more canvas. Then he intends "to attack the cypresses and the mountains. I think that this will be the core of the work that I have done here and there in Provence." If he does return to Paris he might realize a great longing: "To paint a bookshop, with the front yellow and pink, in the evening, and the passersby black—it is such an essentially modern subject" and "seems to the imagination such a rich source of light." "[It] would go well between an olive grove and a wheat field, the sowing season of books and prints."

Mother must have been in Leiden for two weeks by now. "I have delayed sending you the canvases for her, because I will put them in with the picture of the 'Wheat Field' [cat. 30] for the Vingtistes."

Wednesday 27 November–Thursday 5 December

Van Gogh continues working outdoors in spite of the cold. He completes his first view in the village of Saint-Rémy of "men at work, under enormous plane trees, repairing the pavements [cat. 44]." In his studio he finishes—"or nearly so"—his copy after Millet's *Men Digging* (F648), and is still occupied with his series of olive orchards.

Friday 6 December

He sends off three packages of studies, including seven canvases for his mother and Wil. The rest are mostly studies of autumn effects. The best of these are "the yellow mulberry tree against a bright blue sky [F637]" and the view of the park and the asylum, of which there are two versions (cat. 33; cat. 33, fig. 31). He does not send some dozen size 30 canvases as they are not yet dry.

Saturday 7 December

The ten meters of canvas requested in Vincent's letter of 26 November arrives. He thanks Theo (LT618), and tells him that the canvases for Mother and Wil were sent off yesterday. He has continued working outdoors until now in spite of the cold: "I think it is doing me good, and the work too."

"You will see that there are no more impastos in the big studies. I prepare the thing with a sort of wash of essence, and then proceed with strokes or hatchings in color with spaces between them. That gives atmosphere, and you use less paint."

Sunday 8 December

Theo writes his first letter in three weeks (T21), responding to three from his brother (LT614, LT615, LT618). He has today received the three rolls of canvases, which include "some in which the harmony is sought in less glaring tones than you generally use; for all that there is a great deal of air in them.…

"Tanguy has been exhibiting a great many of your pictures recently; he told me he hopes to sell the bench with the ivy [cat. 2, fig. 3]. It was a fine choice you made for Brussels. I have ordered the frames."

Theo recalls that Vincent used to say in Paris that a book ought to be published on Monticelli. He has just seen some twenty lithographs after Monticelli's pictures done by an artist named A.-M. Lauzet (1865–1898). Lauzet will look at their collection of Monticellis and decide which he can reproduce.

"That friend of Bernard's named Aurier looked me up— you know, the one who came to see me once in the Rue Lepic. He is very interested in what you are doing, and he showed me a little paper which he edits, and in which he wrote about Tanguy's shop, on which occasion he mentioned your pictures."

Winter has hit Paris; there is snow on the roofs. Theo has written to Dr. Peyron (the letter is lost) to ask that a fire be provided for warmth in Vincent's workroom and that the cost be added to his account. Wil is coming to stay with them in January to lend a helping hand during Jo's confinement.

Monday 9 or Tuesday 10 December

Vincent receives Theo's letter, and letters from his mother and Wil. The latter give him news of their new home in Leiden, of Cor in South Africa, and of Aunt Mina, widow of his art dealer uncle Vincent (Vincent van Gogh, 1820–1888).

He replies to his mother and to Wil. To his mother (LT616) he talks mostly of family matters, and of his health. However, he does refer to his forthcoming exhibition with Les XX in Brussels and also to his wish to spend a great part of next year in Saint-Rémy, because he can work on a regular basis, and because "the country here has not been painted yet, at least not much. For this is a part of the South no warmer than with us, and the other painters usually go somewhat farther on, to Nice or so."

In writing to Wil (W16), he lists the six pictures he plans to send to Les XX, and tells her he is working on twelve large canvases, most of them olive orchards, and one of "tall weather-beaten pine trees against a red evening sky [cat. 34]." He even interrupts the writing of this letter to add a few brushstrokes to this last canvas. He has just had "a very good letter from Theo…[who] says that you may come to stay with them." Soon Theo will forward the canvases he has painted for them. He then devotes several paragraphs to Bernard, describing his character

and some of his pictures, including the "bizarre and highly debatable biblical subjects." But "Bernard has parents who give him shelter and food with very bad grace, and continually reproach him because he does not earn money."

c. Thursday 12 December

Gauguin replies to van Gogh's letter of 22 November (GAC36). He apologizes for being so long in answering, knowing how Vincent, in his isolation in Provence, likes to receive news of his *copains*. But circumstances have prevented his writing sooner. He and de Haan have undertaken a fairly large task, the decoration of the dining room at the inn owned by Marie Henry where they are staying in Le Pouldu. They began with one wall and finished by painting all four, even the stained glass. Gauguin encloses a sketch of de Haan's large painting (52⅝ x 79½ in.) of peasants working hemp against a background of haystacks. Gauguin has painted a peasant knitting by the edge of the sea, with a dog and a cow (*Joan of Arc*, private collection, U.S.A.). And over the two doors are their portraits. Gauguin then answers van Gogh's attack on the use of religious subject matter. Simplicity and rusticity, Catholicism and superstition, he says, are synthesized in the very costume of the Breton peasants and in the somber colors and shapes (like the cross). He has consulted nature, and he is far from "mannered." At present he is working on a large canvas of women gathering seaweed (Museum Folkwang, Essen). And he continues to argue that "natural" and "mannered" are far from self-evident categories, nor indeed can they be easily separated. He recalls the sculpted apostles on the porch of Saint-Trophime in Arles, "executed quite differently from men of the North with *proportions* very far from nature, and that you admired, without nightmares." He also takes up van Gogh's argument concerning the polarity of "thought" and "dream."

Friday 13 December

De Haan writes to Theo from Le Pouldu, describing something of the decoration that he and Gauguin have done at Marie Henry's inn, and mentioning that Gauguin has sent van Gogh a drawing of de Haan's large picture.

Saturday 14 December

Van Gogh probably receives Gauguin's letter. He sends off to Theo the *Wheat Field with Rising Sun* (cat. 30) for the exhibition of Les XX, as well as the two versions of the *Bedroom* (F483, F484). He also puts in two drawings (cat. 38; F1545).

Jacob Meijer de Haan. *Breton Women Scutching Hemp*, 1889.
Fresco transferred to canvas, 52⅝ x 79½ in. (133.7 x 201.9 cm.).
Private foundation, San Diego

Vincent writes to Theo (LT617), a delayed answer to his letter of 8 December. He is delighted to hear of Lauzet's projected publication of colored lithographs after Monticelli, and hopes that their *Bouquet of Flowers* will be reproduced, since it is "a thing of the first order." He himself would like one day to make one or two such lithographs after his own paintings—one he is currently working on, for instance, of women gathering olives (F655). He doubts that he will work in impasto much more; "it is the result of the quiet, secluded life that I am leading, and I am all the better for it. Fundamentally I am not so violent as all that, and at last I *myself* feel calmer."

He tells Theo of the pictures and drawings he sent off yesterday; that he is quite resigned to staying in the asylum next year—it would be good for his work and would enable him to do the cypresses and the Alpines again; and that he has received Gauguin's letter, "again very nice,…steeped in the nearness of the sea; I think he ought to do some fine things, a bit wild."

By staying on in the South, he will have "a series of really sympathetic Provençal studies, which will somehow be linked, I hope, with our distant memories of our youth in Holland." Yet he often thinks it would have been better if he had remained an art dealer with Goupil's, "for in business, even if you yourself do not produce, you make others produce. Just now so many artists need support from the dealers, and only rarely do they find it." He encloses an order for paints and canvas, and recalls two portraits by Pierre Puvis de Chavannes (1824–1898) that he saw at the Galerie Durand-Ruel in Paris in December 1887.

"I am going to work a little outside: there is a mistral. Toward sunset it generally grows a little calmer; then there are superb sky effects of pale citron, and the mournful pines with their silhouettes standing out in relief against it with exquisite black lace effects. Sometimes the sky is red, sometimes of an extremely delicate neutral tone, and again pale citron, but neutralized by a delicate lilac. I have an evening effect of another pine tree against pink and yellow green [cat. 34]."

Friday 20 December or Saturday 21 December

Vincent sends Theo a postcard (now lost), asking if the pictures he intends to exhibit in Brussels will be framed and ready in time (T22).

Sunday 22 December

Theo composes a long and news-filled letter to Vincent (T22). The package with the pictures of the wheat field and the two bedrooms has arrived; he especially likes the "last one"—"like a bouquet of flowers in its coloring."

The wheat field is being framed by Tanguy, and on 3 January everything will go to Brussels. Lauzet visited the apartment to look at the Monticellis. But what pleased him most were Vincent's canvases and drawings. "Oh, my dear fellow, that man understands them!" Theo presented him with a drawing of a figure gathering fallen apples; the following day he visited Theo's gallery, and this time Theo exchanged an early Saint-Rémy drawing of "a small cluster of somber trees against a sky with a waxing moon, on the right a low wooden gate" for a copy of Lauzet's Monticelli album.

Dismissing Vincent's notion that he would have done better to have remained an art dealer, Theo uses his own experience as an example, taking the case of Gauguin. Although he is fully aware of Gauguin's talent and has many of his pictures, he cannot sell a single one. "It is obvious that Gauguin, who is half Inca, half European, superstitious like the former, and advanced in his ideas like a number of the latter, cannot work in the same manner every day…. His most recent pictures are less salable than those of last year. Last week he wrote to tell me that [in Copenhagen] one of his children fell out of a window, and was picked up nearly dead. And yet they hope to save him. He would do anything to get a little money, but I am unable to procure it."

"Pissarro too is at his wits' end. He is working like a slave. He made a very pretty fan for Jo: peasant women running about in the fields with a rainbow in the background." So far, Pissarro has not seen Dr. Gachet—"at least he does not write anything on the subject." It might therefore be best for Vincent to come and stay with Theo next spring, and then find a boardinghouse in the country. Wil is expected on 2 January. Cor writes often from the Transvaal.

Theo looks forward to seeing the paintings of the olive trees; he likes the two drawings he received (cat. 38; F1545). This week, the two sunflower pictures (F454, F456) were on show at Tanguy's. They made "a very good effect…[and] brighten up Tanguy's shop."

He has just received Vincent's postcard; "the pictures will be ready in time [for Brussels]."

Monday 23 December

Vincent writes to his mother (LT619) and includes a note to Wil (W18). He reminds them that it is exactly a year since his first attack in Arles. He is working on a repetition of women gathering olives (F656): "I have been working very hard and ceaselessly for two weeks." He tells his mother he is also working on a picture of a ravine (F661) and one of the asylum park with big pine trees against an evening sky (cat. 33, fig. 31). He encloses an English poem for Wil which he likens to James Abbott McNeill Whistler's *Portrait of the Artist's Mother* (1871; Musée

Camille Pissarro. *Landscape,* 1889. Pastel, 11 x 22 in. (28 x 56 cm.). Rijksmuseum Vincent van Gogh (Vincent van Gogh Foundation), Amsterdam

d'Orsay, Paris) and to some old Dutch pictures, and wishes them "a happy Christmas and a good Old and New Year's Eve."

Soon after writing these letters, van Gogh has another attack. He was, he tells Theo later (LT620), "working perfectly calmly on some canvases that you will soon see and suddenly, without any reason, the aberration seized me again."

Tuesday 24–Tuesday 31 December

The attack lasts throughout this week. Probably about 28 December, Dr. Peyron writes to Theo (the letter is lost). He gives the impression that the attack is a serious one: van Gogh has tried to poison himself by eating his paints. Under the circumstances, Peyron advises that he not be allowed to paint, but for the moment only draw (T23, T24).

1890

Wednesday 1 January

Vincent writes to Theo (LT620), responding to his brother's letter of 22 December, wishing him and Jo a happy New Year, and apologizing that he has "once more been deranged." Although there may have been some misunderstanding about the pictures to be shown at Les XX because Vincent had told Dr. Peyron during his illness that he did not wish to exhibit, he now assures Theo that there was "no justification for that" and hopes

the pictures were sent off. He is disturbed by Gauguin's recent misfortune, his child's falling from a window. And he has just received letters from Mother and Wil.

Thursday 2 January

The Reverend Salles visits van Gogh, who is agreeably surprised to see him. Van Gogh repeats his dismay at being confined with his "companions in misfortune who do nothing all day, week, month, year," as he has told Theo many times, and urges Salles never to recommend this asylum (LT622). He gives him "a little canvas with some pink and red geraniums against a perfectly black background, like one I did before in Paris" (the picture is lost).

Wil arrives in Paris from Leiden to stay with Theo and Jo and help during Jo's confinement. (She will stay until 9 February.)

Friday 3 January

Vincent writes to Theo (LT621), telling him of the Reverend Salles's visit. He has sent off today a batch of some fifteen canvases. These need to be stretched, and each viewed in a white frame. He sends off two canvases to his friend James Roulin, the postal worker from Arles, who now lives in Marseilles: "a white house among the olives [F664], and a wheat field with a background of lilac mountains and a black tree [F663]." He takes a walk in the fields. And looks at an illustrated volume of Jules

Michelet's *L'Histoire de France* (1833–43). But he does not begin painting.

Theo answers Vincent's letter of 1 January (T23). After receiving Dr. Peyron's note, telling him that Vincent had tried to eat his paints, he is delighted to hear from his brother so quickly. Nonetheless, Vincent should put away his paints for a time and make drawings. The pictures for Brussels will be sent off today. He has no news of Gauguin.

Dr. Peyron probably writes a reassuring letter (now lost) to Theo.

Saturday 4 January

Vincent replies immediately to Theo (LT622), even though he wrote only yesterday. Trying to console his brother, he reports: "I have never worked with more calm than in my last canvases [those he sent the day before]." He is hoping to be able to work outdoors when the weather permits: "I must do some more canvases of cypresses and mountains to give an idea of Provence."

He would like to go to Arles again, perhaps toward the end of February.

"Just now I have done a little portrait of one of the servants here, which he wanted to send to his mother. That means I have already started working again, and if he saw any objection, M. Peyron would probably not have let me do it."

c. Sunday 5 January

No doubt thinking of his possible visit to Arles, he writes to the Ginoux (LT622a), telling them of his recent illness: "A rather bad attack, [which] passed off very quickly; I have not had any for a week." He recalls that a year ago Madame Ginoux was taken ill at the same time as himself; she is still unwell, and he hopes she will soon recover. "In my own case my disease has done me good—it would be ungrateful not to acknowledge it. It has made me easier in my mind, and is wholly different from what I expected and imagined." Within two weeks he hopes to visit Arles "in order to try and distract our dear patient for a moment, so that she may once again show us her habitual smile."

Tuesday 7 January

The consignment of some fifteen canvases sent to Theo on 3 January arrives in the evening.

Wednesday 8 January

Theo acknowledges the safe arrival of the consignment of paintings (T24). He likes especially *La Veillée*, after Millet (F647), the *Ravine* (F662), and the *Road Menders* (cat. 44): "There is more atmosphere in these last works, more distance than in the preceding ones." A second letter from Dr. Peyron has arrived, which reassures Theo about Vincent's continuing to paint. Should Vincent wish to come and stay in the spring, he can have a little room in Theo and Jo's apartment. Jo is in very good health, but Wil arrived with such a bad cold "she had to stay in bed until this morning."

c. Friday 10 January

Vincent replies to Theo's letter (LT623). A package of canvas and paints has just arrived; "I have enough subjects for pictures in my head for when the weather will let me work outdoors." He intends to do more copies after Millet.

This morning he saw Dr. Peyron: "He says that he is leaving me completely at liberty to distract myself, and that I must fight against depression as much as I can." An attendant at the asylum knows of another asylum, at Montdevergues, near Avignon. It is cheaper than Saint-Paul-de-Mausole, the patients' clothes are provided, and, more important, instead of remaining idle the patients work on the land and there is also a forge and a carpenter's shop. This would provide not only more active companions but also models for pictures and drawings. He is going to begin work on copies after Millet's "snow-covered field [*Winter: The Plain of Chailly*, 1862; F632]" and *First Steps* (cat. 46). He would also like to make painted copies of Honoré Daumier's (1808–1879) *The Drinkers* (cat. 47) and Félix-Élie Régamey's (1844–1907) *Convict Prison* from wood engravings that he would like Theo to send.

He writes to Gauguin (the letter is lost), asking if he and de Haan intend staying on in Brittany. If they do, they might like the use of his furniture (at present stored with the Ginoux), and he himself might even join them. He encloses two drawings, one of women picking olives (now lost), and mentions that his pictures have been sent to Brussels.

Sunday 12 January

Lauzet visits Theo and is shown van Gogh's recent batch of paintings (T25). "This is the true character of Provence!" comments Lauzet, himself born a Provençal.

Friday 17 January

It is probably on this day that Theo takes Wil to visit Hilaire-Germain-Edgar Degas (1834–1917) in his studio (LT626).

Title page of the catalogue of the seventh annual exhibition of Les XX, Brussels, 1890. Rijksmuseum Vincent van Gogh (Vincent van Gogh Foundation), Amsterdam

Saturday 18 January

Opening of the exhibition of Les XX in Brussels.

Gauguin probably replies to van Gogh's letter of about 10 January (GAC38). He is extremely depressed: after three months in Le Pouldu, he has 30 francs in his pocket; feels it is useless to continue painting; in Copenhagen, one of his children has fallen from a third-floor window. He very much likes the two drawings van Gogh has sent, especially the one of women picking olives. He is hoping to go to Tonkin. De Haan, too, has money problems.

Sunday 19 January

Van Gogh goes to Arles, where he visits Madame Ginoux.

In Paris, the Reverend Salles calls on Theo and Jo, but they are not at home (T25).

Lauzet leaves Paris to spend two weeks in Marseilles. Theo hopes he will call on Vincent in Saint-Rémy.

★ ARTISTES INVITÉS ★

Eugène BOCH	P.-A. RENOIR
Paul CÉZANNE	L.-O. ROTY
Alexandre CHARPENTIER	G. SEGANTINI
Albert DUBOIS-PILLET	Paul SIGNAC
Louis HAYET	A. SISLEY
Xavier MELLERY	Ch. STORM DE S'GRAVESANDE
Georges MINNE	G.-W. THORNLEY
Lucien PISSARRO	H. DE TOULOUSE-LAUTREC
Odilon REDON	Vincent VAN GOGH

Angleterre, Belgique, France, Hollande, Italie

Catalogue listing of participating artists in the seventh annual exhibition of Les XX, Brussels, 1890. Rijksmuseum Vincent van Gogh (Vincent van Gogh Foundation), Amsterdam

No direct news of van Gogh during this last week. He continues to work on copies after Millet, and evidently does not paint outdoors.

Monday 20 January

Vincent writes to Wil (W19). He does not specifically say that he has been to Arles, only that he saw "a patient [Madame Ginoux] who had a rather disquieting nervous complication with distressing climacteric troubles." He hopes she will like the picture of women picking olives that he intends for her and Mother. "I sent a drawing of it to Gauguin a few days ago, and he told me that he thinks it good." Next month he is going to work outdoors. Has she read anything recently? He hasn't, "not a thing." He asks her to write to him.

Vincent also writes to Theo (the letter is lost), referring to his visit to Arles (compare Theo's response in T25).

He probably writes to Gauguin, also describing his visit to Arles.

Tuesday 21 January

Once again van Gogh suffers a breakdown, two days after visiting Arles. This attack lasts a week.

Wednesday 22 January

Theo writes to Vincent (T25), unaware of his most recent episode: "I felt greatly reassured after hearing that you are feeling well, and that the trip to Arles was accomplished without ill effects." He goes on to talk of Lauzet, of Les XX (referring to a newspaper review), of the forthcoming Salon des Indépendants in March, of how much he admires Vincent's paintings of olive trees—"the one with the sunset especially is superb."

Wil also probably writes to Vincent from Paris.

c. Saturday 25 January

Theo sends a roll of papers by post. These include more Millet reproductions, from which Vincent can continue his series of copies; a review of the exhibition of Les XX in Brussels; a copy of Aurier's article "Les Isolés: Vincent van Gogh," published in *Le Mercure de France* (see Appendix III); and copies of Daumier's *The Drinkers* and Gustave Doré's (1832–1888) *Prisoners' Round* (1872), which Theo apparently sent instead of the Régamey requested by Vincent on 10 January.

c. Tuesday 28 January

Gauguin writes to van Gogh about the proposition of living together again (GAC39). He suggests Antwerp,

First page of "Les Isolés: Vincent van Gogh," by G.-Albert Aurier. *Le Mercure de France*, January 1890

where he, Vincent, and de Haan might set up a studio; there are museums there, and they could be in touch with the Vingtistes. (Gauguin may have confused "Anvers"—Antwerp—with "Auvers," which van Gogh almost certainly referred to in his letter.) But since this proposition is still nebulous, Gauguin is continuing to pursue his Tonkin project.

Wednesday 29 January

Her delivery imminent, Jo writes to Vincent—at midnight—with Theo, Wil, and her mother sitting around the table (T26): "Theo brought along the article from the *Mercure* this morning, and after we read it, Wil and I talked about you for a long time." She expects the baby soon, perhaps by tomorrow morning. And she and Theo are eager for Vincent's next letter.

Dr. Peyron writes to Theo (Hulsker, "Vincent's Stay in the Hospitals at Arles and St.-Rémy," p. 41), telling him that

Announcement of the birth of Vincent Willem van Gogh, 31 January 1890.
Rijksmuseum Vincent van Gogh (Vincent van Gogh Foundation), Amsterdam

van Gogh is "once more the victim of another attack." Peyron therefore confirms receipt of Theo's registered letter of 22 January and of the roll of papers sent by post. The attack took place two days after a journey to Arles last week. "Today he is unable to do any work at all and only replies incoherently to any questions put to him. I trust that this will pass again as it has done before."

Friday 31 January

Vincent receives Jo's letter and responds immediately (LT624). He awaits news of the birth of the baby: "How happy Theo will be, and a new sun will rise inside him when he sees you recovering." He is feeling better, even though he is "not yet quite calm"; has read Theo's letter of 22 January with pleasure; has had "a nice letter" from Gauguin; and asks Jo to tell Wil that he has received her letter.

Theo writes to Vincent (T27), infinitely sorry to hear (from Dr. Peyron's letter of 29 January) of yet another attack, but conveying the long-awaited news that Jo has "brought into the world a beautiful boy, who cries a good deal, but who looks healthy." He will be called Vincent (Vincent Willem van Gogh, 1890–1978), and they hope he will be "as persevering and as courageous as you."

Van Gogh receives a letter from his mother, "fairly long and very contented" (LT625).

c. Saturday 1 February

Van Gogh writes to his friend the Australian painter John Russell (1858–1931) for the first time since the autumn of 1888 (LT623a). Russell is now living permanently on Belle Ile, off the coast of Brittany. Van Gogh feels moved to contact him mainly because of Gauguin's recent letter suggesting that they set up a studio in Antwerp, but also, no doubt, thinking that Russell may yet buy a Gauguin painting. Additionally, however, he decides to pass on to Russell the small roll of photographs of Millet pictures that Theo has only just sent—"to remind you of myself and my brother." Bringing Russell up to date with his news, he reports that Theo is now married and about to become a father; Gauguin is still struggling on, at present in the company of a Dutch artist, Meijer de Haan; he and Gauguin are "still friends, but perhaps you are not unaware that I am ill, and that I have had serious nervous crises and delirium more than once. This was the cause of our parting company, he and I, for I had to go into a lunatic asylum. But, before that, how many times we spoke of you!" Van Gogh also sends Russell an article on the exhibition of Les XX. He asks Russell, when he is next in Paris, to choose one of his canvases at Theo's to form part of the collection that Russell is making for his native Australia. He sends greetings to the American Dodge MacKnight (1860–1950).

Sunday 2 February

Vincent receives the good news that Jo is safely delivered of a boy; he replies immediately (LT625). He is somewhat surprised at Aurier's article, and discusses at length his reading of it. He reports on Gauguin's vague proposal to found a studio in Antwerp with de Haan and himself, "but he said that he is insisting on going through with his Tonkin project, and seems to have cooled off greatly...about continuing to paint." He has just written to Russell, "to remind him a little of Gauguin.... Gauguin and Russell are countrymen at heart; not uncouth, but with a certain innate sweetness of far-off fields." He has severe "scruples of conscience" about appearing to plagiarize Millet, so he has taken the pile of photographs that Theo sent and "unhesitatingly sent them to Russell, so that I shall not see them again until I have made up my mind.... My illness makes me very sensitive now, and for

the moment I do not feel capable of continuing these 'translations' when it concerns such masterpieces. I am stopping at the 'Sower' [cat. 37, fig. 35], which I am working on, and which is not coming off as I should wish."

He hopes Lauzet will visit him when he comes south; is still concerned about Madame Ginoux; asks Theo to thank Wil for her letter, but says he will put off replying for several days; will send Theo a note for Aurier, and will give Aurier a painting in return for his article.

c. Monday 3 February

Van Gogh writes to Ginoux (LT626b), explaining that because he has been "indisposed during the past week" he has not been able to call on Madame Ginoux and inquire after her health. He tells him he had a letter from Gauguin "the other day" (GAC39), and that articles on his own paintings have been published in Brussels and Paris.

John Russell. *Self-Portrait*, 1886. Oil on canvas, 8⅛ x 7⅞ in. (20.6 x 20.1 cm.). Musée Rodin, Paris

Tuesday 4–Friday 7 February

He copies Daumier's *The Drinkers* (cat. 47) and Doré's *Prisoners' Round* (F669), and reworks *Cypresses* (cat 19, fig. 15), which he intends to present to Aurier (LT626).

Saturday 8 February

Gauguin arrives in Paris from Brittany.

Sunday 9 February

Theo writes to Vincent (T28). Jo and the baby are both well. Wil left Paris this morning: "She has been an extremely helpful housekeeper. She is a dear good girl. I took her along once to see Degas, who said she reminded him of various figures in the old Dutch paintings, and that she made him want to go and see the museums in our native country. He trotted out quite a number of his

Wood engraving after Gustave Doré, *Prisoners' Round.* Rijksmuseum Vincent van Gogh (Vincent van Gogh Foundation), Amsterdam

things in order to find out which of them she liked best." Theo and Wil also visited the Louvre, where several pictures have been rehung, and one can now see, as never before, a painting by Vermeer and Rembrandt's *A Philosopher Absorbed in Meditation* (1633) and *A Philosopher with an Open Book* (1633), both of which have been cleaned.

"Gauguin arrived in Paris yesterday, and asked a lot of questions about you. He came here to see whether he couldn't find something, no matter what, to do to earn a living, for it seems that de Haan is very hard up too." Theo describes a still life by de Haan of onions, apples, and an earthenware pot.

During this past week, van Gogh has been thinking about his reply to Aurier's article.

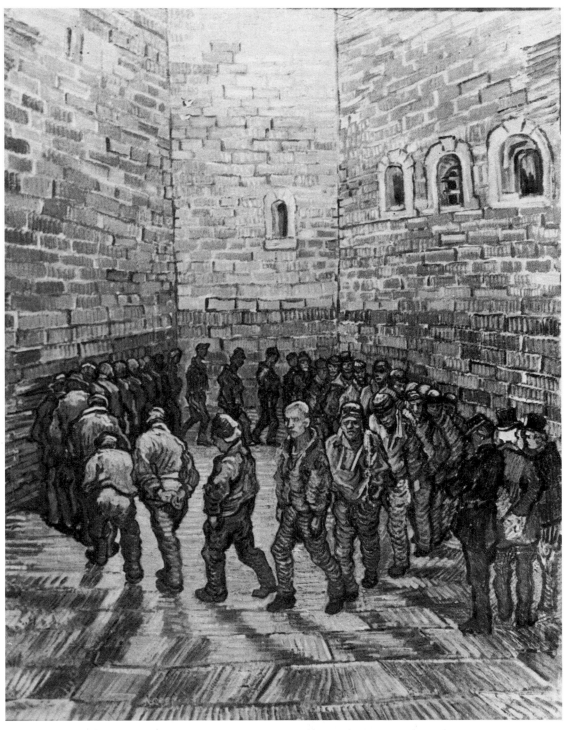

Prisoners' Round (after Doré) (F669). Oil on canvas, 31½ x 25¼ in. (80 x 64 cm.). Pushkin State Museum of Fine Arts, Moscow

Monday 10 February

Van Gogh completes his letter to Aurier (LT626a). He is busy writing to Theo, enclosing the letter for Aurier, when Theo's letter of 9 February arrives. He throws away what he has written and begins again (LT626). He is very happy with the news of Jo and of Wil—"I think she was lucky to see Degas at his home."

"And so Gauguin has returned to Paris. I am going to copy my reply to M. Aurier to send to him, and you must make him read this article in the *Mercure*." The canvas of *Cypresses* for Aurier is in "a terribly thick impasto and worked over like some Monticellis."

As for the Salon des Indépendants in March: "I hope to send you a few more canvases which are drying at the moment; if they do not arrive in time, you can make a selection from the ones that are at old Tanguy's."

He is still of the opinion that it is better to stay on in Saint-Rémy, though he might pay a short visit to Theo in Paris.

Discussing Gauguin's idea of setting up a studio in Antwerp, he says he has little faith in its materializing. At any event, he will write to Gauguin soon, mainly to send him his reply to Aurier's article. If Gauguin's attempts to find a place to live in Paris fail, perhaps he could come to the South. But he is very clever and probably will succeed. Van Gogh suggests that Gauguin can take the copies of the *Sunflowers* (F455, F459) and a copy of *La Berceuse* in exchange for something of his that Theo would like.

He encloses his letter to Aurier and requests that after Theo has read it, he forward it to Aurier.

Tuesday 11–Monday 17 February

Van Gogh works on a portrait of an Arlésienne, and probably also on a picture of "a blue sky with branches full of blossoms standing out against it [cat. 49]," destined for his nephew (W20). He probably writes also to Gauguin, enclosing a copy of his letter to Aurier.

Tuesday 18 February

Wil, back in Leiden, writes to Vincent.

Theo also writes (the letter is lost), reporting that one of Vincent's pictures has been sold in Brussels for 400 francs (LT627), and also that he is organizing a one-man show of Camille Pissarro at his gallery (T29).

Wednesday 19 February

Vincent receives Theo's letter telling him of the sale of his picture in Brussels.

c. Thursday 20 February

He receives Wil's letter from Leiden and replies to it (W20), as well as to her earlier letter from Paris of about 22 January. He tells her of his paintings of almond blossoms and of the Arlésienne; of his responses to Aurier's article; of his success in Brussels; of his belief in the greatness of Millet, painter of peasants. "Tomorrow or the day after I shall try to make the trip to Arles once again, as a kind of trial, in order to see if I can stand the strain of traveling and of ordinary life without a return of the attacks."

Van Gogh writes to his mother (LT627), which he has delayed doing for almost three weeks: "I intended to answer your letter many days ago, but I could not bring myself to write, as I sat painting from morning till night." The picture of white almond blossoms will hang in Theo and Jo's bedroom. "These last days we have had rather bad weather here, but today it was a real spring day, and the fields of young wheat, with the violet hills in the distance, are so beautiful, and the almond trees are beginning to blossom everywhere." He was very surprised by Aurier's article; he has sold a painting in Brussels; Gauguin wants to work in Antwerp, but this seems unlikely; he himself prefers to begin in the North "by trying it a few weeks in Paris."

Friday 21 February

Vincent must surely have responded to Theo's letter telling of the sale of his picture in Brussels for 400 francs. However, nothing survives of either letter.

Saturday 22 February

Van Gogh visits Arles, taking with him a version of *L'Arlésienne*, clearly intended as a gift for Madame Ginoux. He suffers another attack, which is reported to Theo by Dr. Peyron (see 24 February).

Sunday 23 February

Learning of van Gogh's attack in Arles, Dr. Peyron sends two men with a carriage to bring him back to the asylum. It is not known where van Gogh spends Saturday night. The painting of the Arlésienne cannot be found.

Monday 24 February

Dr. Peyron writes to Theo, acknowledging receipt of a registered letter addressed to Vincent, and reporting the attack that has taken place in Arles. "I notice that the attacks are becoming more frequent and take place quite suddenly after every journey he undertakes away from the asylum. I do not believe that he gives himself over to

19, Boulevard Montmartre, Paris

ADR·TÉLÉGR·BOUSSOVAL·PARIS.

Messieurs Boussod, Valadon & Cie

prient M _____

de leur faire l'honneur de visiter l'Exposition

particulière des Œuvres récentes de

Camille Pissarro.

Les Lundi 24, Mardi 25 et Mercredi
26 Février, de 10 heures à 6 heures.

Invitation to the private viewing of the Camille Pissarro exhibition at
Boussod & Valadon, Paris, February 1890. Rijksmuseum Vincent van Gogh
(Vincent van Gogh Foundation), Amsterdam

any excess when he is at liberty, for I have always known him sober and reserved. However, I am forced to recognize the fact that each time he undertakes a little journey he becomes ill. It will only be for a few days and he will regain his sanity as before" (Hulsker, "Vincent's Stay in the Hospitals at Arles and St.-Rémy," p. 43).

Unfortunately, Dr. Peyron's optimism in an early recovery proves unfounded. Theo and Jo continue to write to Vincent during the month of March.

Wednesday 19 March

Private viewing of the Salon des Indépendants, where van Gogh is represented by ten paintings. Having attended the opening with Jo, Theo writes to his brother in the evening (T29). He and Jo "regret from the bottom of our hearts that you cannot give us better news. You will need an enormous amount of patience to surmount the trouble your condition must give you....Your pictures are very well placed and make a good effect. Many people came

to us and asked us to send you their compliments. Gauguin said that your pictures were the chief attraction of the exhibition.... He proposed an exchange of one of his canvases for the one of the Alpine foothills [F661]." Theo describes the pictures exhibited by Seurat, Guillaumin, and Toulouse-Lautrec. His Camille Pissarro exhibition is ended; many people saw it, and five works were sold. Bernard and Aurier plan to see van Gogh's latest paintings next Sunday (23 March). Theo encloses Aurier's response to Vincent's letter (the letter is lost). Maus has written about van Gogh's success at Les XX, and has sent Theo the money from the sale of the painting.

Gauguin also writes to van Gogh (GAC 40), complimenting him on his work at the Indépendants and proposing an exchange of one of his paintings for the *Ravine* (F661), a picture he has discussed at length with Aurier, Bernard, and many others. "I hesitated very much to write to you, knowing that you have just had a fairly long crisis; also I beg you only to answer me when you feel quite strong enough. Let us hope that with the coming of the warmer weather you will at last recover; winter is always dangerous for you."

Sunday 23 March

Bernard and Aurier probably visit Theo to look at van Gogh's pictures.

c. Wednesday 26 March

Theo meets Dr. Gachet for the first time.

Saturday 29 March

Jo writes to Vincent, sending him greetings for his birthday (T30). The baby is growing well, but allows his mother little leisure. However, she "managed to escape for a little while at the opening of the Indépendants to see your pictures there.... Here it is like the height of summer—indescribably hot—and I dread the hot days yet to come."

Theo also writes to his brother (T31), sending good wishes for his birthday. He has met Dr. Gachet: "When I told him how your crises came about, he said to me that he didn't believe it had anything to do with madness, and that if it was what he thought, he could guarantee your recovery." Theo has not been back to the Indépendants, "but Pissarro, who went there every day, tells me that you have achieved real success with the artists." He encloses some reproductions of etchings by Rembrandt.

Sunday 30 March

Van Gogh's thirty-seventh birthday.

Paul Gauguin. Sketch in a letter (GAC40) of Vincent van Gogh, *The Ravine* (F661). Rijksmuseum Vincent van Gogh (Vincent van Gogh Foundation), Amsterdam

Tuesday 1 April

Dr. Peyron writes to Theo: "M. Vincent has not yet regained his full clarity of mind and for the time being he is unable to reply to your letters. This attack takes more time to wear off than the previous ones. One is at times inclined to believe that he is coming to himself; he explains the feelings he is experiencing, but a few hours later a change takes place, the patient once more becomes despondent and suspicious and replies no more to the questions put to him. I am confident that he will regain his sanity as before.... As soon as he feels capable of writing he will let you hear from him" (Hulsker, "Vincent's Stay in the Hospitals at Arles and St.-Rémy," pp. 43–44).

Wednesday 2–Tuesday 22 April

No news of van Gogh during this period. Apparently, Dr. Peyron sends no further reports to Theo, and nothing survives from Theo to Dr. Peyron (e.g., a response to the 1 April letter). Nonetheless, during his long illness (22 February to 24 April), van Gogh is not entirely inactive. "What am I to say about these last two months? Things didn't go well at all. I am sadder and more wretched than I can say.... Nevertheless, while I was ill I did some little canvases from memory...memories of the North" (LT629).

Describing his activity to his mother and Wil (LT629a) he explains, "I continued painting even when my illness was at its height, among other things a memory of Brabant, hovels with moss-covered roofs and beech hedges on an autumn evening with a stormy sky, the sun setting amid ruddy clouds [F673]. Also a turnip field with women pulling out the green tops in the snow [F695]."

He makes many small drawings during this two-month crisis, the dominant theme being "memories of the North" (F1585–F1620). During his illness, he receives a letter from John Russell (the letter is lost), probably dating from the end of February. Van Gogh, it would appear, does not answer.

Wednesday 23 April

Theo writes (T32): "Your silence proves to us that you are still suffering, and I feel urgently impelled to tell you, my dear brother, that Jo and I suffer too because we know that you are ill." Last week it was already a year since his marriage. Pissarro has invited him and Jo to spend two days at Eragny during Whitsuntide (25–26 May). Van Gogh's ten pictures at the Indépendants "are having a lot of success," praised by artists as different as Ernst-Ange Duez (1843–1896; "Give your brother my compliments and tell him that his pictures are highly remarkable"), Monet ("Your pictures are the best in the exhibition"), and Charles-Emmanuel Serret (1824–1900), whom Theo describes as being "enraptured " ("He said that if he had

no style of his own in which he could still express some things, he would change his course and go seek what you are seeking"). Lauzet has returned to Paris from Marseilles, and regrets he was unable to make a detour to Saint-Rémy.

Thursday 24 April

Vincent receives Theo's letter of 23 April and replies immediately (LT628): "Today I wanted to read the letters which had come for me, but I was not clearheaded enough yet to be able to understand them. However, I am trying to answer you at once, and I hope that this will clear away in a few days." He promises to send some canvases soon, and asks to be remembered to the Pissarros. Gauguin and Russell have written to him. "I have a great desire to start working again." He hopes to write again tomorrow or the day after.

Tuesday 29 April

Having intended to write to Theo, Vincent has until now failed to do so. He now writes (LT629), especially to wish his brother a happy birthday on 1 May. He is sending a batch of pictures—as they are "not... intended for the public, perhaps you will eventually make presents of these to our sisters." Included are copies after Millet, some olive orchards, versions of *L'Arlésienne* (one of which is for Gauguin), and the *Cypresses* for Aurier. He encloses an order for paints, brushes, and canvas. He is now working again and has just finished "a corner of a sunny meadow, which I think is fairly vigorous [cat. 50]." And he asks for some of his old drawings of Nuenen, since he plans to redo some of his Nuenen subjects. He tells Theo that he has still not read the letters from home, as Dr. Peyron is away. He insists that he must leave the asylum: "But where to go? I do not think I could be more shut up and more of a prisoner in the homes where they do not pretend to leave you free, such as at Charenton or Montdevergues."

Later in the day he also writes to his mother and Wil (LT629a), repeating that he is "longing to get away from here," and writing that over the past few days he has been working on "the picture of a lawn in the blazing sun with yellow dandelions [cat. 50]," and that he would like them to send him some of his old studies and drawings.

In both letters, he associates the publication of Aurier's article with his two-month breakdown. "As soon as I heard that my work was having some success, and read the article in question, I feared at once that I should be punished for it; this is how things nearly always go in a painter's life: success is about the worst thing that can happen." And to Theo: "Please ask M. Laurier [*sic*] not to write any more articles on my painting, insist upon this, that to begin with he is mistaken about me, since I am too overwhelmed with grief to be able to face publicity."

Thursday 1 May

Theo's thirty-third birthday.

Friday 2 May

With Dr. Peyron's return, van Gogh is given several letters from his family. He replies to Theo (LT630), thanking him for the reproduction etchings after Rembrandt, in particular the *Raising of Lazarus*. "Early this morning I looked at it and I remembered not only what Charles Blanc said of it, but in fact everything he didn't say." He is happy to make an exchange with Gauguin, whose letter (GAC40) of about 19 March he encloses. He yearns now to return to the North, and has discussed this possibility with Dr. Peyron. He asks Theo to fix a date for his arrival in Paris, and he will arrange to be accompanied to either Tarascon or Lyons. He will leave his furniture for the time being with the Ginoux in Arles. "As soon as I got out in the park, I got back all my lucidity for work; I have more ideas in my head than I could ever carry out....The brushstrokes come like clockwork." He believes that, once freed from here, he will "find [his] balance" in the North. "Dr. Peyron was very kind to write to you [letter of 1 April]; he wrote you again today [the letter is lost]."

Saturday 3 May

Theo writes to Vincent (T33), expressing delight at receiving the letters of 24 April and 2 May. The pictures have arrived, with "very beautiful ones among them": the portraits of Trabuc (cat. 24) and "the other fellow with his swollen face [F703], [which] are extraordinary"; the branch of almond blossoms (cat. 49); and "the copies after Millet [which] are perhaps the best things you have yet done." The paints from Tasset and Tanguy have been sent off. The painting of cypresses for Aurier is "one of the finest you have done so far; it has the richness of a peacock's tail." The frame has been made according to Vincent's wishes, and Theo will deliver the picture to Aurier very soon. Theo "approve[s] absolutely" of Vincent's plan to return to the North; but Vincent must have Peyron's approval, and he must be accompanied for the entire journey. As for himself, "business is good and I have everything I want."

While Theo is writing from Paris, van Gogh sends another letter from Saint-Rémy (LT632), underscoring his need to return to the North. *"I think the best thing will be for me to go by myself to see this doctor in the country as soon as possible,* then we can soon decide if I shall go to stay with him or temporarily at the inn; and thus we shall avoid too prolonged a stay in Paris, a thing I dread." In his letter is enclosed a sketch of a painting he has done of the three figures in the background of Rembrandt's *Raising of Lazarus* (F677). He has also completed "another one of a nook of greenery [F672]"; and has tried to do a copy of Delacroix's *The Good Samaritan* (F633). In *Le Figaro* he has read that Ernest Quost (1844–1931) has a "tremendous picture" at the Salon. (In *Le Figaro* of 30 April, Albert Wolff wrote of Quost's *Easter Flowers*: "M. Quost paints with virtuosity flowers *en plein air,* in full light, in full green, and in full yellow.")

Sunday 4 May

Vincent receives Theo's letter of 3 May, with a photograph of Jo and the baby enclosed. He replies immediately (LT631), categorically insisting that he need not be accompanied all the way to Paris. He has pointed out to Dr. Peyron that "such attacks as I have just had have always been followed by three or four months of complete quiet." Repeating his warning of six months ago, he stresses the need to act quickly, certainly within a fortnight at most—a week would please him better. He agrees to be escorted as far as Tarascon, "even one or two stations farther if you insist." Once in Paris, he thinks he should not stay at Theo's more than two or three days, but leave for Auvers and Dr. Gachet, staying at the inn to begin with. So Theo must write without delay to Dr. Gachet (Vincent composes a draft paragraph), and

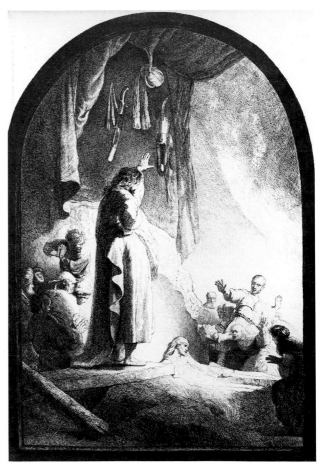

Rembrandt van Rijn. *The Raising of Lazarus* (Bartsch 73). Etching. Rijksmuseum Vincent van Gogh (Vincent van Gogh Foundation), Amsterdam

also to Dr. Peyron, "asking to let me go, say on the fifteenth at the latest."

He has finished "two canvases of the fresh grass in the park [cat. 50; F672], one of which is extremely simple." He would like to try to do a painting after the photograph of Jo and the baby.

Monday 5–Friday 9 May

No letters are exchanged between Theo and his brother. Van Gogh continues working on still lifes of irises and roses and on landscapes.

Friday 9 May

Following Vincent's exhortation Theo writes two letters, one to Dr. Peyron (the letter is lost), the other to Dr. Gachet: "Allow me to remind you of the conversation we had when I had the honor to make your acquaintance [i.e., about 26 March]. We spoke of my brother, the painter, who at the moment is in Saint-Rémy, at the house of Dr. Peyron. You gave me hope that in your care he may possibly regain his normal condition. He is very well for the moment and writes me very reasonable letters. He ardently wishes to come to Paris for a few days and then to go and work in the country....Would it be wise to have him accompanied by someone during the trip?... [He] begs me to let him travel alone. I should very much like to have your opinion on this" (Gachet, *Deux Amis des impressionnistes*, pp. 106–7).

Saturday 10 May

Theo writes to Vincent (T34), thanking him for his letters of 3 and 4 May. He agrees to his brother's proposals for traveling. Yesterday he wrote to both Dr. Gachet and Dr. Peyron. He has not yet visited the Salon, which is said to be "pretty mediocre; but there is an exhibition of Japanese drawings and crêpe prints—you will see it when you are here—which is superb. I wish you were here already." (The exhibition, at the École des Beaux-Arts, opened on

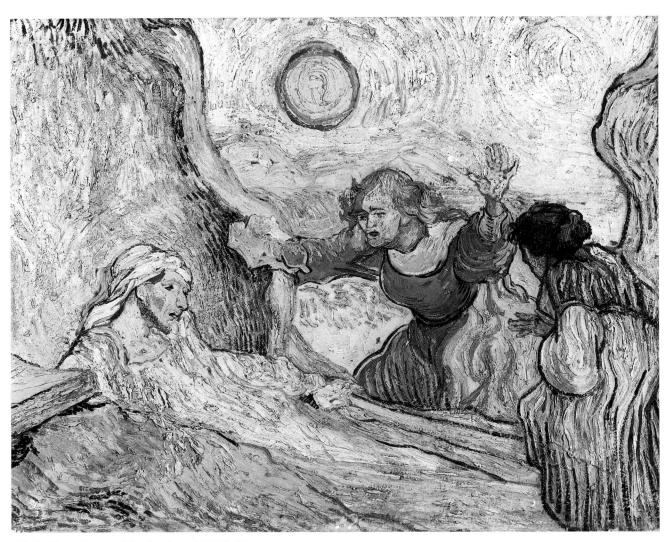

The Raising of Lazarus (after Rembrandt) (F667). Oil on canvas, 19 x 24¾ in. (48.5 x 63 cm.). Rijksmuseum Vincent van Gogh (Vincent van Gogh Foundation), Amsterdam

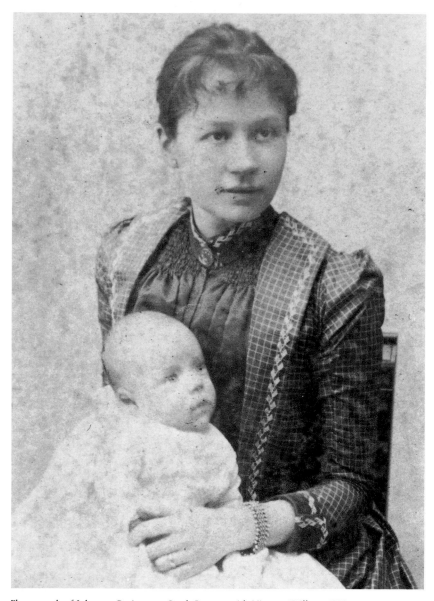

Photograph of Johanna Gesina van Gogh-Bonger with Vincent Willem, 1890.
Rijksmuseum Vincent van Gogh (Vincent van Gogh Foundation), Amsterdam

23 April and closed on 30 June 1890.) Theo encloses 150 francs for the journey.

Sunday 11 or Monday 12 May

Vincent writes to Theo (LT633), acknowledging receipt of the 150 francs. He has also received the canvas and paints from Tasset. "At present all goes well; the whole horrible attack has disappeared like a thunderstorm, and I am working to give a last stroke of the brush here with a calm and steady enthusiasm." He is doing a still life of roses (cat. 53) and two of violet irises (cat. 51, 52). "These canvases will take a whole month to dry, but the attendant here [Trabuc] will undertake to send them off after my departure." Today he is starting to pack.

He also writes to Ginoux (LT634a), asking that his two beds and mirror be sent by freight train to Paris, as he is returning to the North, and expressing regret that he fell ill the day he came to Arles to say good-bye.

Tuesday 13 May

Vincent again writes to Theo (LT634). He has had a last discussion with Dr. Peyron, who has given him permission to pack. His luggage has been sent by train to Paris. He himself will bring some frames, his easel, and stretchers. He hopes to be in Paris before Sunday, "so as to spend your free day quietly with you all. I very much hope to see Andries Bonger too at the first opportunity." He has just finished another canvas (cat. 53, fig. 46), and has written to Ginoux about his beds.

"In Paris—if I feel strong enough—I should very much like to do at once a picture of a yellow bookshop (gaslight effect), which I have had in mind for so long. You will see that I'll be fit for it the day after my arrival. I tell you, I feel my head is absolutely calm for my work, and the brushstrokes come to me and follow each other logically."

Friday 16 May

Van Gogh leaves the asylum at Saint-Rémy for Paris. He telegraphs Theo from Tarascon, telling him that he will arrive at the Gare de Lyon at 10 A.M. the following day. Theo is unable to sleep because of his anxiety about his brother's traveling unaccompanied on the long journey from Tarascon to Paris.

Dr. Peyron records his observations in the register of the asylum's voluntarily interned: "The patient, though calm most of the time, has had several attacks during his stay in the establishment which have lasted from two weeks to one month. During these attacks the patient was subject to frightful terrors and tried several times to poison himself, either by swallowing the paints which he used for his work or by drinking kerosene which he managed to steal from the attendant while the latter refilled his lamps. His last fit broke out after a trip which he undertook to Arles, and lasted about two months. Between his attacks the patient was perfectly quiet and devoted himself with ardor to his painting. Today he is asking for his release to live in the North of France, hoping that its climate will be favorable." In the column headed "Observations" is the word "cured."

Release register. Archives of the asylum of Saint-Paul-de-Mausole, Saint-Rémy-de-Provence

Paris, 17–20 May 1890

Saturday 17 May

Van Gogh arrives in Paris at 10 A.M. at the Gare de Lyon, where he is met by Theo. In the fourth-floor apartment at 8 Cité Pigalle, Jo awaits their return: "It seemed an eternity before they came back. I was beginning to be afraid that something had happened when at last I saw an open fiacre enter the Cité; two merry faces nodded to me, two hands waved—a moment later Vincent stood before me." Jo is surprised to find "a sturdy, broad-shouldered man, with a healthy color, a smile on his face, and a very resolute appearance…[who] looks much stronger than Theo." The two brothers go to look at the sleeping baby in his cradle; "both had tears in their eyes." Smil-ingly, Vincent turns to Jo and points to the simple cro-cheted cover: "Do not cover him too much with lace, little sister" (*The Complete Letters*, p. l).

For his part, Vincent's first impression of Theo is that he is looking paler than when the brothers separated in February 1888, and that his cough is worse. "But when I talked with him and saw him at close range it seemed certain to me that, all things considered, there is a change rather for the better, and Jo is full of good sense, as well as good intentions. The little one is not weakly but on the other hand he is not strong either" (W22). He also observes that Theo has less appetite: "Our constitu-tions need very solid nourishment. So be sensible about this, especially Jo too, having her child to nurse" (LT637).

Theo's impressions of Vincent are conveyed in a letter to Wil of 2 June: "He has never looked so healthy, and in the

8 Cité Pigalle, Paris, c. 1960. Rijksmuseum Vincent van Gogh
(Vincent van Gogh Foundation), Amsterdam

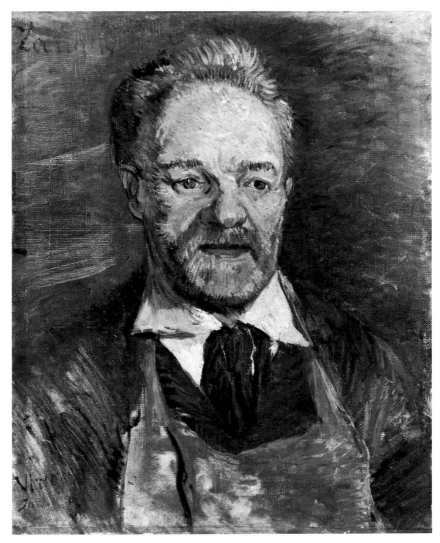

Portrait of Tanguy (F263). Oil on canvas, 18½ x 15⅜ in. (47 x 38.5 cm.).
Ny Carlsberg Glyptotek, Copenhagen

way he talks he is also quite normal. Even so he feels that those attacks may return and is afraid of that. It appears that it happens all of a sudden and that in Saint-Rémy at any rate nothing was done about it other than making him rest" (Hulsker, "What Theo Really Thought of Vincent," p. 22).

Vincent probably spends the entire day in the apartment.

Sunday 18 May

He rises very early, anxious to look at his pictures: in the dining room over the mantelpiece, the *Potato Eaters* (F82); in the sitting room, the *Harvest (Blue Cart)* (F412), *Starry Night Over the Rhône* (cat. 14, fig. 11), recently exhibited at the Indépendants, and, hung over the piano, the painting of almond blossoms (cat. 49) specially done for his nephew. In addition, enormous piles of unframed canvases are spread on the floor, where he studies them with great attention, and yet others are stored under the bed (LT640).

The two brothers visit Tanguy's shop at 14 Rue Clauzel, where Vincent is able to see the attic room that Theo has recently rented in order to store not only Vincent's paintings but also those from their joint collection by artists such as Russell, Guillaumin, and Bernard. They also visit the Salon du Champ de Mars, a secessionist group from the Old Salon, headed by Meissonier, whose inaugural exhibition has just opened, on 15 May. Vincent is profoundly impressed by Puvis de Chavannes's *Inter Artes et Naturam*. He also notices some pictures by Louis Dumoulin (1860–1924) painted in Japan. However, they do not visit the Old Salon or the Japanese exhibition at the École des Beaux-Arts, as Vincent had hoped (LT633).

Pierre Puvis de Chavannes. *Inter Artes et Naturam* (central panel), 1888–90. Oil on canvas, 25½ x 67½ in. (64.8 x 171.5 cm.). Musée des Beaux-Arts, Rouen. Photograph courtesy Giraudon/Art Resource

In the evening he sees Jo's brother, Andries Bonger, who is "looking strong and calm and, upon my word, reasoned with much correctness on artistic subjects" (W22). Bonger himself writes to his parents on 21 May: "I saw [Vincent] on Sunday evening. He looks better than ever and has put on weight. He spoke normally and with animation. I believe it has done him good to have left that institution" (Boon, *Liber Amicorum,* p. 69). Although Jo speaks later of "many visitors," she does not name them (*The Complete Letters,* p. li). It is certain that Gauguin, though still in Paris, does not see Vincent, nor does Vincent see any of his paintings (LT643). There is no evidence that he meets any other artists—the Pissarros, Guillaumin, Toulouse-Lautrec, Bernard, Signac. Nor does he meet the art critics Aurier and Isaäcson (Isaäcson is back in Holland). But he does read Isaäcson's two recent articles of 10 and 17 May on the Impressionists in *De Portefeuille.*

Monday 19 May

Jo reports later that Saint-Rémy was not mentioned during van Gogh's stay in Paris, where he was "cheerful and lively all the time.... He went out by himself to buy olives, which he used to eat every day and which he insisted on our eating too" (*The Complete Letters,* p. l). Nonetheless,

Photograph of Andries Bonger, c. 1886. Rijksmuseum Vincent van Gogh (Vincent van Gogh Foundation), Amsterdam

after only three days in Paris, he feels "very strongly that all the noise there was not for me" (LT635); "[it] had such a bad effect on me that I thought it wise for my head's sake to fly to the country" (LT643). He also confesses that "after that long seclusion, the days seem like weeks to me" (LT636). His decision to leave Paris after three days prompts Theo to write his letter of introduction to Dr. Gachet. Dated 19 May, it is written from 8 Cité Pigalle and not the offices of Boussod & Valadon, and therefore probably composed in the evening:

"My brother only arrived last Saturday, so we could not come to your consultation [on Friday, in Paris]. As he does not wish to tire himself too much in Paris, he has decided to leave for Auvers and to go and see you. You will see that at present he is very well. I should be much obliged to you if you would look after him, and give him advice on a possible place to live. I will permit myself to come to see you one of these Fridays to ask your instruction and your impressions" (Gachet, *Lettres impressionnistes,* pp. 149–50).

Van Gogh leaves Paris without having done any painting —neither retouching his old canvases nor beginning his long-dreamed-of picture of a Paris bookshop by gaslight.

The Boulevard Mirabeau, Saint-Rémy-de-Provence, 1950s. Rijksmuseum
Vincent van Gogh (Vincent van Gogh Foundation), Amsterdam

Saint-Rémy: Catalogue

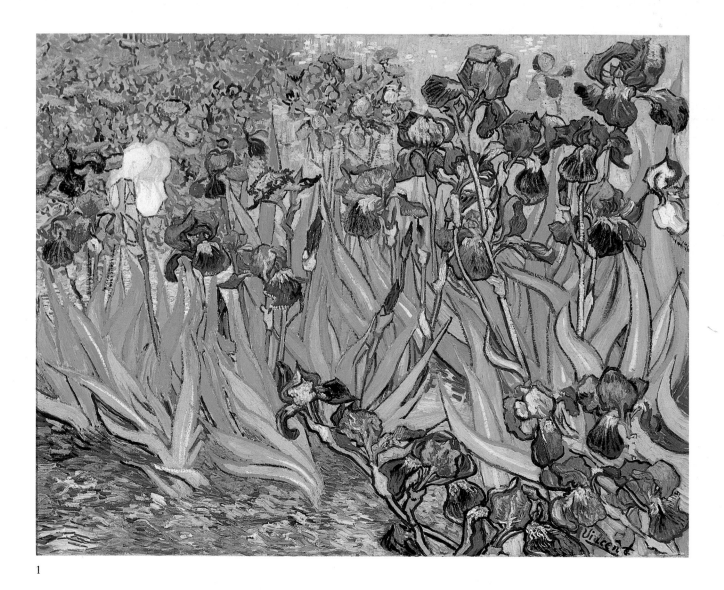

1

1. Irises

Oil on canvas, 28 × 36¾ in. (71 × 93 cm.)
Signed, lower right: Vincent
The Joan Whitney Payson Gallery of Art, Westbrook College,
 Portland, Maine. The Joan Whitney Payson Collection

F608 H606 JH1691

This friezelike close-up of life-size irises was painted within the first week of van Gogh's arrival at the asylum of Saint-Paul-de-Mausole in Saint-Rémy. Writing to his brother Theo on about 15 May 1889, he reported that he was working on two canvases: "some violet irises and a lilac bush, two subjects taken from the garden" (LT591). These first paintings can be identified as the present *Irises,* and *Lilacs,* now in Leningrad (fig. 1), where clumps of irises grow close to the dominant lilac bushes.

 By the end of the second week, two more paintings were under way (cat. 2, fig. 3; F734). They too show motifs taken from the large area of garden to the south of the men's quarters, the only part of the grounds where van Gogh was permitted to work during his first month at the asylum. One of these paintings he described at length and also sketched in a letter (LT592, reproduced on page 30).

There is no indication why van Gogh chose these particular motifs, nor why, strangely, they have no counterparts in the dozen or so garden drawings he also did in May. All size 30 canvases, two vertical and two horizontal, they are each devoted to one predominant flower or plant—iris, lilac, ivy, rose.

In this concentrated group portrait of violet-blue irises, one lone white flower stands out like a giant butterfly. Reddish earth and orange marigolds provide a vivid color contrast. Each delicately headed flower, each tough and spearlike leaf is brilliantly rendered in this living frieze. Such an obsessively claustrophobic examination of a fragment of nature would seem to echo van Gogh's own decreed confinement. Yet neither van Gogh nor Theo interpreted *Irises*—or the other three garden paintings—as emotionally disturbing or psychologically charged. For Theo they reflected his wish that Vincent should try to observe nature without searching unduly for style or meaning, without torturing the forms or taxing his energies.

Irises was among the eleven pictures van Gogh sent to Theo in July. He classified it as a study—that is, among those which are "more studies from nature than subjects for pictures" (LT600), whereas he considered *Lilacs* a picture. But such a distinction clearly did not worry Theo, who submitted *Irises* to the Salon des Indépendants in September 1889. It was listed, incorrectly, in the first edition of the catalogue as *Étude d'oies* (Study of Geese; fig. 2). It was noticed there by at least one critic, Félix Fénéon, who wrote in *La Vogue*: "The 'Irises' violently slash their petals to pieces upon swordlike leaves." And after the exhibition closed, Theo told his brother on 16 November: "'Irises' was seen by a lot of people, who talk to me about it" (T20). Subsequently, in 1892, it was acquired by another critic, Octave Mirbeau, from the dealer Julien (Père) Tanguy.

Analogies of subject can be found in Japanese woodblock prints, such as Hokusai's *Irises* from the "large-sheet flower series" of the late 1820s, but infrequently in the work of van Gogh's French contemporaries. The closest stylistic analogy is to be found in a lost painting by Gauguin, *Geese*, which is dated 1889. *Irises* has the palpable "thereness" of a Courbet, yet it is also an unconscious

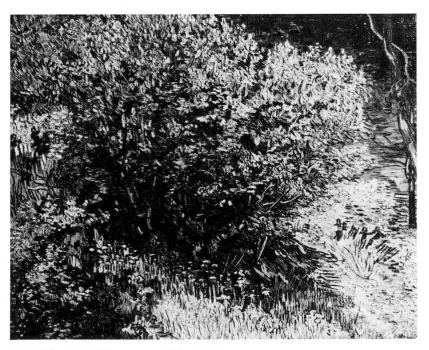

Fig. 1. *Lilacs* (F579). Oil on canvas, 28¾ x 36¼ in. (73 x 92 cm.). The Hermitage Museum, Leningrad

Fig. 2. Catalogue listing for the Salon des Indépendants, Paris, September 1889

harbinger of the more artificial and stylized voice of Art Nouveau. In van Gogh's own work it acts as an intermediary between the friezelike still life of sunflowers painted in Paris in late 1887 (F452) and the branch of chestnut leaves and blossoms painted in Auvers in May–June 1890 (F820).

As well as appearing in *Lilacs,* irises can be seen in a drawing of the hospital garden (cat. 4) and in an oil painting now in Ottawa (F601). In May 1890, just before leaving Saint-Rémy, van Gogh painted two still lifes of irises in Provençal pots (cat. 51, 52).

2. Tree with Ivy in the Asylum Garden

Pencil, chalk, reed pen and brown ink on Ingres paper,
 24 × 18¼ in. (62 × 47 cm.)
Watermark: PL Bas
Unsigned
Rijksmuseum Vincent van Gogh (Vincent van Gogh Foundation),
 Amsterdam

F1532 JH1696

"Since I have been here, the deserted garden, planted with large pines beneath which the grass grows tall and unkempt and mixed with various weeds, has sufficed for my work, and I have not yet gone outside," van Gogh reported to his brother on 22 May 1889 (LT592), two weeks after his arrival at the asylum.

During May he made five pen-and-ink drawings of the asylum garden (the present one; cat. 4; F1501, F1505, F1531). In fact he had done few pen drawings since August 1888, and no major series since that of Montmajour in July 1888. A few days before leaving Arles he told Theo: "I am . . . thinking again of beginning to draw more with a reed pen, which, like last year's views of Montmajour, for instance, costs less and distracts my mind just as much. Today I made a drawing of

Fig. 3. *A Corner of the Asylum Garden* (F609). Oil on canvas, 36¼ x 28¼ in. (92 x 72 cm.). Present location unknown

2

that sort. . . . It's something which will keep me occupied enough and in some fashion might even make me a sort of livelihood" (LT590). He completed two such drawings in Arles, both views of gardens, one in the Place Lamartine (F1468), the other in the hospital courtyard (F1467).

Once in Saint-Rémy, van Gogh continued to make these large drawings, quickly establishing the composition with soft pencil and black chalk worked over with reed pen. Like the Montmajour series, these were entirely independent entities not associated with any painting. At the same time, they were therapeutic exercises and potentially salable.

Here the pen strokes are fiercely and freely applied and less systematically organized than in the Montmajour suite; the dot, so much a part of the Arles armory, is abandoned. Fading of the ink has altered the tonal relationships, often

3

unduly softening them. But the present drawing has retained much of its coruscating bite, and also its subtle transitions, with atmospheric nuances suggesting depth.

The device of a tree trunk cutting across the picture plane, used in the Arles *Sower* (F450), is used again here. With this enlarged foreground element, van Gogh combines a glimpse of the garden beyond, as he did in *Japonaiserie: Flowering Plum Tree (after Hiroshige)* (F371), which he painted in Paris in 1887.

Throughout his life van Gogh was strangely ambivalent about ivy. When writing to Theo and to his sister Wil a few days before leaving Arles (LT587, W12), he rather morbidly equated ivy growing on tree trunks with cancer developing in human beings. On the other hand, especially in his younger days, he spoke fondly of the plant, quoting Dickens: "A strange old plant is the ivy green" (LT84). In the same vein, he said of a painting of a similar motif (fig. 3): "[It] represents the eternal nests of greenery for lovers. Some thick tree trunks covered with ivy" (LT592). For Theo the motif had no unwholesome, symbolic overtones; it became for him almost the paragon of a normal, healthy slice of nature: "It seems to me, " he wrote on 22 October 1889, when discussing the painting together with *Irises* (cat. 1), "that you are stronger when you paint true things like that. . . . The form is so well defined, and the whole is full of color" (T19).

The drawing was probably sent to Theo on 18 June among several "hasty studies made in the garden" (LT595).

3. Stone Steps in the Asylum Garden

Pencil, black chalk, reed pen and brown ink, watercolor, gouache
 on paper, mounted on cardboard, 24¾ × 17¾ in. (63 × 43.5 cm.)
Unsigned
Rijksmuseum Vincent van Gogh (Vincent van Gogh Foundation),
 Amsterdam

F1535 JH1713

The low stone wall in the garden of the asylum, visible in the middle ground of *Tree with Ivy in the Asylum Garden* (cat. 2), is here given added prominence, as are the stone steps that divide the garden into two areas. The upper area was less cultivated than the lower one, where fountain, stone seats, terraced path, and

Fig. 4. *The Asylum Garden in Summer* (F1536). Watercolor, 18¼ x 24¼ in. (46.5 x 61.5 cm.). Present location unknown.

flowering bushes were contiguous to the main building of the men's wing (see the more encompassing view in cat. 33). Van Gogh's eleven garden drawings of May 1889 can be divided between these two levels, those of the lower being the more numerous.

They can also be divided into the five pen-and-ink drawings (see cat. 2) and the six watercolors and gouaches (the present one; fig. 4; F1526, F1527, F1533, F1537; F1534 seems to be a pastiche of F1533). They all began as chalk and reed pen and brown ink drawings. This can clearly be seen in the present work, where variegated strokes of brown ink articulate the surface and create color contrasts. Indeed, it is possible that van Gogh completed these drawings and only then decided to rework them and heighten them with color. The body of the fluently applied color is substantial (especially in the sky and in the hard metallic green of the central cypress tree in the present work), virtually transforming the drawings into painted studies (and therefore rendering them more salable).

The present view, with modifications in angle and height of viewpoint, recurs in two paintings of autumn 1889 (F640, F731).

Compare also the picture that is shown hanging on the wall of van Gogh's studio in cat. 7, of a cypress framed by two pine trees.

4. A Corner of the Asylum Garden

Pencil, chalk, reed pen and brown ink on faded pink paper,
24¼ × 19 in. (63 × 48 cm.)
Watermark: PL Bas
Unsigned
Verso, in pencil: 219 (crossed through), 502
The Trustees of the Tate Gallery, London

F1497 JH1852

Dominated by pine trees, the southwest corner of the asylum garden is seen here. Part of the same composition can be seen in a drawing now in the Rijksmuseum Kröller-Müller, Otterlo (fig. 5), where much overworking and rephrasing with pen and ink, which has faded unevenly, gives the sheet a somber ghostlike appearance

Fig. 5. *A Corner of the Asylum Garden* (F1505).
Charcoal, brush, pen and brown ink, 18 x 23¾ in.
(45.5 x 60.5 cm.). Rijksmuseum Kröller-Müller, Otterlo

and the motif a peculiarly sinister effect. This is partly inherent in the chosen view, enclosed and claustrophobic. By contrast, the deeper space, the more open view, and the larger expanse of sky give the Tate drawing a unique place among the early group of garden drawings. Faintly visible are vertical, horizontal, and diagonal pencil lines, which suggest that van Gogh may have returned to the use of a perspective frame, an unexpected feature of his working methods at this time, since it would appear that he abandoned this mechanical aid after his visit to Saintes-Maries in early June 1888. While no other drawing of this period discloses this kind of armature, van Gogh certainly still considered using a perspective frame in both Saint-Rémy and Auvers: sketches of such a frame can be seen on two sheets (F1611, F1637).

The irises in the lower left suggest that van Gogh made the drawing in May 1889 (cf. cat. 1). Figures are rare in the first drawings in Saint-Rémy, and the

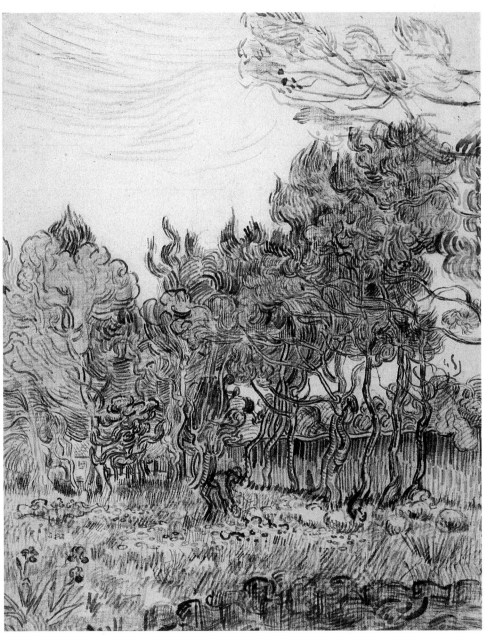

4

bending figure at center was a late addition. The style is less abruptly simplified, the pen less brutally persistent than in the drawing of the ivy-covered tree (cat. 2). It seems probable that the drawing was included with the other "hasty studies made in the garden" that van Gogh sent to Theo about 18 June (LT595).

Pine trees in the asylum garden are only rarely glimpsed in van Gogh's paintings of May through July: in *Lilacs* (cat. 1, fig. 1) and in *A Corner of the Asylum Garden* (cat. 2, fig. 3). Not until the autumn were they featured prominently in a group of major paintings (cat. 32–34). Van Gogh explored anew the wide variety of motifs afforded by the pine trees in some twenty small sketchbook drawings (F1564–F1577, F1579–F1582). One of these in particular, F1581, is a compositional variant of the Tate Gallery drawing. By standing farther back, the artist allowed himself a full view of the large pine whose upper branches intrude their lacelike effect in the sky of the Tate drawing.

5. The Vestibule of the Asylum

Black chalk and gouache on pink Ingres paper,
 24¼ × 18½ in. (61 × 47 cm.)
Unsigned
Watermark: AL (in oval) Bas
Recto (in pencil), lower right: 13. Verso (in pencil):
 no. 13 Hospice à St Rémy Arles
Rijksmuseum Vincent van Gogh (Vincent van Gogh Foundation),
 Amsterdam

F1530 JH1806

6. Corridor in the Asylum

Black chalk and gouache on pink Ingres paper,
 24⅜ × 18½ in. (61.5 × 47 cm.)
Unsigned
Watermark: AL (in oval) Bas
Recto (in pencil), lower right: 14. Verso:
 no. 14 (in pen) Hospice à St Rémy (in pencil)
The Museum of Modern Art, New York.
 Abby Aldrich Rockefeller Bequest

F1529 JH1808

7. Window of van Gogh's Studio in the Asylum

Black chalk and gouache on pink Ingres paper,
 24⅜ × 18½ in. (61.5 × 47 cm.)
Unsigned
Watermark: AL (in oval)
Rijksmuseum Vincent van Gogh (Vincent van Gogh Foundation),
 Amsterdam

F1528 JH1807

Two weeks after his arrival in Saint-Rémy, van Gogh responded at great length to Theo's request for some description of life in the asylum (LT592). Describing the garden, his work there, the other patients, and his bedroom, he conveys the impression of an establishment in decline, symbolized by the curtains and armchair in his room—"relics of some rich and ruined deceased"—and the "unkempt" and "deserted" garden. There were thirty empty rooms in the men's ward, and one of these had been assigned to him as a studio. Of this, and of the building itself, he

says little, only that one of the patients "thinks he hears voices and words in the echoes of the corridors." And, somewhat fancifully, in a later letter, he regrets that the building could not be moved elsewhere: "It would be splendid to hold an exhibition in, all the empty rooms, the large corridors" (LT596).

Vividly illustrating these sparse comments, the three gouaches of the asylum interior were probably done in late May or early June. Essentially intended to give Theo a visual idea of his environment, they may also in some measure have helped van Gogh acclimatize to his new surroundings (figs. 6, 7). Yet neither he nor Theo ever refers to them.

Demonstrably, their physical characteristics imply a contemporaneous execution. All share the same-size pink paper, the same chalk lay-in, the same fluid application of gouache, and the same ocherous yellows, dried-blood reds, and dull greens.

Stylistically, the proto-Expressionist palette, the heavy contours, the bold hatchings, and the simplified, if not always entirely flat, color areas surely derive from the motif rather than from a programmatic intention. The stark functionalism of the early nineteenth-century interior is conveyed in the gloomy corridors and iron-barred windows. Only in the long, echoing corridor (cat. 6) is a figure—a late addition—shown, probably fleeing from the distressing sounds.

But two of these gouaches include other presences, pictures within pictures. In the vestibule (cat. 5) a framed painting leans against the wall at the right, with

Fig. 6. The vestibule of the asylum of Saint-Paul-de-Mausole, c. 1935. Photograph by John Rewald

Fig. 7. Corridor in the asylum of Saint-Paul-de-Mausole, c. 1935. Photograph by John Rewald

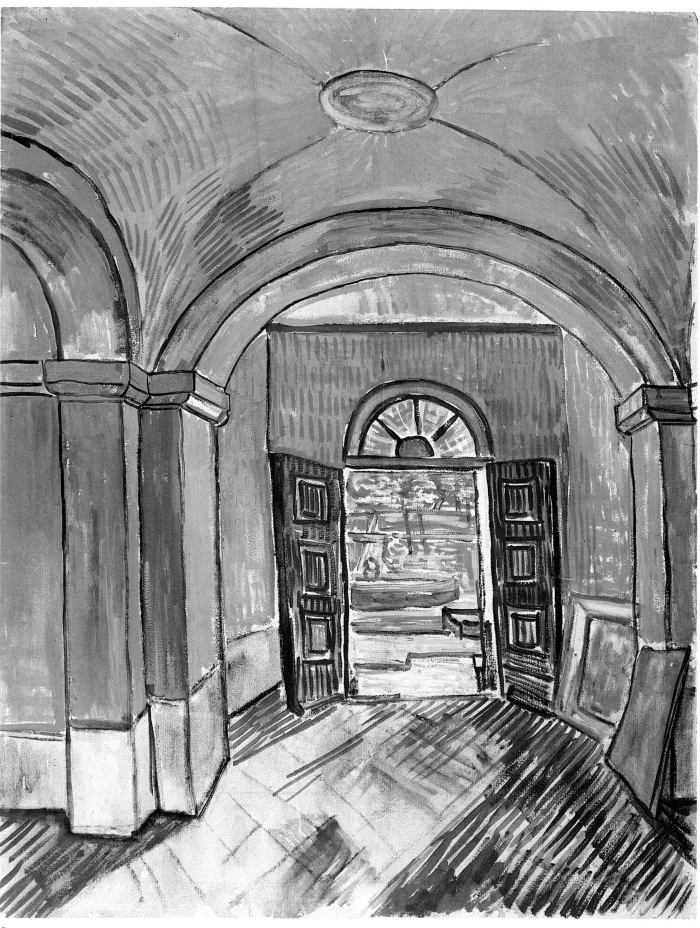

5

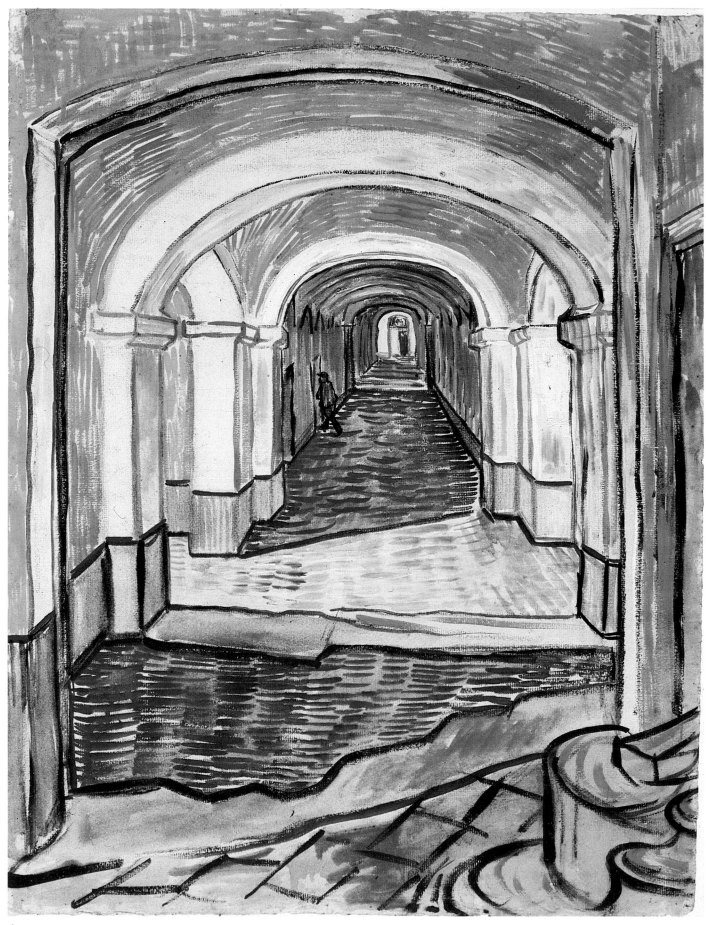

6

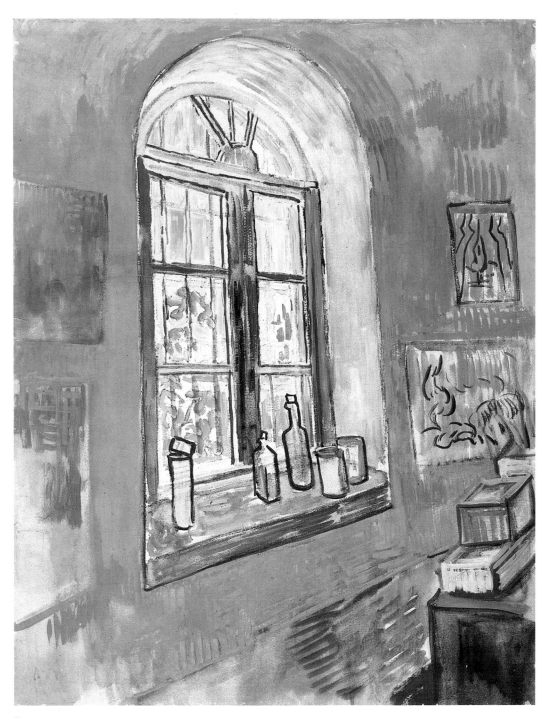

7

an unframed canvas (or possibly a portfolio with drawings) nearby. Both appear to be views of the very garden that is glimpsed through the open doors, in ironic contrast to the grim interior. And on the walls of the studio (cat. 7) hang four unframed works. Only one of these can be clearly observed. Showing a small cypress between two pines, the canvas may represent an actual work; it is similar in composition to two garden paintings of autumn 1889 (F640, F731). If it does represent one of these canvases, the dating of the gouache has to be changed. But it may, on the other hand, be a projected view reflecting what van Gogh could see

of the garden through his studio window, a further ironic comment on the interior–exterior relationship.

The idea of a triptych, envisaged by van Gogh in his series of Arles orchards (LT477) and again when he proposed that *La Berceuse* should be flanked by two upright canvases of sunflowers (LT592), recurs in these gouaches of the asylum interior. This is the first time they have been exhibited together.

8. Green Wheat Field

Oil on canvas, 28¾ × 36¼ in. (73 × 92 cm.)
Unsigned
Loan at Kunsthaus Zürich

F718 H615 JH1727

"Through the iron-barred window I see a square field of wheat in an enclosure, a perspective like van Goyen, above which I see the morning sun rising in all its glory," van Gogh wrote to his brother on 22 May 1889 (LT592). This walled field was part of the asylum property, situated at the eastern end—hence the rising sun—quite separate from the garden on the southwestern side, where he spent his first weeks drawing and painting.

During these weeks, van Gogh was not allowed outside the asylum walls; indeed, he was not even allowed into the walled field beneath his window. By about 5 June, Dr. Peyron agreed to lift this restriction. It is ironic that his first outside painting, *Mountainous Landscape Behind the Asylum,* now in Copenhagen (fig. 8), was actually done from inside the walled field he had observed for so long, one of "two views taken in the hills," as he rather misleadingly described it

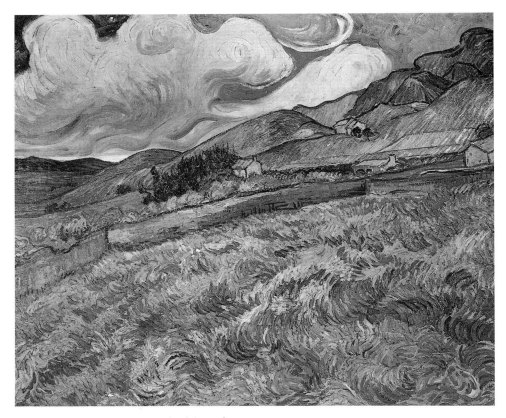

Fig. 8. *Mountainous Landscape Behind the Asylum* (F611).
Oil on canvas, 28 x 35 in. (70.5 x 88.5 cm.). Ny Carlsberg
Glyptotek, Copenhagen

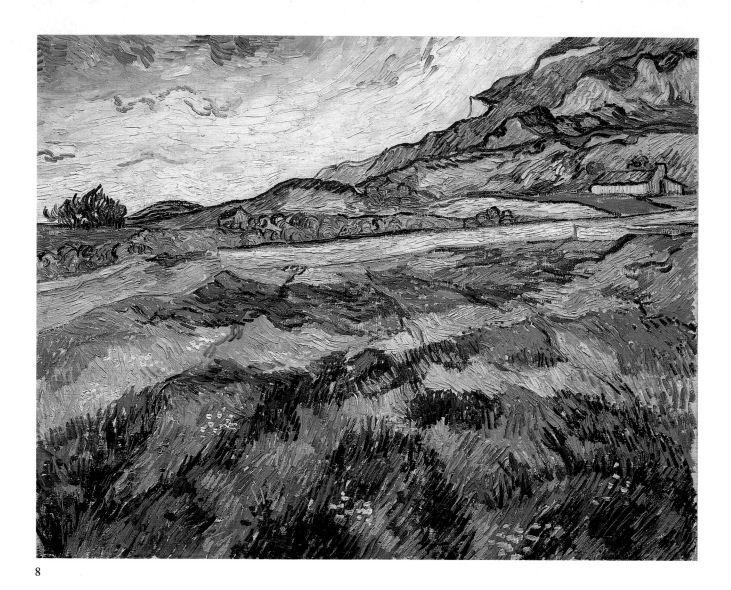

8

to Theo on 9 June. It shows "the country that I see from the window of my bedroom. In the foreground, a field of wheat ruined and hurled to the ground after a storm. A boundary wall and beyond the gray foliage of some olive trees, some huts and the hills. Then at the top of the canvas a great white and gray cloud floating in the azure" (LT594).

No such description of *Green Wheat Field* exists. It is not the second view taken in the hills; that is much more likely to be *Field with Poppies* (cat. 9). No drawing was made after it for Theo. And it was not listed as being among the batches sent to Paris.

From the still-green wheat and the profusion of poppies, *Green Wheat Field* must have been painted in early May. Commonly assigned to May 1889, it seems, rather, to date from May 1890, during van Gogh's last days in Saint-Rémy. It could be the "wheat field" that he cited among the Saint-Rémy paintings he received in Auvers in June 1890 (LT644).

Of the many pictures of wheat in the walled field, *Green Wheat Field* is the gentlest in color, with its turquoise, salmon-pink, and pale-blue touches. Spatially, it is the least acerbic: the wall is not sharply angular, but a calming horizontal; the

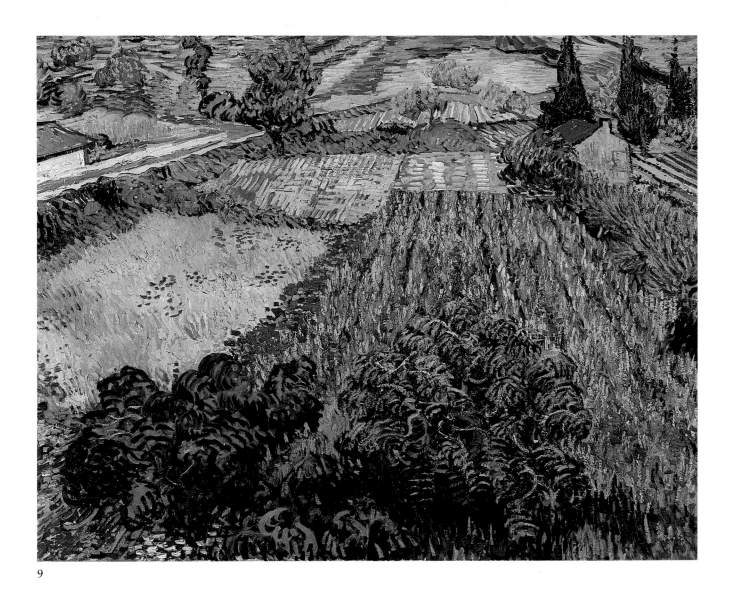

9

lines of the furrows are understated, and the Alpilles unaggressively profiled. As in *Mountainous Landscape Behind the Asylum,* the viewpoint is from ground level in the field itself, and not—as is so often suggested—from van Gogh's bedroom window.

For other treatments of this recurring motif, see cat. 23, 27–30.

9. Field with Poppies

Oil on canvas, 28 × 35¾ in. (71 × 91 cm.)
Unsigned
Kunsthalle Bremen

F581 H696 JH1751

Although not specifically described in van Gogh's letters, *Field with Poppies* must be the second of the "two views taken in the hills" referred to on about 9 June 1889 (LT594). The hills are just visible in the background, and in the irregular pattern of cultivated fields the wheat is turning yellow, which suggests that this landscape was painted a week or so before the "bread-crust" colored wheat of the

Prague canvas of mid-June (cat. 10). It is actually van Gogh's first landscape outside the hospital enclosure.

Perhaps to celebrate his release, van Gogh emphasized the luxuriant summer growth, open space, and distant vista, uninterrupted by any too insistent horizontals—the very reverse of his restricted views inside the asylum garden. Choosing a high viewpoint, he looked down on the foreground bushes and rapidly receding fields cutting out the sky. The rushing orthogonals recall some of the Hague compositions of 1882–83, views from his studio window (e.g., F943) and the open landscape of a potato field (F1037). Compositionally, the picture also recalls one of his drawn panoramic views from Montmajour of the previous July (F1420). And it looks forward to an Auvers landscape of June 1890 (F760) with its viewpoint taken from above, irregularly receding fields, and varied crop cultivation. In terms of the Saint-Rémy paintings, however, this deep-spaced landscape is unique.

Given the direct, elaborately textural, and cursive handling of *Field with Poppies,* it is hardly surprising that Claude Monet greatly admired the painting when he saw it in van Gogh's large one-man show at the Galerie Bernheim Jeune in Paris in 1901.

Van Gogh made a drawing after this canvas (cat. 16) and included it among the ten drawings he sent to Theo on 2 July. The drawing lacks the house and cypress at upper right. They were probably added to the painting later, wet on dry, perhaps in early September, when van Gogh spoke of "touching up the studies of this summer" (LT604).

The painting was sent to Theo on 28 September. Van Gogh called it both "Study of Fields" (LT607) and "Poppies" (LT608).

10. Wheat Field

Oil on canvas, 29 × 36½ in. (73.5 × 92.5 cm.)
Unsigned
Národní Galerie, Prague

F719 H610 JH1725

Van Gogh provided his sister Wil with a fairly detailed inventory of this landscape, now in Prague: "I have just finished a landscape . . . a field of wheat turning yellow, surrounded by blackberry bushes and green shrubs. At the end of the field a pink house with a tall and somber cypress which stands out against the far-off hills with their violet like and bluish tones, and against a sky the color of forget-me-nots with pink streaks, whose pure hues contrast with the scorched ears, which are already heavy, and have the warm tones of a bread crust" (W12).

This was reported on 16 June, a week after van Gogh had described his first painted view of the walled field, now in Copenhagen, to Theo (cat.8, fig. 8). If he is to be taken literally, he must have only just finished painting *Wheat Field*—perhaps that day, or the day before—at any rate, a week or so after he had completed the "after a storm" Copenhagen picture. This would seem to be confirmed by comparing the wheat in the two canvases: still predominantly green in the earlier painting, it is now bread-crust ripe. (Van Gogh explained to his mother about 2 July how rapidly the wheat ripened in the South of France, something that had taken him by surprise in Arles a year earlier.)

The Prague landscape cannot be identified as the second view "taken in the hills." Rather, it is the very opposite. Van Gogh turned his back to the Alpilles,

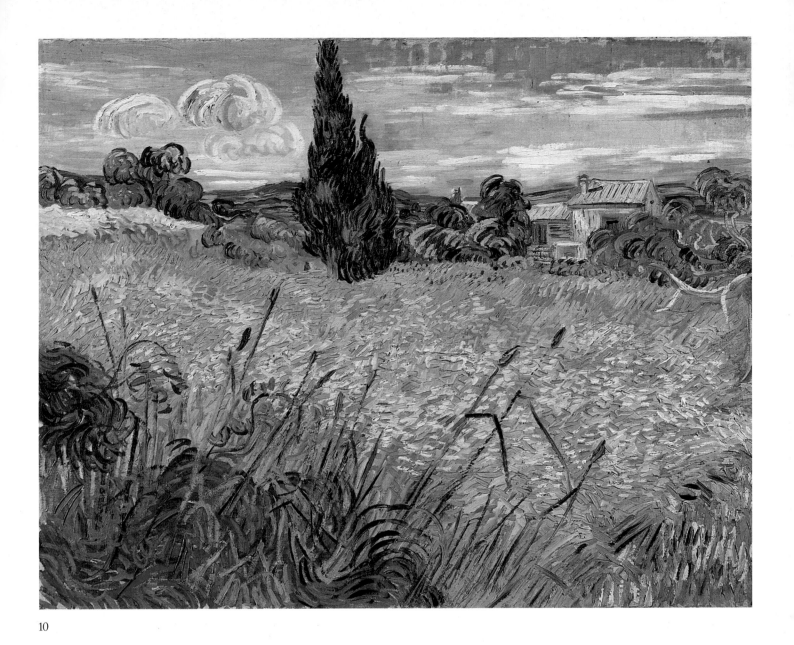

10

looking north to the distant range that includes Mont Ventoux, a view he rarely took during his year in Saint-Rémy (cf. cat. 20).

Without the Alpilles, and substituting poplars for the cypress, *Wheat Field* could easily be mistaken for an Ile de France landscape, its compositional formula being interchangeable with that of several pictures by Monet, Pissarro, Renoir, and Sisley. On the other hand, compared to high Impressionist practice, color is used more locally and the brushstrokes are more organic and vigorously hatched. With no spatial distortions, no excessively heightened color tonalities, and no revelatory symbolism, this landscape affirms its normality within an Impressionist convention. It neither manifests psychological tension nor projects a morbid vision.

Van Gogh included a drawing made after the painting (cat. 17) among the ten or so drawings that he sent to Theo in early July.

The painting itself, listed as "Wheat Field," was included in the third consignment of works sent to Paris on 28 September (see Appendix II).

11. Olive Orchard

Oil on canvas, 28¼ × 36¼ in. (72 × 92 cm.)
Signed, lower left: Vincent
Rijksmuseum Kröller-Müller, Otterlo

F585 H706 JH1758

Van Gogh painted some fifteen pictures of olive orchards in Saint-Rémy, eleven of them on size 30 canvases, all executed in 1889. Olive trees were a recurring theme, one that he wrestled with, on and off, from June to December 1889. One immediate problem is which painting was first. It could be the present canvas. Van Gogh never mentioned it in a letter, nor did he make a drawing after it for inclusion in the group sent to Theo on 2 July. But it is one of only seven Saint-Rémy paintings that van Gogh signed. The signature on this canvas may have a special significance. It could imply that the painting was the fifth from Saint-Rémy included in the first batch of work sent to Theo in July: the other four—all of the asylum garden, painted in May—are also signed. This signature is comparable to those. It was probably added in early July, together with some final touches, in the same deep blue, in the tree at left.

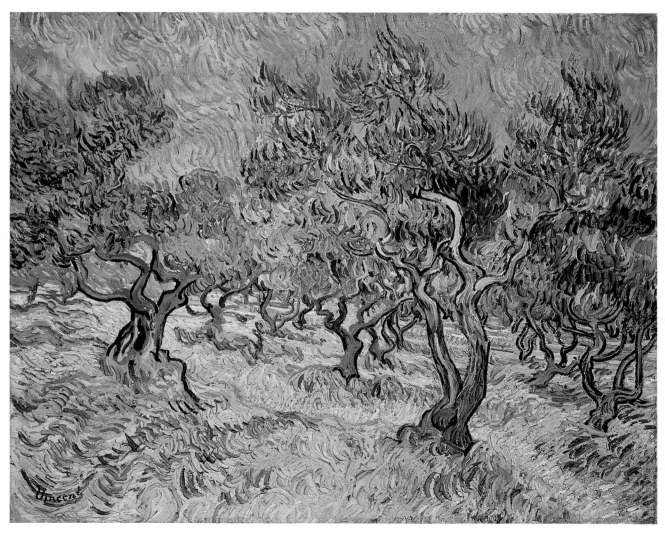

11

If this *Olive Orchard* was the one sent to Theo in early July, it must have been painted at least three weeks before that date in order to be dry enough to roll. Therefore, a date of about 12–14 June seems tenable.

Provençal olive trees show little variation in leaf color during the long summer season, so that dating the painting by the color of the trees is difficult. But the grass is not the bleached, dry yellow of high summer, and a date of mid-June seems not impossible.

Stylistically, the painting can be compared with the securely documented picture of the walled wheat field of early June (cat. 8, fig. 8). The same dense, curvilinear brushstrokes characterize the grass, for example; and they extend not only into the foliage but also into the sky, giving the painting a uniform overall rhythm.

The sky has no parallel in any other Saint-Rémy landscape. The only existing comparison is with the *Self-Portrait* now in the Musée d'Orsay, Paris, of September 1889 (cat. 22, fig. 19), where the rhythmic, flamelike shapes of the bluish turquoise background have often been interpreted as psychological markers of van Gogh's mental condition. It does not seem probable that he intended anything other than a stylistic convention in the sky of *Olive Orchard*.

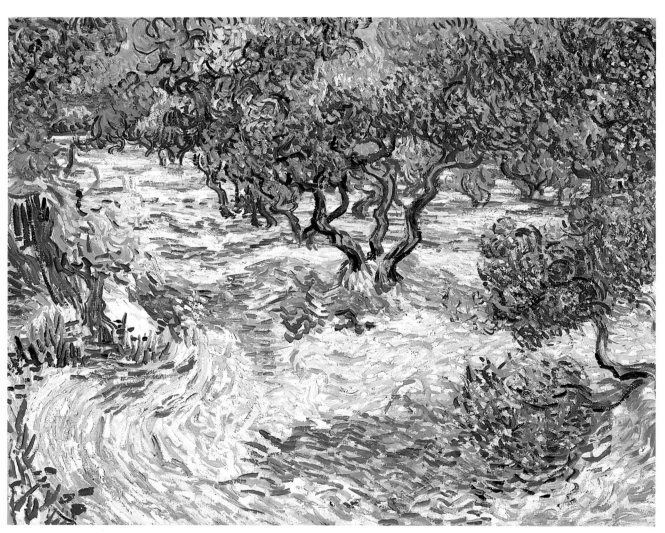

12

12. Olive Orchard

Oil on canvas, 28¾ × 36¼ in. (73.1 × 93.1 cm.)
Unsigned
The Nelson-Atkins Museum of Art, Kansas City, Missouri.
 Nelson Fund
F715 H641 JH1759
Reproduced on page 99

This is almost certainly the painting referred to by van Gogh when he wrote to his sister Wil on 16 July 1889: "I have just finished a landscape representing an orchard of olive trees with gray leaves, somewhat like those of the willows, their violet shadows lying on the sunny sand" (W12). As in the Kröller-Müller canvas (cat. 11), it was seen as a pictorial challenge, not yet as a quintessential symbol of Provence.

This *Olive Orchard* evokes the time "when the tree bears its pale flowers, and big blue flies, emerald rose beetles and cicadas in great numbers are hovering around it" (LT614a). And although the sun is hidden, its dominating force is revealed in the dappled light and shadow, observed empirically rather than schematically as in later paintings of the olive orchards (cat. 42, 43). The loose, Impressionistic style would have been recognized—and applauded—by Monet, as it was in *Field with Poppies* (cat. 9). Within a day or so of painting this canvas, van Gogh produced the more dramatically stylized *Olive Trees with the Alpilles in the Background* (cat. 13). This is typical of the incredible stylistic heterogeneity of the June paintings.

The picture was sent to Theo on 19 September 1889 (LT607).

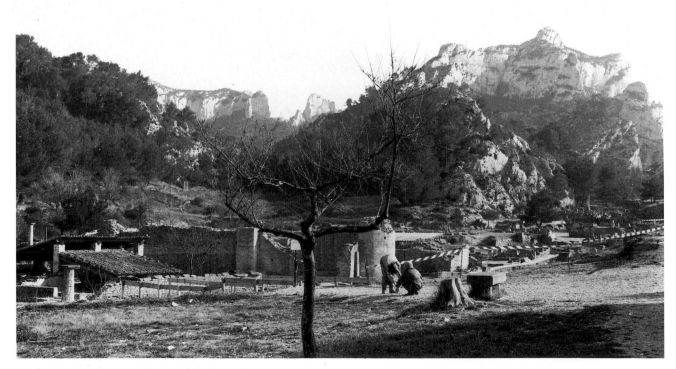

Fig. 9. Mont Gaussier, 1986. Photograph by Jean Delrieux

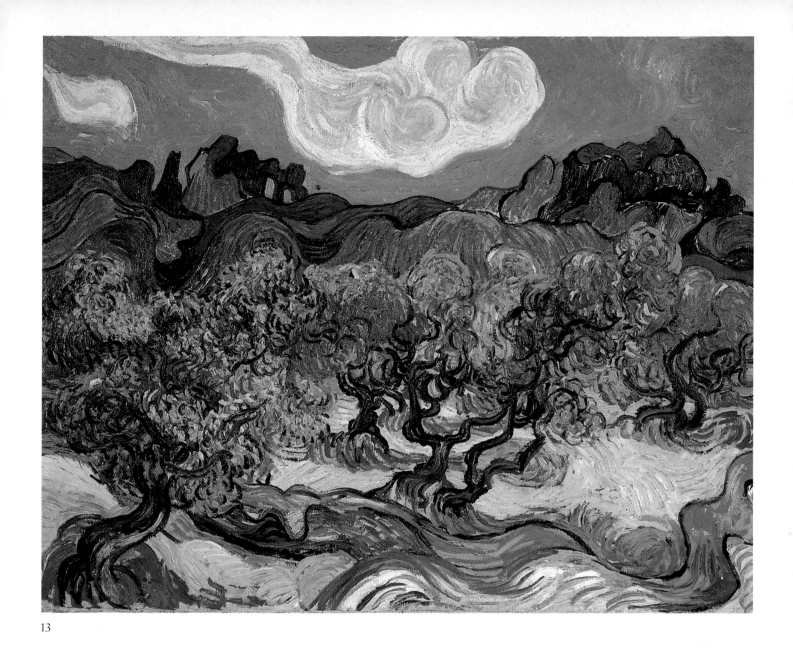

13

13. Olive Trees with the Alpilles in the Background

Oil on canvas, 28½ × 36¼ in. (72.5 × 92 cm.)
Unsigned
Collection Mrs. John Hay Whitney

F712 H635 JH1740

Van Gogh announced to Theo on about 18 June 1889: "At last I have a landscape with olives and also a new study of a starry night" (LT595). These two paintings (the present canvas and cat. 14) were always bracketed together in van Gogh's mind. He never actually called them pendants, yet not only do they share certain stylistic features (which he was at pains to emphasize and explain), they also predicate the contrast of day and night.

Olive Trees with the Alpilles in the Background was painted *sur le motif.* The seemingly tortured and turbulent shapes of the mountains are not a bizarre, exaggerated expressionist outpouring of van Gogh's disturbed psyche. The Alpilles were viewed on a particular alignment showing their most strikingly dramatic features: at left Les Deux Trous (Two-Holes Rock) and at right Mont

Fig. 10. *Olive Trees with the Alpilles in the Background* (F1544).
Pencil, pen, reed pen and ink, 18½ x 24½ in. (47 x 62.5 cm.).
Nationalgalerie, East Berlin

Gaussier. Because of the uncovering of the archaeological site of Glanum, begun in 1921, which has caused considerable changes in ground level, the motif is difficult to photograph (fig. 9). Van Gogh chose the same part of the Alpilles, but from a position more to the right than here, in *Mountains at Saint-Rémy* (cat. 20).

In the series of olive pictures, *Olive Trees with the Alpilles in the Background* is unique in setting the olives in their unmistakable Saint-Rémy landscape. The others are simply Provençal orchards; even the small glimpse of the Alpilles in *Olive Trees with Yellow Sky and Sun* (cat. 40) gives little more than a generalized backdrop.

While the motif is recognizable and in itself fantastic and unreal in configuration, van Gogh imbued it with his own stylistic imprint. This was a conscious artistic decision, a stylistic amalgam that derived from Eugène Delacroix but had its most immediate source in the ideas and practices of Paul Gauguin and Émile Bernard. As if by osmosis, this is a Pont-Aven picture painted in Saint-Rémy.

The cool blue-green color scale is remarkably close to that of the Kansas City *Olive Orchard* (cat. 12). But a comparison of the two canvases emphasizes the degree of deliberate and exaggerated stylization in the present version.

A drawing after the painting (fig. 10) was included in the group sent to Theo on 2 July.

14. The Starry Night

Oil on canvas, 29 × 36¼ in. (73.7 × 92.1 cm.)
Unsigned
The Museum of Modern Art, New York. Acquired through the
 Lillie P. Bliss Bequest, 1941

F612 H612 JH1731

Van Gogh said very little about the *Starry Night,* providing neither a minimal inventory nor any explanation as to why he painted it when he did. Later commentators have concentrated on its complex symbolic imagery. Suggested sources range from the Bible (Genesis or Revelations) to Whitman and Longfellow, from Zola and Daudet to Dickens and Carlyle.

Early in June 1889, van Gogh referred to the *Starry Night Over the Rhône* (fig. 11), a canvas done in Arles in September 1888, and he suggested that Theo exhibit it at the forthcoming Salon des Indépendants: "It might give somebody else the idea of doing night effects better than I did" (LT593). In his next letter, of about 9 June, he told his brother, "I have seen an announcement of a coming exhibition of impressionists called Gauguin, Bernard, Anquetin and other names" (LT594). And writing again about 18 June, he exclaimed, "At last, I have a landscape with olive trees and also a new study of a starry sky" (LT595).

These three quotations are closely connected. In painting the *Starry Night Over the Rhône,* van Gogh wanted to demonstrate that night subjects should be done at night on the spot rather than during the day in the studio, and that a whole range of colors—not just blue-black—was to be found in them; he was also surely questioning the stated practices of the American artist James Abbott McNeill Whistler (1834–1903) in his Nocturnes. To exhibit his Arles night scene in Paris would be a public affirmation of his own beliefs and practices. The announcement he had read of the exhibition of the work of Gauguin and Émile Bernard at Volpini's café clearly led him to reconsider their beliefs and practices as well, especially the arbitrary use of color and the antinaturalistic use of line. Memories of their painting and of his own in Arles combined to act as a catalyst to the realization of a new study of a starry night. The stimulus had been with him since his arrival at the asylum. From the window of his bedroom, he looked east and southeast onto an open landscape culminating in the Alpilles. Seldom in his lifetime could he have had so vast and uninterrupted a view of the night sky. "This morning I saw the country from my window a long time before sunrise, with nothing but the morning star" (LT593).

But when van Gogh came to paint his new starry night, he did not follow his earlier procedure of doing it on the spot. Instead, he was forced to revert to the very convention he objected to. At the asylum, he had been given a room overlooking the garden to use as a studio. But from the studio, unlike the bedroom, he had no view of the Alpilles. In that studio in mid-June, several recently painted canvases were drying (see W12). From two of them, *Mountainous Landscape Behind the Asylum* (F611) and the *Wheat Field* now in Prague (cat. 10), van Gogh extracted elements that he then used in his new painting. From the one he took the outline of the Alpilles, and from the other he took the cypresses.

The village and church in the *Starry Night* are often said to be based on a drawing showing a panoramic view of Saint-Rémy (fig. 12). This, however, is unlikely, since the drawing was probably done much later. In any case, the elongated church spire seems more Dutch than Provençal, a conflation of several spires van Gogh had painted and drawn in Nuenen (F25, F87, F1238). The *Starry Night,* with its Dutch village inserted into a Southern landscape, thus becomes the first of van Gogh's "memories of the North." And with its mixed genesis, its

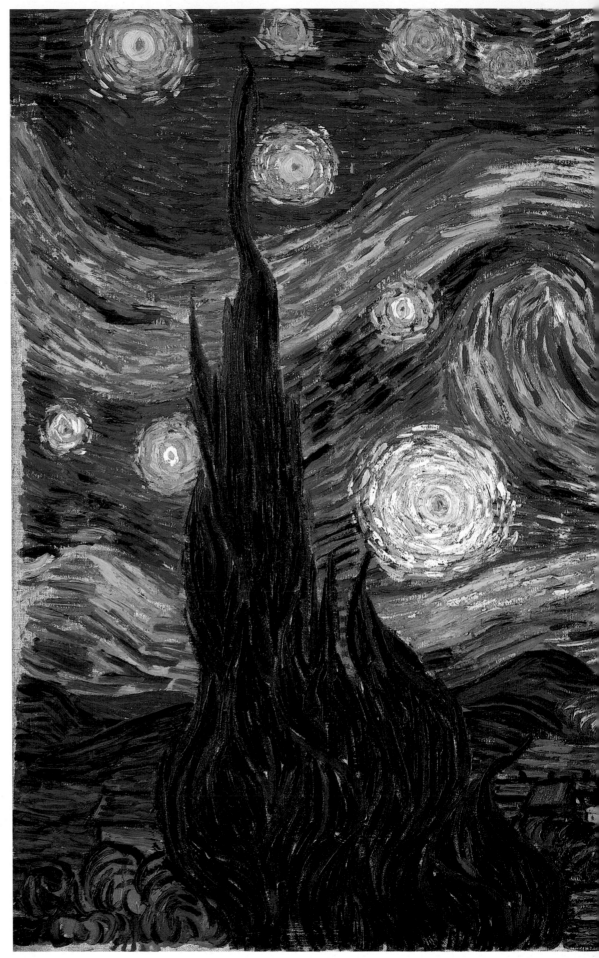

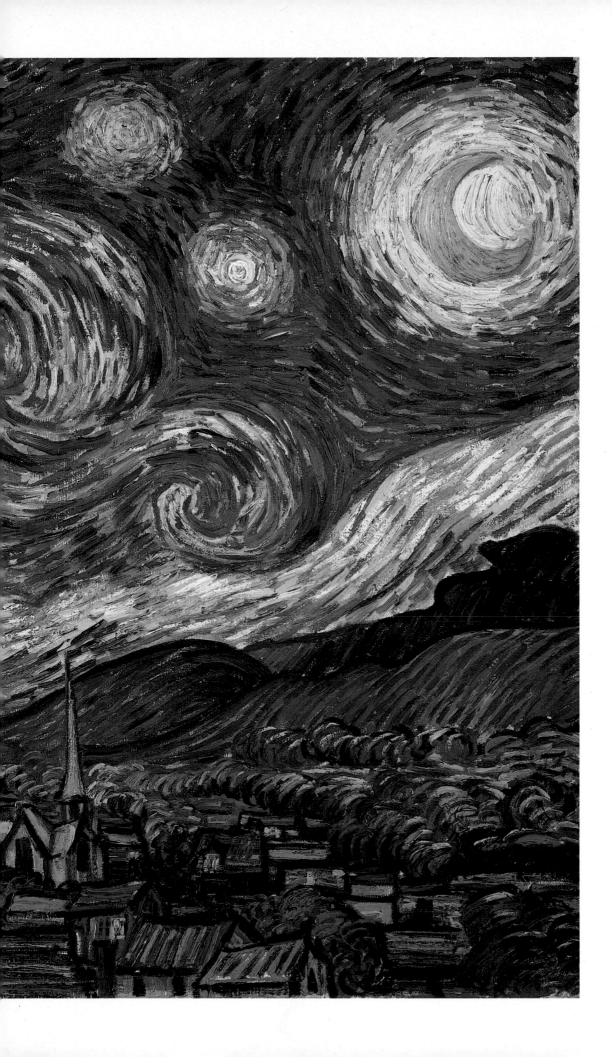

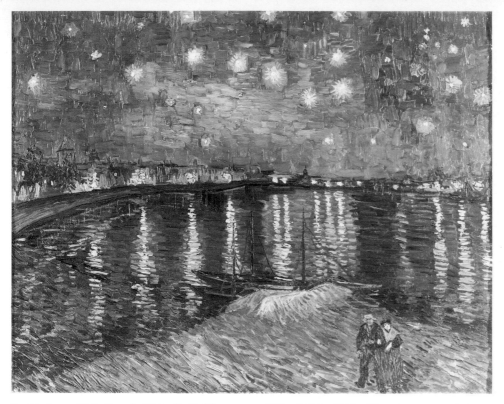

Fig. 11. *Starry Night Over the Rhône* (F474). Oil on canvas, 28½ x 36¼ in. (72.5 x 92 cm.).
Collection Mr. and Mrs. Robert Kahn-Sriber. Gift, reserving life interest,
to the Musées Nationaux (Musée d'Orsay), Paris

composite procedures, and its arbitrary collage of separate motifs, it is overtly
stamped as an "abstraction" of the kind he painted in Arles under the tutelage of
Gauguin (e.g., F496). Its complex and distinctive morphology bears little resem-
blance to the rest of his June oeuvre. Together with *Olive Trees with the Alpilles in
the Background* (cat. 13), the *Starry Night* is a perfect instance of what might be
called stylistic osmosis. It is a Pont-Aven picture painted in isolation but under-
taken to achieve a closer communion with the work that Gauguin and Bernard
were exhibiting at Volpini's. "Though I have not seen either Gauguin's or Bernard's
last canvases, I am pretty well convinced that these two studies I've spoken of are
parallel in feeling" (LT595).

Van Gogh made a drawing after the painting sometime between 25 June and
2 July (fig. 13). It shows more changes from the parent painting than any of the
other ten drawings sent to Theo on 2 July; in particular, many of the cottage roofs
are now thatched and several chimneys emit long spirals of smoke, enhancing the
Dutchness of the village. Additionally, there are only ten stars, not the eleven
necessary for supporting the argument that the painting is an exegesis of
Revelations. Proportionately, there is more sky in the drawing and the moon and
stars are larger. The cypresses are opened out, like some strangely tentacled
tropical plant.

Promised to Theo in the second batch of paintings sent on 19 September
(LT607), the *Starry Night* was not sent to Paris until 28 September, when it was
included in the third batch (see Appendix II). Theo's response to the painting was
interesting. He made no comment on the cypresses, the mountains, or the bizarre
gyrations in the sky, referring to the picture only as "the village in the moonlight,"
thereby perhaps giving recognition to a shared memory of their Dutch past. "I
think that the search for some style is prejudicial to the true sentiment of things,"
he wrote (T19).

Fig. 12. *View of Saint-Rémy* (F1541v). Pencil, pen, wash, 6½ x 11¾ in.
(16.5 x 30.1 cm.). Rijksmuseum Vincent van Gogh
(Vincent van Gogh Foundation), Amsterdam

Fig. 13. *The Starry Night* (F1540). Pen and ink, 18½ x 23¾ in.
(47 x 62.5 cm.). Destroyed; formerly Kunsthalle Bremen

15. Cypresses

Oil on canvas, 36¾ × 29⅛ in. (93.3 × 74 cm.)
Unsigned
The Metropolitan Museum of Art, New York. Rogers Fund, 1949
F613 H616 JH1746

Van Gogh's discovery of the cypress was the cardinal event of June 1889. He celebrated it in his letter of 25 June. Telling Theo that the weather had been glorious and he had twelve size 30 canvases in progress, he added that among them were "two studies of cypresses of that difficult bottle-green hue; I have worked their foregrounds with thick layers of white lead, which gives firmness to the ground. I think that very often the Monticellis were prepared like this. On top of that one can then put on other colors. But I do not know if the canvases are strong enough for that sort of work" (LT596).

He explained, in the same letter, something of the fascination that the motif had for him: "The cypresses are always occupying my thoughts; I should like to make something of them like the canvases of the sunflowers, because it astonishes me that they have not yet been done as I see them. It is as beautiful in lines and proportions as an Egyptian obelisk. And the green is of so distinguished a quality. It is a splash of *black* in a sunny landscape, but it is one of the most interesting black notes, and the most difficult to hit off exactly that I can imagine. But then you must see them against the blue, *in* the blue rather."

And after further interjections, he went on: "I think that of the two canvases of cypresses, the one I am making this sketch of will be the best [fig. 14]. The trees in it are very big and massive. The foreground, very low with brambles and brushwood. Behind some violet hills, a green and pink sky with a crescent moon. The foreground especially is in heavy impasto, clumps of brambles with yellow, violet and green reflections."

Fig. 14. Sketch of *Cypresses* (LT596). Rijksmuseum Vincent van Gogh (Vincent van Gogh Foundation), Amsterdam

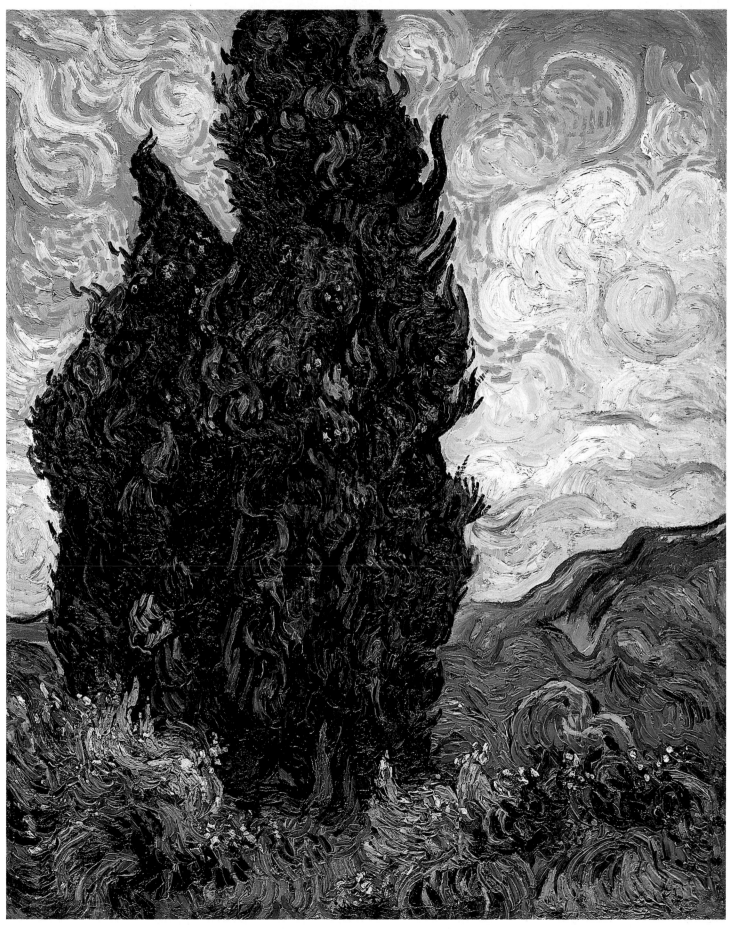

15

In Arles, van Gogh occasionally painted cypresses in their utilitarian guise, as windbreaks in orchards and fields (F513, F554); sometimes as a picturesque foil to a small farmhouse (F407); and most extensively in one of the Poet's Garden series (F485). But the motif did not really fire his imagination there, nor did he grapple with its coloristic and architectural challenge. In his first paintings outside the asylum, he continued to observe the cypress as he had in Arles, from a distance (e.g., cat. 9). While the "dark and somber" cypress asserts its presence more in the Prague *Wheat Field* (cat. 10), it still remains but a part of the landscape. Only in the *Starry Night* (cat. 14) is it audaciously thrust into prominence.

That was by mid-June. By the end of the month, the series of cypress canvases was fully launched, with the present painting, its large upright pendant now in Otterlo (cat. 19, fig. 15), and the horizontally contrasting *Wheat Field with Cypresses* (F717). These are van Gogh's most heavily impastoed paintings, not only in the thickly encrusted foregrounds, fields, and hills but also in the turbulently treated skies. Whether this near-bas-relief articulation of textures resulted from what van Gogh believed to be a procedure used by Monticelli—the working of layers of paint over a white ground—or whether it occurred during the act of painting—the consequence of repeated viewings inciting him to use more super-imposed color, wet on wet—is not easily determined.

The cypress is traditionally the symbol of death in Mediterranean countries; hence its frequent presence in graveyards. While seeing it as a "splash of *black*," van Gogh does not directly state that he is using it as a death symbol. In wishing to make of the cypress what he had made of the sunflower, he was probably thinking of using it in a series of five or six canvases as a decoration for a room, and possibly as a representation in opposition to the sunflower, symbol of life, consolation, and gratitude.

As things turned out, however, he did not complete a series. He reworked the upright canvas for G.-Albert Aurier in February 1890, and made a painted reduction of it for his mother and sister (F621). But the only other major painting of cypresses was *Road with Cypress and Star* (cat. 55).

The Metropolitan picture was sent to Theo on 28 September 1889 as "Study of Cypresses" (LT608). Already in early July, Theo had received the drawing made after the painting (cat. 18). This canvas was almost certainly the one exhibited at the April 1890 Salon des Indépendants as catalogue number 832, "Le Cyprès."

16. Field with Poppies

Pencil, reed pen and brown ink on cream wove paper,
18 × 24¼ in. (46.5 × 62.5 cm.)
Unsigned
Private collection

F1494 JH1752

Drawn after the Bremen painting *Field with Poppies* (cat. 9) between 25 June and 2 July and sent to Theo in Paris on 2 July 1889.

This is one of ten large drawings that van Gogh made after his first group of Saint-Rémy paintings. He announced their beginnings in his letter of 25 June (LT596): "I will send you drawings of them [two paintings of cypresses] with two other drawings that I have also done." The remaining six were executed within the following week, and all ten were then dispatched to Theo on 2 July, "in order that you have some idea of what I am doing" (LT597).

16

Van Gogh's choice reflects very strongly the work he had completed since being allowed outside the asylum—that is, his paintings of June. He made only one drawing (F1522) after his May quartet of garden pictures, although the drawing in Ottawa (F601), worked up with oils, may be based on a small part of the Leningrad *Lilacs* (cat. 1, fig. 1). His procedure varied. In some he laid in a rapid composition with soft pencil, which he then built up with reed and quill pen; in others (e.g., cat. 17 and F1547) he drew directly with the pen. The proportions of the respective formats of painting and drawing never coincide, and differences in placement of individual parts occur. These drawings are never exact copies. Sometimes they reveal more, clarifying a painted ambiguity; on other occasions, their own dynamic rhythms falsify and distort the original painting. But retrospectively, as documents, they reveal changes that van Gogh made to some of his paintings. The most striking example is in the Chicago drawing of cypresses (cat. 19). In the present drawing, the absence of the farmhouse and the three cypresses at the right clearly confirms that these were added to the Bremen painting, probably in September.

Of the ten drawings, the present one and *Wheat Field* (cat. 17) are the least distorted and improvisatory. But then they were done after the two most direct and Impressionistic paintings of June 1889.

17

17. Wheat Field

Reed pen and brown ink on cream wove paper,
 18 × 24½ in. (46.7 × 61.7 cm.)
Unsigned
Watermark: Latune et Cie Blacons
Verso, in brown ink, upper left: 202 (by another hand)
The Pierpont Morgan Library, New York. Gift of Mrs. Gerard B.
 Lambert in memory of Gerard B. Lambert

F1548 JH1726

Drawn after the Prague painting *Wheat Field* (cat. 10) between 25 June and 2 July, and one of ten drawings sent to Theo in Paris on 2 July 1889.

Van Gogh drew directly with reed pen, boldly and unhesitatingly. Compared with the Prague painting, the composition is extended laterally and more space is given to the sky. The result is to reduce the impact of the cypress and make the field of wheat seem correspondingly larger. While van Gogh controlled the relentless bravura of the pen, he could not resist adding a few more flamelike strokes to the cypress. The motif is similar to that of certain paintings and drawings of wheat fields done in Arles in June 1888—for instance, F565 and F1478. And the cursive articulation in the sky recalls another Arles drawing, F1488. The dot, used so compulsively and so logically in the Arles drawings, virtually disappears from those of Saint-Rémy. Only here does it make its last substantial

appearance, as van Gogh uses it to simulate the "bread-crust" yellows of the ripening wheat.

This drawing negates any preconceptions about the so-called stylistic excesses of the Saint-Rémy graphic style: swirls and whorls interpreted as manifestations of van Gogh's psychic condition. Like *Field with Poppies* (cat. 16), it is sober in style, spatially legible, and undemonstrative in mood.

18. Cypresses

Pencil, quill and reed pen, brown and black ink on
 white wove paper, 24½ × 18 in. (62.3 × 46.8 cm.)
Unsigned
Watermark: Latune et Cie Blacons
The Brooklyn Museum. Frank L. Babbott and
 A. Augustus Healy Fund

F1525 JH1747

Drawn after the painting *Cypresses* (cat. 15) by 25 June and sent to Theo in Paris on 2 July 1889.

In his letter of 25 June (LT596), in which van Gogh repeatedly returned to his two recently completed paintings of cypresses, he included a thumbnail sketch of one of them (cat. 15, fig. 14), done after the Metropolitan painting. In the same letter he promised to send Theo the two drawings that he had just made after the paintings. These are the present drawing and cat. 19.

In format the present drawing is slightly narrower than the painting, and the relationship of tree to ground, mountains, and sky is less clearly defined. The intricate spirals and whorls, seemingly exaggerated and unstructured, are an attempt to find a graphic equivalent, a suitable shorthand, for the "difficult" black green and the almost impenetrable form of the cypress. It is that challenge, consciously faced, which produces the almost musical repetition of aggressively pulsating curves. Far from being an expression of van Gogh's disturbed psyche, they are carefully and logically derived from a long and close scrutiny of the motif itself.

The fact that these drawings after paintings were executed on sheets much larger than their Arles predecessors invited a broader and coarser treatment. Van Gogh emphasized the main shapes and masses, showed much less interest in texture and surface, and therefore exploited a smaller range of graphic signs. This more summary and economical treatment made some of them difficult to read. Hence Theo's reaction when he received the drawings in July 1889: "The last drawings give the impression of having been made in a fury, and are a bit further removed from nature. I shall understand them better when I have seen one of these subjects in painting" (T12).

19. Cypresses

Pencil, reed pen and brown ink on cream wove paper,
 24½ × 18 in. (62.5 × 46.8 cm.)
Unsigned
The Art Institute of Chicago. Gift of Robert Allerton, 1927

F1524 JH1749

Drawn after the painting *Cypresses* (fig. 15) by 25 June and sent to Theo in Paris on 2 July 1889.

This drawing shows the first completed state of the painting. Van Gogh did not include the canvas in the batches he sent to Theo in 1889 and early 1890. It was

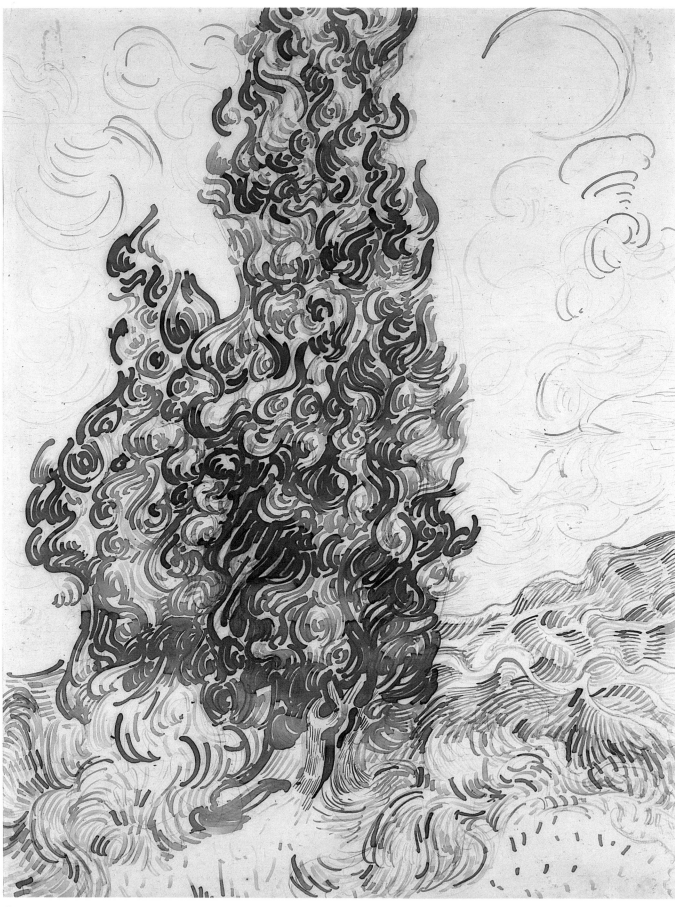

18

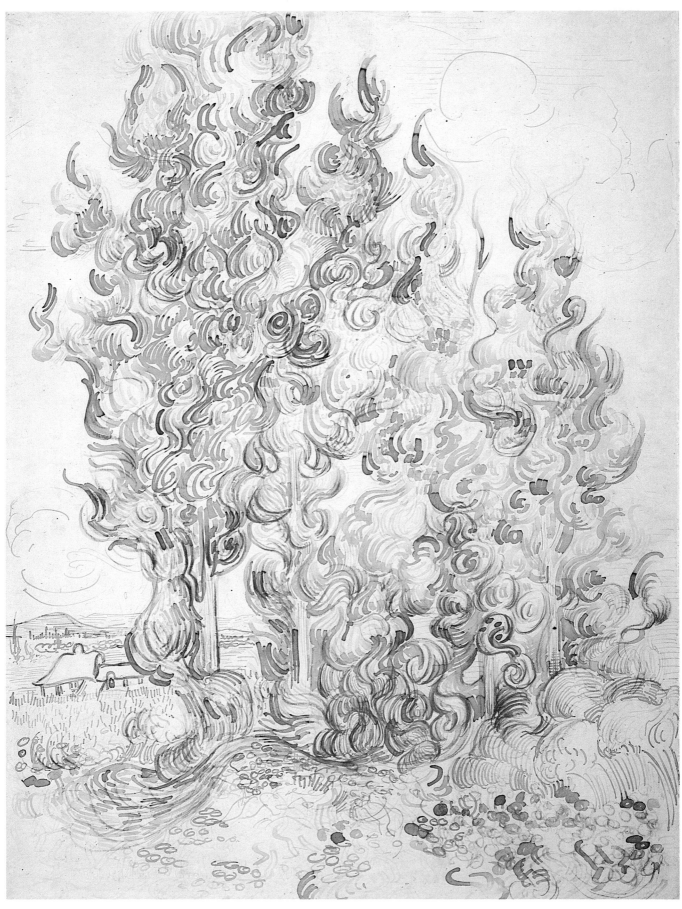

19

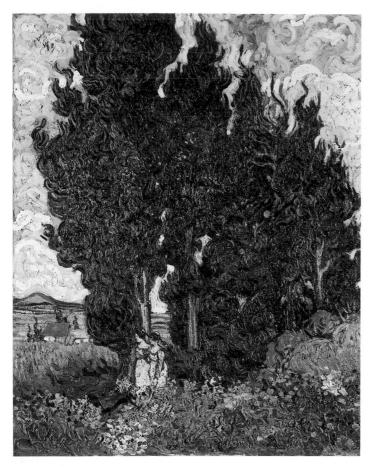

Fig. 15. *Cypresses* (F620). Oil on canvas, 36¼ x 28¾ in.
(92 x 73 cm.). Rijksmuseum Kröller-Müller, Otterlo

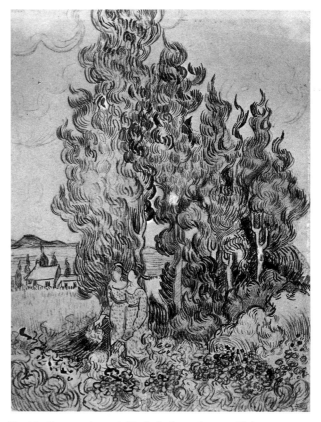

Fig. 16. *Cypresses* (F1525a). Black chalk, reed pen and ink,
12¼ x 9 in. (31 x 23 cm.). Rijksmuseum Kröller-Müller, Otterlo

still with him when he received G.-Albert Aurier's article, "Les Isolés: Vincent van
Gogh," from the January 1890 issue of *Le Mercure de France*. Aurier wrote of van
Gogh's cypresses as "blackened, shooting up their nightmarish silhouette of
flames." Van Gogh responded about 10 February: "In the next batch that I send
my brother, I shall include a study of cypresses for you, if you will do me the favor
of accepting it in remembrance of your article. I am still working on it at the
moment, as I want to put in a little figure. . . . The study I have set aside for you
represents a group of them in the corner of a wheat field during a summer mistral.
So it is a note of a certain nameless black in the restless gusty blue of the wide sky,
and the vermillion of the poppies contrasting with this dark note" (LT626a).

Having reworked the painting and added two figures, van Gogh then made a
second drawing after it to show Theo its revised state (fig. 16). The painting was
included in the last batch sent from Saint-Rémy, on 29 April 1890: "The cypresses
are for M. Aurier. I should have liked to do them again with a little less impasto,
but I haven't time" (LT629).

20. Mountains at Saint-Rémy

Oil on canvas, 28¼ × 35¾ in. (71.8 × 90.8 cm.)
Unsigned
Solomon R. Guggenheim Museum, New York.
 Gift of Justin K. Thannhauser

F622 H619 JH1766

Toward mid-July, van Gogh told Theo: "The last canvas I have done is a view of mountains with a dark hut at the bottom among some olive trees" (LT600). Topographically, there is little problem in identifying the motif (fig. 17). It is that part of the Alpilles with Les Deux Trous in the center and Mont Gaussier at right, seen from an angle different from that in *Olive Trees with the Alpilles in the Background* (cat. 13).

One question raised by the Guggenheim painting is the influence of literature on van Gogh's choice and treatment of a subject. Did he paint this landscape to illustrate a passage in a novel, *Le Sens de la vie* (1889), by the minor Swiss author Édouard Rod, which he had read some two weeks before beginning the picture?

The novel was sent to him by his sister Wil. By 25 June, he had read it and was unimpressed: "The title *Le Sens de la vie* is really a little pretentious for the

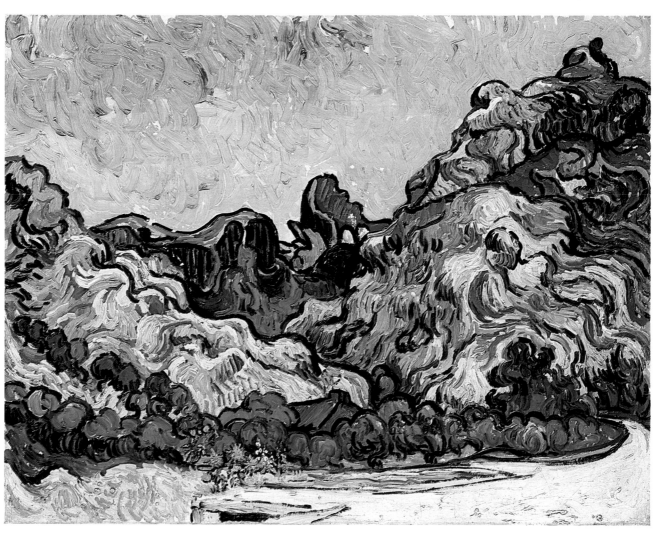

20

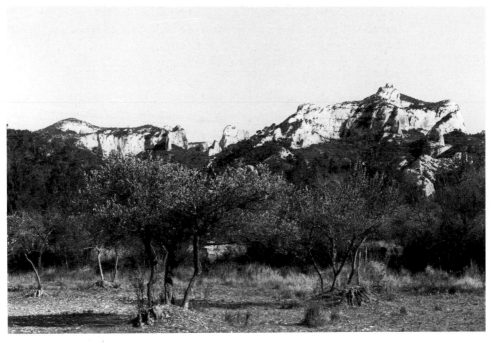

Fig. 17. Les Deux Trous and Mont Gaussier, 1986.
Photograph by Jean Delrieux

Fig. 18. Eugène-Guillaume Boch. *The Crachet-Picry Mine, Borinage,* 1888–90.
Oil on canvas, 22 x 30¾ in. (56 x 78 cm.). Rijksmuseum Vincent van Gogh
(Vincent van Gogh Foundation), Amsterdam

contents, it seems to me," he told Theo (LT596). In thanking Wil for sending it, he was less dismissive, going so far as to admit that he enjoyed reading it (W13). But when he mentioned the canvas to Theo in mid-July, he said nothing of Rod's novel. He first connected the two on 22 August, when writing to his brother immediately after recovering from his breakdown: "While I have no extravagant liking for Rod's book, all the same I have made a canvas of the passage where he speaks of the mountains and the dark huts" (LT601). And when eventually he sent Theo the painting, which he simply called "The Mountain," he reinforced the connection. "They will tell me that mountains are not like that and that there are black outlines of a finger's width. But, after all, it seemed to me it expressed the passage in Rod's book—one of the very rare passages of his in which I found something good—about a desolate country of somber mountains, among which are some dark goatherds' huts where sunflowers are blooming" (LT607).

The passage in Rod's *Le Sens de la vie*, identified by Vivian Endicott Barnett (*The Guggenheim Museum: Justin K. Thannhauser Collection*, p. 84), translates: "They seem indifferent to life's comforts: their wooden huts are small and black . . . they eat the vegetables which they have grown in their little gardens where an occasional sunflower sways."

Clearly, Theo accepted the literary connection. Some months later, in June 1890, when the Belgian artist Eugène-Guillaume Boch chose the picture in exchange for his recent painting the *Crachet-Picry Mine, Borinage* (fig. 18), Theo referred to it as "the canvas you did after reading the book by Rod" (T38).

21. Entrance to a Quarry

Oil on canvas, 23½ × 28½ in. (60 × 72.5 cm.)
Unsigned
Rijksmuseum Vincent van Gogh (Vincent van Gogh Foundation),
 Amsterdam
F744 H636 JH1802

Van Gogh painted two pictures of quarries, the present one and cat. 35. From his letters we know that one was painted in mid-July 1889, the other in October of the same year. The present painting has always been assumed to be the October version. There are, however, documentary, seasonal, and stylistic reasons for identifying it as the painting done in mid-July.

Retrospectively, van Gogh twice referred to this mid-July painting. On 22 August he wrote: "This new attack, my dear brother, came on me in the fields when I was busy painting on a windy day. I will send you the canvas that I finished in spite of it. And truly it was a more sober attempt, matte in color without showing it, in broken greens, and reds and rusty yellow ocher, just as I told you that sometimes I felt a great desire to begin again with the same palette as in the North. I'll send you this canvas as soon as I can" (LT601). And when he eventually sent Theo the canvas on 19 September, he explained: "I rather like the 'Entrance to a Quarry' that I was doing when I felt this attack coming on, because to my mind the somber greens go well with the ocher tones; there is something sad in it which is healthy, and that is why it does not bore me" (LT607).

These "somber greens" and "ocher tones" can only describe the present painting; the greens are much less evident in the October version. This return to "the same palette as in the North" in the use of earth colors, which dominated his

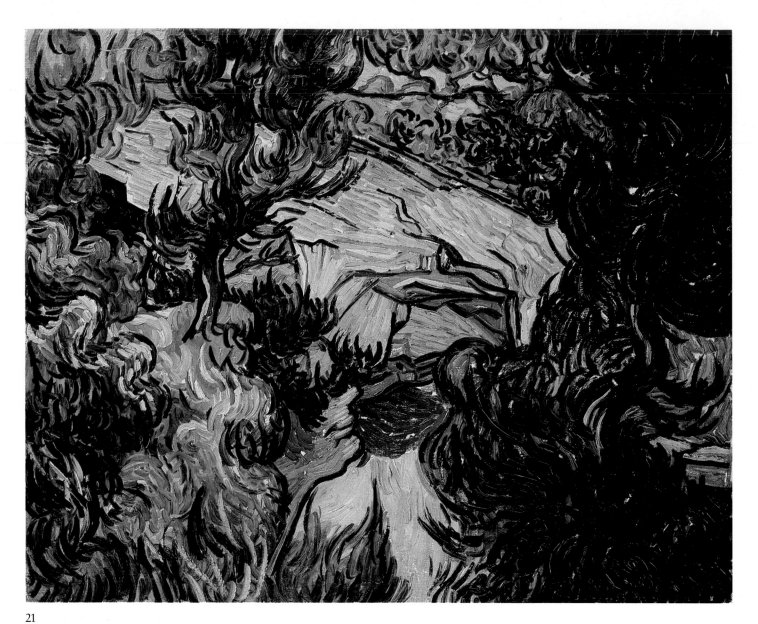

21

Dutch pictures and were largely absent from his Arles paintings, was already in van Gogh's mind by early June: "I feel tempted to begin again with the simpler colors, the ochers for instance" (LT594).

The restricted palette—almost equivalent to that of early Cubist landscapes by Picasso and Braque of 1908–9—and the thick contours can be directly compared to those in *Mountains at Saint-Rémy* (cat. 20). The effect of the wind seems tangibly present in the trees. Were the strokes of the brush handle, visible toward the upper left, caused accidentally by the wind, or by the onset of van Gogh's attack? Seasonally, it is surely high summer, with the rich, vibrant greens of the interpenetrating foliage.

Quarries abounded in Saint-Rémy below the foothills of the Alpilles, many of them worked since Roman times. Some were to be found just outside the asylum, providing easily accessible motifs for van Gogh.

See also cat. 35.

22. Self-Portrait

Oil on canvas, 22½ × 17¼ in. (57 × 43.5 cm.)
Unsigned
Collection Mrs. John Hay Whitney
F626 H624 JH1770

During his first months in the asylum, van Gogh was far too eager to be outdoors working on landscape motifs to consider the question of figure painting. Least of all was his mood sufficiently introspective for him to think of undertaking a self-portrait. It is hardly surprising, then, to find no figure paintings from May to July 1889; and even in his landscapes, only the *Reaper* (cat. 27, fig. 28) includes a figure, which is small and far from dominant.

A reversal of attitudes took place in late August–September, following his five-week breakdown. Retreating to his studio, refusing to go out, even into the garden, he returned to his interest in figure painting. As well as making copies after Delacroix and Millet, he did portraits and self-portraits. Immediately upon "getting up," he set the trend in motion, telling Theo (LT604): "They say—and I am very willing to believe it—that it is difficult to know yourself—but it isn't easy to paint yourself either. So I am working on two portraits of myself at this moment —for want of another model—because it is more than time I did a little figure work. One I began the day I got up; I was thin and pale as a ghost. It is dark violet-blue and the head whitish with yellow hair, so it has a color effect. But since then I have begun another one, three-quarter length on a light background" (fig. 19).

Wearing his painter's smock, a symbol of his profession not seen in any other self-portrait, and holding his palette and brushes, van Gogh overtly presents himself as the artist at work in his studio. This challenging assertion of his profession was surely intended as a demonstration piece for Dr. Peyron. Although just recovering from a serious breakdown, he is still quite capable of painting, and also determined to be allowed to resume painting, since that is now safe (he will not try to poison himself by eating the paints) and necessary to his recovery.

The present *Self-Portrait* seems to be almost entirely the work of one painting session, without later retouching. The green shadows on the pale sunken face and on the neck contrast with the angularly cascading light from above the temple to the neck, thereby helping to model the head. Against the dark blue, not quite violet, background—subtly nuanced and different shades of blue characterize the smock—the head emerges, unearthly, from the surrounding darkness. The background strokes create a halo effect of the kind that appeared occasionally in earlier self-portraits. Bold, thick contours are reserved for the smock and the palette; apart from the nose, the head is remarkably contourless.

On 19 September, van Gogh wrote more explicitly about his ideas on portraiture to his sister Wil: "I painted two pictures of myself lately, one of which has rather the true character, I think, although in Holland they would probably scoff at the ideas about portrait painting that are germinating here. Did you see the self-portrait by the painter [Armand] Guillaumin at Theo's?...When Guillaumin exhibited his self-portrait, public and artists were greatly amused by it, and yet it is one of those rare things capable of holding their own beside the old Dutch painters, even Rembrandt and Hals. I always think photographs abominable, and I don't like to have them around, particularly those of persons I know and love. Those photographic portraits wither much sooner than we ourselves do, whereas the painted portrait is a thing which is felt, done with love or respect for the human being that is portrayed. What is left of the old Dutchmen except their

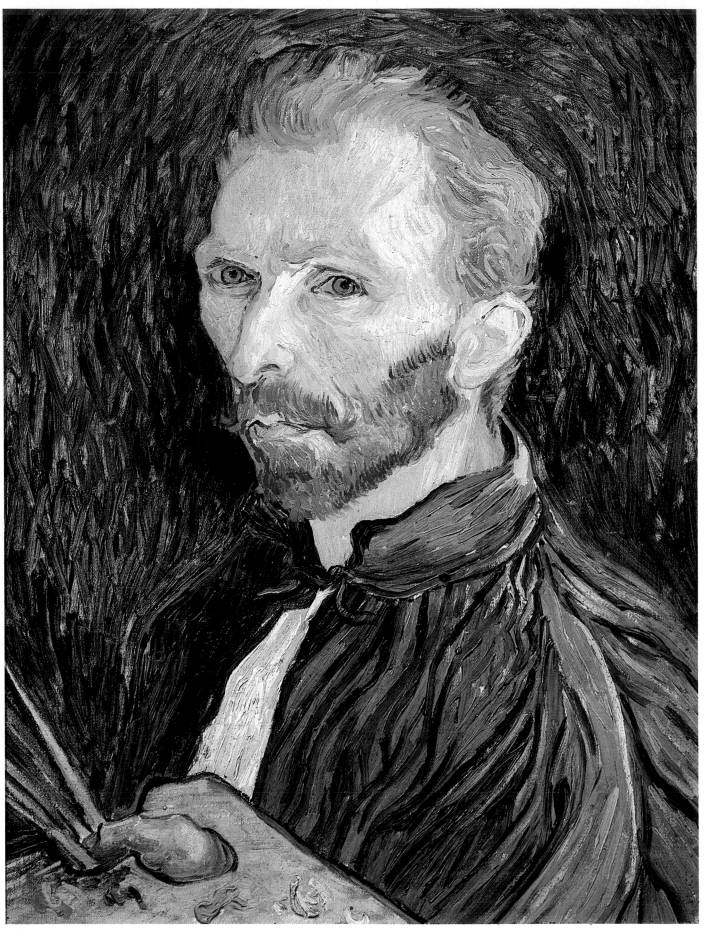

22

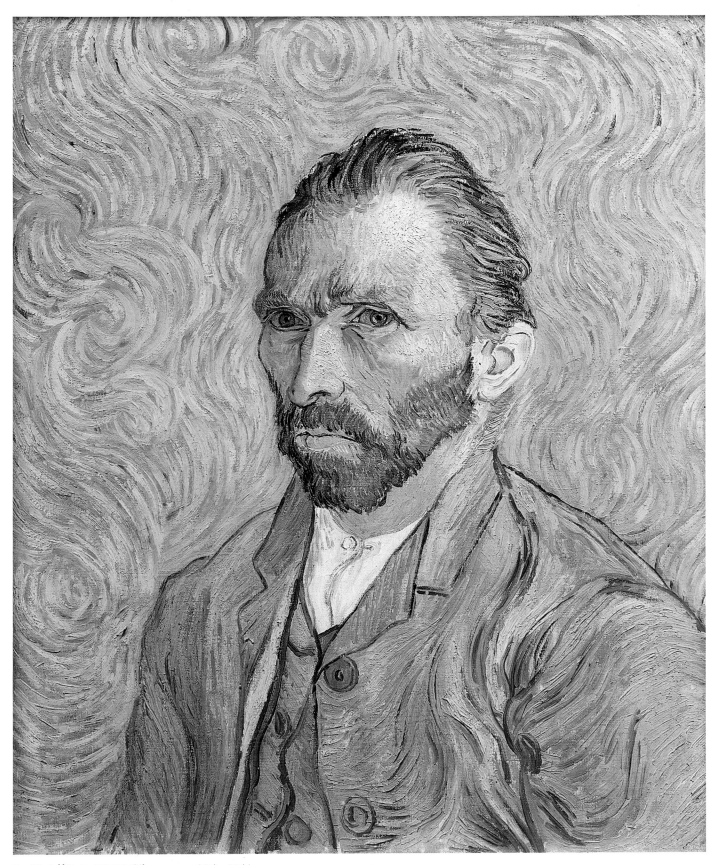

Fig. 19. *Self-Portrait* (F627). Oil on canvas, 25½ x 21¼ in.
(65 x 54 cm.). Musée d'Orsay, Paris. Gift of Paul and
Marguerite Gachet. NOT IN EXHIBITION

123

portraits?" (W14). Van Gogh here asserts his Dutch lineage—and his French linkage, although both he and Theo tended to overrate Guillaumin. His notion of the painted portrait as antiphotographic, as a re-created image, as a "felt" experience is reaffirmed, also to Wil, when he describes his *Portrait of Dr. Gachet* (cat. 62).

The immediate fate of the *Self-Portrait* is unclear. Van Gogh did not list it in the batches he sent to Theo in Paris. Its first recorded owner was the Dutch artist and art critic J. J. Isaäcson.

23. Enclosed Field with Ploughman

Oil on canvas, 19¼ × 24½ in. (49 × 62 cm.)
Unsigned
Private collection, U.S.A.

F625 H622 JH1768

Toward the end of August 1889, van Gogh wrote to Theo: "Yesterday I began to work a little again—on a thing that I see from my window—a field of yellow stubble that they are ploughing, the contrast of the violet-tinted ploughed earth with the strips of yellow stubble, background of hills" (LT602). He added a small sketch in the letter (fig. 20).

Van Gogh saw the view from his bedroom window, facing east, but he painted it in his studio overlooking the asylum garden, from where it was impossible to see the motif. That the painting was composed from memory is confirmed

Fig. 20. Sketch of *Enclosed Field with Ploughman* (LT602).
Rijksmuseum Vincent van Gogh (Vincent van Gogh Foundation),
Amsterdam

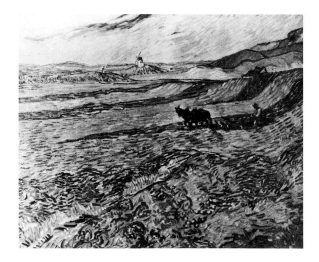

Fig. 21. *Enclosed Field with Ploughman* (F706). Oil on canvas,
21¼ x 26½ in. (54 x 67 cm.). Collection W. A. Coolidge,
Cambridge, Massachusetts

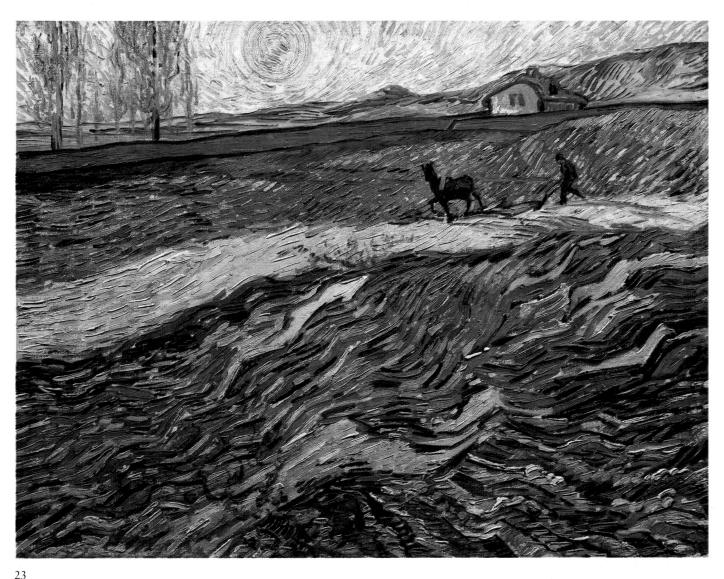

23

by three elements. The two forlorn-looking trees did not exist beyond the enclosing wall at left—that area was an orchard of olives—but were invented for compositional reasons. The Alpilles have been reduced to comparative insignificance. And the small hut set against the exterior wall has been pulled too close to the dividing wall and also converted into a cottage by the addition of windows and a chimney. It should also be noted that the motif is presented as seen from ground level, and not from a high vantage point.

The rising sun casts a blue shadow on the inside of the wall. A comparable phenomenon, more carefully observed, can be seen in the later *Wheat Field with Rising Sun* (cat. 30). In the present painting, the audacious strokes have a loose and vigorous quality, indicating that it was probably the first one that van Gogh did after recovering from his five-week breakdown.

A variant of *Enclosed Field with Ploughman* was painted some weeks later (fig. 21). There the topographical license taken is even greater, extending to the introduction of a windmill based vaguely on Daudet's mill at Fontvieille, near Arles.

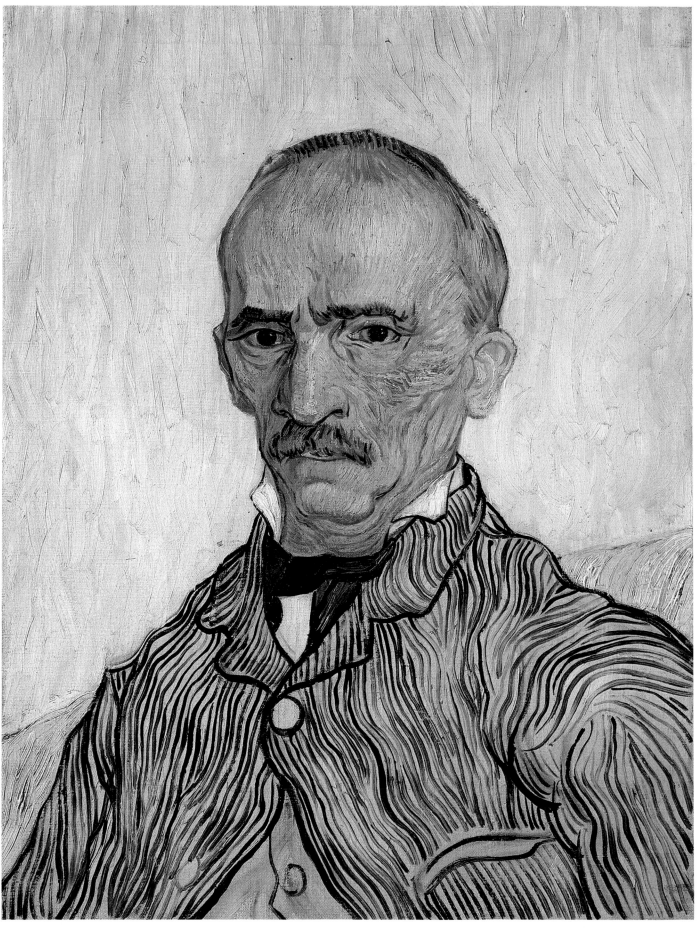

24

24. Portrait of Trabuc

Oil on canvas, 24 × 18¼ in. (61 × 46 cm.)
Unsigned
Kunstmuseum Solothurn. Dübi-Müller-Stiftung

F629 H626 JH1774

In the beautifully coordinated soliloquy delivered in a letter to Theo between long and intensive painting sessions in the early days of September 1889 (LT604), van Gogh revealed something of his own state and that of his work. He deliberately isolated himself in his studio, avoiding all contact with other patients. But the one person he must have seen fairly regularly was the asylum's head attendant, Trabuc.

Probably on 3 September, he announced to Theo: "Yesterday I began the portrait of the head attendant; perhaps I shall do his wife too, for he is married and lives in a little house a few steps away from the establishment. A very interesting face; there is a fine etching by Legros, representing an old Spanish grandee, if you remember it, that will give you an idea of the type. He was at the hospital in Marseilles through two periods of cholera; altogether he is a man who has seen an enormous amount of suffering and death, and there is a sort of contemplative calm in his face, so that I can't help being reminded of Guizot's face—for there is something of that in this head, but different. But he is of the people and simpler. Anyway, you will see it if I succeed with it and if I make a duplicate."

Van Gogh's analogies are remarkable in their breadth and surprising in their precision. The etching by Alphonse Legros (1837–1911) suggests the type (fig. 22), while Trabuc's "contemplative calm" is equated with the face of François-Pierre-Guillaume Guizot (1787–1874), premier of France under Louis Philippe, statesman, historian, elitist. Guizot's features were familiar to van Gogh from the illustrations he had once collected in French periodicals (fig. 23). But Trabuc is "of the people."

Fig. 22. Alphonse Legros. *Le Grand Espagnol*, c. 1870. Etching. New York Public Library. Prints Division

Fig. 23. James Dromgole Linton. *Two Veteran French Statesmen: M. H. Thiers and Guizot*, 1872. Wood engraving. Title page in *The Graphic*. Rijksmuseum Vincent van Gogh (Vincent van Gogh Foundation), Amsterdam

Fig. 24. *Portrait of Madame Trabuc* (F631). Oil on canvas mounted on panel, 25¼ x 19¼ in. (64 x 49 cm.). Present location unknown

As such, his portrait belongs to the "Heads of the People," the clear-cut category of working-class types drawn in the 1870s by the illustrators of the English weekly periodical *The Graphic,* which van Gogh avidly collected and greatly admired. Interestingly, all these analogies come from prints, etchings, and wood engravings that he had known for at least fifteen years, and which would seem to have no place in a Post-Impressionist's *musée imaginaire.* Not a hint is given in the letter of the colors he used or of the color effect he sought. He emphasized character and type, wanting to convey characterization and psychological interpretation.

The soliloquy continued, probably on 5 September: "This afternoon I have been working on the portrait of the head attendant, which is getting on. If it were not a good deal softened—completely softened—by an intelligent look and an expression of kindliness, it would be a veritable bird of prey. It is very much a Southern type."

In his next letter, of about 6 September, he was able to announce: "I have done the portrait of the head attendant, and I have a duplicate of it for you. This makes a rather curious contrast with the portrait I have done of myself, in which the look is vague and veiled, whereas he has something military in his small quick black eyes" (LT605). The comparison is with the Musée d'Orsay *Self-Portrait* (cat. 22, fig. 19), painted a day before he began the portrait of Trabuc.

Within the space of five days, van Gogh had painted Trabuc's portrait twice. The first version, from life, presented to the sitter, is lost. Only the studio copy, intended for Theo, survives. It was probably painted in one session, rapidly and thinly on an unprepared canvas, and not always to the edges. The figure was copied first; the background was then filled in with subtle infusions of turquoise and pink, the brushstrokes abutting the contours of the figure. In his references to the portrait, van Gogh never described the color. And the color, restrained and undramatic, seems subservient to the insistently linear patterns created in the coat and repeated in the head and neck and, more broadly and loosely, in the background articulation. Van Gogh seems to be vividly demonstrating what he was soon to write of *Olive Trees with the Alpilles in the Background* (cat. 13) and the *Starry Night* (cat. 14): "exaggerations from the point of view of arrangement, their lines are twisted as in old wood" (LT607).

Charles-Elzéard Trabuc was nearly sixty years old when van Gogh painted his portrait. He was born in Manosque, Basses-Alpes, on 28 March 1830, and he died in Saint-Rémy on 25 September 1896. A few days after completing Trabuc's portrait, van Gogh also painted his wife, Jeanne Lafuye Trabuc (1834–1903). As with her husband, van Gogh painted her from life and presented the portrait (now lost) to her, and then did a studio copy for Theo (fig. 24). In describing Madame Trabuc's portrait, he concentrated on the color effect: "The withered face is tired, pockmarked—a sunburned, olive-colored complexion, black hair. A faded black dress relieved by a geranium of a delicate pink, and the background in a neutral tone, between pink and green" (W14).

Although he promised Theo a duplicate of Trabuc's portrait in early September, van Gogh held it back until the end of his stay in Saint-Rémy. Did he suspect that Theo might find it too stylized and audacious? Certainly no parallel exists in late nineteenth-century portraits that Theo might have seen by Gauguin, Seurat, Cézanne, Degas, or Toulouse-Lautrec. But this combination of irregular yet persistent pattern with a searchingly deep characterization would rub off on Fauvist and German Expressionist artists, and on early Miró and Otto Dix. Nonetheless, when Theo acknowledged the painting's arrival in his letter of 3 May 1890 (T33), he found it "extraordinary."

25. Self-Portrait

Oil on canvas, 15¾ × 12¼ in. (40 × 31 cm.)
Unsigned
Private collection, Switzerland

F525 H545 JH1665

Having painted himself in the mirror soon after "getting up" in late August 1889 (cat. 22), and having done a more considered self-portrait, now in Paris, in early September (cat. 22, fig. 19), van Gogh began to think of a picture that would be suitable to give to his mother for her seventieth birthday, on 10 September. He told Theo: "I have a great desire to do the 'Reaper' once again for Mother; if not, I will paint her another picture for her birthday" (LT604). By 19 September he had written to his mother, sending her belated congratulations: "I intend to send you a picture shortly," he told her (LT606), but he did not explain which one. Only by 28 September did he reveal that among the smaller canvases destined for his mother and his sister Wil were not only the *Reaper* but also a "little self-portrait" (LT608).

It was not until about 20 October that he was more forthcoming about this little self-portrait, the present picture, which would soon be sent to Leiden. "You

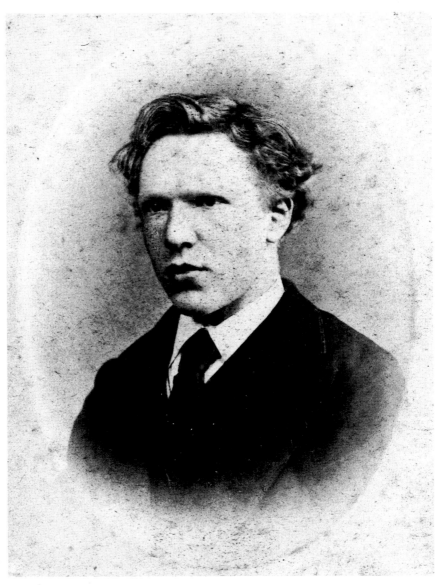

Fig. 25. Photograph of Vincent van Gogh, age eighteen.
Rijksmuseum Vincent van Gogh (Vincent van Gogh Foundation),
Amsterdam

will see from the self-portrait . . . that though I saw Paris and other big cities for many years, I keep looking more or less like a peasant of Zundert . . . and sometimes I imagine I also feel and think like them, only the peasants are of more use in the world" (LT612).

Painted sometime between 19 and 28 September, almost a month after the Whitney *Self-Portrait* (cat. 22), it projects an entirely different image. Unmistakably, this is a younger-looking van Gogh, clean-shaven and sturdy-featured, as his mother might have remembered him when he was eighteen years old—as he looked in a photograph, for instance (fig. 25). And it recalls his sister-in-law Jo's description of their first meeting in Paris in May 1890: "A strong broad-shouldered man, with a healthy color, a smile on his face, and a very resolute appearance."

This robust, earthy portrait was probably intended to reassure his mother— just as he had written to Theo of the Paris *Self-Portrait*: "I am even inclined to think that the portrait will tell you better than my letter how I am, and that it will reassure you" (LT604).

And if this were not enough to comfort his mother, he underlined the message by using the same self-portrait as a picture within a picture. Painted soon after the present *Self-Portrait,* the reduced version of the *Bedroom* (fig. 26) was meant to convey a yeomanlike simplicity, which van Gogh likened to the character of George Eliot's *Felix Holt* (W15). On the wall in the *Bedroom* is shown, framed, this peasant self-portrait: note the button on the coat, prominently displayed.

He sent the *Self-Portrait,* together with the *Bedroom* and five other canvases for his mother and sister, to Theo in early December, for eventual dispatch to Leiden (T618).

Although van Gogh envisaged this picture as a reassuring image for his mother, it is his most reflective and disturbing image of himself. It is the last self-portrait he painted.

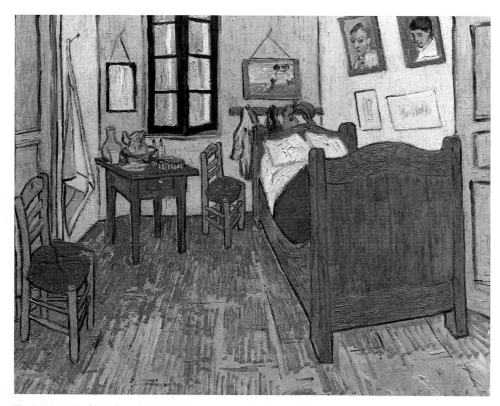

Fig. 26. *Van Gogh's Bedroom* (F483). Oil on canvas, 22¼ x 29 in. (56.5 x 74 cm.). Musée d'Orsay, Paris

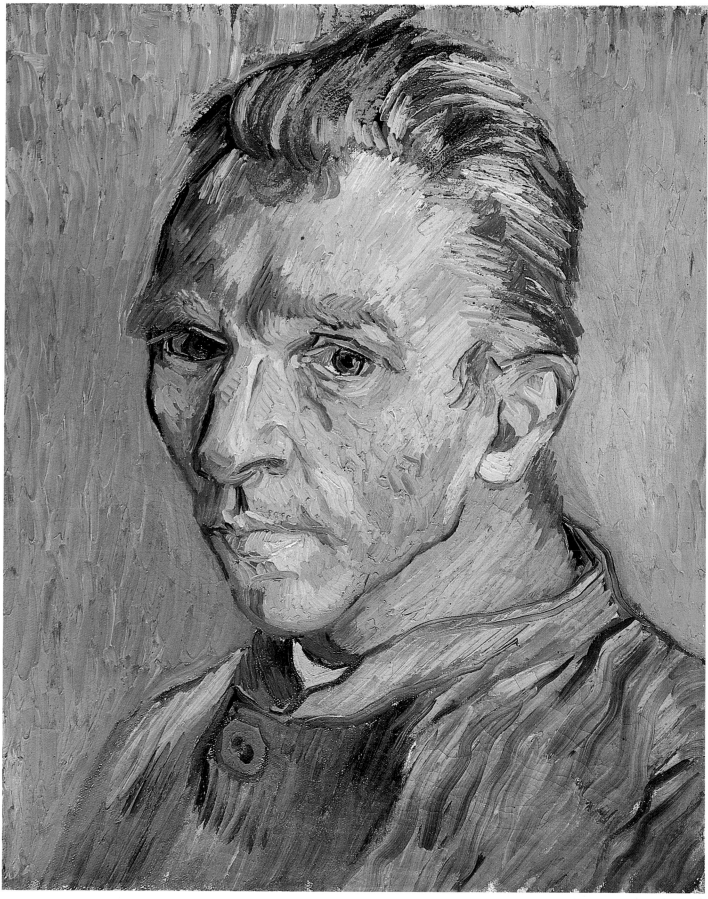

25

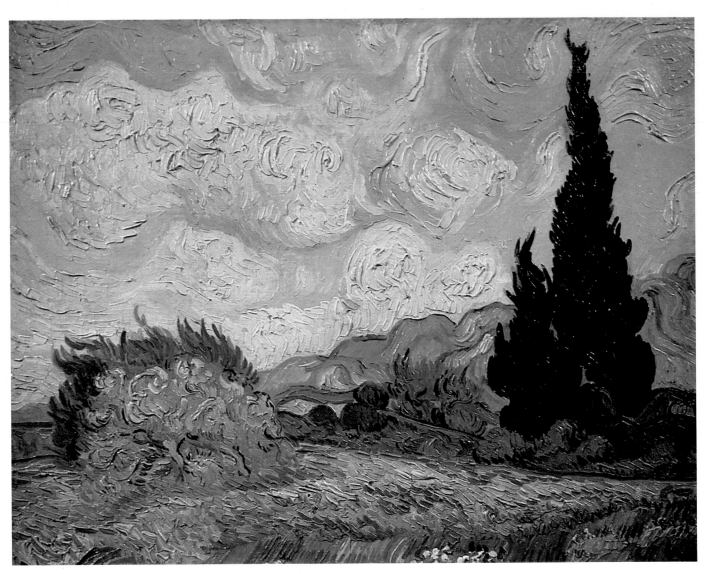

26

26. Wheat Field with Cypresses

Oil on canvas, 20¼ × 25⅝ in. (51.5 × 65 cm.)
Unsigned
Private collection

F743 H634 JH1790

Wheat Field with Cypresses is one of several small copies—reductions, he called them—that van Gogh made in September 1889 from his summer compositions of the previous June and July. The notion was partly instigated by Wil, who, in a letter of August, asked her brother to send her a picture. Van Gogh told Theo of this request in late August (LT602). In early September, having completed large copies of both the *Bedroom* and the *Reaper,* he could think of Wil's request, relating it also to his mother's seventieth birthday. By 19 September, he explained to her: "I don't know yet which canvases I am going to send you and Mother, probably a field of wheat and an orchard of olive trees" (W14). Nine days later, he was able to confirm to Theo that he had finished "four or five studies that I want to give Mother and our sister. These studies are drying now; they are size 10 and

12 canvases, small copies of the 'Wheat Field and Cypress,' 'Olives,' the 'Reaper' and the 'Bedroom' and a little self-portrait" (LT608).

The present picture is the "Wheat Field and Cypress." Van Gogh's first painting of the motif, a size 30 canvas, was completed in late June (F717) and a large drawing made after it for dispatch to Theo on 2 July (F1538). A copy, also on a size 30 canvas, was made in early September (fig. 27). Both canvases were sent to Theo on 28 September (LT608).

In making the reduction for his mother and Wil, van Gogh worked more closely from the June version, although there were inevitably some minor changes, not least in facture and color. It was among the seven small pictures destined for Holland that van Gogh sent to Theo on 7 December (LT618).

Earlier, on about 20 October, van Gogh had indicated to Wil how he preferred his paintings to be framed and hung. "Don't be afraid to hang them in the passage, in the kitchen, on the staircase—above all, my paintings are meant to be seen against a simple background. . . . Here in the South we have bare walls, white or yellow, or covered with wallpaper with large colored flowers. So it seems to me that it is a matter of using frank contrasts of colors. The same is true of the frames—the frames I use cost me five francs at the outside, whereas the gilt frames, which are less strong, would cost thirty or more. And if a picture shows to advantage in a simple frame, why put gilt around it?" (W15).

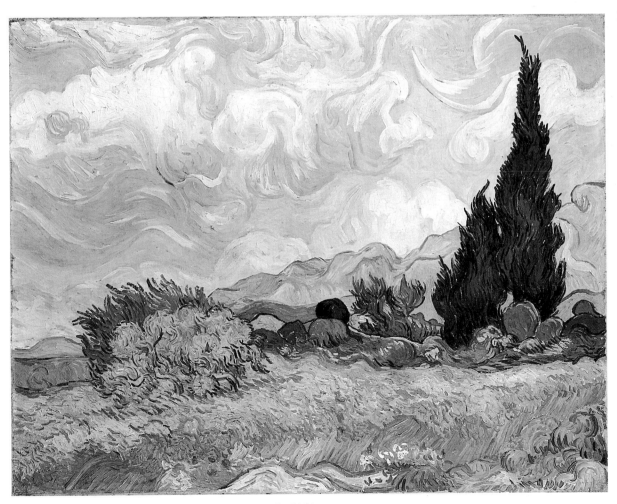

Fig. 27. *Wheat Field with Cypresses* (F615). Oil on canvas, 28¾ x 36¼ in. (72.5 x 91.5 cm.). The Trustees of the National Gallery, London

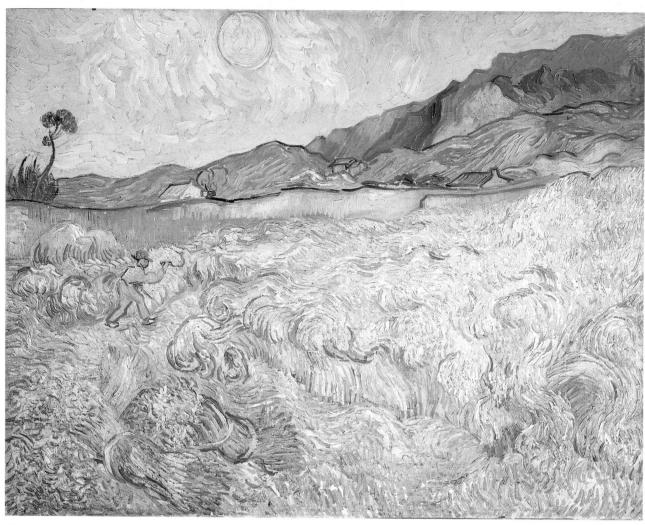

27

27. The Reaper

Oil on canvas, 29¼ × 36¼ in. (74 × 92 cm.)
Unsigned
Rijksmuseum Vincent van Gogh (Vincent van Gogh Foundation),
 Amsterdam

F618 H613 JH1773

Van Gogh first painted the *Reaper* in late June 1889 (fig. 28). "The latest one I've started is the 'Wheat Field,' in which there is a little reaper and a big sun. The canvas is all yellow except for the wall and the background of violet-tinted hills" (LT597). In the same letter, of 2 July 1889, he told Theo that he had sent him a drawing after the painting (fig. 29). The painting was evidently complete by then, though not yet dry enough to include with the batch he sent nearly two weeks later.

 After his long breakdown, van Gogh returned to the painting in early September. "I am struggling with a canvas begun some days before my indisposition, a 'Reaper'; the study is all yellow, terribly thickly painted, but the subject was fine and simple. For I see in this reaper—a vague figure fighting like the devil in the midst of the heat to get to the end of his task—I see in him the image of death, in the sense that humanity might be the wheat he is reaping. So it is—if you

like—the opposite of that sower I tried to do before. But there's nothing sad in this death, it goes its way in broad daylight with a sun flooding everything with a light of pure gold. Look, there I am at it again, but I don't let go my hold, and with a new canvas I shall try again" (LT604).

This suggests that van Gogh retouched the summer painting. But he took his new canvas and almost certainly completed a second version (the present painting) in one day, probably 4 September: "The 'Reaper' is getting on . . . it is very, very simple" (LT604). He broke off his letter to continue painting, and then took up his pen again. "There! The 'Reaper' is finished. I think it will be one of those you keep at home—it is an image of death as the great book of nature speaks of it—but what I have sought is the 'almost smiling.' It is all yellow, except for a line of violet hills, a pale, fair yellow. I find it queer that I saw it like this from between the iron bars of a cell."

At this juncture, van Gogh preferred the September replica, a picture he felt Theo should keep at home rather than store at Tanguy's. It is more a reinterpretation of the summer composition than a mere copy: the sun is higher, the conical

Fig. 28. *The Reaper* (F617). Oil on canvas, 28⅜ x 36¼ in. (72 x 92 cm.). Rijksmuseum Kröller-Müller, Otterlo

Fig. 29. *The Reaper* (F1546). Pen, reed pen and ink, 17¾ x 23¼ in. (45 x 58.5 cm.). Nationalgalerie, East Berlin

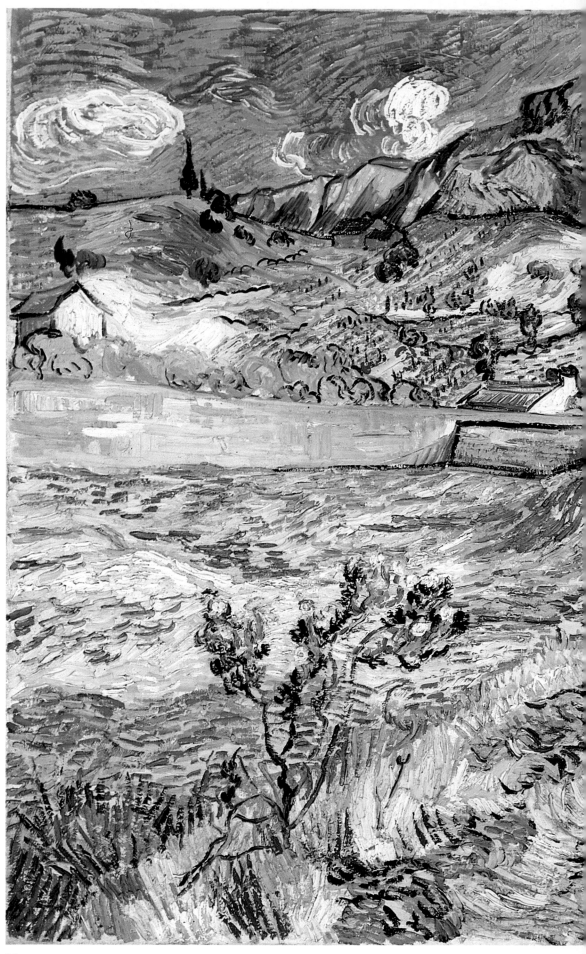

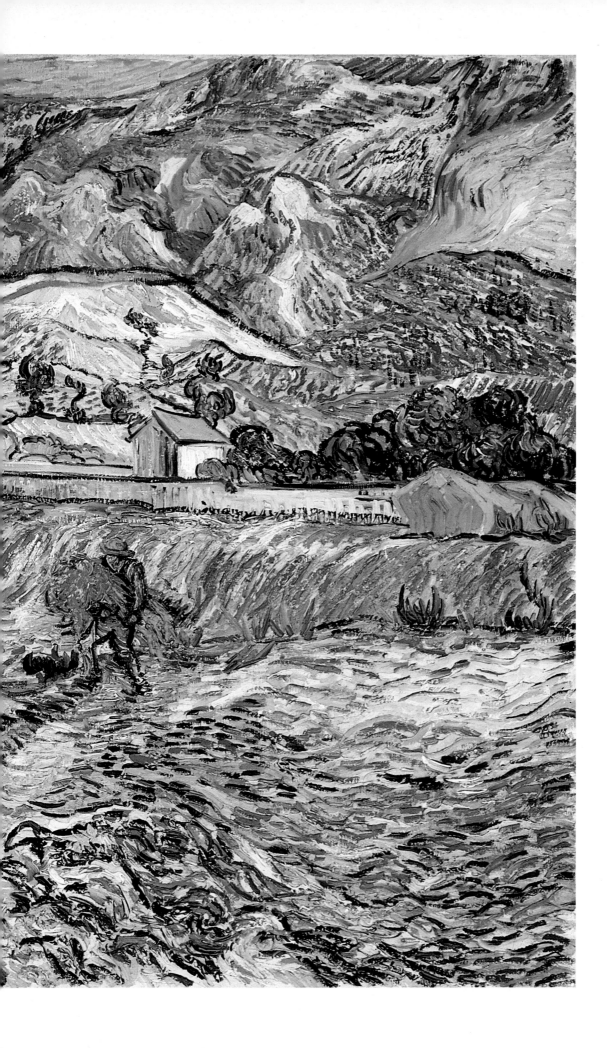

pile of sheaves is gone from the foreground, and a slender tree has been added at left.

However, van Gogh changed his mind on the relative merits of the two paintings. When he sent them both to Theo on 28 September, he explained: "First I thought that the large-size duplicate that I am sending you was not bad—but afterward, when the days of mistral and rain came, I preferred the canvas done from nature, which seemed rather strange to me" (LT608). And when he wrote later to Émile Bernard, on about 22 November, he still preferred the summer canvas: "Have you seen a study of mine with a little reaper, a yellow wheat field and a yellow sun? It isn't *it* yet; however, I have attacked that devilish problem of the yellows in it again. I'm speaking of the one with the heavy impasto, done on the spot, and not of the replica with hatchings, in which the effect is weaker" (B21).

Van Gogh's vision of the *Sower* in Arles was brought full circle with his vision of the *Reaper* in Saint-Rémy. Creation versus death: two poles of his symbolic imagery, and two of his most haunting statements in paint.

28. Enclosed Field with Peasant

Oil on canvas, 29 × 36¼ in. (73.5 × 92 cm.)
Unsigned
Indianapolis Museum of Art. Gift in memory of
 Daniel W. and Elizabeth C. Marmon
F641 H649 JH1795
Reproduced on pages 136–37

Van Gogh described this landscape twice on the same day, 12 October 1889. First to Émile Bernard: "a size 30 canvas with ploughed fields, broken lilac, and a background of mountains rising to the very height of the picture; so nothing but rough fields and rocks, with a thistle and dried grass in a corner, and a little fellow, violet and yellow" (B20). And then to Theo: "I have just brought back a canvas on which I have been working for some time, representing the same field again as in the 'Reaper.' Now it is clods of earth and the background of parched land, then the rocks of the Alpines. A bit of green-blue sky with a little white and violet cloud. In the foreground a thistle and some dry grass. A peasant dragging a truss of straw in the middle. It is again a harsh study, and instead of being almost entirely yellow, it makes a picture almost entirely violet. Broken violet and neutral tints. But I am writing you because I think this will complement the 'Reaper' and will make clearer what that is. For the 'Reaper' looks as though it were done at random, and this will give it balance" (LT610).

Painted out of doors over several days, this view of the enclosed field differs from all the other size 30 canvases of the motif. It shows much more of the dividing wall to the right, and it is the most accurate topographically, not only in the position of hut and cottages but, above all, in the close delineation of distant vegetation and trees. The resulting rich, variegated surfaces are expressed in a series of short, slender, brick-shape brushstrokes that are very close to those in the second painting of a quarry (cat. 35).

Van Gogh's most revealing comment on *Enclosed Field with Peasant*, however, lies in the striking contrast, in color and facture, that he sets up between it and the *Reaper.* This notion stayed with him, for when he sent the canvas to Theo on 3 January 1890, he described it as: "'Ploughed Field,' with background of mountains—it is the same field as the reaper's of last summer and can be a pendant to it; I think that one will set off the other" (LT621).

29. Rain

Oil on canvas, 29 × 36½ in. (73.5 × 92.5 cm.)
Unsigned
Philadelphia Museum of Art. The Henry P. McIlhenny Collection
in memory of Frances P. McIlhenny

F650 H656 JH1839

If van Gogh was especially forthcoming, offering description, explanation, and interpretation, when talking of the *Reaper* (cat. 27), and equally forthcoming when offering the notion of color contrast and pendant in relating the *Reaper* to the Indianapolis canvas *Enclosed Field with Peasant* (cat. 28), he was remarkably parsimonious in his references to the present landscape. In early November 1889, he told Theo only: "I have a rain effect going" (LT613). And on 3 January 1890, in making his list of eleven canvases to send to Theo, he reminded himself: "I must not forget 'Rain'" (LT621).

During the three weeks that separated the painting of *Enclosed Field with Peasant* from the painting of *Rain*, the walled field was sown with wheat. (In Arles this happened in mid-October; presumably the same system operated in Saint-Rémy.) This seasonal change is indicated in the pictures; it is not, however, the only difference between them. Van Gogh's viewpoint has altered in *Rain*, swinging to the left and encompassing more of the field. Field and wall—especially the plunging diagonal at left—dominate the picture space, diminishing the impact of the landscape beyond, including the Alpilles.

The detailed topographical accuracy of the Indianapolis picture is rejected. Instead, the tilted space and the audacious play of orthogonals give *Rain* a radically different pictorial expression. The only comparable example among the paintings of the walled field, in its even more exaggerated spatial displacements, is the *Enclosed Field* (F720) in the Rijksmuseum Kröller-Müller, Otterlo.

Refined harmonies of broken color—subdued greens, grape blues, and soft violets—help create the atmospheric mistiness. The convention found in Japanese woodblock prints of using slanting lines to suggest the effect of rain was familiar to van Gogh. In 1887, in Paris, he had made a copy of Hiroshige's *Bridge in the Rain* (F372). This dramatic interpretation of falling rain was made once more by van Gogh in one of his double-square canvases done in Auvers (F811). In Saint-Rémy he also used it in two drawings of sowers in the rain, F1550 and F1551r.

30. Wheat Field with Rising Sun

Oil on canvas, 28 × 35¾ in. (71 × 90.5 cm.)
Unsigned
Private collection

F737 H739 JH1862

Wheat Field with Rising Sun is the majestic finale to van Gogh's series of views of the walled wheat field in 1889. He observed the field exhaustively throughout the seasons: the predominantly green wheat in early June (F611); the ripe yellow wheat being reaped in late June (cat. 27; cat. 27, fig. 28); the stacks of wheat at moonrise in early July (F735); the ploughing in late August (cat. 23); the ploughed field in early October (cat. 28); the newly sown wheat in the rain in early November (cat. 29); and finally the same young wheat, more advanced, in the present picture.

Wheat Field with Rising Sun is an exhibition picture, painted specially for Les XX in Brussels. Once van Gogh had received Octave Maus's official letter of invitation of 15 November 1889, he responded with a list of six paintings that

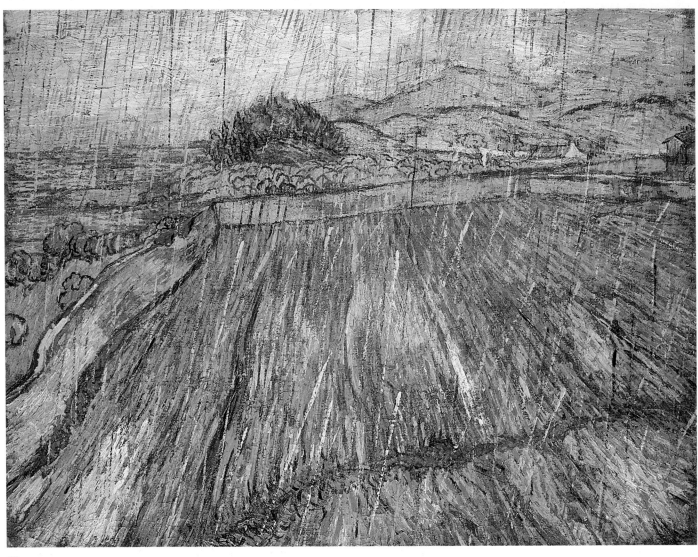

29

included a "Wheat Field at Sunrise (Saint-Rémy)." At the same time, he told Theo that he was working on this picture (LT614). A little later, about 22 November, he enlarged upon his description to Émile Bernard: "the sun rising over a field of young wheat; lines fleeting away, furrows rising up high into the picture toward a wall and a row of lilac hills. The field is violet and yellow-green. The white sun is surrounded by a great yellow halo" (B21). As late as 9 or 10 December, he told his sister Wil that he was still working on the painting, and he provided her with a similar description. By mid-December, it was sent to Theo: "I am curious to know what you will say about the 'Wheat Field'; perhaps it needs to be looked at for some time" (LT617). Theo responded on 22 December: "The wheat field has . . . poetry in it; it is like a memory of something one has once seen. Tanguy is framing it at the moment, and on January 3 everything will go to Brussels" (T22).

The painting marks a conscious change in van Gogh's style, first announced in a letter to Theo of 7 December. "There are no more impastos in the big studies. I prepare the thing with a sort of wash of essence, and then proceed with strokes or hatchings in color with spaces between them. That gives atmosphere, and you use less paint" (LT618). And he returned to this in his letter of mid-December: "I

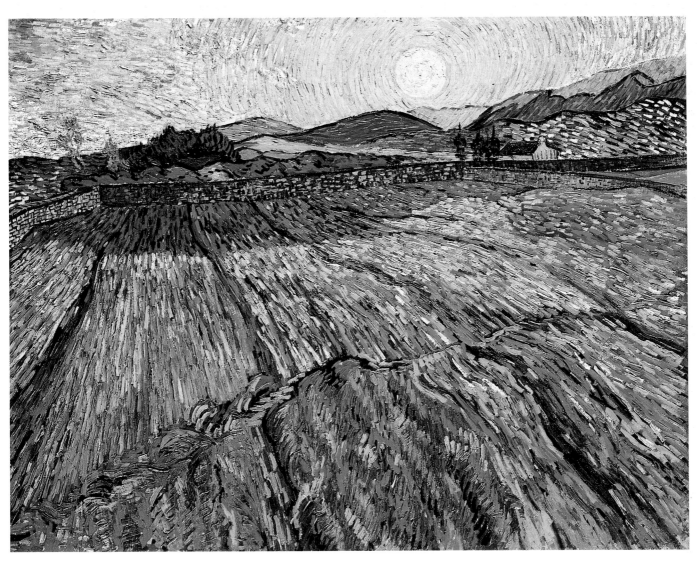

30

think that probably I shall hardly do any more things in impasto; it is the result of the quiet, secluded life that I am leading, and I am all the better for it. Fundamentally I am not so violent as all that, and at last I *myself* feel calmer" (LT617).

When he first discussed with Theo his choice of works for Les XX, he thought of *Wheat Field with Rising Sun* as a pendant to the spring 1889 *Orchard in Bloom,* from Arles (F516). He elaborated to Wil: "It is (along with the orchard in bloom, which Theo liked, he said) the most delicate thing I have painted yet" (W16).

Serene in mood, the picture is delicate in technique and, ultimately, deeply consoling: "I have tried to express calmness, a great peace," he wrote, responding to Bernard's religious compositions; "It is not necessary to portray the characters of the Sermon on the Mount in order to produce a consoling and gentle motif" (B21).

After being exhibited with Les XX in Brussels, the painting was among the ten works that Theo submitted to the spring 1890 Salon des Indépendants; it was listed as catalogue number 839, "Lever de Soleil en Provence."

For the drawing made after the painting, see cat. 38.

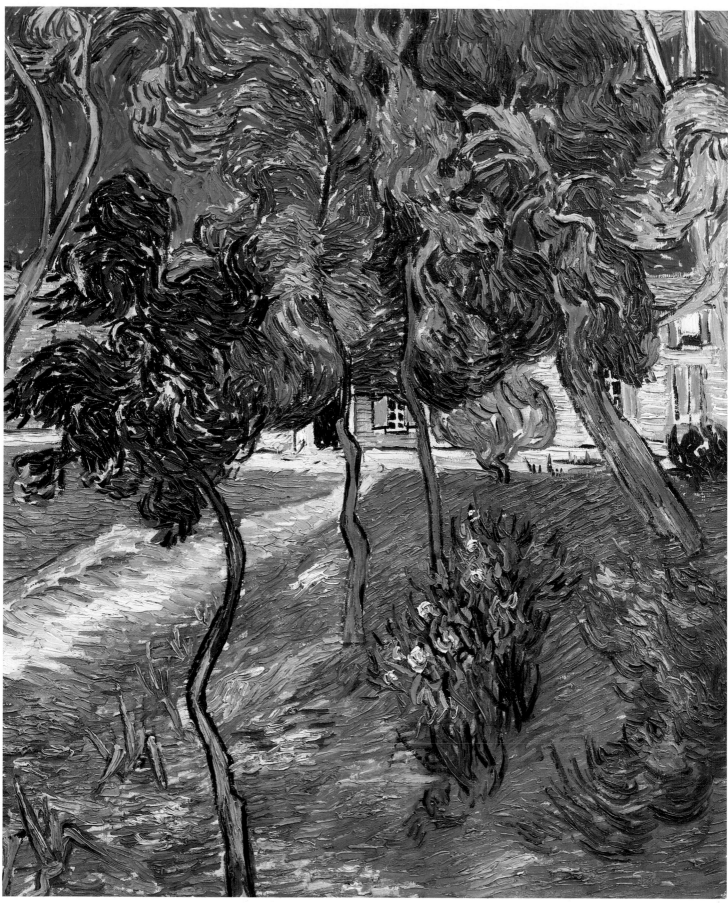

31

31. Trees in the Asylum Garden

Oil on canvas, 28¾ × 23¾ in. (73 × 60 cm.)
Unsigned
Private collection, U.S.A.

F642 H647 JH1798

Van Gogh's autumn views of the asylum garden differ from his early summer views (see cat. 1–4). The first series is dominated by drawings and gouaches. Three of the four paintings in the series are close-ups of pine trees, lilacs, and irises; only one (F734) shows a part of the men's wing. In the autumn series, paintings replace drawings. The façade of the men's wing appears in most of them, and the pine trees become an important and recurrent motif.

In his summer letters, van Gogh always referred to this area as the "garden"; from October onward, he referred to it—almost without exception—as the "park." This larger concept fitted the more expansive views that he now favored.

He began the autumn series with two medium-size canvases, one vertical, the present work, the other horizontal, F730. Both are variations on the set motif, a view of the façade of the men's wing, with pines and cedars. The brilliant blue sky characterizes several of van Gogh's outdoor paintings of October 1889, as if he willed this color after his long confinement indoors.

Trees in the Asylum Garden, together with F730, was probably among the batch of medium-size canvases sent to Theo on 6 December 1889. Van Gogh referred to it as "the study of the house and the park, of which there are two variants" (LT618).

32. Pine Trees in the Asylum Garden

Oil on canvas, 35½ × 28⅞ in. (90.2 × 73.3 cm.)
Unsigned
The Armand Hammer Collection

F643 H648 JH1799

Just as van Gogh took topographical liberties in some of his views of the walled wheat field for compositional reasons (see cat. 27–30), so he was not averse to doing the same with motifs taken in the asylum garden. Writing to Theo on 12 October, he explained: "I also have two views of the park and the asylum, where this place looks very pleasing. I tried to reconstruct the thing as it might have been, simplifying and accentuating the haughty, unchanging character of the pines and cedar clumps against the blue" (LT610).

No painting answers this description so supremely as *Pine Trees in the Asylum Garden.* Playing his variation on the theme of façade, garden, and blue sky, van Gogh minimized the building, giving the pines the lofty grandeur of a Gothic cathedral nave against the dazzling ultramarine sky. The trees have been disposed in a kind of ragged symmetry, enhancing their "haughty, unchanging character" and catching the essence of their majestic forms.

The pine with the sawed-off branch described by van Gogh in *A Corner of the Asylum Garden* (cat. 33) can be recognized as the central tree here. It is more prominent in a smaller variant of the picture (fig. 30), reported to Theo about 2 November: "I have also done a canvas for M. Peyron, a view of the house with a big pine" (LT613). Both paintings also show the shadowy yellow-hatted figure standing in the entrance, which must be a self-portrait.

Van Gogh added a final touch to his reconstruction of the motif. Beneath the enormous pines, figures can be seen walking, including a woman with a red

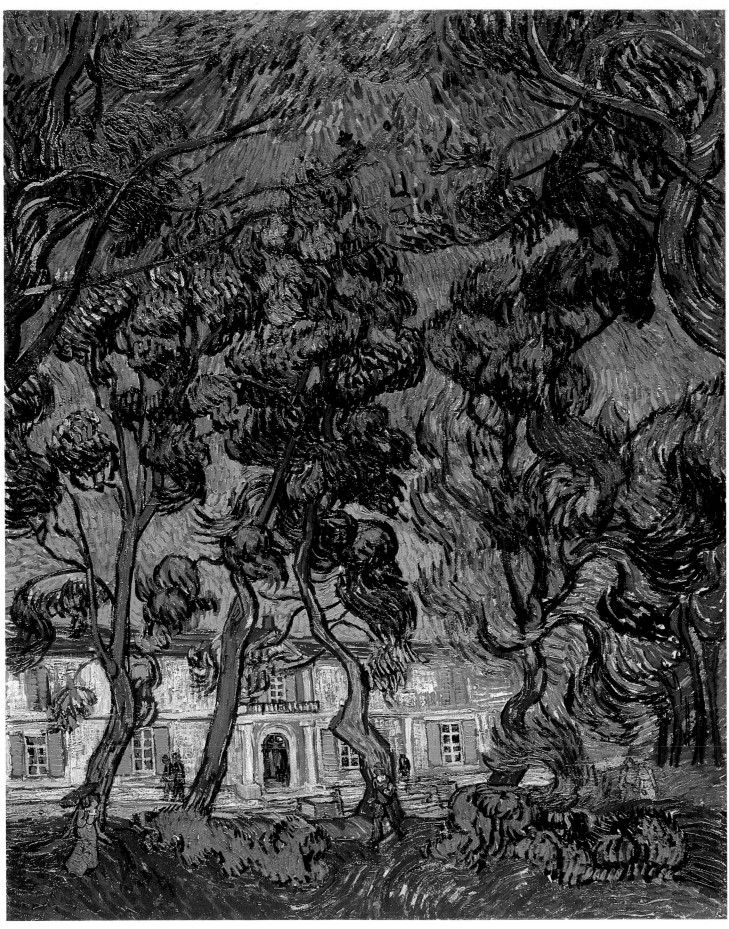

Fig. 30. *Pine Trees with Figure in the Asylum Garden* (F653). Oil on canvas, 22⅞ x 17¾ in. (58 x 45 cm.). Musée d'Orsay, Paris

parasol reminiscent of a strolling Arlésienne. By introducing these promenading figures, van Gogh altered the ambience from that of an asylum garden to that of the grounds of a country house.

33. A Corner of the Asylum Garden

Oil on canvas, 29 × 36¼ in. (73.5 × 92 cm.)
Unsigned
Museum Folkwang, Essen
F660 H669 JH1849

Writing to Theo on about 2 November 1889, van Gogh referred to "an evening effect with some big pines" (LT613). In a succinctly argued postscript, he went on to ask Theo not to "cultivate a prejudice" against his attempts "to mass things by means of a drawing style which tries to express the interlocking of the masses." He admitted that "the studies in the last batch, drawn with such great sinuous lines, were not what they ought to have been." And he concluded: "Anyhow, you will see that in a big landscape with some pines, trunks of red ocher defined by a black stroke, there is already more character than in the previous ones."

Here he used *A Corner of the Asylum Garden* as a defense; some three weeks later he used it as an attack, demonstrating to Émile Bernard that a modern artist should not paint biblical compositions. With Theo he argued style and technique; with Bernard he argued interpretation and symbol.

"Here is the description of a canvas which is in front of me at the moment," he wrote to Bernard about 22 November. "A view of the park of the asylum where

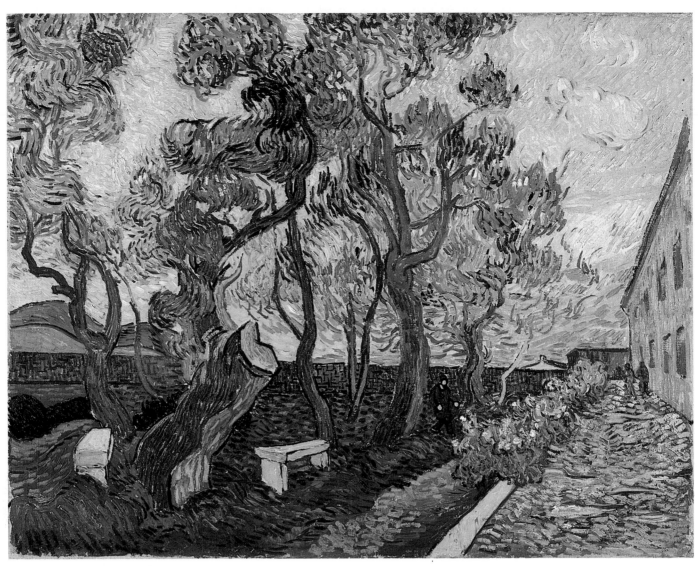

33

I am staying; on the right a gray terrace and a side wall of the house. Some deflowered rose bushes, on the left a stretch of the park—red ocher—the soil scorched by the sun, covered with fallen pine needles. This edge of the park is planted with large pine trees, whose trunks and branches are red ocher, the foliage green gloomed over by an admixture of black. These high trees stand out against an evening sky with violet stripes on a yellow ground, which higher up turns into pink, into green. A wall—also red ocher—shuts off the view, and is topped only by a violet and yellow ocher hill. Now the nearest tree is an enormous trunk, struck by lightning and sawed off. But one side branch shoots up very high and lets fall an avalanche of dark green pine needles. This somber giant—like a defeated proud man—contrasts, when considered in the nature of a living creature, with the pale smile of a last rose on the fading bush in front of him. Underneath the trees, empty stone benches, sullen box trees; the sky is mirrored—yellow—in a puddle left by the rain. A sunbeam, the last ray of daylight, raises the somber ocher almost to orange. Here and there small black figures wander around among the trees.

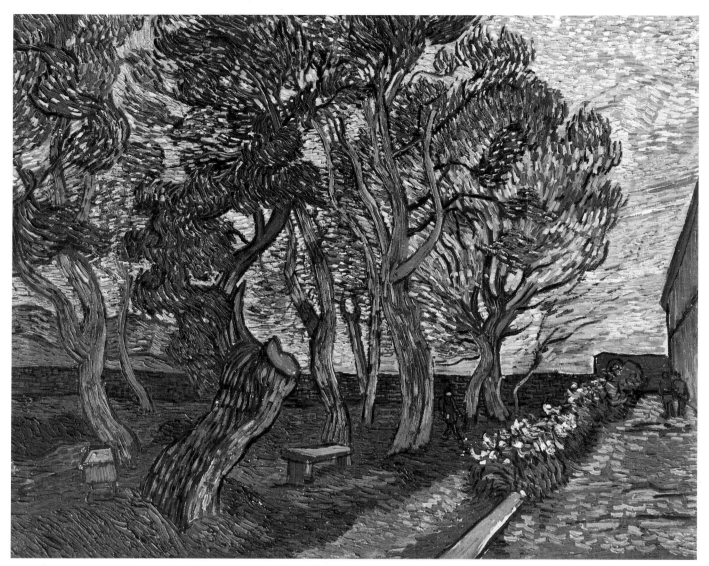

Fig. 31. *A Corner of the Asylum Garden* (F659). Oil on canvas,
28⅜ x 35⅞ in. (71.5 x 90.5 cm.). Rijksmuseum Vincent van Gogh
(Vincent van Gogh Foundation), Amsterdam

"You will realize that this combination of red ocher, of green gloomed over by gray, the black streaks surrounding the contours, produces something of the sensation of anguish, called 'noir-rouge,' from which certain of my companions in misfortune frequently suffer. Moreover, the motif of the great tree struck by lightning, the sickly green-pink smile of the last flower of autumn serve to confirm this impression. . . . One can try to give an impression of anguish without aiming straight at the historic Garden of Gethsemane" (B21).

A drawing made after the painting (F1545) was almost certainly sent to Theo in mid-December (LT617). At the same time van Gogh began a full-size painted copy for his mother and Wil. This copy, now in Amsterdam (fig. 31), is reported in three letters—to his mother (LT619), to Wil (W17), and to Theo (LT622). It was one of three such canvas size 30 copies that van Gogh made for his mother and sister; the other two are the *Ravine* (F661) and *Olive Pickers* (probably F655).

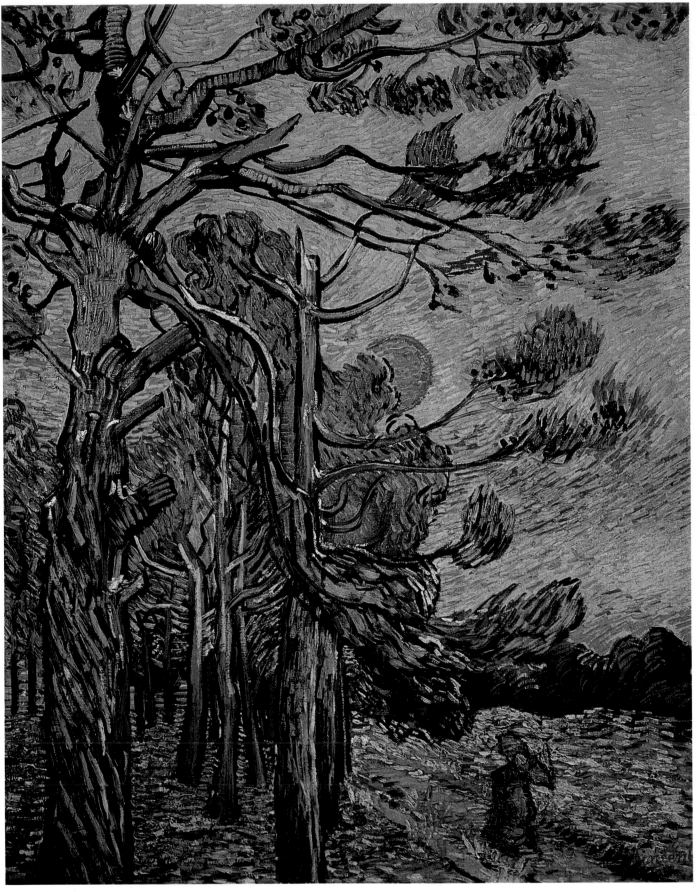

34

34. Pine Trees with Setting Sun

Oil on canvas, 36¼ × 28¾ in. (92 × 73 cm.)
Signed, lower right: Vincent
Rijksmuseum Kröller-Müller, Otterlo

F652 H573 JH1843

"Tall weather-beaten pine trees against a red evening sky" was how van Gogh first described this picture to his sister Wil on 9 or 10 December 1889 (W16). Far more revealing, however, are his further comments in the same letter: "While I was writing this letter I got up in order to put a few brushstrokes on a canvas I'm working on—the very picture of those weather-beaten pine trees against a red, orange, yellow sky—it was very fresh yesterday—the tones pure and brilliant—well, I don't know what thoughts came into my head while I was writing, but when I looked at my canvas I told myself it was not right. Then I took a color that was there on the palette, a dull dirty white, which you get by mixing white, green and a little carmine. I daubed this greenish tone all over the sky, and behold, at a distance it softens the colors, whereas one would think that one would spoil and besmirch the painting."

Such descriptions of the act of painting, such insights into the intimacy of studio decisions are rare in van Gogh's letters. He described the painting again to Theo a few days later, prefacing it with an evocative account of late autumn sunset effects. "I am going to work a little outside: there is a mistral. Toward sunset it generally grows a little calmer, then there are superb sky effects of pale citron, and the mournful pines with their silhouettes standing out in relief against it with exquisite black lace effects. Sometimes the sky is red, sometimes of an extremely delicate neutral tone, and again pale citron, but neutralized by a delicate lilac. I have an evening effect of another pine tree against pink and yellow-green" (LT617).

Powerfully conceived, with an almost brutal coloristic and symbolic imagery, this was the last of van Gogh's autumn studies of pine trees. It is one of only seven signed canvases from Saint-Rémy.

35. Entrance to a Quarry

Oil on canvas, 20½ × 25¼ in. (52 × 64 cm.)
Unsigned
Private collection

F635 H644 JH1767

Often considered the picture van Gogh was working on when he had his first attack in Saint-Rémy in mid-July 1889, this canvas is in fact the one he reported as just completed in early October. Two references in letters, both written on 12 October 1889, support such a conclusion. First to Theo: "This week I have also done the 'Entrance to a Quarry,' which is like something Japanese; you remember there are Japanese drawings of rocks with grass growing on them here and there and little trees" (LT610). Then to Émile Bernard: "Among these studies is an 'Entrance to a Quarry': pale lilac rocks in reddish fields, as in certain Japanese drawings. In the drawing and in the division of the color into large planes there is no little similarity to what you are doing at Pont-Aven" (B20).

Little trees and lilac-colored rocks occur only in the present painting, and not in the July canvas (cat. 21). And the large color planes, which van Gogh suggests are equivalent to Bernard's Pont-Aven style, are to be found only in this October canvas. He suggests a further analogy to the Pont-Aven style when describing to Bernard the *Ravine* (F662), a mountainous landscape with little sky.

Fig. 32. Noé's Quarry, 1986.
Photograph by Jean Delrieux

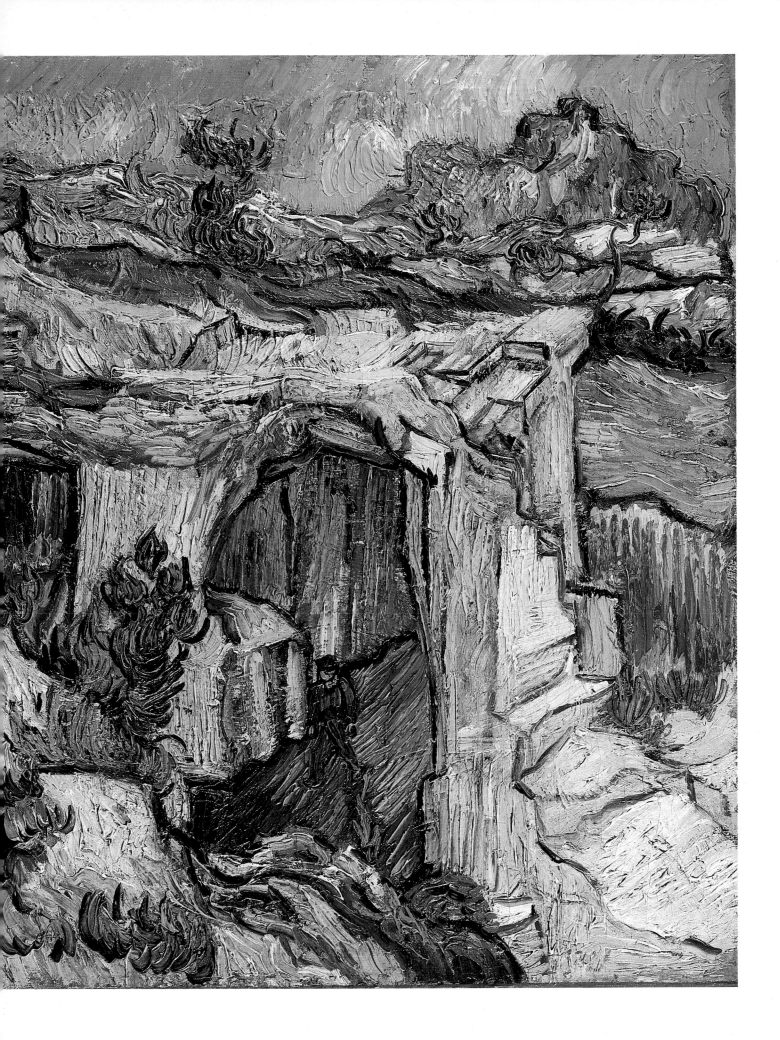

The color, facture, and especially the little trees on the rocks in the *Ravine* make it very close to the present painting. Equally close stylistic and seasonal parallels can be found in *Enclosed Field with Peasant* (cat. 28), which is described in the same letters to Theo and Bernard.

The quarry is that of Salade or Noé (fig. 32), its distinctive twin openings clearly visible; beyond is Mont Gaussier. Today, trees obscure the view of the mountain.

36. View of the Church of Saint-Paul-de-Mausole

Oil on canvas, 17½ × 23¾ in. (44.5 × 60 cm.)
Unsigned
Collection Elizabeth Taylor

F803 H791 JH2124

This painting has repeatedly been placed among van Gogh's last works in Auvers, and said to represent the church of Labbeville, a few miles to the north. John Rewald (*Post-Impressionism*, p. 339) has shown that it depicts the asylum at

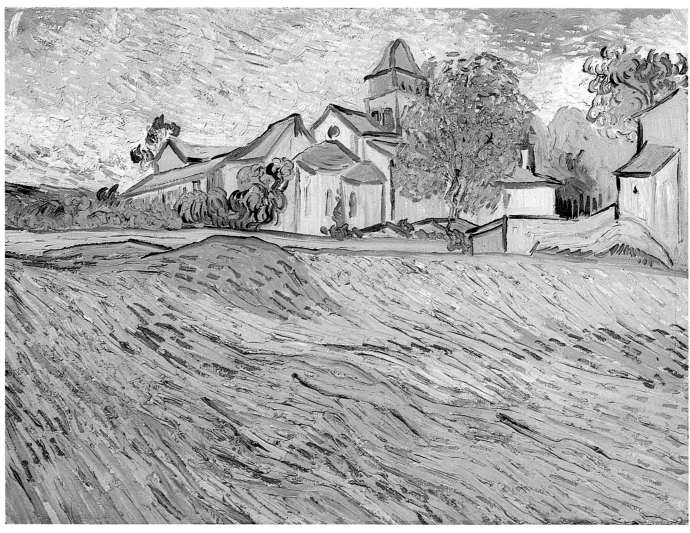

36

Fig. 33. The asylum of Saint-Paul-de-Mausole, showing the Romanesque
tower of the original Augustinian monastery, c. 1950s. Rijksmuseum
Vincent van Gogh (Vincent van Gogh Foundation), Amsterdam.
Photograph by Marc Edo Tralbaut

Saint-Rémy, which a photograph showing the asylum wall and field (fig. 33)
clearly confirms.

The view is unique in van Gogh's entire Saint-Rémy oeuvre. It is the only
work that affords a glimpse of the twelfth-century Romanesque tower of the
original Augustinian monastery; in this respect, it can be compared with several
views of the Romanesque tower of Saint-Trophime in Arles (e.g., F409, F515). Also
visible is the dividing wall of the asylum, parts of which were included so often in
the sequence of canvases of the walled wheat field (see cat. 8, 23, 27–30). Van Gogh
must have stood in almost the same position to paint this motif as he did for the
Indianapolis view (cat. 28): here he looked southwest, there he looked southeast.

Apart from topographical considerations, there are seasonal ones. This
canvas shows an autumn scene (which would have been impossible from Auvers,
since he went there at the end of May). One of several medium-size "studies of
autumn," as van Gogh referred to them when sending some of them to Theo in
early December, it must have been painted in October 1889 (LT618). Stylistically, it
can be compared with *Entrance to a Quarry* (cat. 35).

37

37. The Sower (after Millet)

Oil on canvas, 31¾ × 26 in. (80.8 × 66 cm.)
Unsigned
Private collection
F690 H675 JH1837

The twenty-one painted copies after Millet that van Gogh made in Saint-Rémy from September 1889 onward were done for a variety of reasons. On 19 September, he explained to Theo: "I can assure you that making copies interests me enormously, and it means that I shall not lose sight of the figure, even though I have no models at the moment. Besides, this will make a studio decoration for me or someone else" (LT607). He compares a painter's making copies to a musician's interpreting Beethoven. And he continues: "I am ill at present; I am trying to do something to console myself, for my own pleasure. I let the black and white by Delacroix or Millet or something made after their work pose for me as a subject. And then I improvise color on it, not, you understand, altogether myself, but searching for memories of *their* pictures—but the memory, 'the vague consonance of colors which are at least right in feeling'—that is my own interpretation. Many people do not copy, many others do—I started on it accidentally, and I find that it teaches me things, and above all it sometimes gives me consolation. And then my brush goes between my fingers as a bow would on the violin, and absolutely for my own pleasure."

Among the Millet reproductions he had asked Theo to send him in September was Paul-Edme Le Rat's etching of the *Sower* (fig. 34). By about 2 November, he wrote: "You gave me great pleasure by sending those Millets. I am working at them zealously. . . . It seems to me that painting from these drawings of Millet's is much more *translating them into another tongue* than copying them" (LT613). He does not describe the color scheme of the *Sower*, saying only that it is

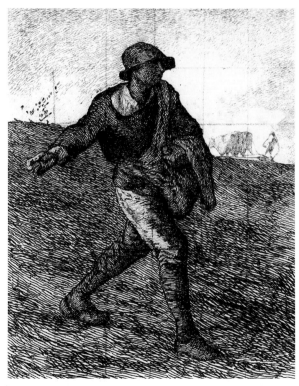

Fig. 34. Etching by Paul-Edme Le Rat after Jean-François Millet, *The Sower.* Rijksmuseum Vincent van Gogh (Vincent van Gogh Foundation), Amsterdam

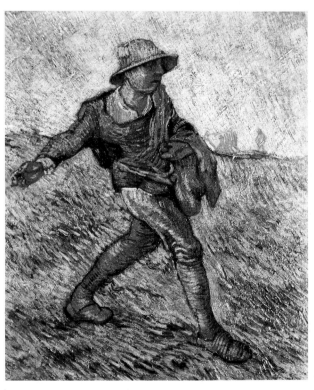

Fig. 35. *The Sower (after Millet)* (F689). Oil on canvas, 25¼ x 21¾ in. (64 x 55 cm.). Rijksmuseum Kröller-Müller, Otterlo

smaller than the others, all of which are size 30 canvases. In making the copy, van Gogh squared up Le Rat's etching and transferred it to the canvas.

Three months later, on 2 February 1890, he told Theo, who had just sent an additional selection of reproductions after Millet, that he was sending these on to his friend the Australian painter John Russell, since he had "scruples of conscience, a fear lest it be plagiarizing." Because of his recent breakdown, he did not feel capable of continuing his "translations." "I am stopping at the 'Sower,' which I am working on, and which is not coming off as I should wish" (LT625).

This second copy of the *Sower* must be the one in the Rijksmuseum Kröller-Müller, Otterlo (fig. 35), smaller than the present picture, and showing traces of having been overworked. By contrast, the present canvas has a clarity and purposefulness in brushstroke and color that must make it the late October painting, akin in these respects to *La Veillée* (F647, reproduced on page 51).

38. Wheat Field with Rising Sun

Black chalk, reed pen and brown ink on toned paper, 18½ × 24¼ in.
 (47 × 62 cm.)
Unsigned
Staatliche Graphische Sammlung, Munich

F1552 JH1863

Drawn after the painting *Wheat Field with Rising Sun* (cat. 30) between mid-November and mid-December and sent to Theo in Paris on about 15 December 1889.

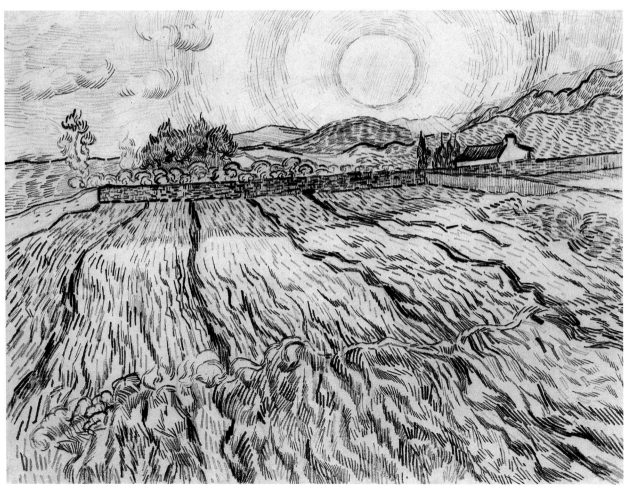

38

Out of a sequence of some two dozen autumn landscape paintings, van Gogh selected only two from which he made large drawings, the present one and F1545, after *A Corner of the Asylum Garden* (cat. 33). They were done, like the group of ten after the summer paintings (see cat. 16–19), to show Theo what he had been working on. However, the present drawing was actually included with its parent painting in the batch sent to Theo in mid-December (LT617). Theo could therefore make the comparison for himself, before sending off the painting to the exhibition of Les XX in Brussels.

Van Gogh's choice of these two drawings was surely not haphazard. The parent paintings are not just among what he considered his best compositions; they are opposites in mood and meaning, as he compared them biblically in a letter to Émile Bernard: the Sermon on the Mount as against the Garden of Gethsemane (B21). They are opposites, too, in their topographical significance. In the one, sunrise from his iron-barred window looking east over the walled wheat field; in the other, sunset in the garden looking west, his studio being situated in this wing. The constant opposition between walled field and unkempt garden, between bedroom and studio, between sunrise and sunset symbolically represents his life and work in the asylum.

Here it is as if he deliberately set himself an exercise in what might be called the ubiquitous matchstick stroke, varied in thickness, length, and direction. He eliminates the dot, and he avoids the pulsating curvilinear rhythms often so dominant in his summer drawings. So single-minded is he that he never uses cross-hatching, even in the shadowed wall or in the long shadow cast by it (which

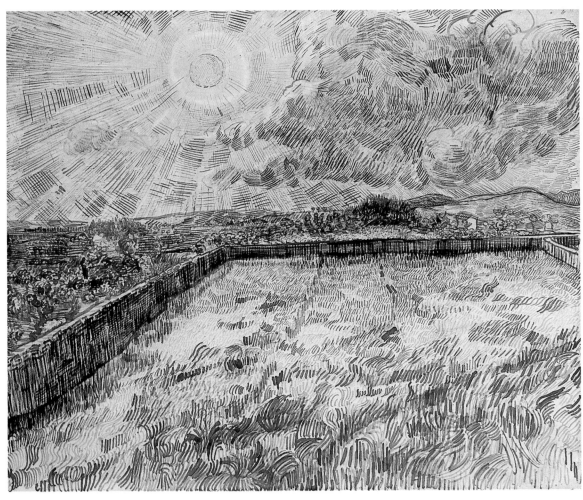

39

the black chalk underdrawing helps to create). As in his very first series of drawings after paintings that he did for Theo in Arles in August 1888, he was determined to be master of his stroke. He also sought an appropriate graphic equivalent to the controlled and complex system of brushstrokes built up in the parent painting.

This stable, restrained, and almost uniform articulation of his graphic means can be contrasted with drawings after paintings of the same walled field from the June–July group (e.g., F1546, F1547).

39. Wheat Field with Sun and Cloud

Black chalk, reed pen and brown ink, heightened with white
 chalk, on Ingres paper, 18¾ × 22 in. (47.5 × 56 cm.)
Unsigned
Rijksmuseum Kröller-Müller, Otterlo
F1728(SD) JH1706
Reproduced on page 157

Unlike the drawing from Munich, *Wheat Field with Rising Sun* (cat. 38), this drawing does not relate directly to a parent painting. But it is another variation on the walled wheat field theme, van Gogh's eastern view from the window of his room. Its closest analogy is *Rain* (cat. 29); common to them both is the plunging diagonal wall at left. Nonetheless, this is an independent drawing, and the only one as such of this motif. Field and sky dominate. The Alpilles appear distant and relatively insignificant, a narrow horizontal band. The drama comes from the sky: an incandescent sun, reminiscent of those in the *Reaper* (cat. 27) and *Wheat Field with Rising Sun* (cat. 30), and a strange, menace-filled cloud, reminiscent of the first painting of the walled field, done in June (F611).

All this is conveyed in a plethora of complex strokes covering every inch of the paper's surface. Van Gogh uses a series of dense hatchings, no longer merely straight, as in the Munich drawing, but curved and often superimposed. And he adds areas of uneven cross-hatching to render the concentric expansion of the sun's rays and, applied more densely, to indicate the deep shadows of the wall. The style is occasioned by the work's very purpose as an independent drawing: it was to be a surrogate painting, analogous to the five large Montmajour drawings of July 1888. The state of the wheat is comparable to that in works of November–December (cat. 30, 38), suggesting that this drawing too belongs to this period rather than May–June 1889.

Pentimenti in the contour of the hills indicate that originally it was lower, especially toward the right. Two sides of the sheet have been trimmed slightly at the upper edge, more so at the left, where the strokes of the pen are abruptly cut.

40. Olive Trees with Yellow Sky and Sun

Oil on canvas, 29 × 36½ in. (73.7 × 92.7 cm.)
Unsigned
The Minneapolis Institute of Arts. The William Hood
 Dunwoody Fund
F710 H638 JH1856

By the end of September 1889, van Gogh had sent three canvases of olive orchards to Theo, all of them painted in June (see cat. 11–13). During his self-imposed isolation in the studio in September, he had done a reduced copy of one of them for his sister Wil (F711?). Otherwise, he had not returned to the olive motif. But toward the end of September, when, for the first time in more than two months,

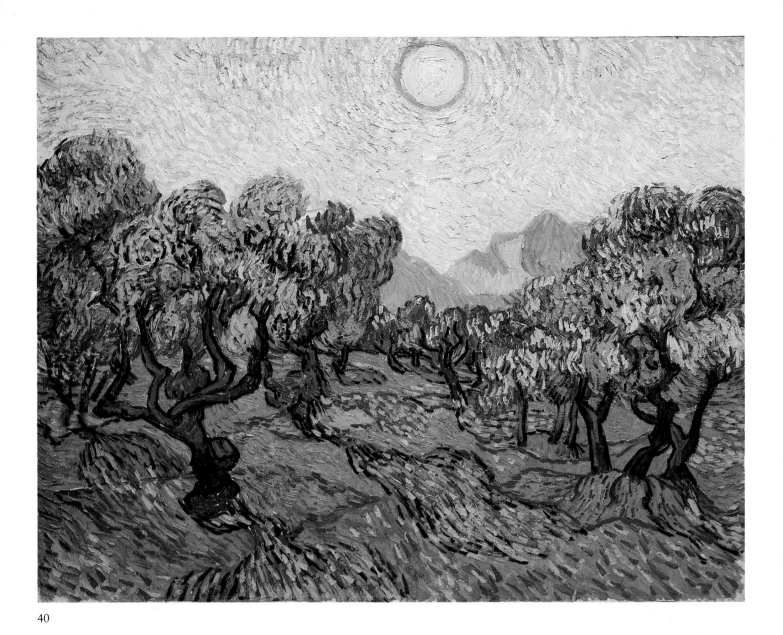

40

he ventured outside the asylum walls, he again became fascinated by the olive orchards. He wrote on 28 September: "The olive trees are very characteristic, and I am struggling to catch them. They are old silver, sometimes with more blue in them, sometimes greenish, bronzed, fading white above a soil which is yellow, pink, violet-tinged or orange, to dull red ocher. Very difficult though, very difficult. But that suits me and induces me to work wholly in gold or silver. And perhaps one day I shall do a personal impression of them as the sunflowers are for the yellows" (LT608).

It would seem from this that van Gogh had already begun work on the olives again. The present canvas may be the one cited in his letter to Émile Bernard of 12 October: "The olive trees here, old man, would be the very thing for you. I haven't had much of a chance to get them right this year, but I intend to return to the charge; they are silver against a soil of orange and violet hues, under the large white sun" (B20). Often in van Gogh's writing it is not clear whether he is describing nature or a painted representation of nature; whether he is stating an

Fig. 36. Olive orchard with the Alpilles in the background, 1986.
Photograph by Jean Delrieux

intention or describing something that has already been realized; whether he is referring to a period of incubation or to a frenzied burst of activity. In a letter to Wil on 9–10 December, however, he refers unequivocally to a picture "with a big yellow sun" (W16). The present canvas is the only olive orchard with such a sun, comparable to that in *Wheat Field with Rising Sun* (cat. 30). And it is the only one of the autumn–winter series to show the Alpilles (fig. 36). Compared with the predominantly cool green-blue tonalities of the June olives, this autumnal evocation has a vibrant orange-yellow effect. It suggests a direct response to the out-of-doors challenge, even though the diagonal back-lit shadows cast by the trees are out of alignment with the position of the sun.

41. Olive Orchard

Oil on canvas, 29¼ × 36½ in. (74 × 93 cm.)
Unsigned
Göteborgs Konstmuseum
F586 H651 JH1854
Reproduced on pages 162–63

On about 22 November 1889, van Gogh told Émile Bernard: "I have just done five size 30 canvases, olive trees" (B21). He saw them as an antidote to the "abstractions" of Gauguin and Bernard, especially such biblical compositions as *Christ in the Garden of Olives* (reproduced on page 53). A few days later, he embellished

on the theme to Theo: "This month I have been working in the olive groves, because their Christs in the Garden, with nothing really observed, have gotten on my nerves. . . . It is not that it leaves me cold, but it gives me a painful feeling of collapse instead of progress. Well, to shake that off, morning and evening these bright cold days, but with a very fine, clear sun, I have been knocking about in the orchards, and the result is five size 30 canvases, which, along with the three studies of olives that you have [cat. 11–13], at least constitute an attack on the problem. The olive is as variable as our willow or pollard willow in the North; you know the willows are very striking; in spite of their seeming monotonous, they are the trees characteristic of the country. . . . What I have done is a rather hard and coarse reality beside their abstractions, but it will have a rustic quality, and will smell of the earth" (LT615).

These five paintings of olive trees are cat. 40–43 and F708 (cat. 43, fig. 37). Van Gogh stressed their real, earthy quality and indicated that he painted them directly from nature. Yet the passionate involvement of van Gogh's response is conveyed with a controlled and impersonal articulation, and a refined, Seurat-like harmony of broken color. He explained to Theo on 7 December that he had given up using impasto. "I prepare the thing with a sort of wash of essence, and then proceed with strokes or hatchings in color with spaces between them. That gives atmosphere, and you use less paint" (LT618).

Van Gogh referred briefly to the painting in a letter to Wil as having "a green and orange sky" (W16). He sent it to Theo on 3 January 1890, describing it as "'Olive Trees'—sunset sky of orange and green" (LT621).

42. Olive Pickers

Oil on canvas, 28¾ × 36¼ in. (73 × 92 cm.)
Unsigned
Rijksmuseum Kröller-Müller, Otterlo
F587 H650 JH1853
Reproduced on pages 164–65

"Lately I have seen the women picking and gathering the olives, but as I had no chance of getting a model, I have done nothing with it. However, now is not the moment to ask me to admire our friend Gauguin's composition, and our friend Bernard has probably never seen an olive tree. Now he is avoiding getting the least idea of the possible, or of the reality of things, and that is not the way to synthesize—no, I have never taken any stock in their biblical interpretations. . . . If I stay here, I shall not try to paint 'Christ in the Garden of Olives,' but the gleaning of the olives as you still see it, giving nevertheless the exact proportions of the human figure in it; perhaps that would make people think. I have no right to meddle with it before doing some more serious studies of it than I have done up to now" (LT614).

Van Gogh wrote this on 17 November 1889. Some five days later, however, he had painted the present picture, one of five canvases of olive orchards he reported as completed to Bernard (B21) and to Theo (LT615). It is clearly based on the Göteborg composition (cat. 41), with its controlled stroke and harmonious interplay of movement and color.

Sending the Göteborg painting to Theo on 3 January 1890, van Gogh remarked, "There is still here a variant with figures" (LT621). It would seem, therefore, that *Olive Pickers* was not dispatched to Theo until the end of April, when he sent the next batch of paintings.

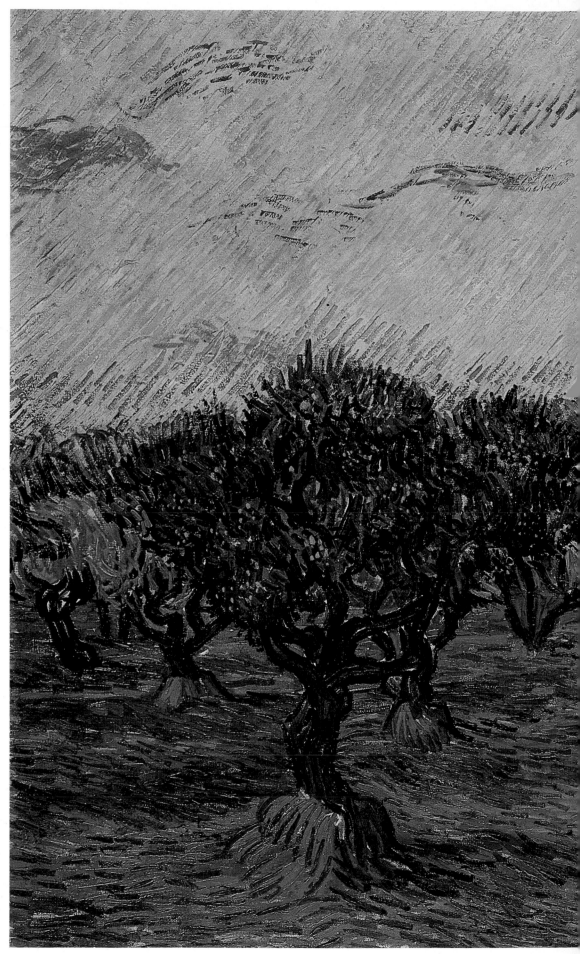

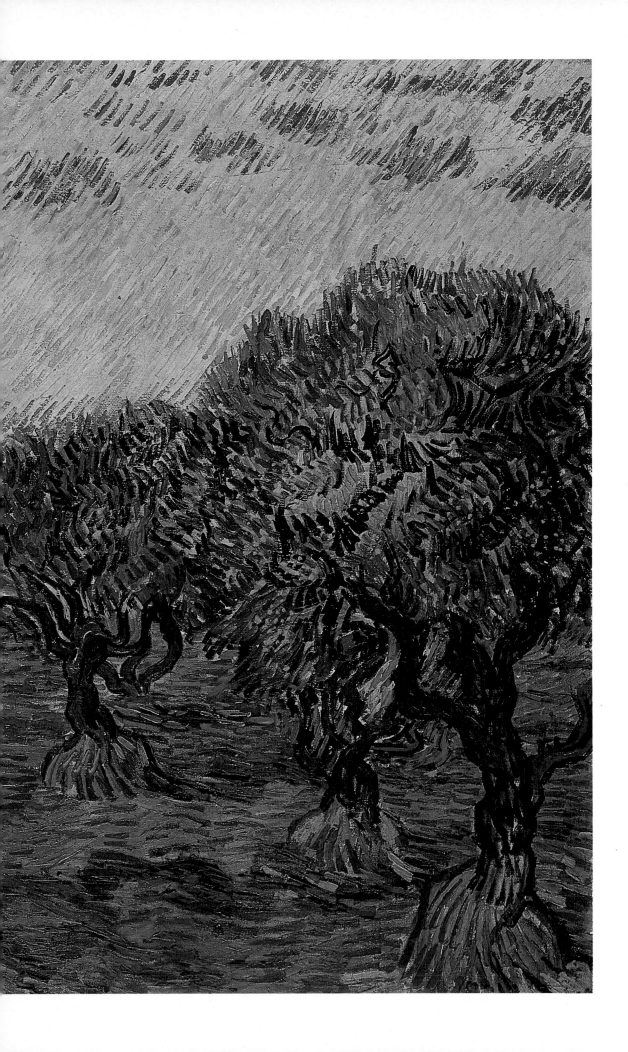

163

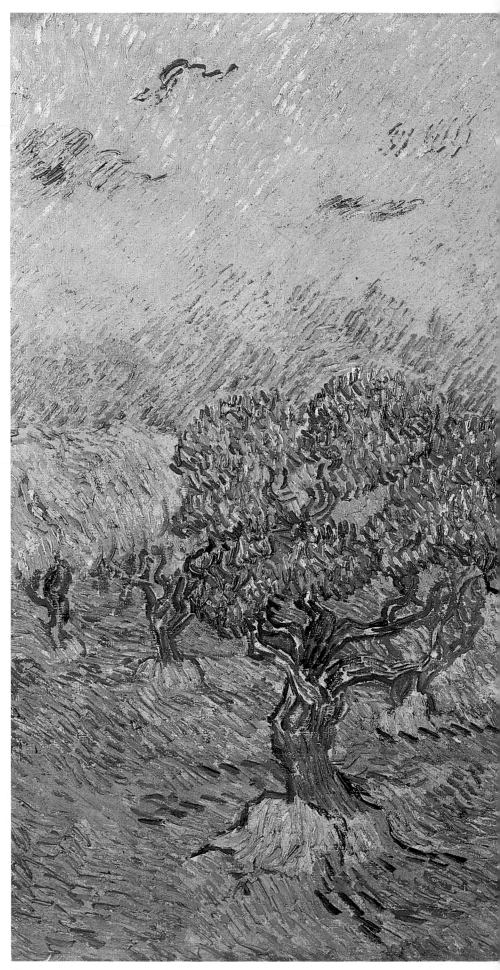

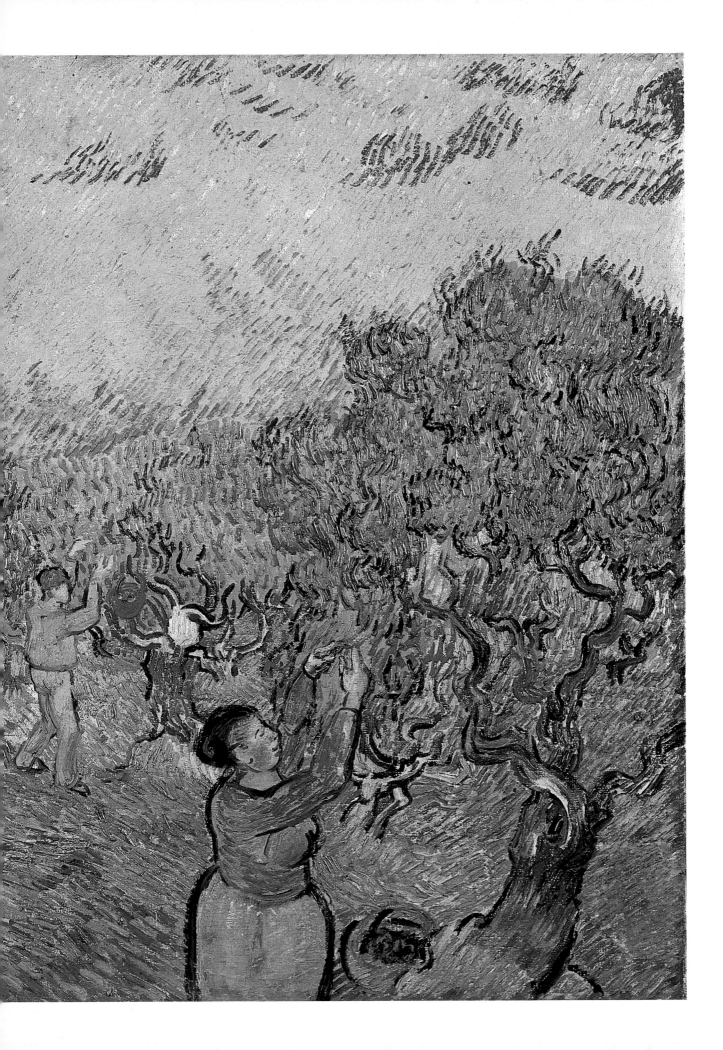

43. Olive Orchard

Oil on canvas, 28¾ × 36½ in. (73 × 92.5 cm.)
Unsigned
Rijksmuseum Vincent van Gogh (Vincent van Gogh Foundation),
 Amsterdam

F707 H639 JH1856

This is one of five paintings of olive orchards that van Gogh reported as having
completed in November 1889 (B21, LT615); the other four are cat. 40–42, and F708
(fig. 37). Stylistically close to the Göteborg *Olive Orchard* (cat. 41) and the Otterlo
Olive Pickers (cat. 42) in its thinly applied paint and uniformly short brushstrokes,
it differs from them in its emphatically diagonalized composition, moving from
lower right to left center. The flattened shadows cast by the trees create an
intricate counter-rhythm, launched by the three areas of shadow at lower left that
are cast by unseen trees. Their schematic shapes, with striking orange and blue
complementaries, take on an abstract life of their own. The foliage is more ragged

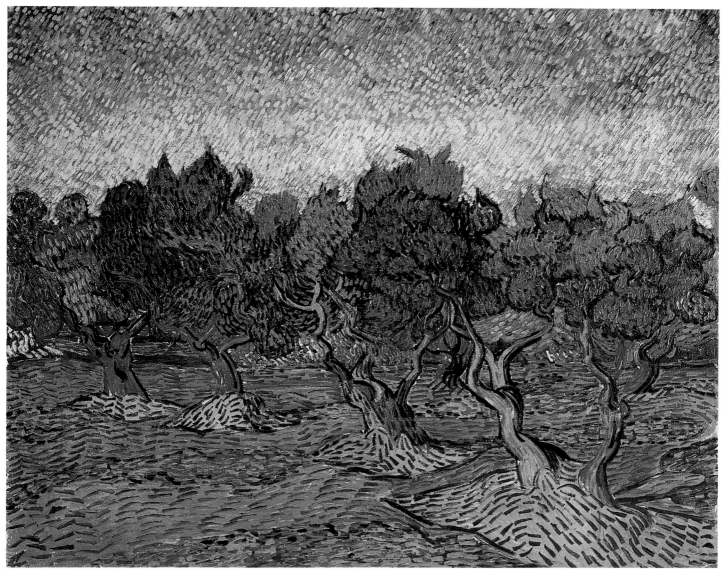

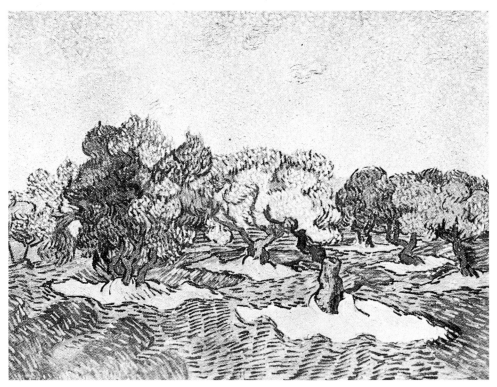

Fig. 37. *Olive Orchard* (F708). Oil on canvas, 29 x 36 in.
(73.5 x 91.5 cm.). Collection Walter H. Annenberg,
Rancho Mirage, California

in outline than in the other two paintings, creating flamelike arabesques.

The stylization is carried further in the fifth canvas (fig. 37). While clearly related compositionally to the present painting, it develops a different vocabulary of color harmonies: yellow-violet instead of blue-orange shadows, reds as well as greens in the trees, sand-dune-like areas without hatchings around the base of the trees, and antinaturalistic green trunks.

Both canvases, sent to Theo on 3 January 1890, were listed as "'Olive Trees, neutral effect'" (LT621).

44. The Road Menders

Oil on canvas, 29 × 36¼ in. (73.7 × 92 cm.)
Unsigned
The Cleveland Museum of Art. Gift of the Hanna Fund

F657 H667 JH1860

Van Gogh made a short visit to the town of Saint-Rémy in early June 1889: "I went once, still accompanied, to the village; the mere sight of people and things had such an effect on me that I thought I was going to faint and I felt very ill" (LT594). He did not describe another visit until he reported the completion of the present canvas on 7 December: "The last study I have done is a view of the village, where they were at work—under some enormous plane trees—repairing the pavements. So there are heaps of sand, stones and the gigantic trunks—the leaves yellowing and here and there you get a glimpse of a house front and small figures" (LT618).

The French novelist and historian Edmond de Goncourt also visited Saint-Rémy, in September 1885. He recorded in his *Journal*: "The little town of Provence

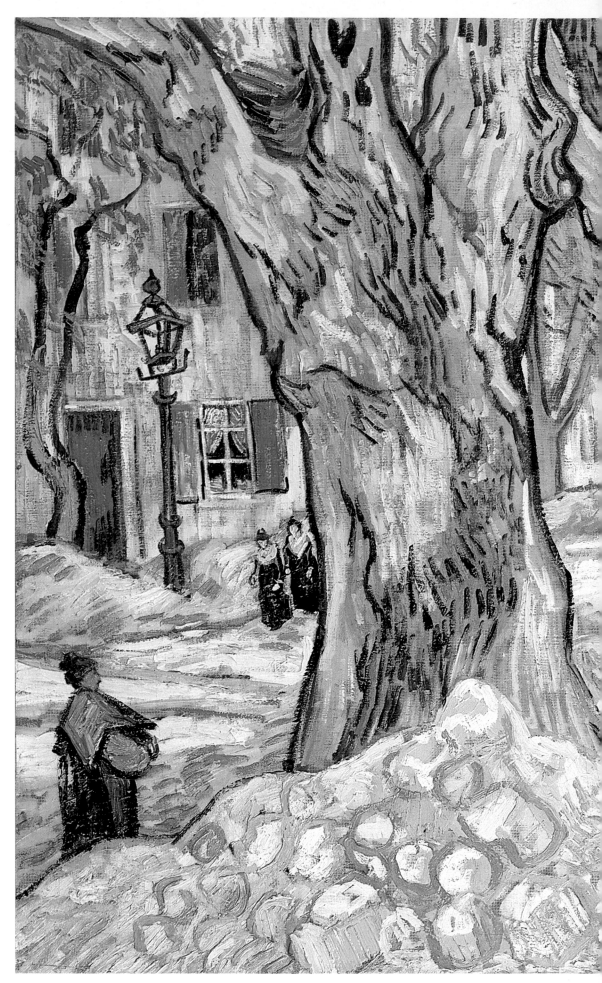

44

under its large plane trees [fig. 38]. . . . And in these street-boulevards, the picturesque perspectives made by the plane trees, whose crisscrossing, above the coming and going of the circulation, is like the stone interlacing of a Gothic nave. They are better than the 'Avenue of Chestnuts' by Théodore Rousseau, these avenues of plane trees, with the whitish colors of their trunks, the architectural outlining of their branches, the zigzags of sunshine playing in the pale green leaves, with, finally, the people, splashed with colors and here and there spattered with light, walking under the gently shadowed vault. And to think that not one known landscape painter has had the idea of making a picture of one of these street-boulevards" (Goncourt, *Journal*, vol. 14, p. 40).

Rousseau's *Avenue of Chestnuts* was painted in 1837 and rejected at the Salon of 1841. Van Gogh knew of it as well as Goncourt. But he did not know of this entry in Goncourt's *Journal*, which was first published in 1894.

In order to draw a parallel between the boulevard and a Gothic nave, Goncourt described the central view. Van Gogh chose an angled view—from the aisle, as it were—which accentuates the "gigantic" forms of the trees. Probably painted in early December, it is one of the last outdoor studies of 1889, and van Gogh's only depiction of Saint-Rémy itself.

The picture was among those sent to Theo on 3 January 1890: "The big plane trees—the chief street or boulevard of Saint-Rémy, study from nature—I have a copy [*répétition*] which is perhaps more finished here" (LT621). Theo responded on 8 January: "I very much like . . . the highway with the road menders" (T24). He then included it among ten of van Gogh's pictures in the spring 1890 Salon des Indépendants as "Rue à Saint-Rémy."

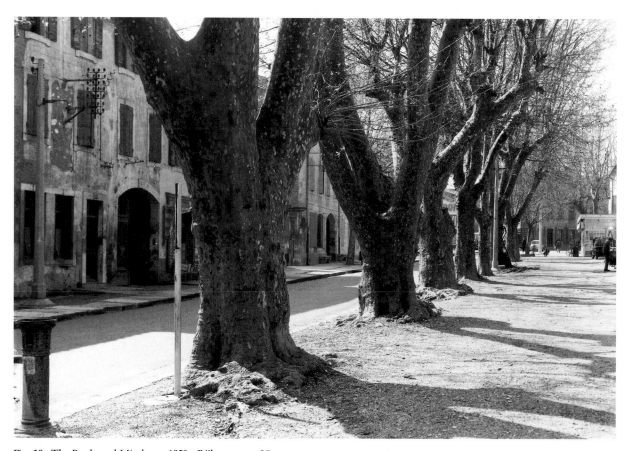

Fig. 38. The Boulevard Mirabeau, 1950s. Rijksmuseum Vincent van Gogh (Vincent van Gogh Foundation), Amsterdam. Photograph by Marc Edo Tralbaut

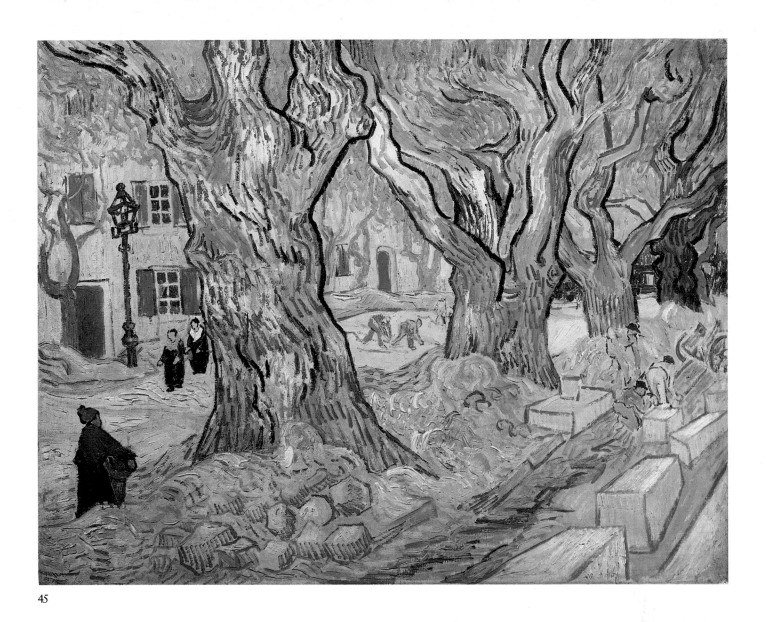

45

45. The Road Menders

Oil on canvas, 28 × 36⅝ in. (71 × 93 cm.)
Unsigned
The Phillips Collection, Washington, D.C.

F658 H668 JH1861

When van Gogh told Theo on 3 January 1890 that he had a "more finished [*plus faite*]" copy of the *Road Menders,* he was referring to the present picture. The handling of the Cleveland version (cat. 44) is more hurried, suggesting that it was the "study from nature." It is less "finished": note how the tree at the far left and the two central workmen are merely outlined over the existing paint surface, while the enormous plane trees have only occasional areas of hatching. In the Phillips copy van Gogh tidied up such impatient or hasty passages, yet did not produce an inherently more continuous surface. In fact, this studio repetition is often thinly painted; areas of canvas are even left untouched. Figures of workers are added. But the slowed rhythm of work in the studio allowed van Gogh to indulge in a more controlled system of hatchings on the plane trees, and to give

more unbroken contours to all elements of the picture, from the foreground stones and cobbles to the trees and distant houses. He also altered certain relationships, raising the street lamp to the height of the first-floor window and opening the shutters of the same window.

The choice of road menders as a motif may not have been accidental. A picture of men digging up a street (F930a) was one of van Gogh's most ambitious multifigure compositions from his Hague period. There is no proof that he knew of Ford Madox Brown's *Work*, 1852–63 (City Art Gallery, Manchester), or of Manet's *Rue Mosnier with Pavers,* 1878 (Fitzwilliam Museum, Cambridge), but the *Road Menders* is also an autumn study of yellowing leaves. In this aspect, its closest prototypes are the canvases of the Alyscamps in Arles (F486, F487, F568, F569).

The old town of Saint-Rémy, with its core of narrow streets haphazardly related, was surrounded on four sides by a continuous exterior boulevard. In 1890 each of the four *cours,* or roads, had a superb double row of plane trees. Van Gogh chose the Cours de l'Est, looking south and slightly uphill. In May 1891, it was renamed the Boulevard Mirabeau.

The Phillips copy was probably executed in mid-December. From his autumn campaign, van Gogh made copies of the *Ravine* (F661) and *A Corner of the Asylum Garden* (cat. 33, fig. 31), both of which were intended for his mother and his sister Wil. In this instance, he did not designate a preferred recipient. The painting was included in the last batch sent to Theo from Saint-Rémy, on 29 April 1890.

46. First Steps (after Millet)

Oil on canvas, 28½ × 35⅞ in. (72.4 × 91.2 cm.)
Unsigned
The Metropolitan Museum of Art, New York. Gift of
 George N. and Helen M. Richard, 1964

F668 H685 JH1883

On 23 October 1889, van Gogh thanked Theo for sending reproductions of Millet's work, among them the *Sower* and *Diggers.* There was also a photograph of *First Steps* (fig. 39). "How beautiful that Millet is, 'A Child's First Steps'!" (LT611).

Nothing more is said on this subject until January. By then, van Gogh had sent his brother several of the copies he had made after Millet, and he was now

Fig. 39. Squared-up photograph of Jean-François Millet, *First Steps.* Rijksmuseum Vincent van Gogh (Vincent van Gogh Foundation), Amsterdam

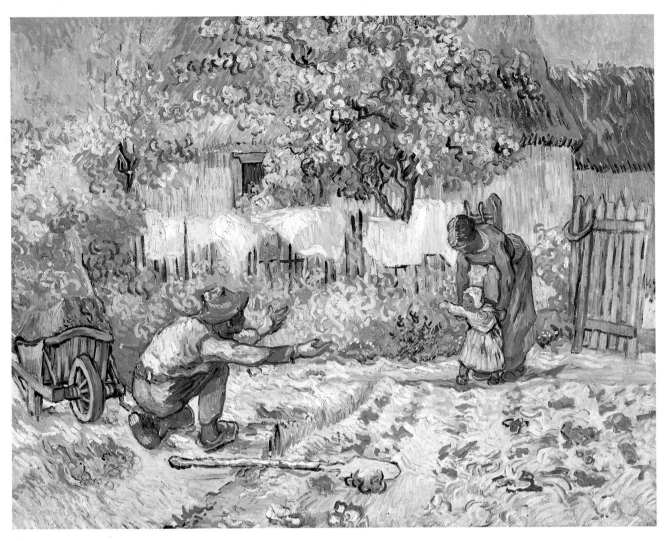

46

preparing to do a new series. "This week I am going to start on the snow-covered field [F632] and Millet's 'The First Steps,' in the same size as the others" (LT623). He took the photograph that he had had since October, squared it up, and transferred it to a size 30 canvas. "The more I think about it, the more I think that there is justification for trying to reproduce some of Millet's things which he himself had no time to paint in oil. Working thus on his drawings or on his woodcuts is not purely and simply copying. Rather, it is translating—into another language—that of color—the impressions of light and shade in black and white" (LT623).

This homely rural scene, with its memories of Barbizon and of the North, was transposed into a gentle harmony of soft greens that in many ways foretells some of the landscapes van Gogh would do in Auvers. There is nothing quite analogous to this muted color range in the paintings done in Saint-Rémy.

First Steps was included in the batch of work sent to Theo on 29 April. "You will see that first of all there are canvases after Millet" (LT629). In acknowledging the safe arrival of the paintings on 3 May, Theo wrote: "The copies after Millet are perhaps the best things you have done yet, and induce me to believe that on the day you turn to painting compositions of figures, we may look forward to great surprises" (T33).

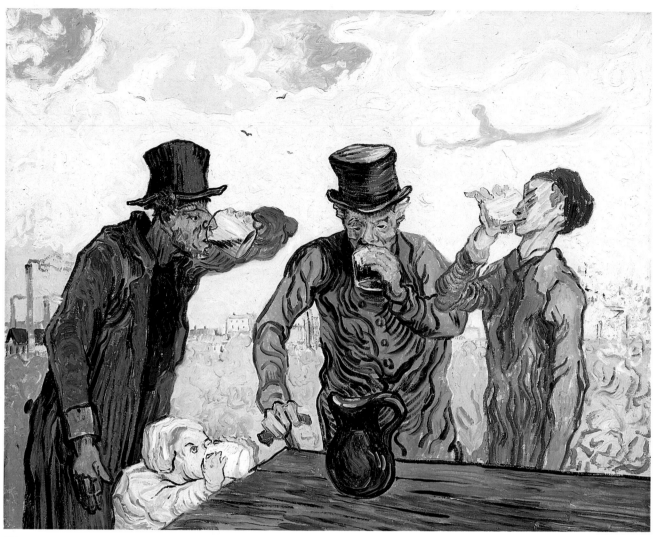

47

47. The Drinkers (after Daumier)

Oil on canvas, 23⅜ × 28⅞ in. (59.4 × 73.4 cm.)
Unsigned
The Art Institute of Chicago. The Joseph Winterbotham
 Collection

F667 H687 JH1884

After his week-long breakdown at the end of December 1889, van Gogh had to await Dr. Peyron's permission before he could begin to paint again. He wrote about 10 January 1890: "I have enough subjects for pictures in my head for when the weather will allow me to work outside" (LT623). Confined to his studio throughout January, he continued his series of copies, primarily after Millet (see cat. 46). And he suggested to Theo: "So what I think I shall do in painting is the 'Men Drinking' by Daumier and the 'Convict Prison' by Régamey. You will find them among the wood engravings."

Van Gogh is here referring to the collection of some 1,500 wood engravings that he had amassed in his early days as an artist, especially when he was living in The Hague in 1882–83. At that time they constituted a *musée imaginaire,* acting as exemplars and as sources for copies. Theo complied with his request, and sent

Fig. 40. Wood engraving after Honoré Daumier, *The Drinkers*. The Metropolitan Museum of Art, New York. Department of Prints and Photographs

the illustration after Daumier (fig. 40). Van Gogh squared up the wood engraving, and transferred the image to a size 20 canvas. He told Theo on 10 February that he found it "difficult" to do the copy (LT626).

Van Gogh's choice of this particular image may have been influenced by Daumier's study of types, reminding him of some of his own drawings from The Hague. In addition, it shows the suburbs of Paris. Writing in June 1889, he contrasted "the purer nature of the countryside . . . with the suburbs and cabarets of Paris. One would try to paint human beings who are also more serene and pure than Daumier had before his eyes, but following Daumier, of course, in the drawing" (LT595). Van Gogh had a profound admiration for the "full rich execution" of Daumier's drawings (LT621). But the *Drinkers* is his only painted copy after Daumier.

48. L'Arlésienne (after Gauguin)

Oil on canvas, 25½ × 21¼ in. (65 × 54 cm.)
Unsigned
Museu de Arte de São Paulo
F542 H713 JH1894

Van Gogh based this portrait on a drawing by Gauguin of Madame Marie Ginoux (fig. 41) which was done in November 1888 and left behind in Arles after Gauguin's departure. It is one of four surviving copies (the others are F540, F541, and F543) that were painted in Saint-Rémy, almost certainly in January–February 1890. During that period, van Gogh made one brief reference to the portrait. Writing to his sister Wil about 20 February, he told her he was working on "a portrait of an Arlésienne, in which I am after another expression than that of the Parisiennes" (W20). And four months later, writing from Auvers, he told her that Theo and Jo had a "new portrait" of the Arlésienne (F543) in their apartment. He made a sketch of the composition in the letter (fig. 42), adding, "I do not succeed in making a good sketch of it" (W22).

The São Paulo version shows Madame Ginoux at her most serious; in the others there is the suggestion of a smile. And, arguably, it is the closest to Gauguin's drawing. Van Gogh wrote enthusiastically to Gauguin in mid-June: "It

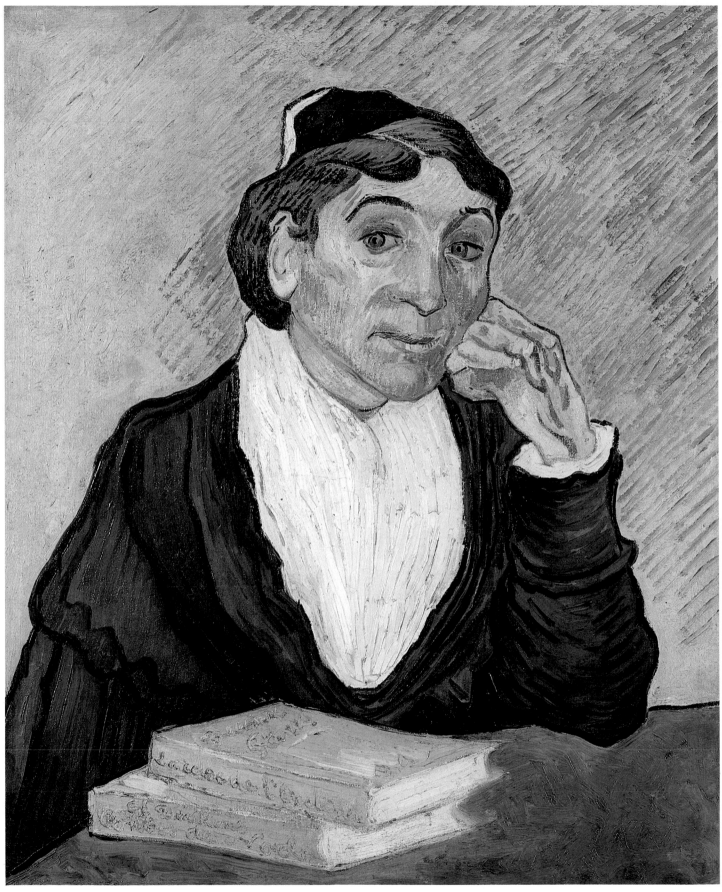

Fig. 41. Paul Gauguin. *L'Arlésienne,* November 1888. Charcoal, crayon, chalk, 22⅛ x 19⅜ in. (56.1 x 49.2 cm.). The Fine Arts Museums of San Francisco. Achenbach Foundation for Graphic Arts, Memorial gift from Dr. T. Edward and Tullah Hanley, Bradford, Pennsylvania

Fig. 42. Sketch of *L'Arlésienne* (W22). Rijksmuseum Vincent van Gogh (Vincent van Gogh Foundation), Amsterdam

gives me enormous pleasure when you say the Arlésienne's portrait, which was based strictly on your drawing, is to your liking. I tried to be religiously faithful to your drawing, while nevertheless taking the liberty of interpreting through the medium of color the sober character and the style of the drawing in question. It is a synthesis of the Arlésiennes, if you like; as syntheses of the Arlésiennes are rare, take this as a work belonging to you and me as a summary of our months of work together" (LT643).

The two books on the table before Madame Ginoux are, in French translation, Harriet Beecher Stowe's *Uncle Tom's Cabin* and Charles Dickens's *Christmas Stories.* They had long been familiar to van Gogh. Just before leaving Arles he had told Wil, in a letter of 30 April 1889: "I have reread *Uncle Tom's Cabin* by Beecher Stowe with *extreme attention,* for the very reason that it is a book written by a woman, written, as she tells us, while she was making soup for the children—and after that, also with extreme attention, Charles Dickens's *Christmas Tales* [*sic*]" (W11). Both books were seen by van Gogh as humanitarian, caring, and sympathetic. He included them in *L'Arlésienne* as magical talismans for the restoration of Madame Ginoux's health.

Marie Ginoux (1848–1911) was twice painted by van Gogh when he was living in Arles (F488, F489). She and her husband, Joseph-Michel Ginoux (1836–1902), ran the Café de la Gare in the Place Lamartine, where van Gogh stayed during the summer of 1888, painted the *Night Café* (F463), and stored his furniture when he left for Saint-Rémy. On his visits to Arles from the asylum, he always tried to meet with them.

A fifth version of *L'Arlésienne,* which van Gogh intended to present to Madame Ginoux, was lost when he suffered a breakdown on his last visit to Arles, in February 1890.

49. Blossoming Almond Tree

Oil on canvas, 28¾ × 36¼ in. (73 × 92 cm.)
Unsigned
Rijksmuseum Vincent van Gogh (Vincent van Gogh Foundation),
 Amsterdam

F671 H688 JH1891

Reproduced on pages 180–81

Van Gogh heard of the birth of his nephew by 2 February 1890 and immediately conveyed his joy at the news to Theo (LT625). Writing again about 10 February (LT626), he said nothing about painting a picture specially for his nephew. Was it to be a surprise? Or, as is more probable, was it mentioned in a letter, now lost, written to Theo about 19 February? As it is, van Gogh first refers to such a picture on 20 February in letters written separately, but sent together, to his mother and to Wil. To his mother: "I started immediately to make a picture for him [the baby], to hang in their bedroom, big branches of white almond blossom against a blue sky" (LT627). And to Wil: "Just as I am writing to his grandmother, some days ago I started painting a big canvas for him, of a blue sky with blossoming branches standing out against it" (W20).

Although frequently seen as a still life of cut almond blossoms, such as van Gogh had painted in Arles a year earlier (fig. 43; F393), and on this assumption equivalent to the cut sunflowers of Paris (F452) or the cut branches of chestnut blossoms from Auvers (F820), this painting was surely done out of doors. Ignoring the trunk, van Gogh looked up into the tree. This seems confirmed by the gnarled lower horizontal branch that is seen from below.

His method was slow and deliberate, part by part. Branches and blossoms were painted first. Only then did he paint the sky in the spaces and interstices of the already established shapes, painting toward their contours or color areas, so that bare canvas can still be seen between the blossoming branches and the sky. Moreover, he modulated the sky by using two different blues and varying the size and direction of the brushstrokes; it is not just a painted backdrop. Although the design may appear to be flat and decorative, the consistent hatching on the lowest branch and its diagonal, seen-from-below thrust into space deny this. Van Gogh emphasizes the *plein-air* aspect in all these ways.

Almond trees, with their distinctively dark branches and delicate flowers, blossom in Provence in late January–early February, at least a month before the other trees. Van Gogh had no choice: the flowers of the almond had to be his symbol of joyous birth, of the cycle of life reaffirmed. This picture was to have been the first in a series of blossoming orchards. But he was prevented from continuing by the longest and most serious of his breakdowns, which incapacitated him for two months. Recalling the painting on 24 April, soon after his recovery, he explained to his brother: "Work was going well. The last canvas of branches in blossom, you will see, was perhaps the most patiently worked and the best thing I had done, painted with calm and with a greater firmness of touch. And the next day, down like a brute" (LT628). And again, five days later: "I fell ill at the time I was doing the flowers of the almond tree. If I had been able to go on working, you can judge from it that I would have done others of trees in blossom. Now the trees in blossom are almost over—really I have no luck" (LT629).

Van Gogh was still working on this canvas on Friday 21 February, the day before he had his breakdown in Arles. It must have been finished then, since it is most unlikely he would have retouched it during the few days before it was

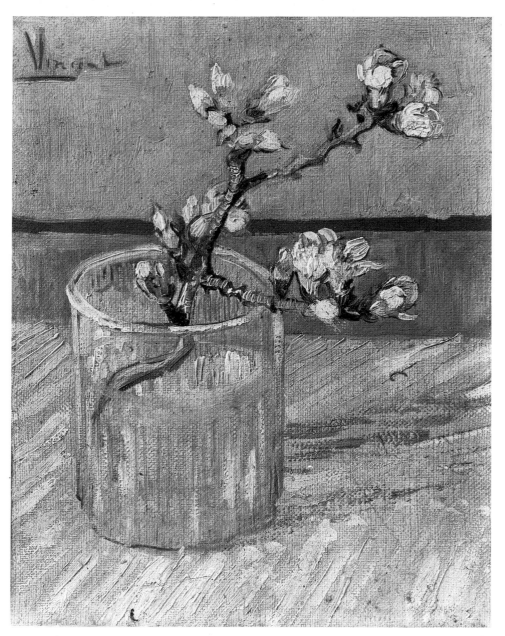

Fig. 43. *Blossoming Almond Branch in a Glass* (F392). Oil on canvas, 9½ x 7½ in. (24 x 19 cm.). Rijksmuseum Vincent van Gogh (Vincent van Gogh Foundation), Amsterdam

dispatched to Paris, on 29 April. Curiously, it was sent without a dedication to his nephew.

Theo acknowledged receiving the picture on 3 May: "The branch of almond blossoms shows that for these themes you have missed the season of trees in blossom" (T33).

During his three-day stay in Paris in mid-May, en route to Auvers, van Gogh saw the picture in Theo and Jo's apartment. He already knew from Jo's letter of 29 March (T30) that one of his Arles canvases of a tree in blossom hung over his nephew's bed. So his specially painted souvenir was instead hung over the piano, as he later told Wil: "White almond blossoms—big branches against a sky-blue [*bleu céleste*] background" (W22). *Bleu céleste,* a rare usage in van Gogh's descriptions of blue, seems uniquely appropriate to this celebratory picture.

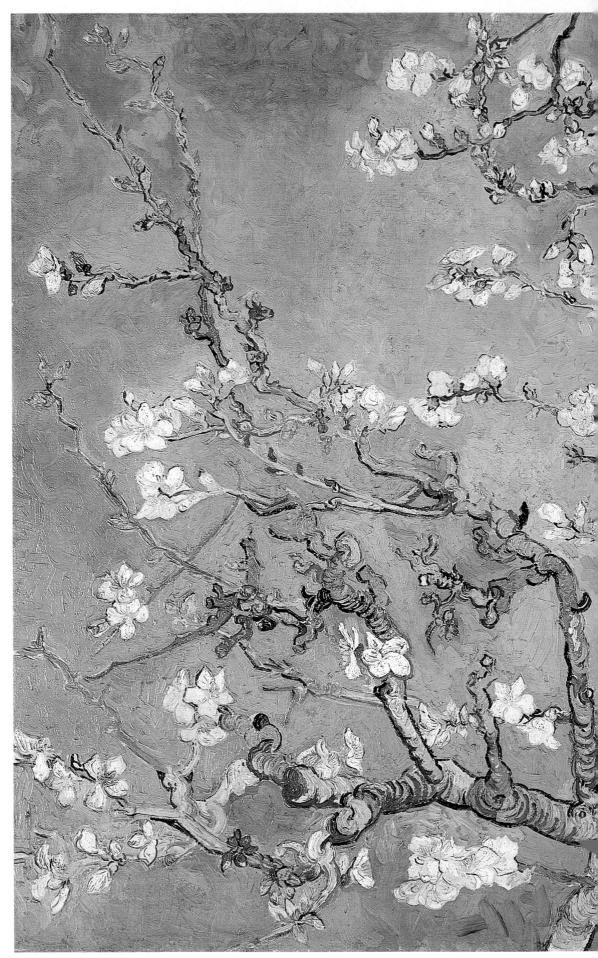

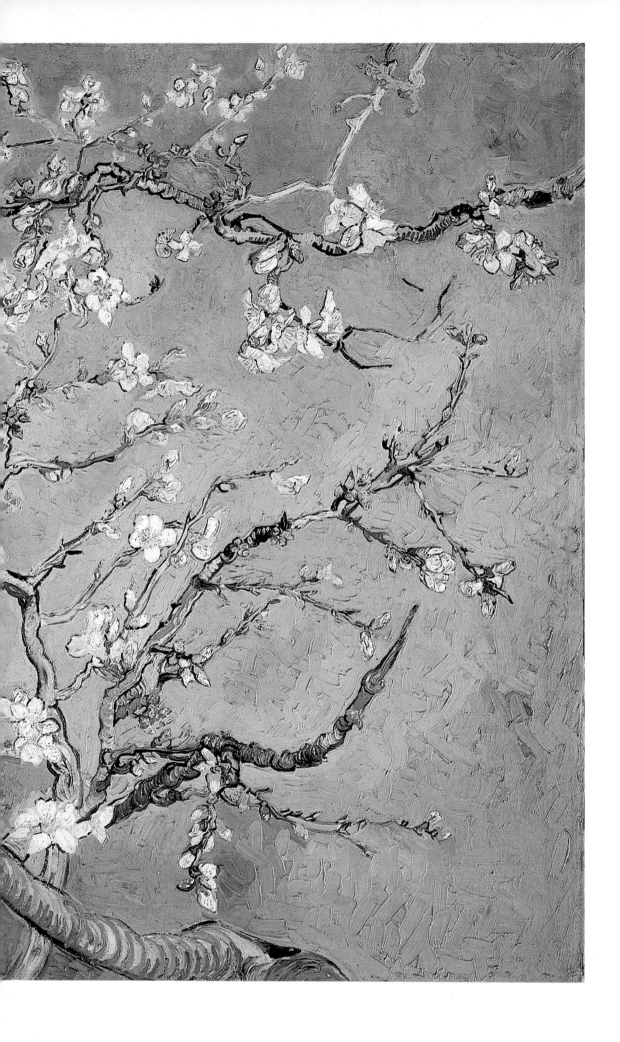

50. Pine Trees and Dandelions in the Asylum Garden

Oil on canvas, 28¼ × 35½ in. (72 × 90 cm.)
Unsigned
Rijksmuseum Kröller-Müller, Otterlo
F676 H697 JH1970

After the last and longest of his breakdowns in Saint-Rémy, from mid-February to late April 1890, van Gogh made a remarkably rapid recovery. The first painting he did was the present magnificent landscape, taken once again from the asylum garden—or park, as he had come to call it. He refers to it several times, beginning with his letter of 29 April to Theo: "I have just finished a corner of a sunny meadow, which I think is fairly vigorous" (LT629). On the same day, he wrote to his mother and Wil: "These last few days I have been working on the picture of a lawn in the blazing sun with yellow dandelions" (LT629a). And then again, on 4 May, to Theo: "I have done two canvases of the fresh grass in the park, one of which is extremely simple; here is a hasty sketch of it [fig. 44]. The trunk of a pine violet-pink and then the grass with white flowers and dandelions, a little rose tree and other tree trunks in the background right at the top of the canvas" (LT631).

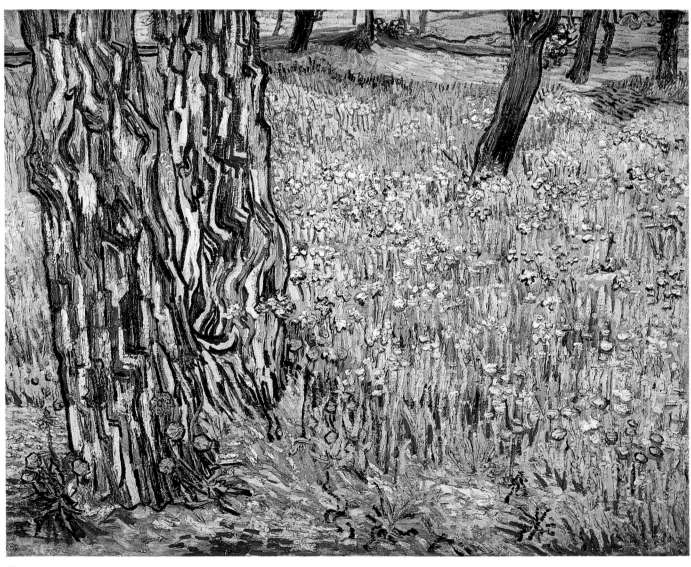

Fig. 44. Sketch of *Pine Trees and Dandelions in the Asylum Garden* (LT631). Rijksmuseum Vincent van Gogh (Vincent van Gogh Foundation), Amsterdam

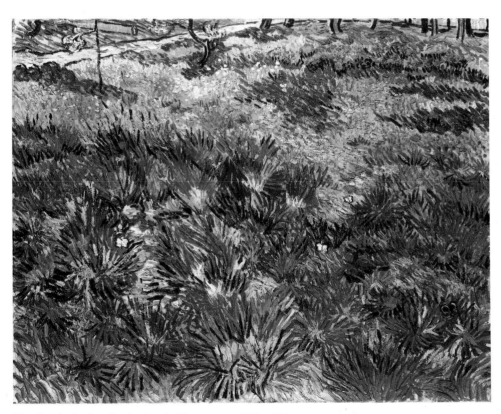

Fig. 45. *The Asylum Garden* (F672). Oil on canvas, 25½ x 32 in. (64.5 x 81 cm.). The Trustees of the National Gallery, London

The second canvas is now in the National Gallery, London (fig. 45). They are van Gogh's last paintings of the asylum garden, even though he told Theo on 2 May: "As soon as I got out into the park, I got back all my lucidity for work; I have more ideas in my head than I could ever carry out, but without its clouding my mind. The brushstrokes come like clockwork" (LT630).

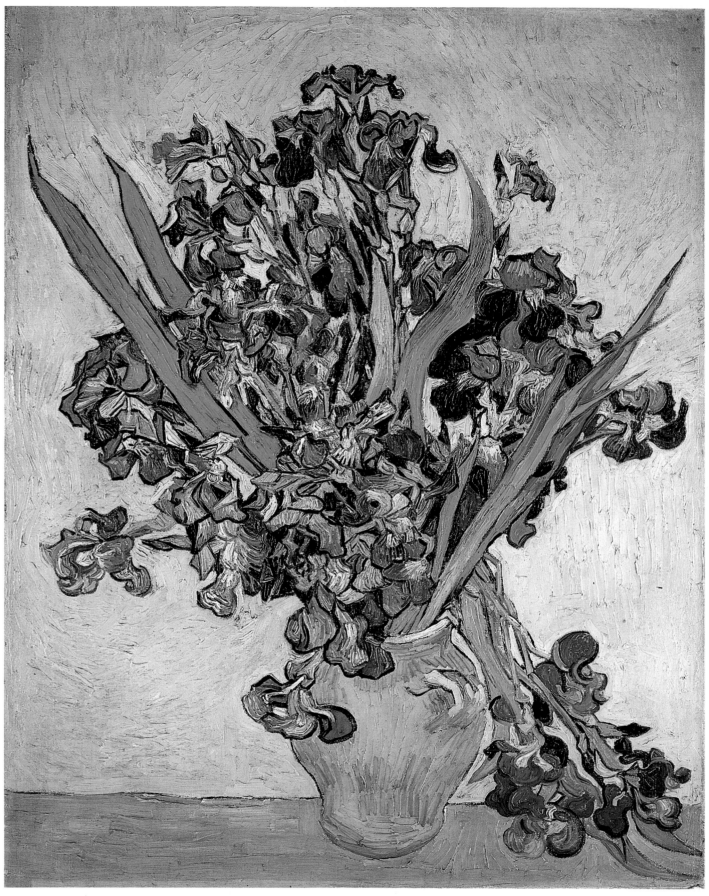

51

51. Irises

Oil on canvas, 36¼ × 29 in. (92 × 73.5 cm.)
Unsigned
Rijksmuseum Vincent van Gogh (Vincent van Gogh Foundation),
 Amsterdam
F678 H700 JH1977

In his penultimate letter from Saint-Rémy, of 11 or 12 May 1890, van Gogh wrote to Theo: "At present all goes well; the whole horrible attack has disappeared like a thunderstorm, and I am working to give a last stroke of the brush here with a calm and steady enthusiasm. I am doing a canvas of roses with a light green background and two canvases representing big bunches of violet irises, one lot against a pink background in which the effect is soft and harmonious because of the combination of greens, pinks, violets. On the other hand, the other violet bunch (ranging from carmine to pure Prussian blue) stands out against a startling citron background, with other yellow tones in the vase and the stand on which it rests, so it is an effect of tremendously disparate complementaries, which strengthen each other by their juxtaposition" (LT633).

In the latter part of this passage, van Gogh reverts to the language of color that he used in Arles, when he was totally absorbed in the idea of using complementary colors, especially in such pictures as the *Sower* (F422). In Saint-Rémy he rarely mentioned using the complementaries in his work, and this was the last time he spoke of deliberately using them in the same painting. In choosing to juxtapose yellows and violet blues in the present painting, he may also have been stimulated by the memory of his visit to Georges Seurat's studio on the day he left Paris for Arles, in February 1888; indeed, he made the connection in the very same letter: "But another strange thing, just as we were so struck by Seurat's canvases on that day, these last days here are like a fresh revelation of color to me."

After his virtual neglect of still-life painting in Saint-Rémy, van Gogh painted four size 30 still lifes during his last days there: two of irises and two of roses, each pair comprising one upright and one horizontal. In these formalistic color exercises he dispensed with a loaded brush and thick impasto, spreading the paint discreetly and carefully plotting the shapes. In the present painting, where the interplay of yellows, the proportion of the table in relation to the background, and the asymmetrical placing of the vase subtly echo one of the Arles *Sunflowers* (F454), he actually painted the flowers, vase, and tabletop before adding the background in and around the established shapes.

52. Irises

Oil on canvas, 29 × 36¼ in. (73.7 × 92.1 cm.)
Unsigned
The Metropolitan Museum of Art, New York.
 Gift of Adele R. Levy, 1958
F680 H701 JH1978

The two still lifes of irises (the present one and cat. 51) provide a fitting climax to van Gogh's stay in Saint-Rémy. He began by painting irises in the asylum garden (cat. 1); and during his last week there, he painted them as indoor still lifes—but on his own terms, as deliberately conceived formalistic color exercises. Unfortunately, the pink background in the Metropolitan canvas has sunk, thus suppressing the complementary color contrasts that van Gogh sought: soft and harmonious pinks and greens as against the yellow violet of the Amsterdam version. The paint

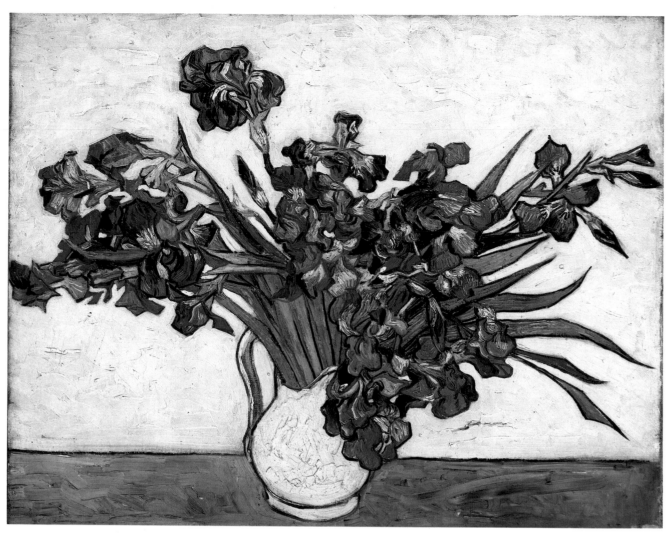

52

surface is thin, with parts of the canvas left untouched—most dramatically, in the jug handle. Although van Gogh later confessed to his sister Wil that "during the last weeks at Saint-Rémy I worked like a man in a frenzy, especially on bunches of flowers" (W22), he actually painted them with a remarkably serene economy of means, no more so than in the present canvas, which presages Matisse in its distilled purity of statement.

53. Roses

Oil on canvas, 28 × 35½ in. (71 × 90 cm.)
Unsigned
Collection Governor W. Averell and Pamela C. Harriman
F681 H702 JH1976
NOT IN EXHIBITION

In his letter of 11 or 12 May 1890, van Gogh announced that he was busy with two still lifes of irises (one vertical, cat. 51; one horizontal, cat. 52), and he added that he was working on "a canvas of roses with a light green background" (LT633). The same Provençal pot is used, seen at exactly the same angle, as in the vertical

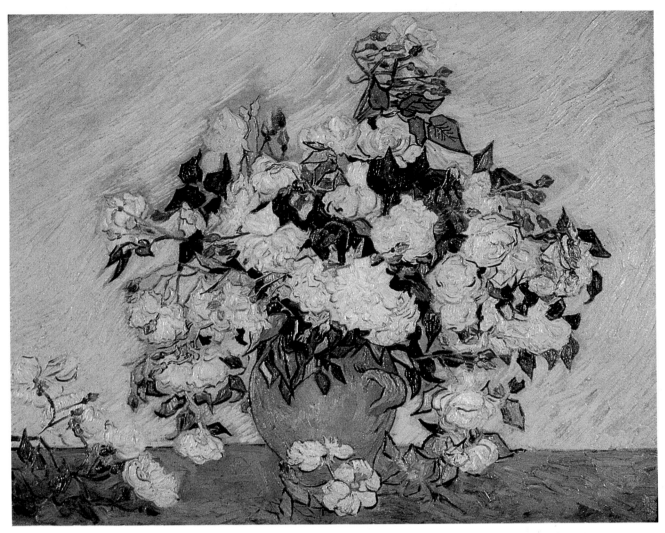

53

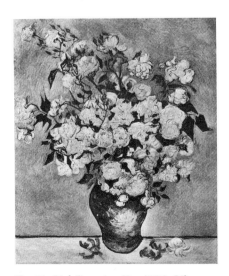

Fig. 46. *Pink Roses in a Vase* (F682). Oil
on canvas, 36⅝ x 28⅜ in. (93 x 72 cm.).
Collection Walter H. Annenberg,
Rancho Mirage, California

canvas of irises; and, as there, the outlines of the pot and tabletop are thin and
delicate. There seems, then, to be a stylistic relationship between the vertical irises
and the horizontal roses.

In his last letter from Saint-Rémy, of 13 May, van Gogh wrote: "I have just
finished another canvas of pink roses against a yellow-green background in a
green vase" (LT634). In this picture (fig. 46), the contours are thick and bold,
dividing the table and vase from the background wall. A stylistic pairing seems to
follow between the horizontal irises and the vertical roses. These pairings cut
across the play of juxtaposed complementary colors that van Gogh celebrated in
the two iris paintings, establishing a further counterpoint in the possible disposi-
tion of this quartet of canvases, which were probably conceived as his final
Provençal decoration. The simple arrangement of horizontal surfaces echoes that
in the sunflower paintings of August 1888, planned as a special decoration for
Gauguin's room in the Yellow House in Arles (F453, F454, F456, F459).

Van Gogh was unable to take these four pictures with him when he left
Saint-Rémy. As he explained to Theo, "These canvases will take a whole month to
dry, but the attendant here will undertake to send them off after my departure"
(LT633). They eventually arrived in Auvers by 24 June.

54. Landscape with Couple Walking and Crescent Moon

Oil on canvas, 19½ × 18 in. (49.5 × 45.5 cm.)
Unsigned
Museu de Arte de São Paulo
F704 H720 JH1981

This painting is not mentioned in any of van Gogh's surviving letters. While it has always been catalogued as a Saint-Rémy picture, various suggestions have been proposed as to its possible date; these range from as early as October 1889 to as late as May 1890.

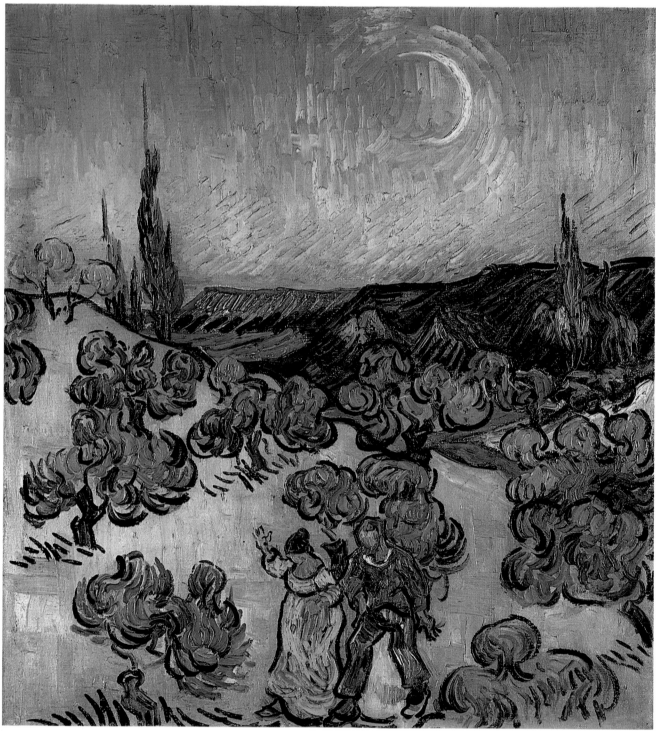

The combination of two figures of lovers and a crescent moon can be found in the fourth and last picture of the Poet's Garden series (F485), painted in October 1888 for Gauguin's room in the Yellow House in Arles. There, however, the lovers walk amid cypresses; here they are among olive trees, with a few cypresses in the background. In the distance, the unusually flattened Alpilles are akin to those in *Road with Cypress and Star* (cat. 55). Thematically, the painting could be called a memory of the South, a conflation of images van Gogh had used in Arles as well as in Saint-Rémy. In this respect, it would seem to be parallel in mode to *Road with Cypress and Star*, a variation on a shared clutch of ideas and symbols.

55. Road with Cypress and Star

Oil on canvas, 36¼ × 28¾ in. (92 × 73 cm.)
Unsigned
Rijksmuseum Kröller-Müller, Otterlo

F683 H695 JH1982

Van Gogh's persistent preoccupation with the cypress in June 1889 (see cat. 15) did not lead to the series he intended. Apart from copies and reworkings of two June paintings (cat. 19, fig. 15; cat. 26), only a few drawings resulted (e.g., F1539r).

It was not until May 1890 that he returned fully to the cypress motif in one of his last pictures from Saint-Rémy. Describing it some five weeks later in the draft of a letter sent to Gauguin from Auvers, he wrote: "I still have a cypress with a star from down there, a last attempt—a night sky with a moon without radiance, the slender crescent barely emerging from the opaque shadow cast by the earth—one star with an exaggerated brilliance, if you like, a soft brilliance of pink and green in the ultramarine sky, across which some clouds are hurrying. Below, a road bordered with tall yellow canes, behind these the blue Alpines, an old inn with yellow lighted windows, and a very tall cypress, very straight, very somber.

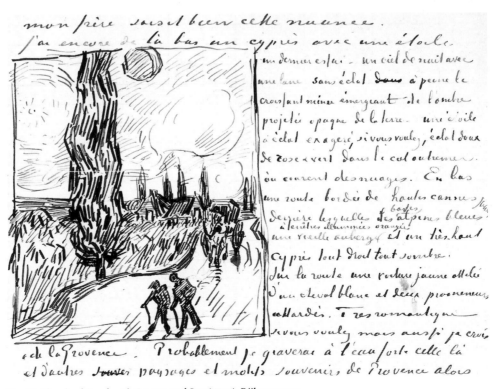

Fig. 47. Sketch of *Road with Cypress and Star* (LT643). Rijksmuseum Vincent van Gogh (Vincent van Gogh Foundation), Amsterdam

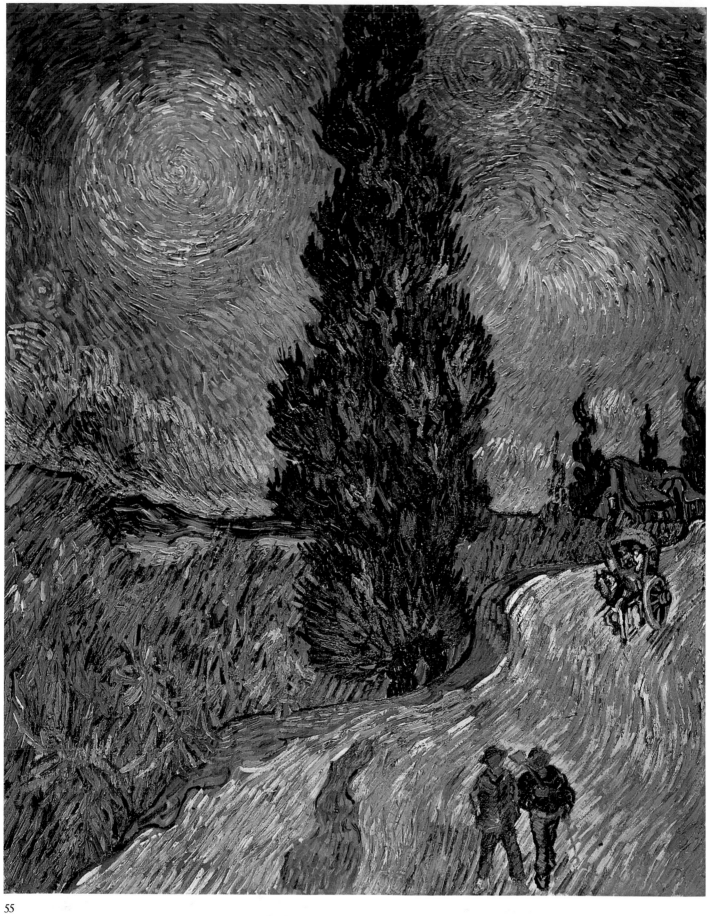

55

On the road, a yellow cart with a white horse in harness, and two late wayfarers. Very romantic, if you like, but also *Provence*, I think" (LT643).

A comparison between the sketch (fig. 47) and the painting shows obvious discrepancies. Van Gogh did the sketch from memory, since the painting was still in Saint-Rémy at the time, arriving in Auvers only after the sketch had been dispatched to Gauguin. He was, in fact, recalling a composition he had painted some six weeks earlier. Nonetheless, it is unlikely that he would have produced so inaccurate a memory drawing. Another possibility is that the drawing was a reasonably accurate rendition of the painting as it was originally done in Saint-Rémy, and that a radical repainting and consequent restructuring of the composition took place after the picture arrived in Auvers. X-rays taken in 1980 do in fact show modifications (e.g., in the two figures), but they fail to provide conclusive evidence. The theory that one of van Gogh's last Saint-Rémy paintings was retouched quite fundamentally in Auvers cannot therefore be sustained.

The image is a composite. In part, it is an echo of the Metropolitan painting (cat. 15) in the conjunction of cypress and crescent moon. Other elements relate to the sequence of drawings that van Gogh called "memories of the North," which he undertook during his long illness in March and April. Among these are one drawing of figures with a carriage on a road (fig. 48) and another of a Northern thatched cottage with cypresses and peasants (fig. 49). Compositionally, the painting is as unreal and artificial as the *Starry Night* (cat. 14). This is evident in the way the curving road is seen from above, a vantage point that does not exist in the actual landscape.

Road with Cypress and Star represents an exalted experience of reality, a conflation of North and South, what both van Gogh and Gauguin referred to as an "abstraction," the Saint-Rémy equivalent of the Arles *Memory of the Garden at Etten* (F496). This is surely what van Gogh had in mind when he called it "a last attempt": it is a last attempt to produce the kind of painting of the imagination that Gauguin had encouraged him to try when the two artists were together in Arles.

Fig. 48. *Carriage with Two Figures on a Road* (F1589r). Black chalk, 11¼ x 9¼ in. (28.5 x 23.5 cm.). Rijksmuseum Vincent van Gogh (Vincent van Gogh Foundation), Amsterdam

Fig. 49. *Thatched Cottage with Cypresses and Peasants* (F1593r). Pencil, 12⅝ x 9½ in. (31.5 x 23.5 cm.). Rijksmuseum Vincent van Gogh (Vincent van Gogh Foundation), Amsterdam

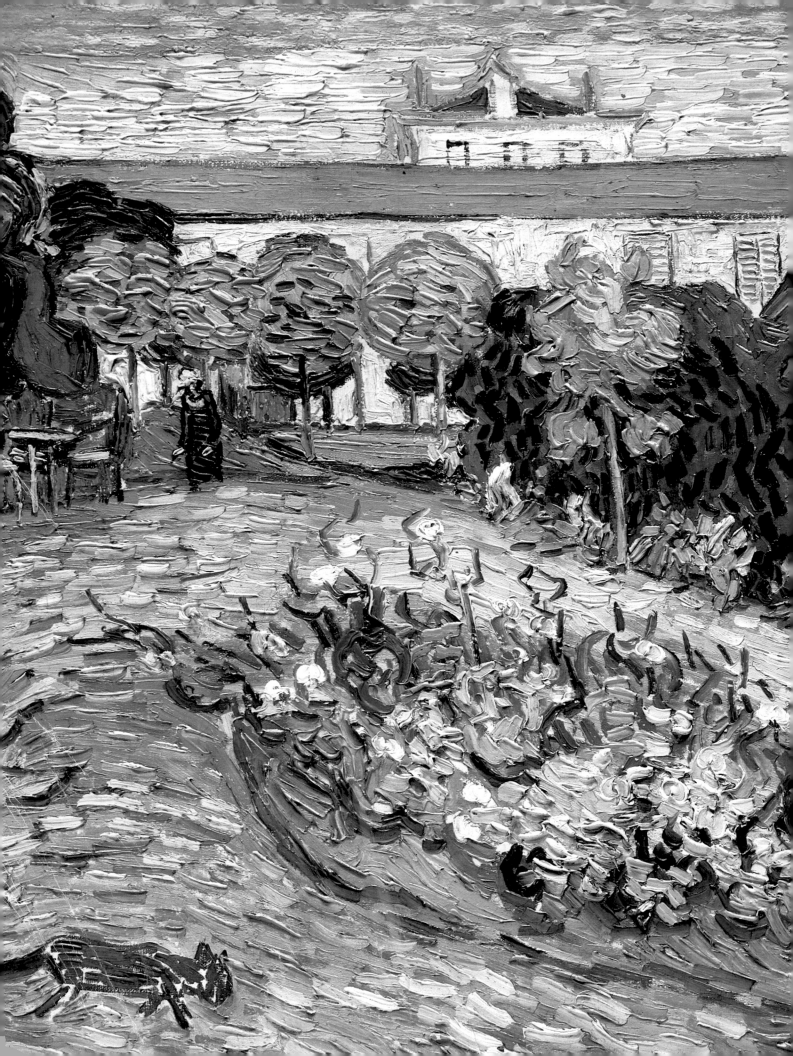

AUVERS

Daubigny's Garden (cat. 84), detail

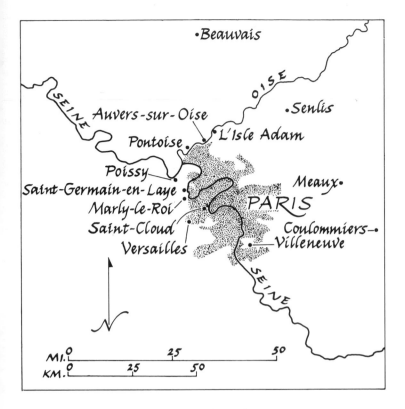

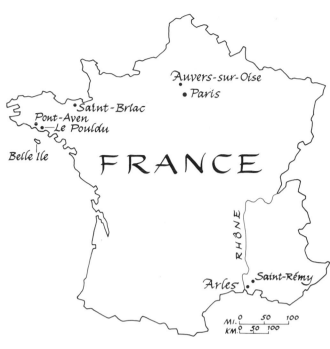

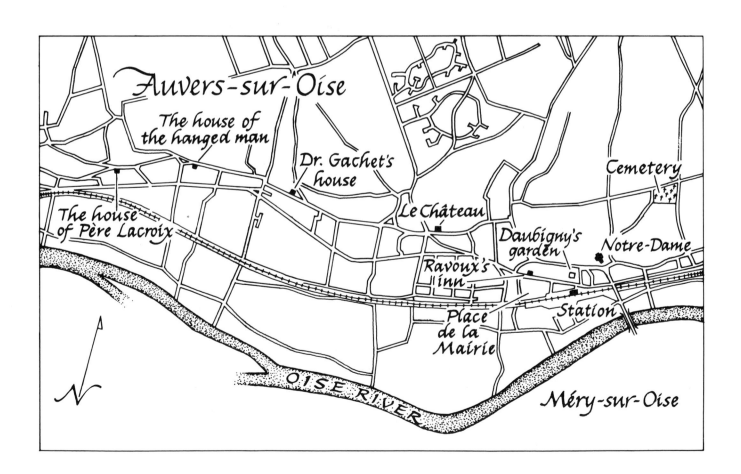

AUVERS-SUR-OISE

"All length, lying along the Oise like a lizard that basks in the sun, set against a long ridge of rocks eaten into by stone quarries, Auvers-sur-Oise…extends to some eight or ten kilometers. A large town, with more than two thousand inhabitants in the winter and three thousand each summer, it has nonetheless the general aspect of a small village, thanks to its being spread out.…Without counting the robust population of stone quarriers and of those women who make 'quarries of mushrooms,' what interesting things! You will go to see 'the house of the hanged man,' where one morning a peasant was found dead by his own hand, and of which the painter Paul Cézanne, who lived some time in Auvers, made a striking study [now in the Musée d'Orsay, Paris]."

It was Paul Alexis, an old friend of Cézanne's, who wrote this during a two-month sojourn at a small inn run by the New York-born George Saunders and his French wife; the article appeared in the newspaper *Le Cri du Peuple* on 15 August 1887. Alexis continued: "And what an interesting artistic colony at Auvers-sur-Oise. Here, first of all, is M. [Eugène] Murer, talented novelist…who owns a marvelous collection of impressionist paintings of the best period by Monet, Sisley, Pissarro, Paul Cézanne, Renoir.…

"Immediately after M. Murer's collection must be placed that of Dr. Gachet [see cat. 61, 62], himself an artist during his free moments, one of the liveliest and most sympathetically original of men. Always on the move, with an extraordinary activity, he has several things on hand at once: his consultations [in Paris], and his painting in Auvers, homeopathy and allopathy, literature and angling, boating—without counting the education of his attractive children, 'M. Coco' and 'the two stupid creatures.'

"During his free moments, he invented a marvelous water, the elixir of Dr. Gachet, which cures all kinds of illnesses, a panacea for men and even for beasts: sprains, cuts, open wounds, etc. And he does not sell his water, he gives it away. He has inundated the village with it, where, as you may imagine, he is immensely popular."

Alexis then cited other artists, among them the French engraver Paul-Adolphe Rajon (1843–1888) and a Cuban-born painter, Martinez, a friend of Camille Pissarro's. He also noted that for two or three summers, Ernest Hoschedé, "ex-millionaire collector" of Impressionist paintings and now an art critic, had lived in Auvers.

Auvers-sur-Oise, some twenty miles from Paris, was "discovered" by the Barbizon painter Charles-François Daubigny (see cat. 84). In 1861, he had a large house and studio built in the center of the village, and there he lived until his death in 1878. Although the railroad was extended to Auvers as early as 1846, it was still "real country," as van Gogh described it, in the 1880s. Other artists followed Daubigny.

Dr. Paul-Ferdinand Gachet moved to Auvers in 1872. Cézanne painted there from 1872 to 1874, and again in 1880 and 1881. And Eugène Murer (1845 – 1906) built a large house there in 1879.

By the 1880s, the number of resident artists had increased. Among them were two Americans, Charles Sprague Pearce (1851–1914) and Robert John Wickenden (b. 1861). In June 1890, van Gogh told his mother: "There are quite a number of painters in this village—next door a whole family of Americans, who are painting away day after day, but I have not seen anything of their work yet—well, as a rule it is far too much below par" (LT641a).

CHRONOLOGY

Auvers-sur-Oise, 20 May–29 July 1890

Tuesday 20 May

Van Gogh leaves Paris for Auvers-sur-Oise, taking with him four Saint-Rémy canvases—*Self-Portrait* (cat. 22, fig. 19), *L'Arlésienne* (F540?), *Pietà* (F630), and probably *Prisoners' Round* (F669)—and also Theo's letter of introduction to Dr. Gachet.

When he meets Dr. Gachet he gets the impression that he is "rather eccentric, but his experience as a doctor must keep him balanced enough to combat the nervous trouble from which he certainly seems to me to be suffering at least as seriously as I." Gachet's house "is full of black antiques, black, black, black, except for the impressionist pictures"—"a *very* fine Pissarro, winter with a red house in the snow [*Chestnut Trees at Louveciennes*, 1869–70], and two fine flower pieces by Cézanne [*Geraniums and Coreopsis in a Small Delft Vase*, 1873; *Bouquet in a Small Delft Vase*, 1873]. Also another Cézanne, of the village [*Dr. Gachet's House*, 1873]." Gachet takes him to an inn, the Café-Auberge Saint-Aubin in the Rue Rémy, where the charge is six francs a day. Van Gogh thinks this excessive and finds one for himself at three-fifty a day. Situated in the Place de la Mairie, opposite the town hall, this small

Camille Pissarro. *Chestnut Trees at Louveciennes,* 1869–70.
Oil on canvas, 16⅛ x 21¼ in. (41 x 54 cm.). Musée d'Orsay, Paris

Paul Cézanne. *Geraniums and Coreopsis in a Small Delft Vase*, 1873.
Oil on canvas, 20½ x 15⅜ in. (52 x 39 cm.). Collection Bernheim Jeune, Paris

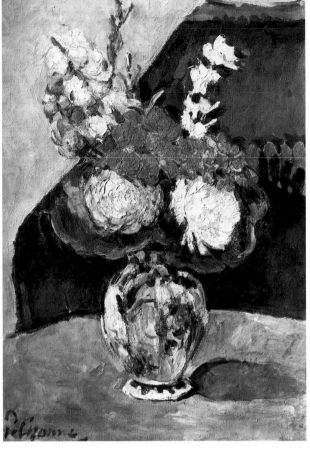

Paul Cézanne. *Bouquet in a Small Delft Vase*, 1873. Oil on canvas,
16⅛ x 10⅝ in. (41 x 27 cm.). Musée d'Orsay, Paris

inn is run by Arthur-Gustave Ravoux, who had come to Auvers from Paris some two years earlier. He is married and has two daughters, aged twelve and one. Van Gogh rents an attic room.

"Auvers is very beautiful, among other things a lot of old thatched roofs, which are getting rare...really it is profoundly beautiful, it is the real country, characteristic and picturesque," he enthuses to Theo and Jo (LT635), reporting on his first day in Auvers.

He also begins a letter to Wil (W21), apologizing for not having answered her letter from Saint-Rémy. It was a great joy for him to see Theo, Jo, and the baby: "Jo made an excellent impression on me; she is charming and very simple and brave." Too much noise and bustle in Paris has driven him to the old village of Auvers, where there are "superb moss-covered thatched roofs." After describing some of his last works at Saint-Rémy, he speaks of his visit to the exhibition at the Champ de Mars, where

there were many things he liked very much. (The letter ends abruptly at this point.)

He has not yet done any painting or drawing (LT636).

Wednesday 21 May

Vincent writes again to Theo and Jo (LT636). He has completed his first picture, "a study of old thatched roofs with a field of peas in flower in the foreground and some wheat, background of hills [cat. 56, fig. 50]." He asks Theo to send money by the end of the week, also 10 meters of canvas, 20 sheets of Ingres paper ("these I need in *any case* so as not to waste time. There is a lot to draw here"), and Bargue's *Exercices au fusain pour préparer à l'étude de l'académie d'après nature,* which he plans to copy. He calls on Dr. Gachet, who is not at home (he has consultations in Paris three days a week). "I can do nothing about my disease. I am suffering a little just now—the thing is that after that long seclusion the days seem like weeks to me. I felt that in Paris and here too, but serenity will come as my work gets on a bit." He

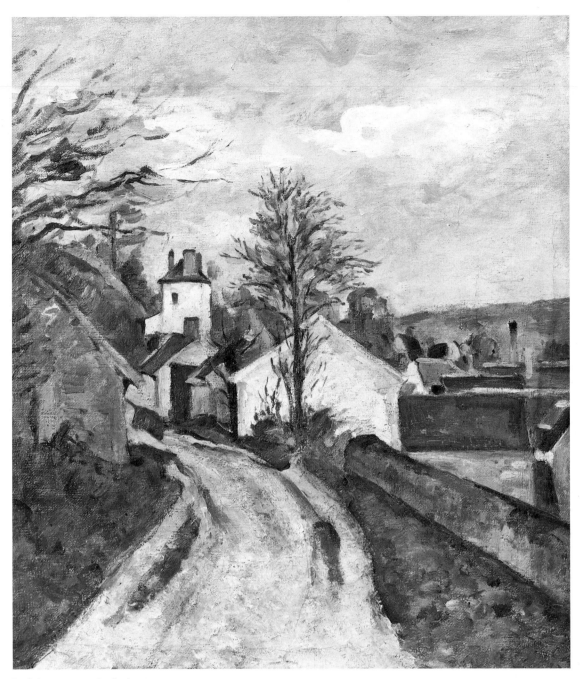

Paul Cézanne. *Dr. Gachet's House*, 1873.
Oil on canvas, 18⅛ x 14¾ in. (46 x 37.5 cm.).
Musée d'Orsay, Paris

very much hopes that Theo and Jo will come to visit him soon.

Friday 23 May

Vincent writes a third letter to Theo and Jo (LT648). This time the tone is pessimistic and critical, accusatory and suspicious. He expresses surprise that he has not yet heard from his brother, and reminds him that he left Paris in confusion, without any firm financial arrange-

ments having been agreed upon. He wonders if his allowance is to be 150 francs a month paid in three installments, as it was in Arles. From his brief stay in Paris, he feels that Theo, Jo, and the child are "a little on edge and worn out," and thinks that the "three-month-old" baby should be raised in the country. "Since you were good enough to name him after me, I should like him to have a soul less unquiet than mine, which is foundering." He therefore advises them to consider spending the month of their vacation in the country at Auvers instead of in

Ravoux's inn, Auvers-sur-Oise, 1890. Rijksmuseum Vincent van Gogh
(Vincent van Gogh Foundation), Amsterdam

Photograph of Arthur-Gustave Ravoux, c. 1910. Rijksmuseum
Vincent van Gogh (Vincent van Gogh Foundation), Amsterdam

Holland ("I fear that the journey to Holland will be the last straw for us all"). He confesses that he too was distraught in Paris. But now he is well and working hard; he has finished four painted studies (cat. 56, fig. 50; F751, F752, and probably F794) and two drawings (cat. 56, 57), one of them "an old vineyard with a figure of a peasant woman." He feels that "we must not count on Dr. Gachet *at all*. First of all, he is sicker than I am, I think, or shall we say just as much." He is also concerned that his paintings and especially those by other artists belonging to himself and Theo are going to ruin in Tanguy's "bed-bug-infested hole" (which Theo had rented specifically to store them in). He might get a lodging, "three rooms at 150 francs a year," which could also serve as a more suitable space for all the paintings at Tanguy's—including his own, which he could then retouch. He hopes they will see each other again "more calmly…with more collected minds," and that Theo will write by return mail.

Dr. Gachet possibly visits Theo at his gallery, before or after his afternoon consultations.

Saturday 24 May

Theo writes his first letter to Auvers, replying to Vincent's letter of 23 May and enclosing 50 francs. (The letter is

lost, but some of its contents can be inferred.) He promises to send the canvas and Ingres paper requested on 21 May. He reminds Vincent that their mother will insist on seeing "the little one," and that the family must therefore spend their vacation in Holland rather than in Auvers. He reports that the Belgian painter Anna Boch (1848–1933) has bought one of Vincent's pictures, and that Gauguin has seen his *Arlésienne* (F543).

Van Gogh drafts a letter to Isaäcson (LT614a), telling him that he has recently read in Paris the continuation of his articles on Impressionism in *De Portefeuille*. While praising Isaäcson's conscientious attempt to inform his Dutch readers of what is happening in Paris, he warns him: "As it is possible that in your next article you will put in a few words about me, I will repeat my scruples, so that you will not go beyond a *few* words, because it is *absolutely certain* that I shall never do important things." His real reason for this letter is to describe at length his own series of paintings of olive groves. He also argues that Puvis de Chavannes has the same importance as Delacroix, and he describes the picture he saw the previous Sunday at the Champ de Mars. "[If] Millet is the voice of the wheat, and Jules Breton too," then Puvis de Chavannes may one day "explain the olive trees to us."

Possibly he paints the *House of Père Pilon* (cat. 59). The weather in Auvers is "wet and stormy."

Sunday 25 May

Again it is wet and stormy in Auvers. Van Gogh sends a telegram to Saint-Rémy about his trunk, which has not yet arrived. He receives Theo's letter. He lunches with Dr. Gachet—evidently for the first time—and afterward (according to Gachet's son) does the etched portrait of him (cat. 61). In the evening he writes to Theo (LT637), still hoping that Theo and Jo will decide "to take a rest in the country instead of the customary journey to Holland." He is intrigued as to which painting Anna Boch has bought and says he must write to her brother, the artist Eugène-Guillaume Boch (whose portrait he had painted in Arles, F462), suggesting the exchange of two of his studies for one each of theirs. He tells Theo again of his drawing of an old vineyard (cat. 57), "of which I intend to make a size 30 canvas" (no such large canvas of this motif exists), and of two paintings of chestnuts (F751, F752). But he hopes to work on the figure a little; already "some pictures are vaguely present in my mind—it will take time to get them clear, but that will come little by little." He encloses a letter for Isaäcson (now lost), based on the previous day's draft.

Theo, Jo, and the baby visit Saint-Cloud. According to Theo (T35) they were "overtaken by a cloudburst such as I have never seen. The café where we took refuge was

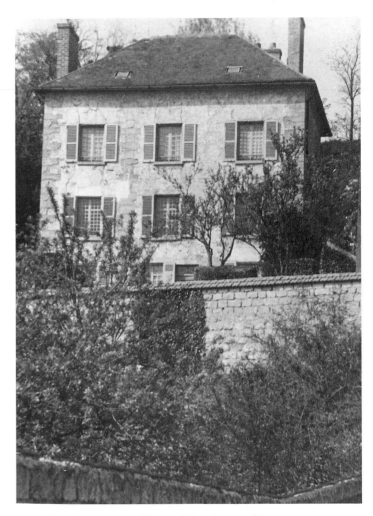

Dr. Gachet's house, c. 1935. Photograph by John Rewald

flooded; there was a foot of water. This and the hurry and jostling at night to catch the train [it was Whitsunday] made us uneasy [about the baby], but all he had was a severe cold in the head, and Jo had nothing wrong with her, though her milk might have been spoiled—this may be caused by wet feet."

Tuesday 27 May

Van Gogh paints at Dr. Gachet's house in the morning, finishing a study of the garden (F755), and then lunches with Gachet and his family. In the afternoon Gachet goes to Ravoux's inn to look at van Gogh's paintings, including the four Saint-Rémy canvases brought from Paris.

An exhibition of the work of Jean-François Raffaëlli opens at Theo's gallery at 19 Boulevard Montmartre.

Wednesday 28–Saturday 31 May

There is no evidence of van Gogh's activities, or of what he paints or draws.

Title page of the catalogue of the Jean-François Raffaëlli exhibition, Boussod & Valadon, 19 Boulevard Montmartre, Paris, May–June 1890

Sunday 1 June

Van Gogh again visits Dr. Gachet's house, where he paints another view of the garden, with "some white roses, vines and a white figure [Dr. Gachet's daughter, Marguerite; F756]," which he presents to Gachet, together with the first garden picture which he had painted on 27 May (LT638). He almost certainly begins work on a portrait of Dr. Gachet (cat. 62).

Monday 2 June

Theo writes to Vincent (T35), his first letter since 24 May. He has been kept very busy with the Raffaëlli exhibition at his gallery, staying open as late as 10 P.M. He hopes that he, Jo, and the baby will be able to spend some time in Auvers, but insists that "we shall also have to go to see Mother and Jo's parents" in Holland. He describes the torrential cloudburst at Saint-Cloud on Whitsunday and tells Vincent that Dr. Peyron has written (the letter is lost), and that a package from Saint-Rémy which he had sent to Auvers was returned.

Theo also writes to Wil, giving her Vincent's Auvers address. "In his last letter he very much insisted that we should go to Auvers instead of Holland. If possible we would like to do both, but it is a matter of time and money. Auvers is not expensive, but I should need to be able to get at least three weeks' holiday or it would not be worth the trouble. I would very much like to be entirely free from business for a while. When times are busy it is quite pleasant, though" (Hulsker, "What Theo Really Thought of Vincent," p. 22).

Tuesday 3 June

In the morning Theo's letter arrives with a 50 franc note enclosed. Vincent replies (LT638), addressing his letter, for the first time from Auvers, to Theo alone. Just as Theo has not written since 24 May, so Vincent has not written since 25 May. He therefore explains: "Already for several days I have been wanting to write you collectedly [à tête reposée], but I've been absorbed by work." Writing his longest and most considered letter to date, dominated by his views of Dr. Gachet, he discourses at length on the man, the doctor, the friend. He describes the house, which is "full, full like an antiques dealer's...there is always something for arranging flowers in or for a still life"; his lunches and dinners, "rather a burden for me...for the good soul takes the trouble to have four—or five—course dinners...as dreadful for him as for me, since he certainly hasn't a strong digestion"; and his garden, the two studies of which (F755, F756) were done "to show him that if it is not a case for which he is paid in money, we will still compensate him for what he does for us." Above all, he has done Gachet's portrait (cat. 62); he adds a thumbnail sketch to his description. The doctor is "absolutely *fanatical*" about the *Self-Portrait* (cat. 22, fig. 19): "He has now got so far as to understand the last portrait of the Arlésienne...he always comes back to these two portraits when he comes to see the studies, and he understands them exactly, exactly, I tell you, as they are." Dr. Gachet also looked at the *Pietà* (F630) for a long time, and asked to have a copy made for him. He may help Vincent find models, and also get him portrait commissions. Vincent is hoping to do a portrait of Gachet's daughter, Marguerite, "with whom I imagine Jo would soon be friends."

"Desmoulins [Dumoulin], the man who has some Japanese pictures at the Champ de Mars, has come back here and I hope to meet him." He asks Theo what Gauguin thought of the last portrait of the Arlésienne (F543)

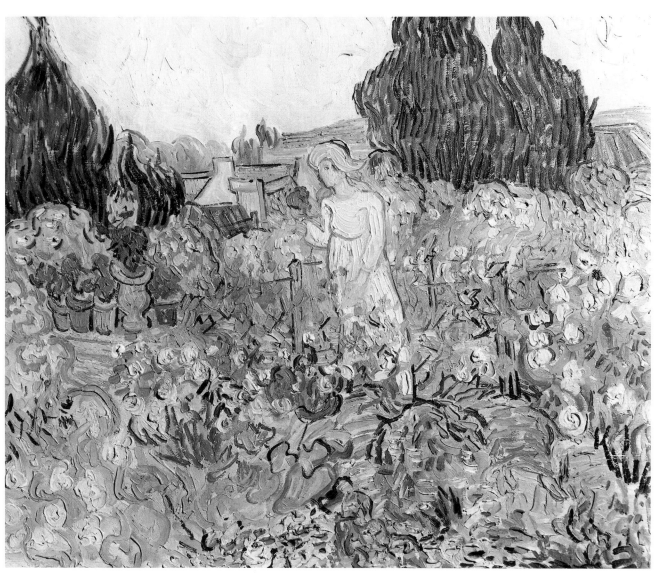

Marguerite Gachet in the Garden (F756). Oil on canvas, 18⅛ x 21⅝ in. (46 x 55 cm.). Musée d'Orsay, Paris

203

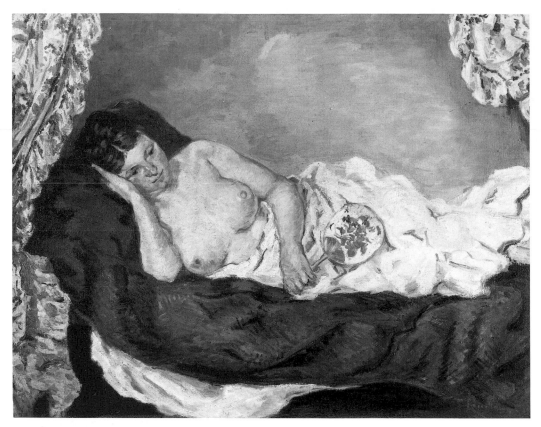

Armand Guillaumin. *Nude Woman on a Bed*, c. 1874. Oil on canvas, 19¼ x 25⅝ in. (48.9 x 65.1 cm.). Musée d'Orsay, Paris

—his first mention of Gauguin since arriving in Auvers. "Gachet has a Guillaumin, a nude woman on a bed, that I think very fine; he also has a very old self-portrait by Guillaumin, very different from ours, dark but interesting."

He has not yet found a studio to which the paintings stored at Tanguy's could be transferred—"I must still touch them up a lot." But he is "living one day at a time; the weather is so beautiful. And I am well. I go to bed at nine o'clock, but get up at five most of the time." He hopes that "this feeling I have of being much more master of my brush than before I went to Arles will last. And M. Gachet says that he thinks it most improbable that it [the illness] will return, and [thinks] that things are going on quite well."

As soon as possible, he would like twelve tubes of zinc white and two tubes of geranium lake from Tasset. And he again asks for Bargue's *Exercices au fusain,* so that he can copy the sixty sheets of nude figures: "If I neglect to study proportion and the nude again, I should be badly muddled later on." He is greatly touched by Dr. Peyron's asking after him; he will write to him this evening.

He possibly paints the *Church at Auvers* (F789); the fall of the shadows suggests early evening.

Wednesday 4 June

Van Gogh writes to Dr. Peyron (the letter is lost). And he composes his first letter to his mother from Auvers (LT639). Recalling his last days in Saint-Rémy and his three-day stay in Paris with Theo and Jo, he goes on to tell her that he has written to Dr. Peyron "today." He speaks kindly of Dr. Gachet, whose care and hospitality he can repay in pictures. He very much hopes that Theo and Jo will spend a few days in Auvers during their coming vacation, before going to Holland.

He also writes to Wil (W22), abandoning the draft he had written on 20 May (W21), but not destroying it. This is his first letter to Wil since leaving Saint-Rémy. He sends news of Theo, Jo, and the baby, and says how pleased he was to see Jo's brother, Andries Bonger, in Paris. He calls Dr. Gachet "a true friend...something like another brother, so much do we resemble each other physically and also mentally.... I painted his portrait the other day, and I am also going to paint a portrait of his daughter, who is nineteen years old [she is actually twenty]."

He describes his two garden pictures (F755, F756) and "a larger picture of the village church [F789]—an effect in which the building appears to be violet-hued against a sky of a simple deep blue color of pure cobalt; the

stained-glass windows appear as ultramarine blobs; the roof is violet and partly orange. In the foreground a little greenery with flowers and a sanded path, rendered pink in the sunshine. It is once again almost the same thing as the studies I did in Nuenen of the old tower and the cemetery [e.g., F84], only now the color is probably more expressive and more sumptuous."

He goes on to tell Wil how he worked "like a man in a frenzy" during his last two weeks in Saint-Rémy, "especially on bunches of flowers, roses [cat. 53; cat. 53, fig. 46] and violet irises [cat. 51, 52]." His picture of almond blossoms, painted for his nephew (cat. 49), now hangs over the piano in Theo and Jo's apartment. He confesses his passion for the modern portrait, citing in detail the *Portrait of Dr. Gachet, L'Arlésienne,* and the *Self-Portrait.* And he repeats to Wil what he wrote to Isaäcson about the "superb" picture by Puvis de Chavannes at the Salon du Champs de Mars, which he sketches, inaccurately, from memory.

Dr. Gachet visits Theo at his Paris gallery and says he thinks Vincent is entirely recovered and sees no reason for a return of the attacks. He invites Theo and his family to visit him the following Sunday in Auvers.

Thursday 5 June

Theo tells Vincent (T36) of Dr. Gachet's visit to his gallery, and says that he and Jo hope to come to Auvers next Sunday. However, this will depend on the health of the baby, who has been "upset" since the Whitsun visit to Saint-Cloud. He tells him too that Guillaumin "has placed at your disposal a magnificent picture of a sunset which he had at Tanguy's. It will show to great advantage in your studio." The Neo-Impressionist painter Léo Gausson (1860–1944) would like to make an exchange of pictures. Aurier is "delighted with your picture of cypresses [cat. 19, fig. 15]," and intends to accompany Theo to Auvers one Sunday.

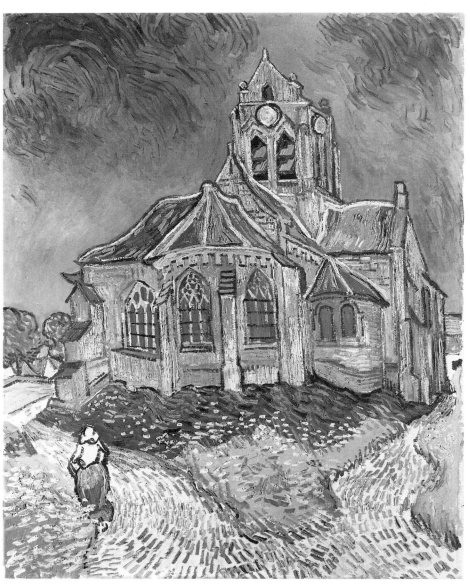

The Church at Auvers (F789). Oil on canvas, 37 x 29⅛ in. (94 x 74 cm.). Musée d'Orsay, Paris

205

Friday 6 June

Theo's letter of 5 June arrives.

Theo sends off Tasset's paints and Bargue's *Exercices au fusain*.

Saturday 7 June

According to Paul Gachet *fils*, van Gogh begins a second portrait of Dr. Gachet (F754) on 5 or 6 June, probably without the model, and finishes it, with the model, at Gachet's house on Saturday 7 June. He also paints a small canvas of acacias which he has noticed in the garden (F821; Tralbaut, pp. 312, 314).

Sunday 8 June

Theo and Jo decide to accept Dr. Gachet's invitation to visit Auvers. They leave Paris by the 10:25 A.M. train and arrive at Chaponval, a small hamlet west of Auvers, at 11:26. Jo recalled the visit in 1913: "Vincent came to meet us at the train, and he brought a bird's nest as a plaything for his little nephew and namesake. He insisted upon carrying the baby himself and had no rest until he had shown him all the animals in the yard." Vincent himself reported to his mother soon after (LT641a): "My little namesake made the acquaintance of the animal world for the first time, for at that house there are eight cats, eight dogs, besides chickens, rabbits, ducks, pigeons, etc., in great numbers."

After lunch in Dr. Gachet's garden, they all take a long walk. Theo talks to Vincent about his Raffaëlli exhibition, especially his arrangement of the drawings on cretonne. Presumably, they go to Ravoux's inn, where Vincent shows him some of his recent paintings, perhaps the *Church at Auvers*, although there is no evidence that they actually go there. "The day was so peacefully quiet, so happy," recalled Jo (*The Complete Letters*, pp. li, lii).

Theo and Jo return to Paris on the 5:58 P.M. train.

Tuesday 10 June

Vincent writes to Theo and Jo (LT640): "Sunday has left me a very pleasant memory; in this way we feel that we are not so far from one another, and I hope that we shall often see each other again. Since Sunday I have done two studies of houses among the trees [probably cat. 63 and F792].

"A whole colony of Americans has just established itself next door to the house where I am; they are painting, but I have not yet seen what they are doing." This prompts Vincent to raise again the question of renting a house. "Here [at Ravoux's], I pay 1 franc a day for sleeping, so *if I had my furniture*, the difference between 365 francs and 400 would be no great matter, I think, and then I should

very much like you two to have a pied à terre in the country along with me. But I am beginning to think that I must consider the furniture lost." He has, however, just written to Madame Ginoux for the third time about his furniture. Coincidentally, Madame Ginoux herself writes to van Gogh this same day.

About his health, he writes: "It is odd that here the nightmares have ceased to such an extent; I always told M. Peyron that returning to the North would free me from it, but it is also odd that under his direction, though he is very capable and certainly wished me well, it was somewhat aggravated."

He returns to the problem of his paintings that are stored in Tanguy's attic. He wants Tanguy "to set to work instantly, taking the nails out of all the canvases that are on stretchers," then to roll the canvases and pack the stretchers and send them to the railroad station at Pontoise, where he will arrange for the Auvers porter to collect them. He also adds that he saw at Theo's apartment "in a heap under the bed a lot I can touch up, I think, to advantage." He regrets not seeing Theo's Raffaëlli exhibition. One day he believes that he will find the means of organizing his own exhibition in a Paris café—adding that he would not mind exhibiting with the poster artist Jules Chéret (1836–1932), three of whose posters Theo had exhibited in his gallery in April 1888. This is the only mention in the Auvers correspondence of van Gogh's wishing to exhibit his work.

Wednesday 11 June

Van Gogh probably works on a painting of vineyards (cat. 64), which Dr. Gachet admires.

Thursday 12 June

He receives Madame Ginoux's letter of 10 June, telling him that his furniture will be sent off from Arles on Saturday, and replies immediately (LT640a). He regrets that he was not able to say good-bye in Arles, but during the last months in Saint-Rémy, "I caught the other patients' disease more than curing my own. The society of the other patients had a bad influence on me." He explains that he therefore moved north, where "the doctor says that I ought to throw myself into my work with all my strength, and so distract my mind. This gentleman knows a good deal about painting, and he greatly likes mine; he strongly encourages me, and two or three times a week he comes to spend a few hours with me to see what I am doing." Articles have been written about his pictures—in Paris, Brussels, and Holland—"and this means that many people have been to see my pictures and that I have sold some on the best terms. And this is not the end of it. Besides, it is certain that since I stopped drinking I have done better work than before, and that is so much gained."

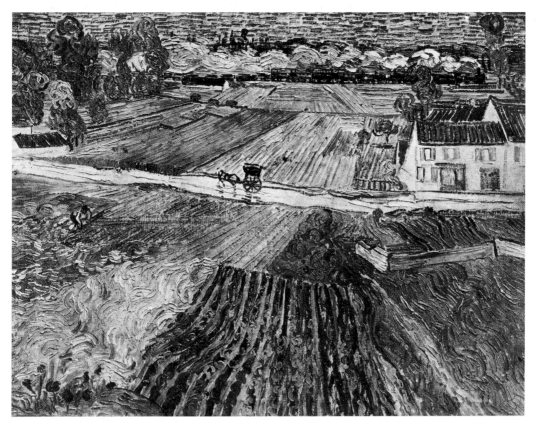

Landscape with Carriage and Train in the Background (F760).
Oil on canvas, 28⅜ x 35⅜ in. (72 x 90 cm.). Pushkin State
Museum of Fine Arts, Moscow

Day of rain showers. Van Gogh works on a size 30 canvas (F760), which he describes in a letter the following day to Wil (W23): "Yesterday in the rain [*dans la pluie*, not *dans la place*, "in the square," as it has previously been transcribed and translated], I painted a large landscape in which one sees fields as far as the eye can reach, viewed from a height. Different kinds of green growth, a somber green field of potatoes, between the regular beds the earth rich and violet, a field of peas in white bloom to one side, a field of alfalfa with pink flowers and the small figure of a mower, a field of long and ripe grass of a fawn color, then wheat fields, poplars, a last line of blue hills on the horizon, below which a train is passing, leaving behind it in the green vegetation an immense trail of white smoke. A white road crosses the canvas. On the road a little carriage, and some white houses with harsh red roofs by the side of this road. A drizzle streaks the whole with blue and gray lines." The motif depicts a view taken quite near Dr. Gachet's house, suggesting that van Gogh may have seen his friend during the day.

Friday 13 June

Van Gogh writes to his mother (LT641a), recalling Nuenen "as through a looking glass darkly," and contrasting past and present, family and isolation, art and life. His work, even though it is little understood, is for him "the only link between the past and the present." He says there are a number of painters in the village, and mentions the family of Americans next door, as he had in his letter of 10 June to Theo and Jo: "I have not seen anything of their work yet—well, as a rule, it is far too much below par. Last Sunday Theo, his wife and their child were here, and we lunched at Dr. Gachet's.... For me, it is a very reassuring feeling to be living so much nearer to them."

Having written to his mother, he adds a two-page letter to Wil (W23): "I am working a good deal and quickly these days; in so doing, I seek to express the desperately swift passing away of things in modern life." He then describes three of his recently completed landscapes (cat. 64, 65; F760), returns to his portrait of Dr. Gachet, and speaks of his desire to paint portraits, including someday one of Wil herself.

Gauguin, still in Paris, writes to Theo about an arrangement he hopes to make with a certain Dr. Charlopin, an inventor who has exhibited at the Paris World's Fair. Dr. Charlopin has sold a patent, but may not receive any money for a month or two. For thirty-eight of his paintings, of which fourteen are at Theo's gallery, and five of his ceramic pots, Gauguin expects to be paid 5,000

francs. He will then go to Madagascar and "buy a small mud hut there and enlarge it myself, industrious sculptor that I am. I shall live like a barbarian peasant. Without worries about money, I shall be able to work there at my art as I have not yet ever been able to do" (Rewald, *Post-Impressionism*, p. 360). Gauguin tells Theo that he is leaving for Brittany the next day, and he encloses a letter for van Gogh (GAC41), the first contact between the two artists since Vincent's last weeks in Saint-Rémy (GAC40).

Saturday 14 June

Gauguin leaves Paris for Le Pouldu in Brittany, accompanied by Meijer de Haan.

Lauzet visits Theo to look at van Gogh's pictures, and admires "the portrait of the woman that you did in Arles [*L'Arlésienne*, F543]."

Vincent writes to Theo (LT641). He has heard from the Ginoux that his furniture is being sent. He encloses an order for some paints, and describes, briefly, his recently completed size 30 canvas—"some fields seen from a height, with a road and a little carriage on it [F760]"—which he compares in style to one of his major paintings from Arles, the *Harvest (Blue Cart)* (F412), "which is in your room where the piano is." At the moment he is working on "a field of poppies in alfalfa [cat. 66]." Dr. Gachet very much liked a vineyard study (cat. 64) "the last time he came to see me."

Sunday 15 June

Van Gogh probably lunches at Dr. Gachet's house. He is likely working on a study of wheat (F767).

Theo writes his first letter to Vincent since visiting Auvers the previous Sunday. The letter (T37) does not address Vincent's suggestions that they rent a house together in Auvers and that Tanguy take the canvases off their stretchers. But Theo does write: "It will be much easier for you when your furniture has arrived, for then you might be able to get a comrade to stay with you too. There is a Dutchman who is going to call on you; he was recommended by de Bock [the artist Théophile Émile Achille de Bock, 1851–1904], who has advised him to go to Fontainebleau, but he doesn't like it. I don't know if he has any talent; he had nothing to show me." He tells Vincent of Lauzet's visit the day before, and of Gauguin's plans to go to Madagascar (which he refers to as Martinique), which depend on a payment to be made to an inventor (Dr. Charlopin) and then to Gauguin, and are therefore uncertain. "Staying with Schuffenecker [Émile Schuffenecker, 1851–1934] doesn't do him any good; he is hardly doing any work, whereas Brittany inspires him. So it is right that he should go away." He encloses Gauguin's letter (GAC41). Tasset's paints are being sent off. Jo sends her greetings; "she is a little indisposed, but I hope it is nothing serious."

Monday 16 June

The Dutch artist Antonius (Anton) Matthias Hirschig (1867–1939) arrives in Auvers and takes a room—the attic room adjacent to van Gogh's—at Ravoux's inn.

Vincent receives Theo's letter of 15 June and the enclosed letter from Gauguin. Gauguin writes that Vincent's last letter from Saint-Rémy gave him the impression that the "return to the North" had meant a return to Holland, and he had been awaiting the new address. "I have seen the canvas of Madame Ginoux [*L'Arlésienne*, F543]. Very beautiful and very curious. I like it better than my drawing [cat. 48, fig. 41]. Despite your illness, you have never worked with as much *equilibrium* while keeping the sensation and the internal heat necessary for a *work of art* just at a period when art is an affair regulated in advance by cold calculations." Gauguin recalls their conversations in Arles about founding a Studio of the Tropics. He is now on the point of executing this plan, if he receives "a small sum necessary to fund the establishment" (he doesn't mention Dr. Charlopin). He intends to go to Madagascar and live simply and self-sufficiently. "Those who later may wish to come there would find all the materials for working at very little cost. And the Studio of the Tropics will form perhaps the Saint John the Baptist of the painting of the future, reinvigorated there by a life more natural, more primitive, and above all less rotten." For the moment, Gauguin is going to Brittany for two months with de Haan. And he hopes that Vincent will recover completely in Auvers.

Van Gogh drafts a reply immediately, and then composes his letter and mails it to Le Pouldu. Only the draft (LT643) survives. In it he thanks Gauguin for having written, and assures him that since he returned north he has thought of him every day. "I stayed in Paris only three days, and the noise, etc., of Paris had such a bad effect on me that I thought it wise for my head's sake to fly to the country; but for that, I should soon have dropped in on you." He is delighted that Gauguin has seen and admired *L'Arlésienne*, and suggests that he "take this work as a work belonging to you and me as a summary of our months of work together."

"Have you seen the olives?" he asks Gauguin, referring to his series of olive orchards. He describes his portrait of Dr. Gachet, and at greater length, with a quick sketch done from memory, a picture of "a cypress with a star [cat. 55]." He plans to etch this and other landscapes as a suite of "memories of Provence."

"Having arrived in Paris a little confused, I have not yet seen your canvases." He is glad that Gauguin is returning

to Brittany with de Haan. "It is very likely that—if you will allow me—I shall go there to join you for a month, to do a marine or two, but especially to see you again and to make de Haan's acquaintance. Then we will try to do something purposeful and serious, such as our work would probably have become if we had been able to carry on down there [in Arles]."

He is at work on a close-up study of wheat (F767), which he discusses at length and illustrates with two rapid thumbnail sketches. It is possible that van Gogh encloses in his letter to Gauguin a proof of his etching of Dr. Gachet (cat. 61).

Tuesday 17 June

Vincent thanks Theo (LT642) for his letter of 15 June and for the 50 franc note enclosed. He had delayed replying until he had received the package of paints and canvas from Tasset, which has just arrived. Discussing the merits of the tube colors of Tasset and Tanguy, he feels that if Tanguy is taking the trouble to send off the canvases stored in his attic, he should be given the next order for paints.

He is pleased to have met "the Dutchman [Hirschig] who came yesterday; he looks much too nice to paint under the present conditions." He thinks Hirschig might find it best to join Gauguin and de Haan in Brittany.

He hopes to do some etchings of "Southern subjects," printing them without cost on Dr. Gachet's press. Gauguin might also make etchings after some of his own canvases, and Theo might serve as publisher. Just as Boussod & Valadon are about to publish Lauzet's lithographs after Monticelli, so this joint Gauguin-Vincent-Gachet-Theo enterprise could be a sequel. "M. Gachet is coming to see my canvases in Paris one day and then we could choose some of them for engraving." He is glad that Gauguin and de Haan are working in Brittany again.

The future of painting is, he believes, in the tropics. Nevertheless, he thinks Gauguin's Madagascar project is almost impossible to put into practice, and he would rather see him go to Tonkin. However, "if [Gauguin] went to Madagascar...I should be capable of following him there, for you must go there in twos or threes. But we aren't that far yet."

He is working on two studies, "one [cat. 67] a bunch of wild plants, thistles, ears of wheat, and sprays of different kinds of leaves—the one almost red, the other bright green, the third turning yellow. The second study [F766] a white house among the trees, with a night sky and an

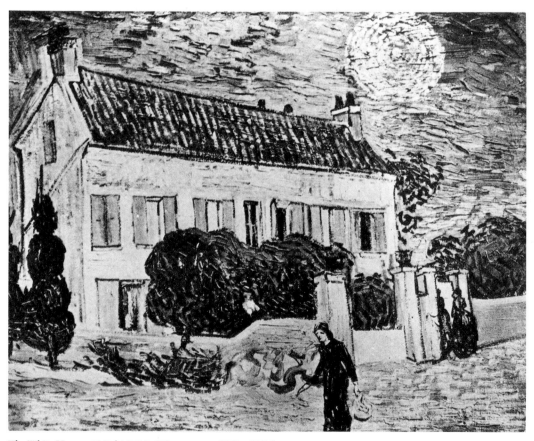

The White House at Night (F766). Oil on canvas, 23⅝ x 28¾ in. (59.5 x 73 cm.). Present location unknown

Luncheon invitation to Vincent van Gogh from Dr. Gachet, 22 June 1890.
Gachet, *Deux Amis des impressionnistes*, fig. 59

orange light in the window and dark greenery and a note of somber pink. That is all for the moment. I am planning to make a more important canvas of Daubigny's house and garden, of which I already have a little study [cat. 84, fig. 67]."

Just as he may have enclosed a proof of his etching of Dr. Gachet to Gauguin on 16 June, so he now probably encloses one to Theo.

Wednesday 18–Saturday 21 June

No letters are exchanged, and van Gogh provides no retrospective account of his activities during these days. Presumably, he sees more of Hirschig and of his work. But it can be inferred (from LT644) that he began, and completed, at least some of the following canvases: "a portrait of a girl of about sixteen, in blue against a blue background [F768], the daughter of the people with whom I am staying. I have given her this portrait, but I did a variant of it for you, a size 15 canvas [F769]." More important, van Gogh launches his series of double-square canvases with three paintings (cat. 78–80).

Sunday 22 June

Van Gogh receives a letter from Dr. Peyron (now lost; probably of 20 June), presumably telling him that the canvases left to dry in Saint-Rémy have been dispatched. It seems likely that they arrive in Auvers this day: two still lifes of irises (cat. 51, 52), two of roses (cat. 53; cat. 53, fig. 46), a wheat field (possibly F718), a canvas with mountains, and a cypress with a star (cat. 55).

He replies to Dr. Peyron (the letter is lost), suggesting that "about 10 francs for the servants [for packing and sending the canvases] would be enough" (LT644). He is invited to lunch at Dr. Gachet's—the invitation still exists—to celebrate his daughter Marguerite's twenty-first and his son Paul's seventeenth birthday (both of which actually fell on 21 June). Dr. Gachet agrees to visit Ravoux's inn on Tuesday to look at the canvases that have recently arrived from Saint-Rémy. It seems possible, too, that at this birthday luncheon van Gogh comes closer to arranging for Marguerite Gachet to sit for her portrait.

Theo visits the Old Salon, accompanied by Eugène Boch. He finds it "deplorably wretched; there is hardly anything there which is not profoundly boring." The only pictures Theo praises are flower still lifes by Quost and by Georges Jeannin (1841–1925). Boch then joins Theo and Jo for lunch at their apartment, after which they look at Vincent's pictures. As part of the exchange proposed by Vincent, Boch chooses *Mountains at Saint-Rémy* (cat. 20). Theo then visits Boch's studio and selects a picture of the mining district of the Borinage (cat. 20, fig. 18).

Monday 23 June

Theo writes to Vincent (T38), telling him of his visit to the Old Salon with Boch, and of the exchange of pic-

tures. He commends Vincent's etching of Dr. Gachet, adding that Boch liked it too. The Raffaëlli show has closed; "now everybody is going to the country.... Last week Jo had to stay in bed...but fortunately that is over now. The little one is well."

Tuesday 24 June

Vincent receives Theo's letter, with 50 francs enclosed, and replies immediately (LT644), his first news to his brother in a week. He is pleased about the exchange with Boch and hopes Jo is better—"Certainly you must come here as soon as possible; nature is very, very beautiful here and I am longing to see you again." He encloses Dr. Peyron's letter of about 20 June, confirms that the Saint-Rémy canvases have arrived, and reports on the past week's work (see 18–21 June). He is dismissive of Hirschig's work: "studies...a little gray, a little green, with a red roof and a whitish road. What is one to say in a case like this?" He is hoping to do Marguerite Gachet's portrait this week and may get a country girl to pose as well. He would like to spend several days in Paris a little later on, "just to go and look up Quost and Jeannin, and one or two others. I should very much like you to have a Quost, and there might probably be some way of exchanging one." Gachet is coming today to see the recently arrived paintings from Saint-Rémy.

Wednesday 25 or Thursday 26 June

Vincent begins work on the portrait *Marguerite Gachet at the Piano* (cat. 81).

Thursday 26 or Friday 27 June

Vincent reports to Theo (LT645): "Yesterday and the day before I painted Mlle Gachet's portrait [cat. 81]....It is a figure that I enjoyed painting—but it is difficult." He sends Theo an order for paints, and possibly begins *Peasant Woman with Straw Hat Sitting in the Wheat* (cat. 68).

Friday 27 June

Gauguin replies to van Gogh's letter of 16 June (GAC42), thanking him for his etching of Dr. Gachet. His reply is late because de Haan and he have spent five days in Pont-Aven and have only just returned to Le Pouldu. "Your letter does not say much. Whether you have seen my studies in Paris at Goupil's, and what you think of them. Whether my projected journey to Madagascar seems to you unreasonable. I dream of it every day, to the point that I am hardly working at present, wishing to rest a little, to gather new strength for down there. And you, you are insatiable: I see that you haven't wasted your time

in Auvers. It is good, however, to rest oneself sometimes, in spirit and body. Your idea of coming to Le Pouldu in Brittany seems excellent to me if it were realizable. For de Haan and I are in a small hole far from the town, without any means of communication other than a hired carriage. And for a sick person who sometimes needs a doctor that is dangerous. At Pont-Aven it is another matter; there is a doctor and people. Besides, if I manage to arrange my project for going to Madagascar, I shall not be here at the beginning of September, nor will de Haan, who is going to return to Holland. There in all frankness is the situation: and yet God knows with what pleasure I should have liked to see friend Vincent near to us. I do not know Dr. Gachet, but I have often heard Father Pissarro talk of him. And it must be pleasant for you to have near you someone who sympathizes with your work and your ideas. Alas, I myself feel condemned to be less and less understood, and I must be prepared to follow my path *alone,* to drag out an existence without family, like an outcast."

Saturday 28 June

Van Gogh possibly works on a second and even a third picture of a young peasant woman (F518; cat. 68, fig. 58).

Sunday 29 June

He receives Gauguin's letter (GAC42), which he describes to Theo and Jo (LT646) as "rather melancholy.... He talks vaguely of definitely having decided on Madagascar, but so vaguely that you can see that he is only thinking of this because he really does not know what else to think of. And carrying out the plan seems almost absurd to me."

He probably answers Gauguin by return mail, lunches at Gachet's, and possibly completes his trio of portraits of the young peasant woman (cat. 68; cat. 68, fig. 58; F518).

Monday 30 June

In the evening Theo writes a long, rather disturbing letter to Vincent, while Jo and the baby are sleeping (T39). He begins, "We have gone through a period of the greatest anxiety; our dear little boy has been very ill, but fortunately the doctor, who was uneasy himself, told Jo, 'You are not going to lose the child because of this.' " This was probably caused by an infection from cow's milk: now the baby is being given ass's milk. All this has been very wearing on Jo, who has spent much of the previous week in bed.

And there are other problems: "Ought we to take another apartment—you know, on the first floor of the same house? Ought we to go to Auvers, to Holland, or not? Ought I to live without a thought for the morrow, and when I work all day long not earn enough to protect that good Jo from worries over money matters, as those rats Boussod and Valadon are treating me as though I had just entered their business, and are keeping me on a short allowance?...Oughtn't I to tell them at last, 'Gentlemen, I am going to take the plunge, and establish myself as a private dealer in my own house'?"

But Vincent must not worry: "What gives me the greatest pleasure is the knowledge that you are in good health and that you are busy with your work, which is admirable."

Theo then recalls the changing of the seasons and the days of their youth in Holland. These memories, however, are not enough. Theo is sustained now by a wife; he hopes that Vincent too will have a wife someday.

"Your portrait of Mlle Gachet must be admirable, and I shall be happy to see it with those spots of orange in the background. The sketch of the landscape makes me think of something exquisite. I am anxious to see it...."

"As soon as Jo is a little stronger and the little one entirely recovered, you must come and stay with us for a day or two, at least on a Sunday and some days after." They will then go and see Quost's painting.

Theo has sold a Corot (Jean-Baptiste-Camille Corot, 1796–1875) to the Dutch artist and collector Hendrik Willem Mesdag (1831–1915) that Messrs. Boussod and Valadon had said could not be sold.

The paints are being sent off.

Tuesday 1 July

Theo adds a small postscript to his letter of the previous evening: "This morning I have woken up with the same ideas. I have firmly decided that, to start with, I am going to rent the apartment in question as I go out. The baby has slept well, he is better this morning—adieu." (This postscript is unpublished: Theo's letter must now be dated 30 June and 1 July.)

Dr. Peyron writes to van Gogh (unpublished letter in the Rijksmuseum Vincent van Gogh, Amsterdam), replying to his letter of 22 June.

Wednesday 2 July

Vincent answers Theo's letter as soon as it arrives, addressing it to Theo and Jo (LT646): "I have just received the letter in which you say that the child is ill; I should

greatly like to come and see you, and what holds me back is the thought that I should be even more powerless than you in the present state of anxiety." But his anxiety about the baby only reinforces his plea that a month in the country would be the best cure for all of them. "It is a great pity that M. Gachet's house is so encumbered with all sorts of things," but Jo could perhaps stay at the inn just across the way at the bottom of the hill.

He reports on three completed works (cat. 68, 78, 79), though two of these were finished more than ten days earlier. He tells Theo he has received Gauguin's letter (GAC42); thanks him for the package of paints, the 50 franc note, and the article on the Indépendants; and alerts him that an Australian artist, E. Walpole Brooke, may come to see the canvases at Theo's apartment. "He will probably show you some of his studies, which are still rather smeary, but all the same he does observe nature. He has been here in Auvers for some months, and we've sometimes gone out together. He was brought up in Japan; you would not know it to look at his paintings—but that may come."

Thursday 3–Saturday 5 July

No evidence of van Gogh's activities, or of what he is working on.

Saturday 5 July

Theo writes three letters. To Gauguin (the letter is lost) he encloses payment for the sale of two paintings. To Pissarro he talks of the impossibility of being able to visit him at Eragny on 14 July with Jo and the baby because of the baby's illness. Instead, on that day, he and M. Valadon will visit Monet at Giverny, and he hopes that afterward "my brother-in-law [Andries Bonger], myself, and perhaps my brother Vincent might come to spend the day at your house. We could sleep anywhere, don't worry. That will give me the pleasure of seeing 'le grand peintre' at home and in his own surroundings" (Rewald, "Theo van Gogh, Goupil, and the Impressionists," pp. 55–56).

To Vincent he writes (T40) that the baby is much better, thanks to the ass's milk; that he will go to Monet's with Valadon on 14 July; and that Vincent should not delay coming to see them. "Please come Sunday by the first train; in the morning you will meet Walpole Brooke, who has just seen your pictures at Tanguy's, and after that we are going to look at a Japanese Buddha at a curio dealer's, and then we are going to lunch at home in order to see your studies. You will stay with us as long as you like, and you are going to advise us with regard to the arrangement of our new apartment...."

"I have been quite lucky in business, although my sales of pictures don't amount to 800,000,000,000 francs, but

among other things I have sold two Gauguins, for which I sent him the money. Pissarro wrote to tell me that he could not pay his rent; I shall send him a little advance on the business we are going to do....

"We count on seeing you Sunday."

Sunday 6 July

Van Gogh catches an early train to Paris to spend the day with Theo and Jo. The precise course of events is difficult to reconstruct. What is certain is that the atmosphere is strained and uneasy. The day was recalled by Jo in December 1913: "Early in July, Vincent visited us once more in Paris. We were exhausted by a serious illness of the baby; Theo was again considering the old plan of leaving Goupil and setting up in business for himself; Vincent was not satisfied with the place where the pictures were kept, and our removal to a larger apartment was talked of—so those were days of much worry and anxiety. Many friends came to see Vincent—among others Aurier, who had recently written his famous article about Vincent and now came again to look at the pictures with the painter himself. Toulouse-Lautrec stayed for lunch and made many jokes with Vincent about an undertaker's man they had met on the stairs. Guillaumin was also expected, but it became too much for Vincent, so he did not wait for this visit but hurried back to Auvers—overtired and excited, as his last letters and pictures show" (*The Complete Letters*, p. lii).

c. Monday 7 July

Van Gogh's furniture arrives from Arles, and he has to pay for its transportation. He writes a brief letter (LT647) to Theo and Jo, but he may not have sent it. (Its condition suggests that it was carried around folded in his pocket.)

Gauguin writes to Theo (GAC25), enclosing the signed receipt for the sale of his two paintings. Bernard may go with him to Madagascar. He has heard nothing from Dr. Charlopin; is hardly working, but saving his strength for the future in Madagascar; and has received "two letters from Vincent, calm enough, which have given me pleasure."

Theo has an interview with Messrs. Boussod and Valadon about his future with the firm (T41).

Tuesday 8 July

Mother and Wil write a letter to Vincent.

Wednesday 9 July

Jo writes to Vincent (the letter is lost).

c. Thursday 10 July

Vincent receives letters from Jo and from his mother and Wil. He replies immediately to Theo and Jo (LT649): "Jo's letter was really like a gospel to me, a deliverance from the agony which has been caused by the hours I had shared with you which were a bit too difficult and trying for us all. It was no slight thing when we all felt our daily bread was in danger, no slight thing when for reasons other than that we felt that our means of subsistence were fragile. Back here, I still felt very sad and continued to feel the storm which threatens you weighing on me too. What was to be done—you see, I generally try to be fairly cheerful, but my life is also threatened at the very root, and my steps are also wavering. I feared—not altogether but yet a little—that being a burden to you, you felt me to be rather a thing to be dreaded, but Jo's letter proves to me clearly that you understand that for my part I am as much in toil and trouble as you are."

Nonetheless, since his return he has painted three large canvases—two of them "vast fields of wheat under troubled skies [cat. 83, 85]," the third "Daubigny's garden [cat. 84], a picture I have been thinking about since I came here." He hopes their imminent journey to Holland will give them a little distraction. He regrets not having seen Guillaumin on Sunday: "If I had waited, I should probably have stayed talking with him so long that I would have missed my train"; and he recalls "with emotion" seeing Toulouse-Lautrec's "amazing" portrait of a musician.

c. Friday 11 July

Vincent replies to his mother and Wil (LT650) in a letter on which his mother was later to write, "Very last letter from Auvers." He tells them he is feeling "much calmer than last year, and really the restlessness in my head has greatly quieted down. In fact, I have always believed that seeing the surroundings of the old days would have this effect."

He is "quite absorbed in the immense plain with wheat fields against the hills, boundless as a sea, delicate yellow, delicate soft green, the delicate violet of a dug-up and weeded piece of soil, checkered at regular intervals with the green of flowering potato plants, everything under a sky of delicate blue, white, pink, violet tones. I am in a mood of almost too much calmness, in the mood to paint this."

He hopes they will spend "very happy days with Theo and Jo, and... will see, as I did, how well they take care of the little child."

Sunday 13 July

Van Gogh observes the preparations for Bastille Day in the Place de la Mairie.

Monday 14 July

Early in the morning, before the festivities of Bastille Day begin, he paints the *Town Hall of Auvers on Bastille Day* (F790). (There is no other documentation of the paintings he produced from 9 July to about 18 July.)

Theo writes a reassuring letter (T41), reinforcing what Jo had written in her letter of 9 July: "We are very glad to learn that you are feeling less dispirited on account of the unsettled business questions than when you were here. The danger is really not as serious as you thought."

Theo does not visit Monet as planned, since he writes that he and Jo are completing their packing for their visit to Holland. They leave tomorrow for Leiden to stay with Mother and Wil. Theo will then go to The Hague on Wednesday 16 July to talk with Mesdag about a painting by Corot, then to Antwerp with a picture by Diaz, returning to Paris, he hopes, by Monday 21 July. He still has no news of Boussod's decision a week after their meeting. He encloses 50 francs.

Tuesday 15 July

Vincent receives Theo's letter. His brother's decision to go to Holland and not to spend even a few days with him in

Auvers must have greatly upset him. He probably writes an angry letter (now lost), addressing it to Leiden.

Theo and his family leave Paris for Leiden.

Wednesday 16 July

Theo visits Mesdag in The Hague.

Saturday 19 July

Theo returns to Paris alone, leaving Jo and the baby to visit her parents in Amsterdam.

Sunday 20 July

Theo writes to Jo in Amsterdam: "I hope [Vincent] is not getting melancholy or that a new attack is threatening again; everything has gone so well lately."

Theo spends some time with Andries Bonger and his wife, Annie, and has dinner with a Dr. Franken.

Monday 21 July

Theo meets with Boussod and Valadon, and evidently they patch up their differences.

The Town Hall of Auvers, c. 1935. Photograph by John Rewald

Tuesday 22 July

Theo writes to Wil, telling her of the events since his return to Paris. The reassuring news to his family is that he will not be leaving Boussod & Valadon.

Theo also writes to Vincent, answering the letter sent to Leiden, which Jo, presumably, had sent on to Paris. (Both letters are apparently lost.)

Wednesday 23 July

Vincent receives Theo's letter, with 50 francs enclosed. He begins to draft a reply immediately (LT652), but abandons it, possibly thinking the tone too harsh. He then writes a second letter (LT651), based on the draft, but in a gentler, more conciliatory vein. He decides to keep the draft and post the finished letter. With this last letter to his brother, he encloses sketches of four paintings (figs.

71–74, reproduced on pages 286–87), as if to affirm, in no uncertain terms, that he is continuing to work. He asks that paints be sent to Hirschig as well as to himself.

Thursday 24–Saturday 26 July

Nothing is known of van Gogh's activities during these days. On Friday 25 July, Theo writes to Jo in Holland, "I have a letter from Vincent which seems quite incomprehensible; when will there come a happy time for him? He is so thoroughly good." (Evidently Theo does not reply to Vincent himself, and he may not have sent the requested paints.)

Sunday 27 July

The only contemporary testimonies to the events of this day are those of Dr. Gachet (letter to Theo), Theo (letters

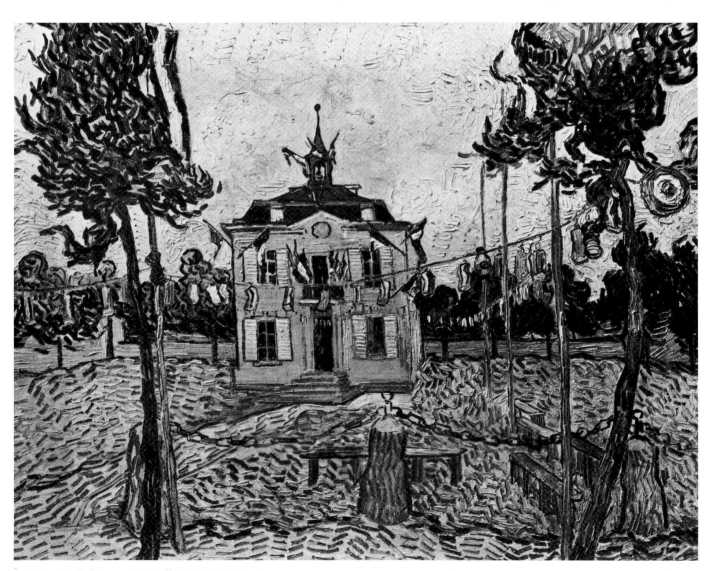

The Town Hall of Auvers on Bastille Day (F790). Oil on canvas, 28⅜ x 36⅝ in. (72 x 93 cm.). Private collection

to Jo, of which only excerpts have been published), and Émile Bernard (letter to Aurier of 1 August 1890). Later testimonies by eyewitnesses — Anton Hirschig (1912 and 1934), Paul Gachet *fils* (1950s), and Adeline Ravoux (1950s)—frequently contradict each other, omit vital information, and are at variance with the more reliable evidence of Theo and Bernard. Until Theo's letters to Jo are printed in full, Bernard's letter to Aurier must be considered the most accurate account. Bernard gathered the information from Ravoux: "On Sunday evening [van Gogh] went into the Auvers countryside, placed his easel against a haystack and went behind the château to shoot himself with a revolver. From the violence of the impact (the bullet had passed below the heart) he fell, but got up—three times in succession—to return to the inn where he lived (Ravoux, Place de la Mairie) without saying anything to anyone of his injury."

Van Gogh climbs to his attic room, where he is eventually discovered by Ravoux. Dr. Mazery, the local practitioner, and Dr. Gachet are summoned, and together they decide that the bullet should not be removed.

Dr. Gachet writes to Theo: "With the greatest regret I must disturb your repose. Yet I think it my duty to write to you immediately. At nine o'clock in the evening of today, Sunday, I was sent for by your brother, Vincent, who wanted to see me at once. I went there and found him very ill. He has wounded himself...as I did not know your address and he refused to give it to me, this note will reach you through Goupil" (*The Complete Letters*, p. lii).

Ravoux, or Ravoux and Hirschig, or Gachet *fils* (depending on which of the later accounts is to be believed) watch by van Gogh's bedside throughout the night.

Paul-Ferdinand Gachet. *Vincent van Gogh on His Deathbed,* 29 July 1890. Charcoal. Musée d'Orsay, Paris

Monday 28 July

Hirschig leaves for Paris on an early train, taking Dr. Gachet's letter to Theo at Boussod & Valadon.

Police visit Ravoux's inn to interview van Gogh. (A police report—if in fact one was made—has yet to come to light.)

Theo arrives in Auvers, probably by midday. He writes later in the day to Jo (who is still in Amsterdam): "This morning a Dutch painter [Hirschig] who also lives in Auvers brought me a letter from Dr. Gachet that contained bad news about Vincent and asked me to come. Leaving everything, I went and found him somewhat better than I expected. I will not write the particulars, they are too sad, but you must know, dearest, that his life may be in danger.... He was glad that I came, and we are together all the time...poor fellow, very little happiness fell to his share, and no illusions are left him. The burden grows too heavy at times; he feels so alone. He often asks after you and the baby, and said that you could not imagine there was so much sorrow in life. Oh! if we could only give him some new courage to live. Don't get too anxious; his condition has been just as hopeless before, but his strong constitution deceived the doctors" (*The Complete Letters*, pp. lii–liii).

Tuesday 29 July

Van Gogh dies at 1:30 A.M. Theo describes the end: "One of his last words was, 'I wish I could pass away like this,' and his wish was fulfilled. A few moments and all was over. He had found the rest he could not find on earth" (*The Complete Letters*, p. liii).

Dr. Gachet makes a drawing of van Gogh on his deathbed. At 10 A.M. his death is registered at the town hall, witnessed by the mayor of Auvers, A. Caffin, and Ravoux and Theo. The coffin is prepared by the carpenter Levert (whose two-year-old son was earlier painted by van Gogh; F785).

Theo has funeral invitations printed quickly at Pontoise, announcing the event for 2:30 P.M. the following day, with a service at the church of Auvers.

Later in the day Teissier, the priest of the Catholic church of Auvers, refuses to use the parish hearse because van Gogh was a suicide. The more progressive township of Méry, across the river Oise, agrees to provide one. The church service is cancelled.

Wednesday 30 July

Friends begin to arrive at Auvers in the morning—Andries Bonger, Tanguy, Lauzet, Lucien Pissarro (but not his father, Camille). Bernard arrives about 10:00 P.M., accompanied by the painter Charles Laval (1862–1894). Bernard describes the scene at Ravoux's inn in his letter to Aurier of 1 August: "The coffin was already closed. I arrived too late to see him again.... On the walls of the room where his body lay all his last canvases were nailed, forming something like a halo around him and rendering—through the brilliance of the genius that shone from them—this death even more painful for us artists. On the

Announcement of the death of Vincent van Gogh. Rijksmuseum
Vincent van Gogh (Vincent van Gogh Foundation), Amsterdam

Mon cher Aurier

Votre absence de Paris a dû vous priver d'une affreuse nouvelle que je ne puis différer pourtant de vous apprendre:

Notre cher ami Vincent est mort depuis quatre jours.

Je pense que vous avez deviné déjà qu'il s'est tué lui même.

En effet dimanche soir il est parti dans la campagne d'Auvers il a déposé son chevalet contre une meule et il est allé se tirer un coup de revolver derrière le château. Sous la violence du choc (la balle avait passé sous le cœur) il est tombé, mais il s'est relevé, et consécutivement trois fois, pour rentrer à l'auberge où il habitait (Ravoux, place de la mairie) sans rien dire à qui que ce soit de son mal. Enfin Lundi soir il expirait en fumant sa pipe qu'il n'avait pas voulu quitter et en expliquant que son suicide était absolument __calculé__ et voulu en toute lucidité. Un fait assez caractéristique que l'on m'a rapporté touchant sa volonté de disparaître est ici c'est a refaire alors, quand le docteur Gachet lui disait qu'il espérait encore le sauver. mais ce n'était hélas plus possible....

Hier. Mercredi 30 Juillet j'arrivai a Auvers vers 10 heures. Théodore Van ghogh son frère était là avec le docteur Gachet. Tanguy aussi était là depuis 9 heures.) Laval Charles m'accompagnait. Déjà la bière était close j'arrivai trop tard pour le revoir lui qui m'avait quitté il y quatre ans si plein d'espoirs de toutes sortes.. L'aubergiste nous raconta tous les détails de l'accident. la visite impudente des gendarmes qui sont venus jusqu'à son lit lui faire des reproches d'un acte dont il était seul responsable.. etc...

Sur les murs de la salle où le corps était exposé. toutes ses toiles dernières étaient clouées lui faisant comme une auréole .et rendant par l'éclat ou génie qui s'en dégageait cette mort plus pénible encore aux artistes. sur la bière un simple drap blanc puis des fleurs en quantité. des soleils qu'il aimait tant. des dahlias jaunes. des fleurs jaunes partout. C'était sa couleur favorite s'il vous en souvient, symbole de la lumière qu'il rêvait dans les cœurs comme dans les œuvres.

First page of letter from Émile Bernard to G.-Albert Aurier, 1 August 1890. Rijksmuseum Vincent van Gogh (Vincent van Gogh Foundation), Amsterdam

coffin a simple white drapery, then masses of flowers, sunflowers which he loved so much, yellow dahlias, yellow flowers everywhere. [According to Theo, "Dr. Gachet was the first to bring a large bunch of sunflowers, because Vincent was so fond of them."] That was his favorite color, if you remember, symbol of the light of which he dreamt in hearts as well as in paintings. Near him also his easel, his folding stool, and his brushes were placed on the floor in front of his coffin.... At three o'clock the body was raised; his friends carried it to the hearse. Several people present wept—Theodorus van Gogh, who adored his brother, who had always supported him in his struggle for art and independence, not ceasing to sob pitifully. Outside, the sun was terribly hot. We climbed the hill of Auvers talking of him, of the bold forward thrust he gave to art, of the great projects that always preoccupied him, of the good he has done to each of us. We arrived at the cemetery, a small new cemetery dotted with new tombstones. It is on the height dominating the harvest fields under the wide blue sky that he would have loved still—perhaps. Then he was lowered into the grave. Who would not have cried at that moment...the day was so much made for him that one could imagine he was still alive. Dr. Gachet (who is a great art lover and possesses one of the best impressionist collections of today, an artist himself) wanted to say a few words to epitomize Vincent's life, but he too wept so much that he could only stammer a very confused farewell...(the most beautiful). He retraced briefly Vincent's efforts, indicated their sublime goal, spoke of the immense sympathy that he had for him (whom he knew for only a short time). 'He was,' said Gachet, 'an honest man and a great artist; he had only two aims: humanity and art. It was art that he cherished above everything, which will make his name live.' Then we returned. Theodorus van Gogh was broken with grief; each one of us was very moved; some withdrew to the country, others went back to the station. Laval and I returned to Ravoux's, and we talked of him."

Friday 1 August

Theo writes to his mother: "One cannot write how grieved one is nor find any solace. It is a grief that will last and which I certainly shall never forget as long as I live; the only thing one might say is that he himself has found the rest he so much longed for.... Dr. Gachet and the other doctor were excellent and have looked after him well, but they realized from the very first moment that there was nothing one could do. Vincent said: 'I would like to go like this,' and half an hour later he had his wish. Life was such a burden to him; but now, as often happens, everybody is full of praise for his talents.... Oh, Mother! He was so my own, own brother"(*The Complete Letters*, p. liii).

The Town Hall of Auvers, c. 1935. Photograph by John Rewald

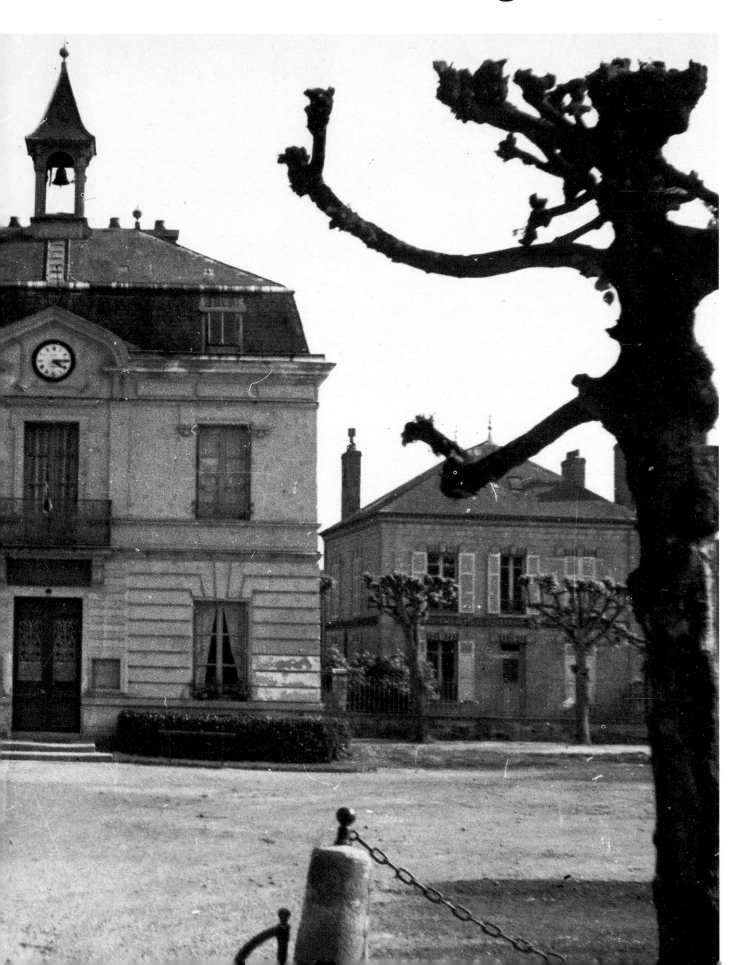

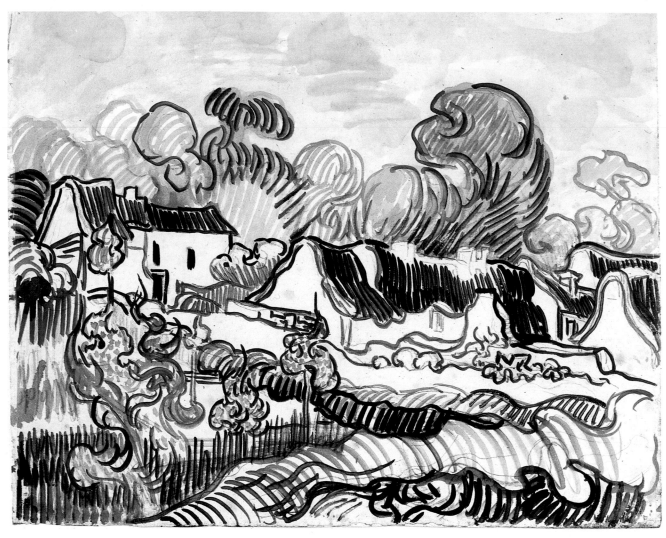

56

56. Cottages with Thatched Roofs

Pencil, brush, watercolor, and gouache,
 17¾ × 21½ in. (45 × 54.5 cm.)
Unsigned
Rijksmuseum Vincent van Gogh (Vincent van Gogh Foundation),
 Amsterdam

F1640r JH1986

After his first day in Auvers, 20 May 1890, van Gogh told Theo: "Auvers is very beautiful; among other things a lot of old thatched roofs, which are getting rare. So I should hope that by settling down to do some canvases of this there will be a chance of recovering the expenses of my stay—for really it is profoundly beautiful; it is the real country, characteristic and picturesque" (LT635). The following day he explained: "I had not yet done anything when I wrote you. Now I have a study of old thatched roofs with a field of peas in flower in the foreground and some wheat, background of hills, a study which I think you will like" (LT636). This painting is now in Leningrad (fig. 50).

 The present drawing shows the same motif, but was made independently of the Leningrad painting. Completed by 23 May (LT648), it depicts the thatched

cottages from a slightly different angle, and includes instead of the hills a continuous screen of trees.

Traces of pencil establishing the composition are still visible, both beneath the various paths of the brush and in the parts left untouched (in the articulation of the chimneys, for example). With an emphatic and expressive brush, van Gogh was more apt to generalize, creating swirling, rhythmic patterns, curvilinear and self-willed, coarser and more brutal than the Saint-Rémy style. Yet why did he limit himself to this unnatural use of blues? Was it because he now saw "violet hues" everywhere? (LT636). Paradoxically, the violet-shadowed cottage walls in the related painting are here left untouched. Perhaps he was recalling Gauguin's advice: "[If you see blue,] then chuck on some blue, and don't go on telling me that it was a blue rather like this or that, it was blue, wasn't it?" (LT607).

While the pencil drawing was clearly done on the spot, the color must surely have been added, from memory, in the studio. In adding the color, van Gogh used a further antinaturalistic convention—his own. The exaggeratedly rounded roof lines, quite different from their counterparts in the Leningrad canvas, are not found in Dutch or French thatched cottages. In fact, they are evident only in van Gogh's "memories of the North," his Southern adaptation of a misremembered Dutch thatched cottage (see especially drawings F1591v and F1595v). In making drawings of this motif in Auvers, van Gogh resorted to this Southern studio convention. The cottages are as unnatural and artificial as the color and the boldly articulated linear configurations.

On the verso of the sheet is a drawing (fig. 51) whose motif is related to, but differs in details from, the painting *Chestnut Tree in Flower* (F752).

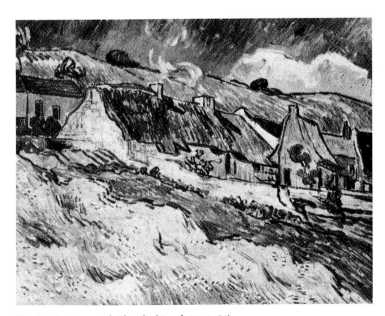

Fig. 50. *Cottages with Thatched Roofs* (F750). Oil on canvas, 23⅝ x 28¾ in. (60 x 73 cm.). The Hermitage Museum, Leningrad

Fig. 51. *House and Chestnut Trees* (F1640v). Black chalk, 17¾ x 21⅝ in. (45 x 54.5 cm.). Rijksmuseum Vincent van Gogh (Vincent van Gogh Foundation), Amsterdam

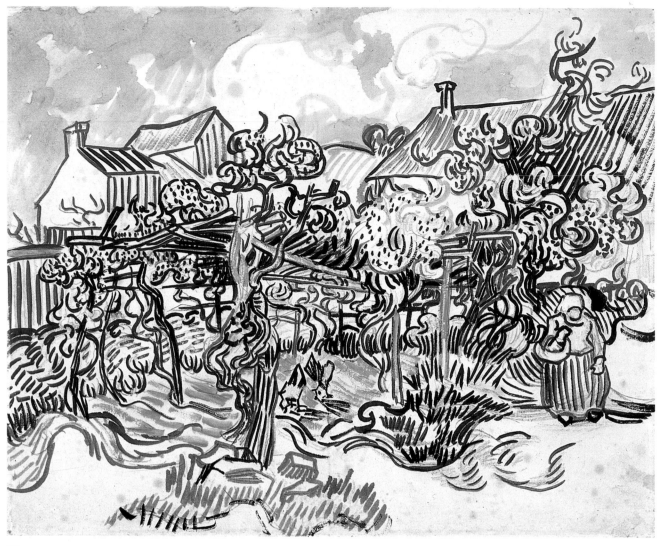

57

57. Old Vineyard with Peasant Woman

Pencil, brush, watercolor, and gouache,
 17¼ × 21¼ in. (43.5 x 54 cm.)
Watermark: Michallet
Unsigned
Rijksmuseum Vincent van Gogh (Vincent van Gogh Foundation),
 Amsterdam

F1624 JH1985

This is the only drawing from Auvers that is precisely documented. Van Gogh
refers to it twice. First in a letter of 23 May 1890: "You will see a drawing of an old
vineyard with the figure of a peasant woman. I intend to make a big canvas of it"
(LT648). And again two days later: "I have a drawing of an old vine, of which I
intend to make a size 30 canvas" (LT637). No such large canvas was done; or, if
done, it has not survived. A smaller painting was executed, however, but with the
motif seen from a quite different vantage point (F794).

 The pencil is used more extensively here than in the drawing of thatched
cottages (cat. 56). Hatched and shaded areas abound to such an extent that van

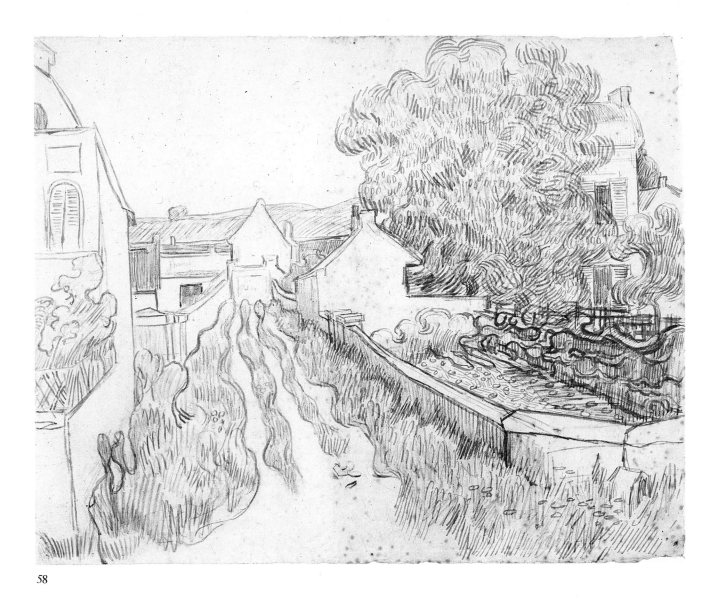

58

Gogh might have chosen to finish it with reed pen and brown ink rather than with brush and color. The insistent surface patterning, riotously alive with a vigorous articulation of stab and hatching, wash and dot, can easily disguise the compositional trellis on which it rests. Quite literally, that trellis is created center stage by the diagonalized recession of the vines as they clamber up and around the wooden structure that helps to support them. The diagonal axes thus established are then echoed and reinforced in the solid, four-square, oddly windowless background buildings. The peasant woman with basket adds a sturdy vertical, and two summarily drawn fowl provide a rustic note. Not even the alternating rhythms of long diagonal and vertical hatchings for the houses, hills, and woman's skirt; the shorter hatchings for the ground; the dots for the foliage; and the washes in the sky can altogether displace the compositional base.

Compared with the drawing of thatched cottages, here the brush has not been given free rein to create its own self-willed patterns. It seems probable that the drawing was partly done on the spot and then finished in the studio.

These two first drawings from Auvers have no progeny, either in their virtual restriction to a blue-violet tonality or in the degree to which the brush is used so fluently.

58. The House of Père Pilon

Pencil, pen and brown ink on laid paper,
 17½ × 21¾ in. (44.5 × 55 cm.)
Watermark: Hallines Dambricourt Frères
Color annotations: jaune, bleu
Unsigned
Rijksmuseum Vincent van Gogh (Vincent van Gogh Foundation),
 Amsterdam
F1638r JH1996
Reproduced on page 225

This is van Gogh's most detailed drawing from Auvers, built up with passionate exactness, part by part, surface texture by surface texture. In its naïve deliberateness, it reverts to his very early Dutch style—for example, the *Vicarage Garden at Etten* (F902), of June 1881. The first Auvers drawings (cat. 56, 57) were hastily established in pencil before brush and color were added; here, by contrast, the drawing is carefully worked up with pencil and then articulated with reed pen and ink. Van Gogh left largely untouched the surfaces of wall and house façade. His most searching graphic equivalents occur in the chestnut tree, where bold, short hatchings combine with near ovals to render leaf and flower (cf. F1624v). He discovers curves and contortions in the cart tracks on the narrow lane, like a pair of snakes suddenly leaping from the sheet.

Just as three other drawings (cat. 56; cat. 56, fig. 51; cat. 57) are related, in varying degrees, to paintings, so too is the present one. A comparison of the drawing with the painted version (cat. 59) shows changes, slight and subtle, partly dictated by differences in format and vantage point. In making the drawing van Gogh stood farther back, enlarging the foreground and sharpening the diagonals of the various walls. The chestnut tree too is more dominant in the drawing, cut by the upper edge, while there is proportionately more sky in the painting.

Contrary to what is generally maintained, there is no drawing on the verso of this sheet.

59. The House of Père Pilon

Oil on canvas, 19¼ × 27½ in. (49 × 70 cm.)
Unsigned
Private collection
F791 H771 JH1995

The day after his arrival in Auvers, van Gogh told Theo: "I find the modern villas and the middle-class country houses almost as pretty as the old thatched cottages which are falling into ruin" (LT636). Partly hidden by a large chestnut tree, the house of Père Pilon, one of the grander modern villas, at 18 Rue François Villon, gives the title to this painting. Van Gogh never mentioned the picture in his letters. But it may well have been painted as early as 24 May 1890. The flowering chestnut is comparable with those in two other paintings (F751, F752) known to have been completed by 23 May (LT648). These flowering chestnuts became a late substitute for the blossoming fruit trees he had been prevented by his illness from painting in Saint-Rémy (see cat. 49).

The rather turbulent sky, with its halo effect, may well show the wet and stormy weather that van Gogh experienced on Saturday 24 and Sunday 25 May.

Compared with the drawing of the same motif (cat. 58), he reduced the foreground and removed some of the diagonals, lowered the line of the hills, increased the area of the sky, and slightly extended the composition at right. More important, he simplified the particularities of the drawing, generalizing forms,

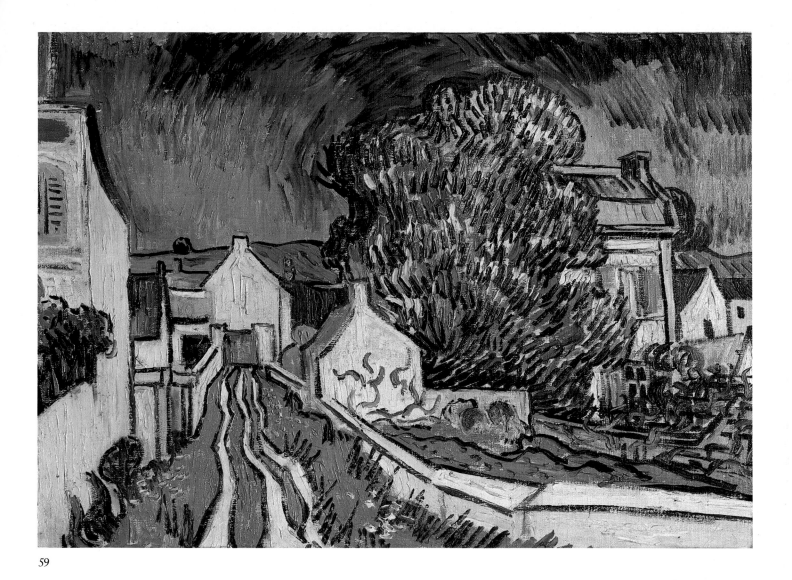

59

shapes, and textures. That drawing and painting were independently conceived seems confirmed by the color of the gate, annotated "blue" in the drawing, but a rich green in the painting.

Views of a receding street are relatively rare from Auvers. This one is made the more piquant by the reduction of the spatial thrust—gables seen head-on, calming the horizontal axis of the distant hills. It is similar in format and close in size to *Village Street and Stairs with Figures* (cat. 60), and the two may have been intended as a pair.

60. Village Street and Stairs with Figures

Oil on canvas, 20 × 28 in. (49.8 × 70.1 cm.)
Unsigned
The Saint Louis Art Museum. Museum Purchase
F795 H783 JH2111

The similarity in size and format of the *House of Père Pilon* (cat. 59) and *Village Street and Stairs with Figures* suggests that they may have been conceived as a pair. Both show characteristic street scenes in Auvers, with their strange snakelike

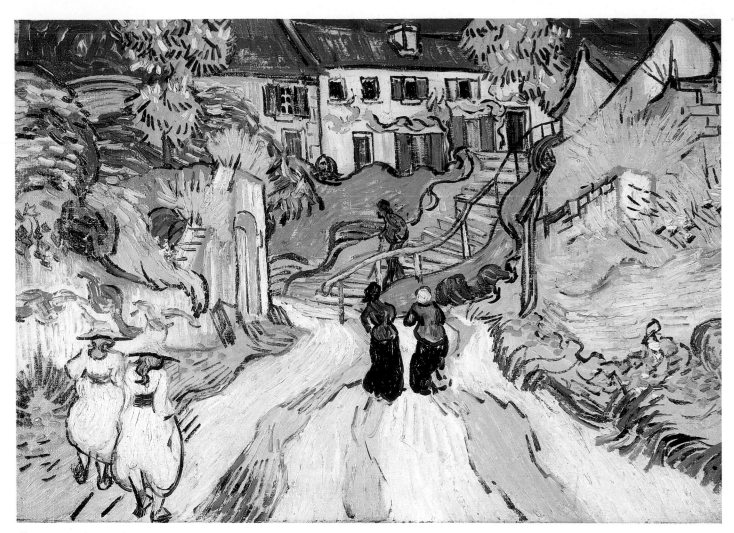

60

cart tracks and receding walls. But while the one is angular, sharply diagonalized, and almost geometric, the other is sinuous and linear and has a rising wavelike motion, especially in the stairs. Curves play off each other—even in the pairs of women and girls, and across the façades of the houses, the only area of contrasting rectangles. As a street scene with figures, the motif can be compared with *Flowering Chestnut Trees* (F751), known to have been completed by 23 May 1890 (LT648). As in that picture, the smaller chestnut trees seen here appear to be in flower, suggesting that *Village Street* was painted between 28 and 31 May (four days about which we know nothing of van Gogh's activity).

The street shown is the one immediately adjacent to Ravoux's inn, the Rue de la Sansonne. The motif is still recognizable today, though the distinctive stairs connecting the two street levels are no longer there. The seemingly unstable composition is less an expression of van Gogh's state of mind (the equation is made more dramatic if the painting is dated, as it generally is, to July rather than late May) than of his utterly truthful acceptance of the idiosyncratic motif: curiously curving walls, odd changes in level, very little sky. Van Gogh made no drawing comparable to the painting, abandoning a working process he followed frequently in his early activity in Auvers. However, a sheet of studies (F1652r) includes a sketch of a young girl seen from behind that is very close to one of the figures in the painting.

61. Portrait of Dr. Gachet (L'Homme à la pipe)

Etching, retouched with pencil, 7 × 6 in. (18 x 15 cm.)
Dated in the plate, upper right: 25 Mai 90
Inscribed, in black chalk, lower right: Inedit 1er État
Josefowitz Collection

F1664 JH2028

The making of this etching was described by Paul Gachet *fils* (1873–1962) in 1952: "On 25 May 1890, Pentecost Sunday, Vincent lunched for the first time at the house: it was then that one really got to know him. The conversation...covered many questions, among them engraving.... The doctor...had the necessary etching materials at hand.... After lunch in the open air in the courtyard, and with their pipes lit, Vincent was given an etching needle and a prepared copper plate, and accepted with enthusiasm that his new friend should be the motif. As soon as it was drawn, the plate was bitten—under the supervision of van Ryssel [Dr. Gachet]—as was the case seventeen years earlier with the plates of Cézanne. Thus was born *L'Homme à la pipe*, van Gogh's only etching. The operation was not yet finished: the printing must have amused Vincent still more. He pulled *illico* [on the sly] several proofs which *came muddy*, because the plate had not been wiped. He himself found them 'a little dirty,' too black, and willingly agreed to pull some more in *sanguine*; in this way, it was necessary to wait and see what happened: other colors were tried: yellow ocher, red ocher, gray, greenish, orange; they all pleased him enormously by their diversity. Vincent was thrilled and talked only of continuing engraving, especially to reproduce some of his canvases.... Many proofs were pulled from the plate during the lifetime of Dr. Gachet, who distributed the proofs widely, responding to Vincent's desire to make his works widely accessible. I have continued even more fully, presenting proofs first to certain museums, distributing them especially to Japanese artists, right up until the day that the dealers became involved" (Gachet, *Souvenirs*).

Doubts have been expressed concerning the date of 25 May imprinted in the plate. Readings range from "15" (in which case it was too early) to "15 June" ("May" being considered an error). Certainly about the middle of June, van Gogh sent proofs to both Theo and Gauguin (LT642, LT643). Theo responded on 23 June: "And now I must tell you something about your etching. It is a real painter's etching. No refinement of process, but a drawing done on metal. I like this drawing very much—Boch liked it too" (T38).

This would suggest that Theo did not see a proof of the etching when he visited Auvers on 8 June, and it may support the argument of those who do not accept the May date. Van Gogh himself did not mention etching until mid-June, when he wrote to both Theo and Gauguin of his plan to reproduce some of his Provençal paintings as etchings, Dr. Gachet having offered to do the printing. None of these was ever executed.

The number and sequence of the proofs pulled under the supervision of Dr. Gachet—and *illico* by van Gogh himself—have still to be determined. The present proof is among them. It is inscribed "unpublished first state" by Dr. Gachet himself. Presumably, therefore, the extensive retouches in pencil on the right arm are by van Gogh.

62. Portrait of Dr. Gachet

Oil on canvas, 26⅜ × 22 in. (67 × 56 cm.)
Unsigned
Private collection, U.S.A.

F753 H752 JH2007

Van Gogh made a thumbnail sketch of the *Portrait of Dr. Gachet* (fig. 52) when he wrote to Theo on 3 June 1890: "I am working at his portrait, the head with a white

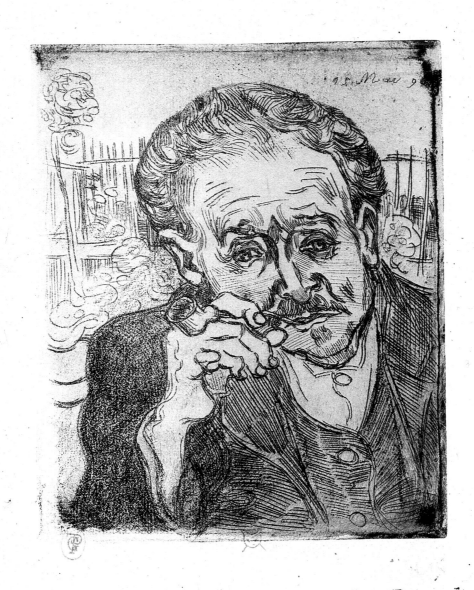

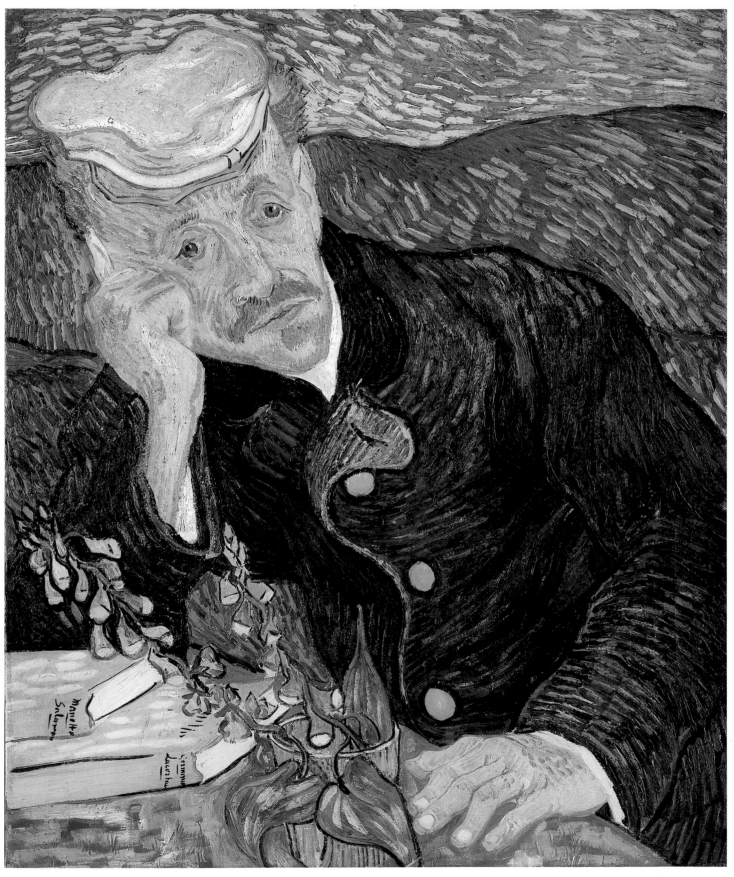

cap, very fair, very light, the hands also a light flesh tint, a blue frock coat and a cobalt blue background, leaning on a red table, on which are a yellow book and a foxglove plant with purple flowers. It has the same sentiment as the self-portrait that I brought with me when I left for this place" (LT638). He tells his brother that Dr. Gachet is "absolutely fanatical" about the *Self-Portrait* (cat. 22, fig. 19) and also greatly admires *L'Arlésienne* (probably F540), both of which he had brought with him to Auvers. Van Gogh repeats this to his sister Wil in a letter of 4 June: "My friend Dr. Gachet is *decidedly enthusiastic* about the…portrait of the Arlésienne…and also about a self-portrait" (W22). He then elaborates his ideas on portraiture: "What impassions me most—much, much more than all the rest of my métier—is the portrait, the modern portrait. I seek it in color, and surely I am not the only one to seek it in this direction. I *should like*—mind you, far be it from me to say that I shall be able to do it, although this is what I am aiming at—I *should like* to paint portraits which would appear after a century to the people living then as apparitions. By which I mean that I do not endeavor to achieve this by a photographic resemblance [fig. 53], but by means of our impassioned expressions—that is to say, using our knowledge of and our modern taste for color as a means of arriving at the expression and the intensification of the character. Thus, the portrait of Dr. Gachet shows you a face the color of an overheated brick, and scorched by the sun, with reddish hair and a white cap, surrounded by rustic scenery with a background of blue hills; his clothes are ultramarine—this brings out the face and makes it paler, notwithstanding the fact that it is brick-colored. His hands, the hands of an obstetrician, are paler than the face. Before him, lying on a red garden table, are yellow novels and a foxglove flower of a somber purple hue."

Gachet practiced homeopathic medicine, symbolized here by the foxglove (*Digitalis*) used for the treatment of heart disease. The two yellow novels—*Germinie Lacerteux* (1864) and *Manette Salomon* (1867–68), both by the Goncourt brothers—signify aspects of *modernité*, the one a study of neurosis, the

il est plus agé et il a perdu il y a quelques années safemme
mais il est très médecin et son métier et sa foi le tiennent
pourtant. Nous sommes déjà très amis et par hasard
il a connu encore Bruas de montpellier et a les mêmes
idées sur lui que j'ai que c'est quelqu'un d'important
dans l'histoire de l'art moderne. Je travaille à son portrait
la tête avec une casquette blanche très blonde très claire les mains
aussi à carnation claire un frac bleu et un fond bleu cobalt
appuyé sur une table rouge sur laquelle un livre jaune et
une plante de digitale à fleurs pourpres. Cela ~~faible~~ est dans
le même sentiment que le portrait de moi que j'ai pris lorsque
je suis parti pour ici. ~~Ils et fanatique p~~
M. Gachet est absolument fanatique pour ce portrait et veut
que j'en fasse un de lui si je peux absolument comme cela
ce que je désire faire aussi. Il est maintenant aussi
arrivé à comprendre le dernier portrait d'arlésienne ~~et~~ dont tu en
as une encore. il revient lorsqu'il vient voir les etudes tout le temps
sur ces deux portraits et il les admet en plein mais en plein tels qu'ils sont.

Fig. 52. Sketch of *Portrait of Dr. Gachet* (LT638). Rijksmuseum
Vincent van Gogh (Vincent van Gogh Foundation), Amsterdam

Fig. 53. Photograph of Dr. Paul-Ferdinand Gachet, c. 1890. Rijksmuseum Vincent van Gogh (Vincent van Gogh Foundation), Amsterdam

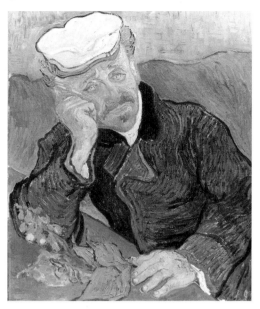

Fig. 54. *Portrait of Dr. Gachet* (F754). Oil on canvas, 26¾ x 22½ in. (68 x 57 cm.). Musée d'Orsay, Paris

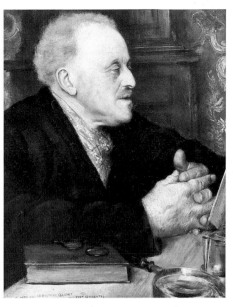

Fig. 55. Norbert Goeneutte. *Portrait of Dr. Gachet*, 1891. Oil on canvas. Musée d'Orsay, Paris

other of the Parisian artistic milieu at mid-century. The pose is the traditional one of melancholia, already present in *L'Arlésienne*.

Van Gogh's first impressions of Gachet were of a rather eccentric man suffering from nervous trouble—"as ill and distraught as you or me" (LT638). In a letter of 13 June to Wil, he returned to the portrait, "with an expression of melancholy, which would seem to look like a grimace to many who saw the canvas. And yet it is necessary to paint it like this, for otherwise one could not get an idea of the extent to which, in comparison with the calmness of the old portraits, there is an expression in our modern heads, and passion—like a waiting for things as well as a growth. Sad and yet gentle, but clear and intelligent—this is how one ought to paint many portraits" (W23).

To Gauguin, on 16 June, he was brief. He had painted Gachet, he wrote, "with the heartbroken expression of our time," and, like Gauguin's *Christ in the Garden of Olives*, it was "not destined to be understood" (LT643).

Although not cited by van Gogh, a second version of the portrait (fig. 54) was painted. According to Gachet's son, it was executed in two sittings, on 6 and 7 June. Color areas are flatter, and the effect is simpler; there are no buttons on Gachet's coat, and the novels and water glass have been removed from the table.

Dr. Paul-Ferdinand Gachet (1828–1909) was sixty-one years old when van Gogh painted him. He had lived in Auvers since 1872. Friend and patron of many artists, including Cézanne, Pissarro, Guillaumin, Monet, Renoir, and the lesser-known Norbert Goeneutte (1854–1894), whose portrait of him (fig. 55), painted a year later than van Gogh's, has an almost Early Netherlandish literalness, Gachet himself was a painter and etcher under the pseudonym van Ryssel.

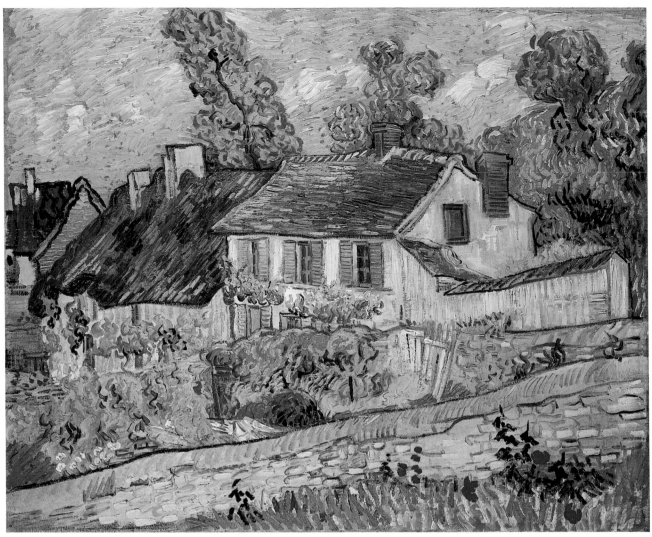

63

63. Houses at Auvers

Oil on canvas, 23⅞ × 28¾ in. (60.6 × 73 cm.)
Unsigned
The Toledo Museum of Art. Gift of Edward Drummond Libbey, 1935

F759 H754 JH1988

Van Gogh greatly admired the pictures by Paul Cézanne that he saw in Dr. Gachet's collection on his very first day in Auvers. Cézanne had lived and worked in Auvers from 1872 to 1874 and had painted some twenty pictures there, most of them landscapes. His motifs were chosen from a relatively small and concentrated area around Dr. Gachet's house at 78 Rue Vessenots—that is, toward the west of the village. At Gachet's, van Gogh singled out one of these landscapes "of the village" (*Dr. Gachet's House*, 1873, Musée d'Orsay, Paris). But he did not mention Cézanne again in his letters from Auvers.

Van Gogh's own landscapes of Auvers do not repeat Cézanne's motifs. He never painted Gachet's house (as Cézanne did rather often), only views of the garden (which Cézanne did not). He may have consciously decided not to try to compete with Cézanne—advised, perhaps, by Dr. Gachet. Occasionally, however, their motifs coincide. *Houses at Auvers* shows the Rue du Gré in Chaponval, a

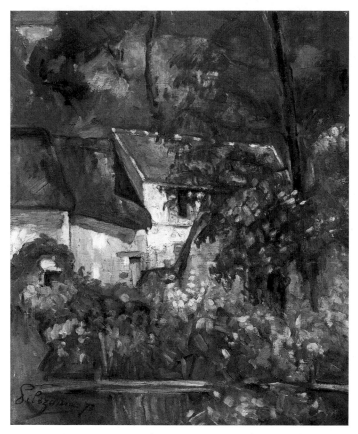

Fig. 56. Paul Cézanne. *House of Père Lacroix,* 1873. Oil on canvas, 24⅛ x 20 in. (61.3 x 50.6 cm.). National Gallery of Art, Washington, D.C. Chester Dale Collection

hamlet to the west of Gachet's house; Cézanne's *House of Père Lacroix* (fig. 56), dated 1873, shows some of the same houses, but from a different viewpoint.

Houses at Auvers is nowhere described by van Gogh. But it may be one of the "two studies of houses among trees" reported to Theo on 10 June 1890 (LT640). The gray-blue and gray-sand green reflect not only the restrained color harmonies of the "return to the North" palette but also van Gogh's response to specific weather conditions. Although the painting was rapidly executed, the paint texture is remarkably thin in parts, with areas of untouched canvas visible; the thickest touches are on the roofs.

The two thatched cottages at the left, set at a right angle to each other, their roofs interpenetrating, reappear in a later canvas (cat. 72). The present picture was first owned by van Gogh's brother-in-law, Andries Bonger.

64. Vineyards with a View of Auvers

Oil on canvas, 25¼ × 31¼ in. (64.2 × 79.5 cm.)
Unsigned
The Saint Louis Art Museum. Gift of Mrs. Mark Steinberg
F762 H751 JH2020

On 13 June 1890, van Gogh wrote to Wil that he had finished a "landscape with vines and fields in the foreground, and beyond them the roofs of the village" (W23). He told Theo, on the following day: "I have a study of vines that M. Gachet liked very much the last time he came to see me" (LT641).

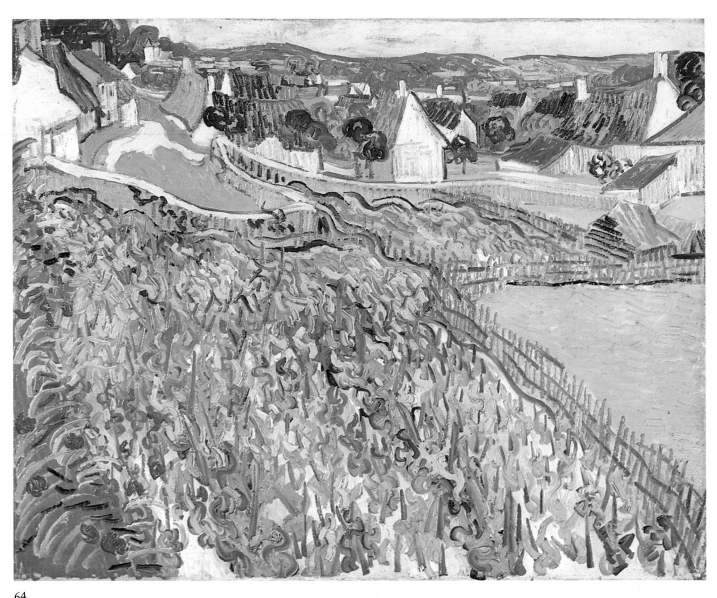

64

Grapevines were cultivated in Auvers largely for wine that was locally consumed. They could often be found in gardens, such as that depicted in one of van Gogh's first Auvers drawings (cat. 57), or in that of Dr. Gachet—"white roses, some vines, and a figure"—painted on Tuesday 1 June (F756). Only *Vineyards with a View of Auvers* shows such an extensive field of vines.

Van Gogh selected an awkward, falling-away viewpoint. Not only did he have to cope with the sloping hillside, he had additional visual complications as well: the disconcerting play of low-angled walls and wooden fences in the foreground, and the irregular disposition of house façades and gable ends, of thatched and red-tiled roofs, that obscure the village streets. He created counters to the prevailing deep space by across-the-surface splashes of red in the poppies and roofs, as well as by the unusually large areas of white.

This characteristic view of Auvers, looking east toward the hills of Montmorency—parts of which are also visible in Cézanne's famous *House of the Hanged Man* of 1873 (Musée d'Orsay, Paris)—can today no longer be seen.

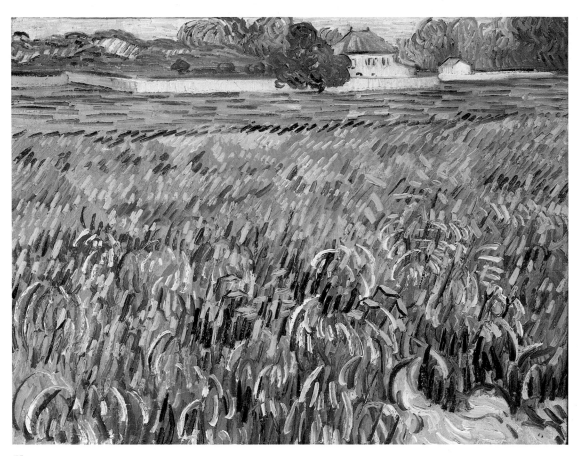

65

65. House at Auvers

Oil on canvas, 19⅛ × 24⅞ in. (48.6 × 63.2 cm.)
Unsigned
The Phillips Collection, Washington, D.C.
F804 H793 JH2018

This landscape was described by van Gogh in a letter to Wil on 13 June 1890 as "nothing but a green field of wheat stretching away to a white country house, surrounded by a white wall with a single tree" (W23).

The compositional formula—a planar disposition of dominant foreground wheat field, high horizon, and very little sky—was used in Arles for a snow scene (F391) and a view of a wheat field (F411); there is a comparable layout in an Auvers landscape (F797). The Phillips painting shows once more how van Gogh brilliantly adapted color and brushstroke to the demands of the motif rather than arbitrarily superimposing a preconceived stylistic scheme. In his dialogue with nature he responded intensely to the effects of weather and light. This can be demonstrated by comparing the present view of a wheat field with views of vineyards (cat. 64) and of poppies (cat. 66), all three painted within the same week. Of the three, the Phillips painting is the most instantaneous and the least worked: in parts it is sparsely painted, especially at the upper right, with untouched canvas functioning as the roof of the small house. Gentle and unassertive, it is reminiscent of some of Sisley's views of Louveciennes of 1872–73, not least in the inclusion of the small *manoir* behind the enclosing wall.

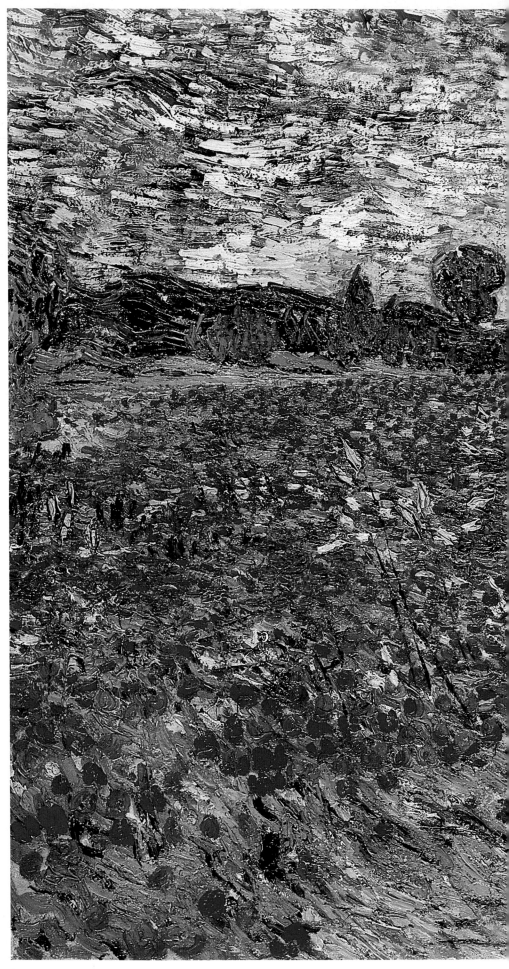

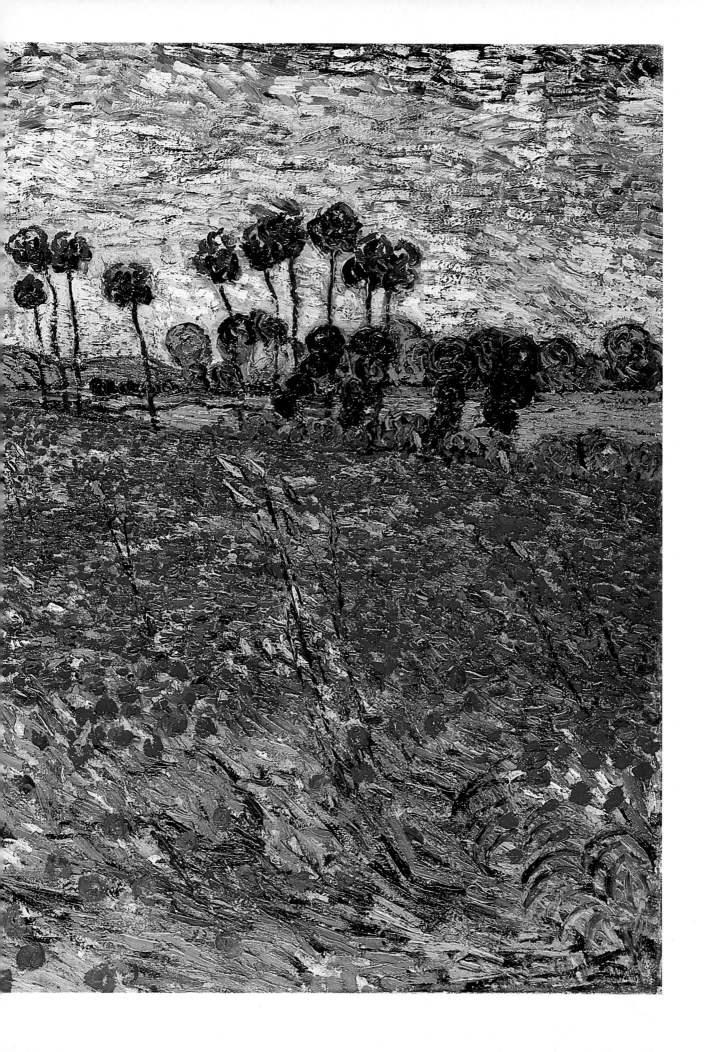

66. Field with Poppies

Oil on canvas, 28¾ × 36 in. (73 × 91.5 cm.)
Unsigned
Rijksdienst Beeldende Kunst, The Hague
F636 H755 JH2027
Reproduced on pages 238–39

In a tremendous outpouring of landscape paintings that characterized his activity in the week after Theo and Jo's visit to Auvers on Sunday 8 June 1890, van Gogh demonstrated how amazingly varied his work could be: two views of "houses in the greenery" (one may be cat. 63); a Sisley-like view of a field of green wheat (cat. 65); the magnificent panorama now in the Pushkin Museum, Moscow (F760); and finally, the present "field of poppies in alfalfa," which he reported to Theo on 14 June (LT641). The motif is reminiscent of several paintings by Monet. But van Gogh's handling is drier, heavier, more insistently graphic, especially in the brick-like strokes of the sky. The color too has none of Monet's delicate luminosity. Unique among the Auvers landscapes are the supremely simplified treatment of the trees and the dense spread of the poppies across the field.

Van Gogh's mobility during the second week of June was as remarkable as his productivity. He produced a body of paintings striking for their sustained quality and easy adaptability to the needs of each motif. Locating the motifs, however, is often difficult: this generalized landscape, for example, has no identifying landmark or building. But there is a suggestion of a tree-bordered stream that will eventually join the river Oise, indicating that the view must have been taken in the valley rather than on the plain above Auvers. Compare two drawings showing small streams, F1578 (often incorrectly placed in Saint-Rémy) and F1628.

67. Wild Flowers and Thistles in a Vase

Oil on linen, mounted on canvas, 26⅜ × 18½ in. (67 × 47 cm.)
Unsigned
Private collection
F763 HXV JH2030

"At the moment I am working on two studies, one a bunch of wild plants, thistles, ears of wheat, and sprays of different kinds of leaves—the one almost red, the other bright green, the third turning yellow," van Gogh told Theo on 17 June 1890 (LT642). What he did not mention was that his frenzy of activity during the previous week had left him without canvas. *Wild Flowers and Thistles in a Vase* was painted on a red-striped linen hand towel of the kind seen hanging in *Van Gogh's Bedroom* (F482). Later relining has obscured this original support (which has erroneously been thought to be paper). He used the same kind of linen towel in his first painted study of Daubigny's garden (F765); that picture has not been relined, and the original support, with its distinctive red stripes, is still visible. It is not merely coincidental that he referred to *Daubigny's Garden* in the same letter in which he described the present still life.

Van Gogh's account of this still life is precise not only in its inventory of contents but also in its color descriptions of the three kinds of leaves: "almost red," "bright green," and "turning yellow."

Although he wrote on 3 June that Dr. Gachet's house was "full like an antiques dealer's of things that are not always interesting," but that nonetheless "there is always something for arranging flowers in or for a still life" (LT638), he produced few still lifes in Auvers. *Wild Flowers and Thistles in a Vase* is the only documented example.

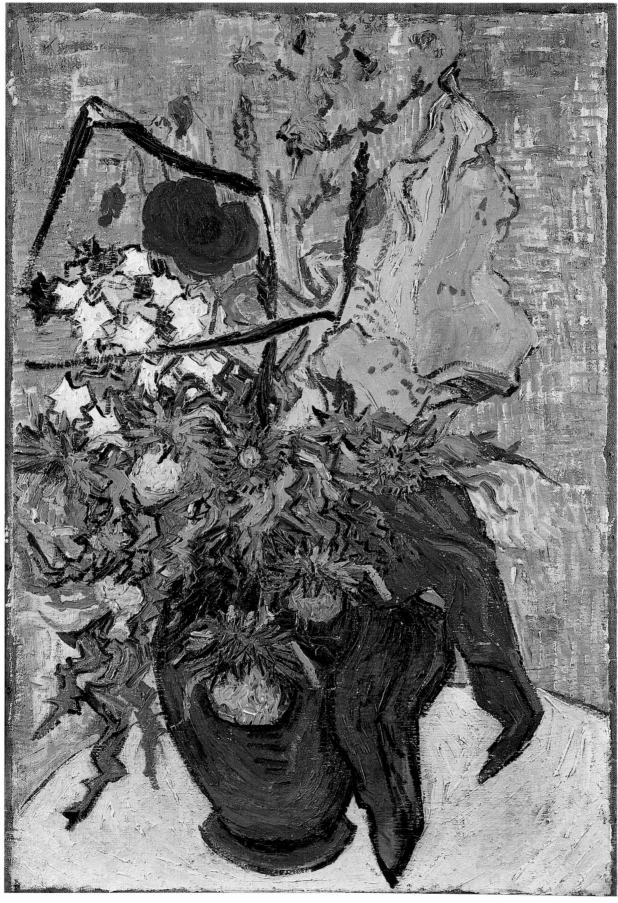

67

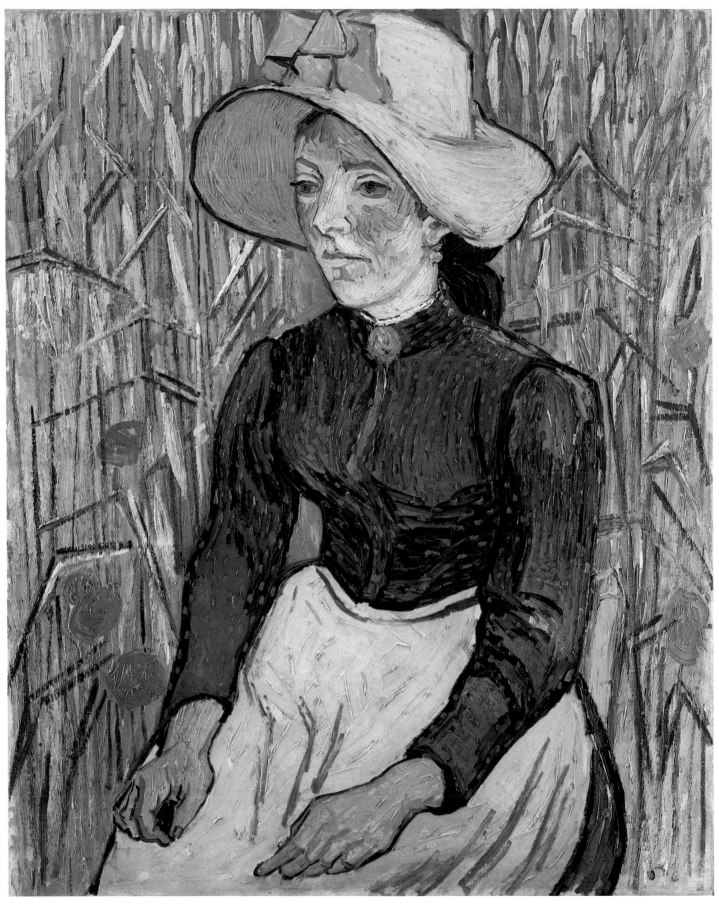

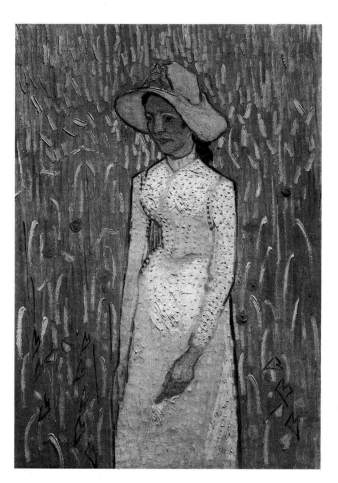

Fig. 57. Sketch of *Peasant Woman with Straw Hat Sitting in the Wheat* (LT646). Rijksmuseum Vincent van Gogh (Vincent van Gogh Foundation), Amsterdam

Fig. 58. *Peasant Woman Standing in the Wheat* (F788). Oil on canvas, 26 x 17¾ in. (66 x 45 cm.). National Gallery of Art, Washington, D.C. Chester Dale Collection

68. Peasant Woman with Straw Hat Sitting in the Wheat

Oil on canvas, 36¼ × 28¾ in. (92 × 73 cm.)
Unsigned
Private collection

F774 H766 JH2053

In mid-June 1890, van Gogh reported to Gauguin: "I am trying to do some studies of wheat…nothing but ears of wheat with green-blue stalks, long leaves like ribbons of green shot with pink, ears that are just turning yellow, edged with the pale pink of the dusty bloom—a pink bindweed at the bottom twisted round a stem. Over that, against a vivid yet tranquil background, I should like to paint some portraits" (LT643).

Van Gogh painted his closeup study of wheat (F767). And his plan to combine an outdoor portrait with a background of wheat was realized by the end of June. On 2 July he sent Theo three small sketches on a page of a letter. One of them (fig. 57) shows "a peasant woman, big yellow hat with a knot of sky-blue ribbons, very red face, rich blue blouse with orange spots, background of ears of wheat. It is a size 30 canvas, but I'm afraid it's really a bit coarse" (LT646).

While the pose has some points of resemblance to *La Berceuse* (F504), the turn and, indeed, the modeling of the head show affinities with van Gogh's first portrait of Madame Roulin (F503). There is another version of the painting, in which the same model is shown standing against the wheat (fig. 58). And the same peasant girl, without a hat and without the background of wheat, was painted in *profil perdu* (F518).

69. Trees

Oil on canvas, 28¾ × 36¼ in. (73 × 92 cm.)
Unsigned
Collection Joseph H. Hazen
F817 H803 JH1319

This magical *sous-bois* has sometimes been thought to have been painted in Paris in 1887—by comparison, presumably, with F305–F309, F309a, and F362. But while all these show *sous-bois*, they are painted in the distinctively adapted Impressionist technique that van Gogh used in Paris. By contrast, the present painting contains the structured strokes, articulating the sky and parts of the ground alike and subtly interplaying with the tender line that contours the young trees, that can be found only in certain Auvers works. The most convincing comparison can be made with the Detroit *Bank of the Oise at Auvers* (cat. 70), in the morphology of brick-shape strokes, distinct and particularized, and in the allover manner of surface articulation. More specifically, the slender trunks and their luxuriant foliage on the wooded bank in the Detroit canvas could easily be interchanged with those in the present work.

Neither picture is mentioned in van Gogh's letters. Although they were probably painted in July, their note of joyous celebration provides a striking contrast to the so-called tragic pictures of van Gogh's last weeks (see cat. 83, 85).

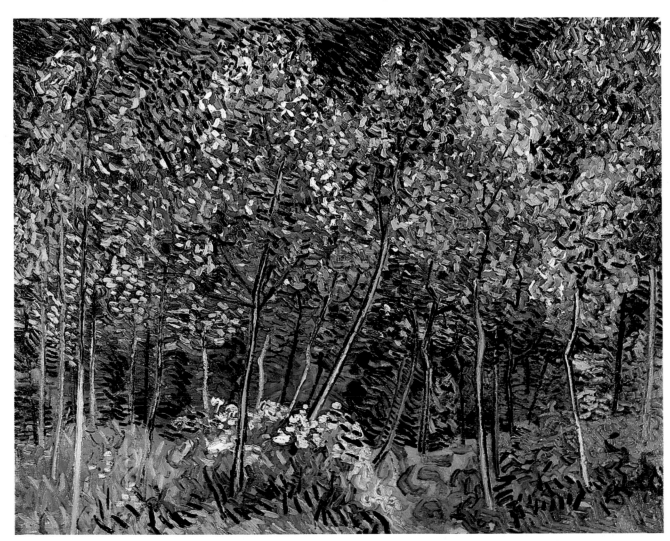

70. Bank of the Oise at Auvers

Oil on canvas, 28⅞ × 36½ in. (73.3 × 93.7 cm.)
Unsigned
Detroit Institute of Arts. Bequest of Robert H. Tannahill

F798 H785 JH2021

Reproduced on pages 246–47

Van Gogh seems to have spent little time by the river Oise. A couple of chalk drawings, F1627 and F1629, take in views across the river, while the more ambitious Tate gouache (cat. 74) includes it in a distant prospect. Only once does van Gogh provide us with an oil painting of the river—the present *Bank of the Oise at Auvers.*

Aptly called La Grenouillère (Frog Pond) by de la Faille and others, the motif is reminiscent of Monet's and Renoir's 1869 paintings of the Seine at Croissy, much closer to Paris. Auvers, despite the railroad, was too far from Paris to attract Parisians in large numbers. But it too had its pleasure spots by the Oise, where boating, yachting, drinking, and dancing took place. It is one of these, situated at Chaponval, that van Gogh depicts. The postcard view of about 1900–1905 (fig. 59), in the similarity of the relationship of boats to bank, is unmistakably that of the location of *Bank of the Oise at Auvers.*

The canvas probably dates from July 1890. In facture it can be compared with *Trees* (cat. 69). In mood it projects a hedonistic view of summer, the two women, one fishing, the other resting in the boat, appearing in marked contrast to the peasant woman amid the wheat (cat. 68).

Such boldly accentuated handling together with this particular subject matter suggests the Fauvist work of Maurice Vlaminck (1876–1958) of 1905–6. Interestingly, Vlaminck worked in and around Auvers in the 1920s, but in a style no longer Fauvist.

7651 - CHAPONVAL (S.-et-O.)
Embarcade Lilot · Pêches · Maison BATLLORI · Restaurant-Hôtel de la Halle

Fig. 59. Bank of the Oise at Chaponval. Postcard, c. 1900–1905.
Bibliothèque Nationale, Paris

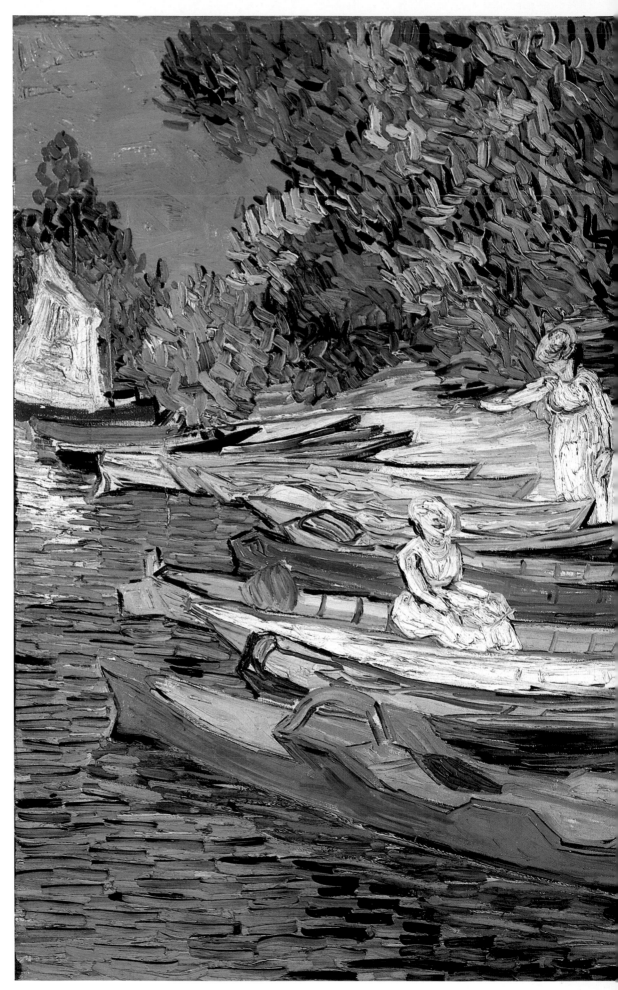

70

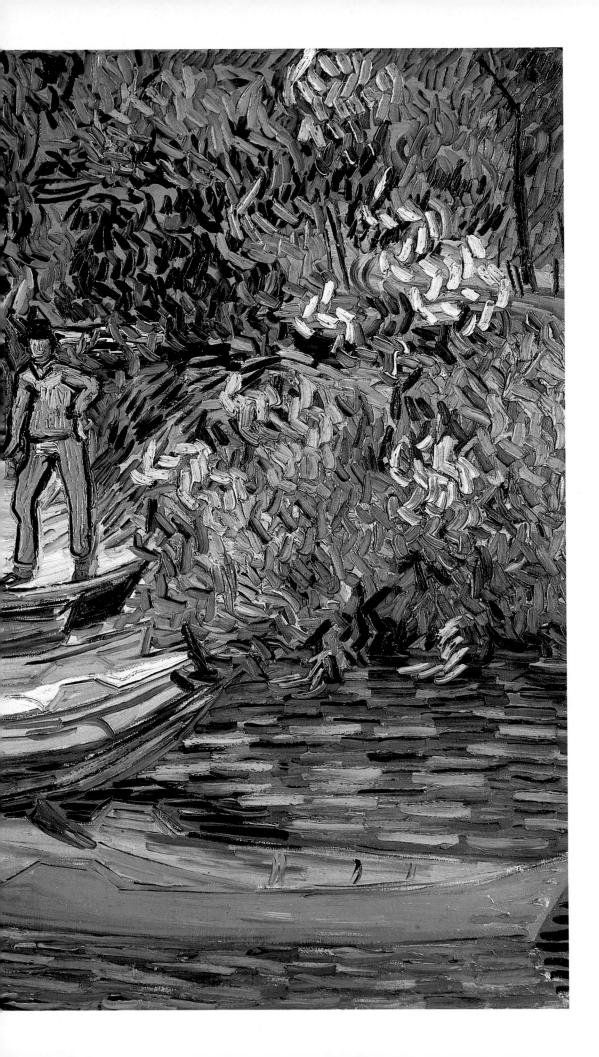

71. Village Street in Auvers

Oil on canvas, 28¾ × 36¼ in. (73 × 92 cm.)
Unsigned
Ateneumin Taidemuseo, Helsinki. Antell Collection
F802 H790 JH2001

In 1891, a small memorial show of van Gogh's work was included in the Salon des Indépendants. One of the catalogue entries read: "1204, Village (dernière esquisse)." This allegedly "last painting" has been identified as the Helsinki canvas (Chatelet, pp. 439–42).

The entry raises many questions. Who provided the information? Was it perhaps Andries Bonger, who was at Auvers for van Gogh's funeral and who, with his sister, Jo, assumed the task of preparing an inventory of van Gogh's oeuvre after his death? And if so, did its being the "dernière esquisse" depend on some kind of oral tradition passed on by Ravoux? Or was it simply an assumption based on the seemingly unfinished state of the picture, especially in the sky? Perhaps evidence from unpublished early inventories and other archives will throw some light on the problem.

What is certain is that van Gogh himself never mentioned the picture. The identification of the motif remains problematic as well.

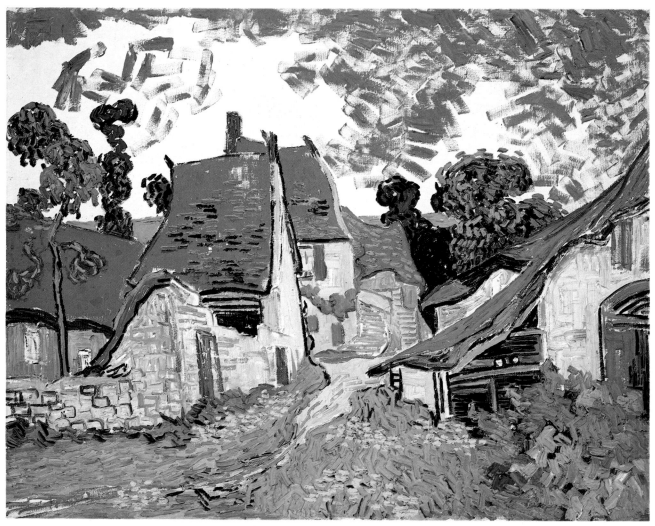

71

This marvelously expressive and aggressively economical painting shows no slackening of the artistic will, no falling away, not the slightest hint of a tormented state of mind. The motif may be elusive, the date may be uncertain, but the painterly attack and control are swift and sure.

72. Thatched Cottages in Auvers

Oil on canvas, 25½ × 32 in. (65 × 81 cm.)
Unsigned
Kunsthaus Zürich

F780 H770 JH2115

Van Gogh's discovery of the picturesque thatched cottage in Auvers was immediately celebrated in his first painting there, *Cottages with Thatched Roofs* (cat. 56, fig. 50). Thereafter, it figured intermittently in his many views of the village. Only in four canvases, however, was it the dominant motif (F758, F792, F806; cat. 82). Here the thatched roofs are very much the subject of the picture.

He included a sketch after the painting (fig. 72, reproduced on page 286) in his last letter to his brother, of 23 July: "I add a sketch of some old thatched roofs" (LT651).

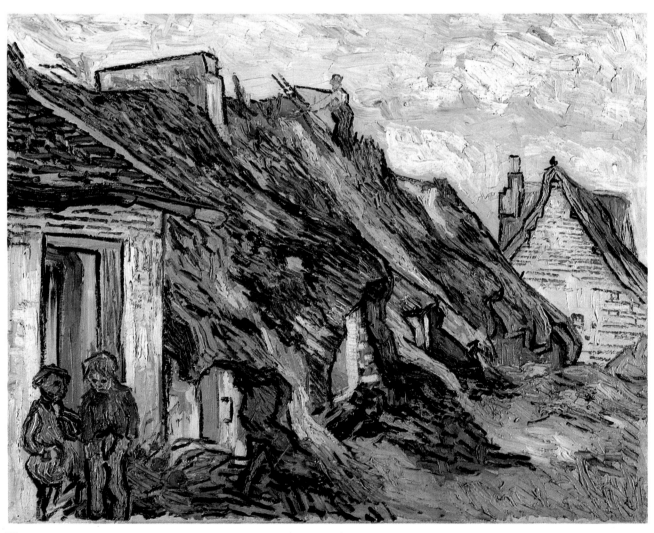

72

The paint is heavily impastoed, as if van Gogh wanted to simulate the rough texture of the thatch itself. But he carries the thick, assertively self-existing strokes into both the sky and the figures of the two children.

The motif was painted in Chaponval, to the west of Auvers, in the same Rue du Gré depicted in the Toledo canvas *Houses at Auvers* (cat. 63), of early June.

Compositionally, in its receding diagonal of cottages, with a closing-off at the end of the street, the picture is extremely close to *Street in Saintes-Maries-de-la-Mer* (F420), of June 1888.

73. Wheat Fields

Oil on canvas, 28¾ × 36¼ in. (73 × 92 cm.)
Unsigned
Museum of Modern Art, Carnegie Institute, Pittsburgh. Acquired through the
 generosity of the Sarah Mellon Scaife family, 1968

F781 H807 JH2102

Writing to his mother and Wil on about 11 July 1890, van Gogh described his fascination with the vast, flat plain above Auvers: "I myself am quite absorbed in the immense plain with wheat fields against the hills, boundless as a sea, delicate yellow, delicate soft green, the delicate violet of a ploughed and weeded piece of ground, checkered at regular intervals with the green of flowering potato plants, everything under a sky of delicate blue, white, pink, violet tones" (LT650).

This description could be applied both to the double-square canvas from

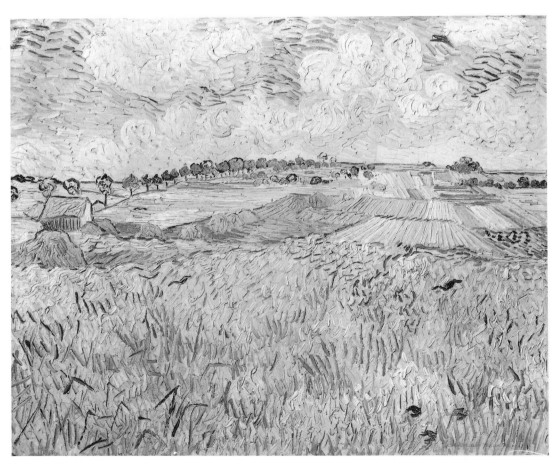

Fig. 60. *Wheat Fields* (F782). Oil on canvas, 29 x 36¼ in.
(73.5 x 92 cm.). Bayerische Staatsgemäldesammlungen, Munich

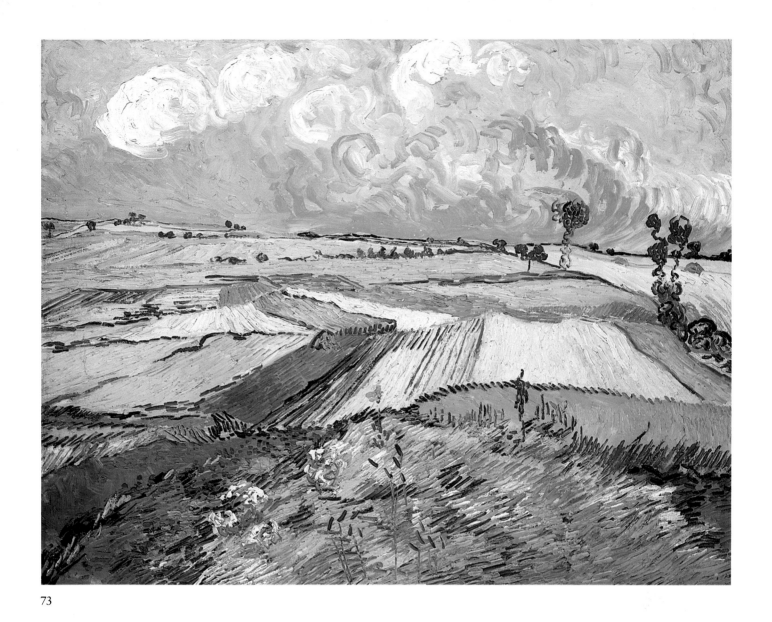

73

Vienna (cat. 78), completed before 24 June, and to the present canvas, which shows part of the same field system but from a slightly different angle. That is, it does not necessarily refer to a specific painting.

Van Gogh's only unequivocal reference to the present canvas occurs in his last letter to Theo, of 23 July. There, among four sketches of recently completed paintings, were two after motifs taken in the immense plain—one (fig. 73, reproduced on page 287) after the present painting, the other (fig. 74) after a painting now in Munich (fig. 60)—with the brief description, "two size 30 canvases representing vast fields of wheat after the rain" (LT651).

It has been suggested that when van Gogh referred to "vast fields of wheat under troubled skies" in an earlier letter, of about 10 July (LT649), he was alluding to these two paintings. But "after the rain" is surely different from "under troubled skies"; and in any case, by comparison with the skies in *Wheat Field Under Clouded Sky* (cat. 83) and *Crows Over the Wheat Field* (cat. 85), those in the Pittsburgh and Munich canvases are not "troubled." It seems much more likely that these paintings were completed after 10 July, probably during the week before van Gogh's last letter, of 23 July.

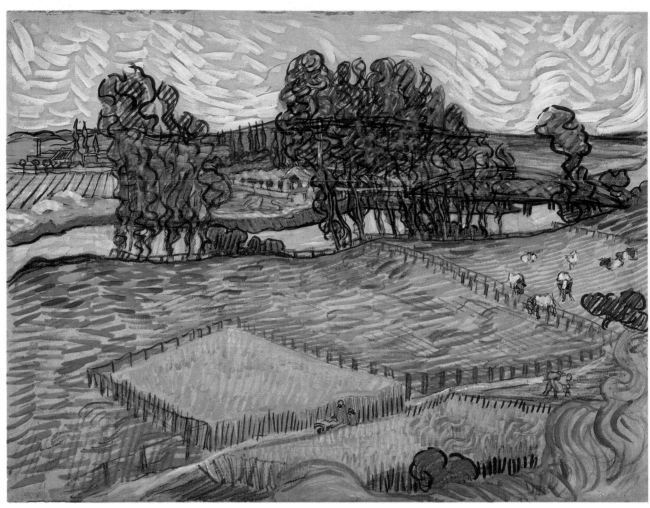

74

74. Landscape with Bridge Across the Oise

Pencil, brush and gouache on pink Ingres paper, 18¾ × 24¾ in.
 (47.8 × 62.8 cm.)
Watermark: AL (in oval) PL Bas
Unsigned
The Trustees of the Tate Gallery, London

F1639 JH2023

The river Oise was the most important motif in Charles-François Daubigny's views of Auvers. Indeed, Daubigny (1817–1878) largely ignored the village, apart from its orchards, vines, and wheat fields. Almost the opposite occurred with van Gogh. The river appears in only one painting, *Bank of the Oise at Auvers* (cat. 70). It is also seen in two small drawings, F1627 and F1629. But the only extensive view is in the Tate Gallery's gouache. Unlike the two early brush drawings, cat. 56 and 57, this one displays a wide range of color. Unfortunately, the pinks in the sky have faded.

 This panoramic view complements that in *Landscape with Carriage and Train* (F760), now in Moscow: the one from the east in Montcel, the other from the west, near Dr. Gachet's house. The vantage point is similar to that in a postcard of about 1905 (fig. 61).

Fig. 61. Auvers-sur-Oise. Postcard, c. 1905.
Collection Ronald Pickvance

"Here one is far enough from Paris for it to be the real country," van Gogh wrote to Theo on 25 May, "but nevertheless how changed it is since Daubigny. But not changed in an unpleasant way; there are many cottages and various modern middle-class dwellings very radiant and sunny and covered with flowers. This in an almost lush country, just at the moment when a new society is developing in the old, is not at all unpleasing; there is so much well-being in the air. I see, or think I see, in it a quiet like a Puvis de Chavannes, no factories, but lovely, well-kept greenery in abundance" (LT637). In fact, the Tate gouache combines old and new. Peasants at work, cattle in the fields, poplars by the river: an idyll of the "real country." But there are modern intrusions. The suspension bridge over the Oise had only recently been inaugurated, on 22 December 1889; and beyond it is a large factory chimney, reminiscent of some of Pissarro's views of Pontoise of 1872–73. In these contrasts of old and new, agrarian and industrial, true country and encroaching modern advances, van Gogh presents an unusual aspect of the Oise, and one that would have surprised Daubigny.

75. Women Crossing the Fields

Oil on laid paper, mounted on canvas, 12⅝ × 24 in. (32 × 61 cm.)
Unsigned
Marion Koogler McNay Art Museum, San Antonio. Bequest of
 Marion Koogler McNay
F819 H750 JH2112

Writing to Theo on 26 or 27 June, van Gogh discoursed on the contrast between art and nature, observation and distillation, a Puvis de Chavannes painting and a

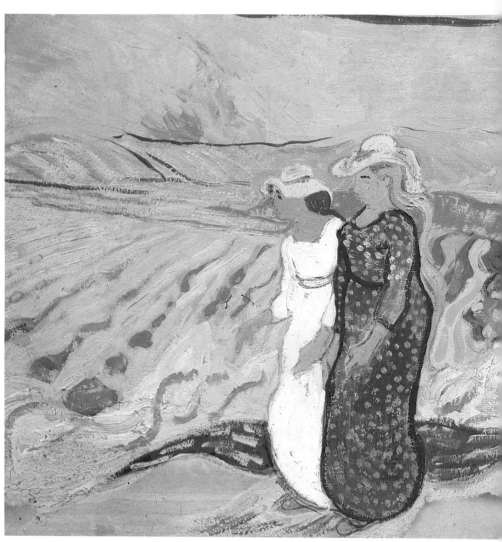

75

walk in the country. "In clothes you see combinations of very pretty light colors; if you could make the people you see walking past pose and do their portraits, it would be as pretty as any period whatever in the past, and I even think that often in nature there is actually all the grace of a picture by Puvis, *Between Art and Nature*. For instance, yesterday I saw two figures: the mother in a gown of deep carmine, the daughter in pale pink with a yellow hat without any ornament, very healthy country faces, browned by fresh air, burned by the sun; the mother especially had a very, very red face and black hair and two diamonds in her ears" (LT645).

One result of van Gogh's deliberations was this unusual, jewellike frieze. It is the tangible answer to Puvis de Chavannes's *Inter Artes et Naturam* (reproduced on pages 76–77), which haunted van Gogh's imagination from the moment he saw it at the Salon du Champ de Mars just before he left Paris for Auvers. He wrote of it to Wil on 4 June: "There is a superb picture by Puvis de Chavannes at the exhibition. The figures of the persons are dressed in bright colors, and one

cannot tell whether they are costumes of today or, on the other hand, clothing of antiquity" (W22).

In van Gogh's composition, in which he combines Auvers scenery, including flowering potato plants and green wheat, with two women in modern clothes of "pretty light colors," he generalizes the forms of the landscape and simplifies the modeling of the figures, enclosing the nearer figure in a single planar contour that calls to mind the work of Gauguin and of Bernard. He has changed the colors of the clothes from those he observed in nature: the nearer of the two women wears a dress colored identically to that of the figure in *Peasant Woman with Straw Hat Sitting in the Wheat* (cat. 68), orange spots on blue.

It seems probable that *Women Crossing the Fields* dates from the end of June, making it contemporaneous with the three portraits of the young peasant woman (see cat. 68).

To make this friezelike format—almost a double square—van Gogh must have cut down a standard full-size sheet. The paper has darkened considerably.

76. Farmhouse in a Field

Black and white chalks, blue pastel, reed pen and ink on faded
 blue-gray laid paper, 18⅝ × 24½ in. (47.3 × 62.2 cm.)
Watermark: MBM
Unsigned
The Art Institute of Chicago. Bequest of Kate L. Brewster

F1642 JH1994

The labors of the field are represented only occasionally in van Gogh's drawings
from Auvers. Among the ten sheets, this large drawing from Chicago is one of the
most ambitious. Like another large drawing, the *Farm of Père Eloi* (F1653), it
includes a field with a peasant at work and a middle-distance cluster of farm
buildings.

The Chicago drawing has a greater variety of mediums and textures than the
other nine sheets and is more worked all over, including the area of the sky. It is the
most extensively dotted of the late drawings. Much of the decorative graphic
shorthand responds to the various kinds of growth represented: the jigsaw shapes
in the foreground, for example. The dense organic spread can be contrasted with
the laconic structure of the drawing *Haystacks* (cat. 77).

76

77. Haystacks

Black chalk, reed pen and brown ink on Ingres paper,
 18¼ × 24 in. (46.5 × 60.7 cm.)
Unsigned
Watermarks: E.D. & C.; PL Bas
Whitworth Art Gallery, University of Manchester

F1643 JH2119

This is the only drawing by van Gogh that shows part of the plain above Auvers and the valley of the Oise. The diagonalized path, the horizontal mass of the haystacks, and the high horizon line parallel to the picture plane also make it one of his simplest compositions. With the sky left untouched and the track through the fields at lower right barely worked, van Gogh largely confined his activity to a virtual triangle, broken by the top of the haystack. He conveys the limitless space of the plain without buildings or figures—just two crows and some distant trees. Similar elements (though without the crows) are present in the painting *Field with Haystacks* (cat. 87), but they are seen in a quite different relationship. Like that painting, the Whitworth drawing must date from July.

77

78

78. Wheat Fields

Oil on canvas, 19⅝ × 39¾ in. (50 × 101 cm.)
Unsigned
Österreichische Galerie, Vienna
F775 H808 JH2038

On 17 June 1890, van Gogh received a package of paints and canvas from Theo. He had been eagerly awaiting it, having probably run low on painting materials. A week later he told his brother that he had done two portraits of Adeline Ravoux, the innkeeper's daughter (F768, F769), and continued: "Then I have a canvas 40 inches long and only 20 inches high, of wheat fields" (LT644). A momentous statement. This is the first announcement of the double-square format that

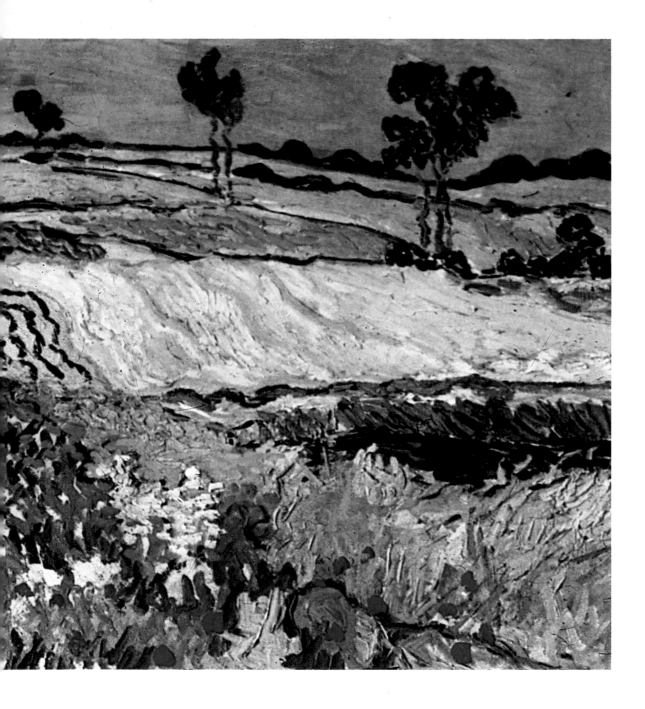

henceforth van Gogh would work on consistently in Auvers. The other paintings completed by 24 June (cat. 79, 80) were referred to in the same letter.

Writing again, probably on 26 or 27 June, he once more referred to this canvas, describing the color as "pale green and greenish yellow" (LT645). Finally, in his letter of 2 July, he enclosed a sketch of it (fig. 62): "the horizontal landscape with fields, like one of Michel's, but then the color is soft green, yellow and green blue" (LT646). The reference is to Georges Michel (1763–1843), whose atmospheric gray-brown landscapes of Montmartre were familiar to both Theo and Vincent.

No other landscape gives such an extensive panoramic view of the complex interlacing wheat fields on the plain. As if by sleight of hand, it is slowly revealed. The rich handling of paint and the rhythmic changes of pace go hand in hand with the expressive, elaborately textural brushstrokes: wriggles, blobs, and single-

Fig. 62. Sketch of *Wheat Fields* (LT646). Rijksmuseum Vincent van Gogh (Vincent van Gogh Foundation), Amsterdam

color areas, with horseshoe shapes in the lower left.

Initially, he conceived of the picture as a pendant to *Undergrowth with Two Figures* (cat. 79). After painting *Marguerite Gachet at the Piano* (cat. 81), however, he thought of it as a pendant to that picture. Almost a month after completing this landscape, van Gogh painted the *Wheat Fields* now in Pittsburgh (cat. 73), which shows the same fields but from a slightly different angle.

79. Undergrowth with Two Figures

Oil on canvas, 19⅝ × 39½ in. (50 × 100.4 cm.)
Unsigned
Cincinnati Art Museum. Bequest of Mary E. Johnston
F773 H764 JH2041
Reproduced on pages 262–63

Undergrowth with Two Figures is among the first three double-square canvases reported as completed by 24 June. Van Gogh described it as a pendant to the *Wheat Fields* (cat. 78), "of undergrowth, lilac poplar trunks and, at their foot, grass with flowers, pink, yellow, white and various greens" (LT644). In a subsequent letter, it was sketched (fig. 63) and described again: "the undergrowth around poplars, violet trunks running across the landscape, perpendicular like columns; the depths of the wood are blue, and at the bottom of the big trunks the grassy ground full of flowers, white, pink, yellow and green, long grass turning russet, and flowers" (LT646).

The *sous-bois* motif has a long history in van Gogh's oeuvre, from one of his first paintings in The Hague of August 1882 (F8) to the more recent views done in the asylum garden at Saint-Rémy (F609, F746; cat. 50). In these Saint-Rémy pictures, however, the view is close, almost claustrophobic. Here in the Auvers canvas, the view is opened up, the trees receding as in a formalized park or garden—the Tuileries Gardens in Paris, for example. It seems probable that the motif was taken on the grounds of the château of Auvers.

Fig. 63. Sketch of *Undergrowth with Two Figures* (LT646). Rijksmuseum
Vincent van Gogh (Vincent van Gogh Foundation), Amsterdam

The figures of two lovers provide scale and a further instance of van Gogh's frequent use of this symbol (see, for example, cat. 54). In a list of his works deposited at Tanguy's made in April 1894, the painting was called "horizontal canvas (woods with two figures in the middle)."

80. Landscape with the Château of Auvers at Sunset

Oil on canvas, 19⅝ × 39½ in. (50 × 100 cm.)
Unsigned
Rijksmuseum Vincent van Gogh (Vincent van Gogh Foundation),
　Amsterdam
F770 H762 JH2040
Reproduced on pages 264–65

This painting is one of the three double-square canvases reported on 24 June as recently completed: "an evening effect—two pear trees quite black against a yellowing sky, with some wheat, and in the violet background the château surrounded by somber greenery" (LT644).

The château of Auvers, dating from the seventeenth century, is most dominant when seen from across the Oise valley. Van Gogh chose to observe it from less far away, at ground level, reducing its classical grandeur to a series of rapid and anonymous marks in the background. The sunset effect is conveyed by heavy orange and yellow strokes in the sky, but the sun itself is not seen. Not once in Auvers did van Gogh paint the sun in his landscapes, as he did so often in Arles and Saint-Rémy.

The canvas was almost certainly completed in one session; the rapidity of execution can be judged by the expressive, fretworklike touches of Prussian blue around the two pear trees. Before the paint surface was completely dry, the painting must have been pressed against another recently painted canvas, picking up some foreign color here and there. The château of Auvers does not appear elsewhere in van Gogh's work.

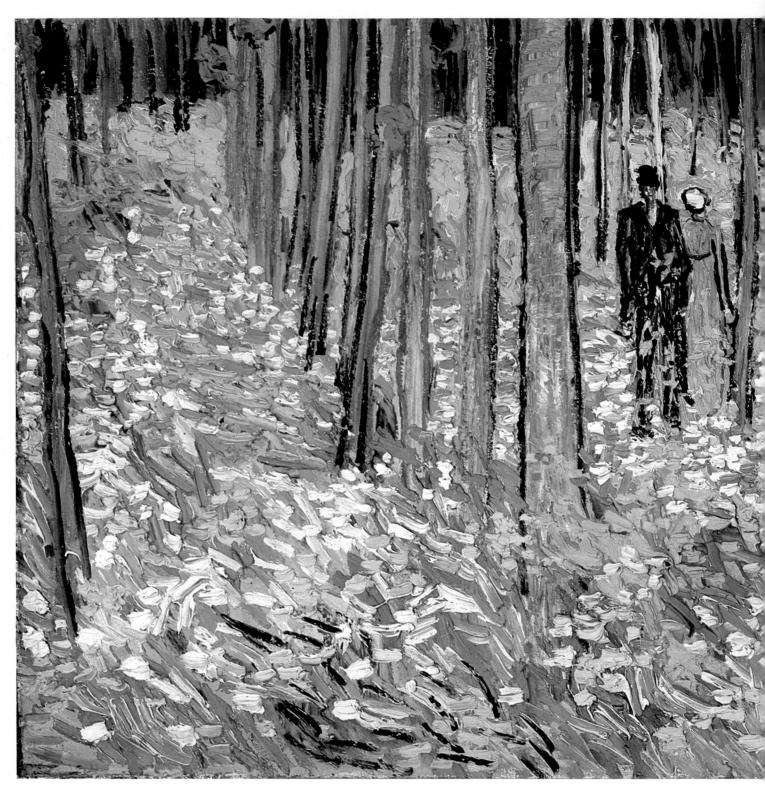

79

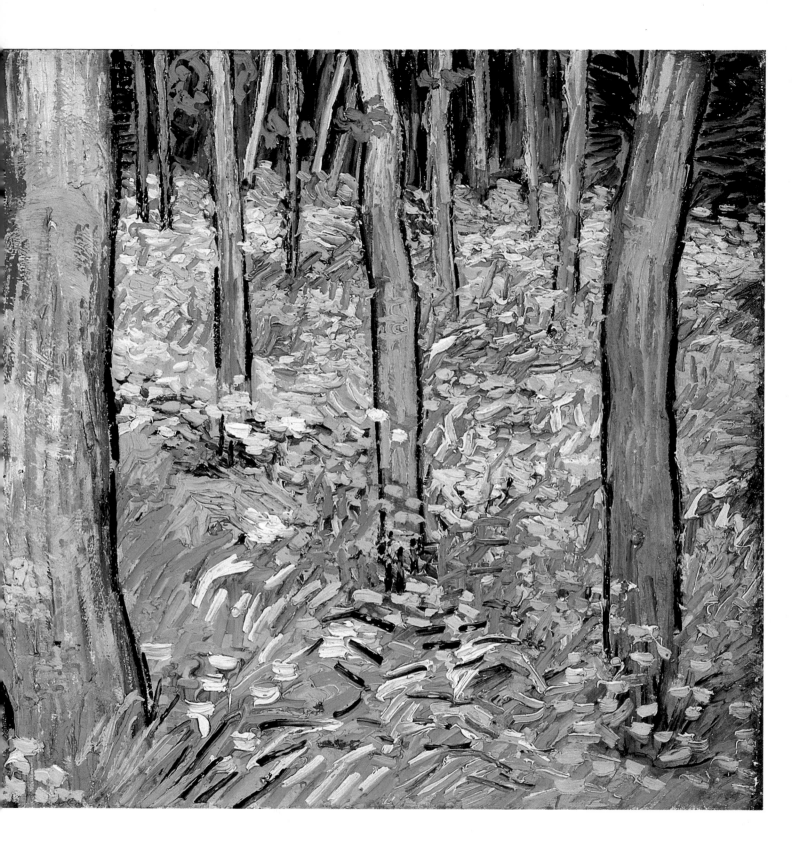

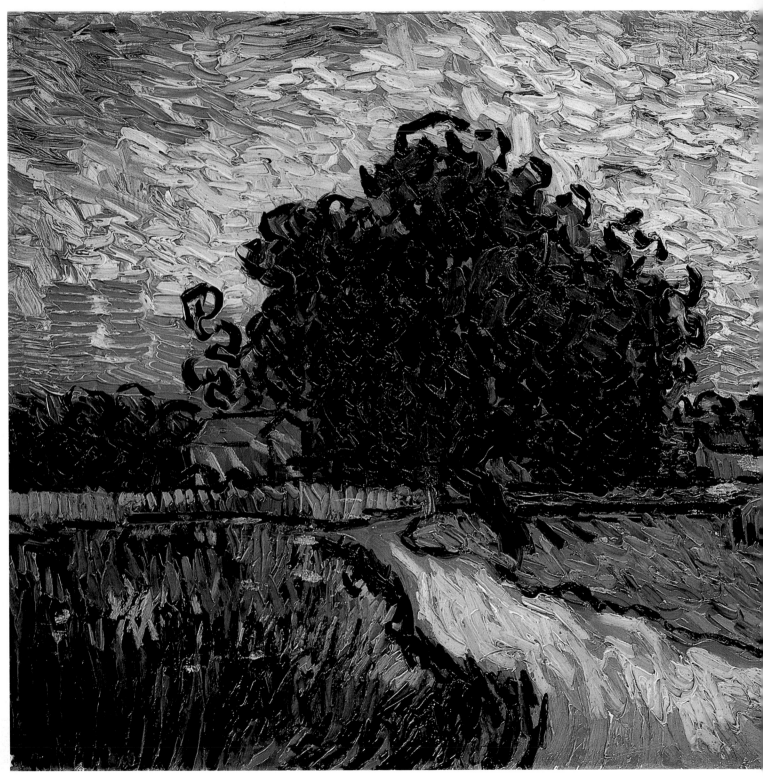

80

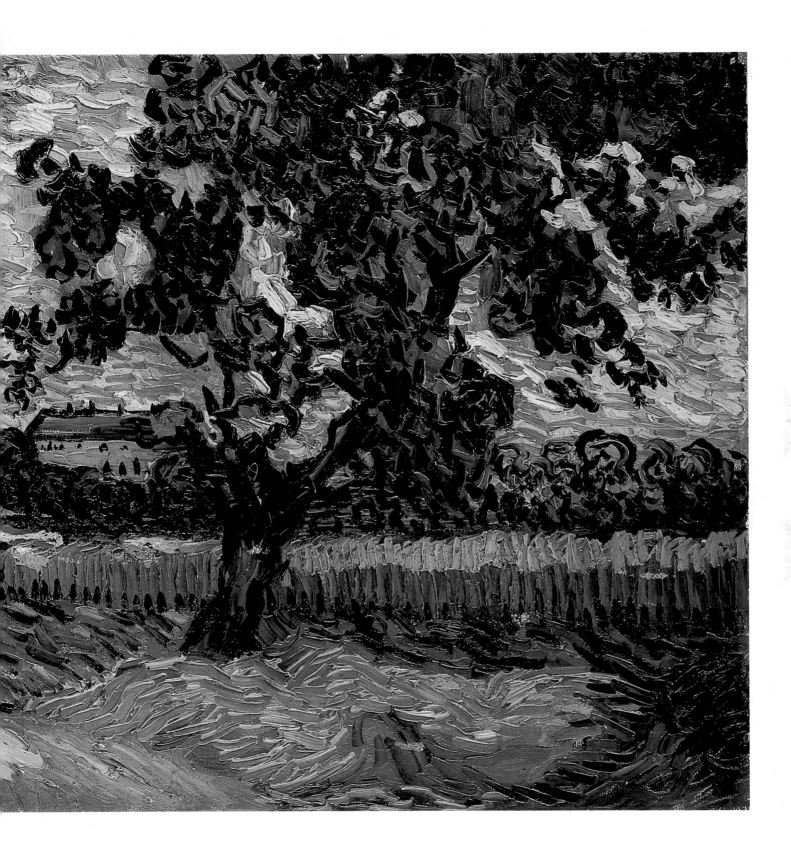

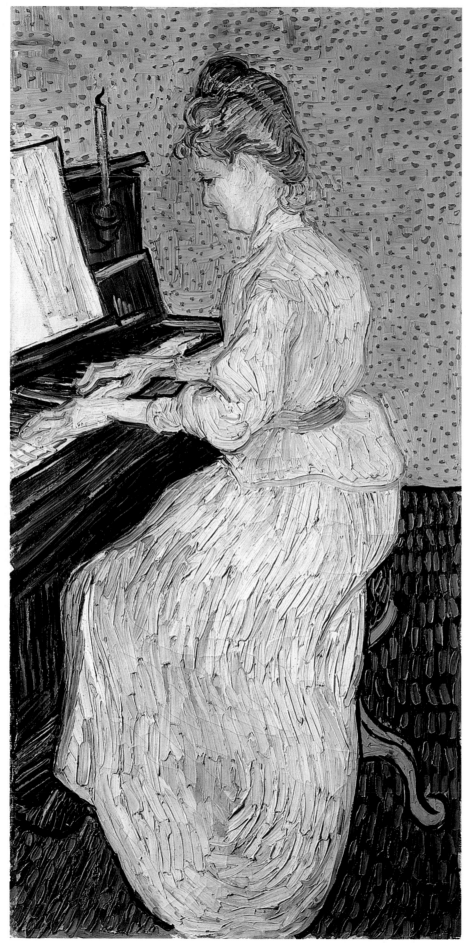

81

81. Marguerite Gachet at the Piano

Oil on canvas, 40⅜ × 19⅝ in. (102.6 × 50 cm.)
Unsigned
Oeffentliche Kunstsammlung, Kunstmuseum Basel
F772 H769 JH2048

In his letter of 3 June 1890, in which he described his portrait of Dr. Gachet, van Gogh added: "I shall most probably also do the portrait of his daughter, who is nineteen years old [*sic*], and with whom I imagine Jo would soon be friends" (LT638). However, three weeks later, by 24 June, he was still hoping to do her portrait "next week" (LT644). Writing again on about 26 or 27 June, he was able to tell Theo: "Yesterday and the day before I painted Mlle Gachet's portrait, which I hope you will see soon; the dress is pink, the wall in the background green with

Fig. 64. Sketch of *Marguerite Gachet at the Piano* (LT645).
Present location unknown

Fig. 65. *Marguerite Gachet at the Piano* (F1623r). Black chalk,
11¾ x 7½ in. (30 x 19 cm.). Rijksmuseum Vincent van Gogh
(Vincent van Gogh Foundation), Amsterdam

orange spots, the carpet red with green spots, the piano dark violet; it is 40 inches high by 20 inches wide. It is a figure that I enjoyed painting—but it is difficult" (LT645). He included in the letter a sketch of the portrait (fig. 64), and a second sketch showing how he conceived the portrait as a pendant to *Wheat Fields* (cat. 78). "I have noticed that this canvas goes very well with another horizontal one of wheat, as one canvas is vertical and in pink tones, the other pale green and greenish yellow, the complementary of pink; but we are still far from the time when people will understand the curious relation between one fragment of nature and another, which all the same explain each other and enhance each other. But some certainly feel it, and that's something" (LT645).

The portrait has not been varnished or relined. The canvas is on a stretcher of simple laths of wood, which must have been specially made for van Gogh by the Auvers carpenter Levert, a friend of Ravoux's. It remained in the Gachet family collection until 1934. A drawing in Amsterdam (fig. 65) is probably a preliminary study to establish the pose.

When van Gogh wrote to Theo that the portrait was finished, he remarked: "[Dr. Gachet] has promised to make her pose for me another time at the small organ. I will do one for you" (LT645). Neither portrait was undertaken.

Marguerite-Clementine Gachet was born on 21 June 1869. She had just celebrated her twenty-first birthday when she sat for van Gogh. All her life she lived in her father's house. She died there on 8 November 1949.

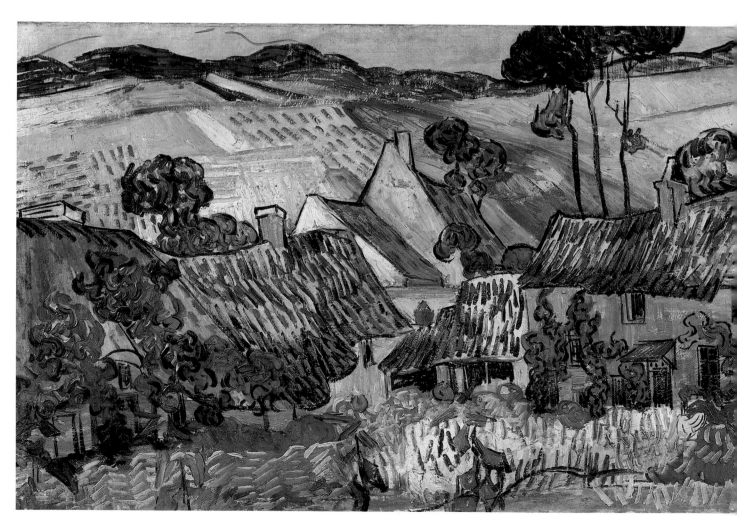

82. Thatched Cottages Against a Hill

Oil on canvas, 19⅝ × 39½ in. (50 × 100 cm.)
Unsigned
The Trustees of the Tate Gallery, London

F793 H781 JH2114

This painting shows the most extensive view of thatched cottages in all van Gogh's Auvers canvases. The motif was painted in the western extremity of the village—in Valhermeil, beyond Chaponval, where, in 1890, most of the remaining thatched houses were to be found. Van Gogh never worked farther west than this. Today the motif is virtually unrecognizable.

Beyond the cottages a patchwork of fields rises up, "delicate yellow, delicate soft green," as van Gogh described it (LT650). The sky is left almost untouched. The farthest line of hills was probably added at a late stage; certainly the green-black trees were added last. The four large sunflowers at lower left suggest contrived studio additions. In depicting the thatched roofs, van Gogh used three colors that are found in the foreground of *Crows Over the Wheat Field* (cat. 85), pea green, red ocher, and an egg-yolk yellow.

A dating in July—suggested by the yellow-ripening wheat—would seem to be most probable. Part of the same motif can be seen in a small canvas now in Amsterdam (fig. 66), which appears to be an independently observed study rather than a preparation for the Tate painting.

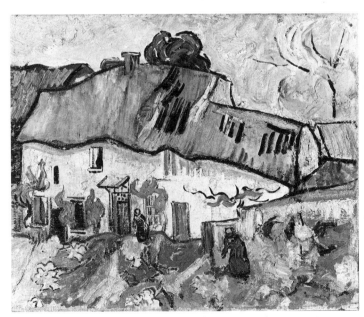

Fig. 66. *Farm near Auvers with Two Figures* (F806). Oil on canvas, 15 x 17¾ in. (38 x 45 cm.). Rijksmuseum Vincent van Gogh (Vincent van Gogh Foundation), Amsterdam

83. Wheat Field Under Clouded Sky

Oil on canvas, 19⅝ × 39½ in. (50 × 100 cm.)
Unsigned
Rijksmuseum Vincent van Gogh (Vincent van Gogh Foundation),
 Amsterdam

F778 H806 JH2097

NOT IN EXHIBITION

Wheat Field Under Clouded Sky is one of van Gogh's most compellingly simple compositions. Land and sky are divided into two horizontal bands, each then broken up into its own shapes and rhythms. Dynamic changes in the size and direction of the brushstrokes help to create the irregular pattern of the fields, dotted only with a few small haystacks. No tree, no building, no figure inhabits this infinity. A more uniformly slablike stroke dominates the sky. It is this picture

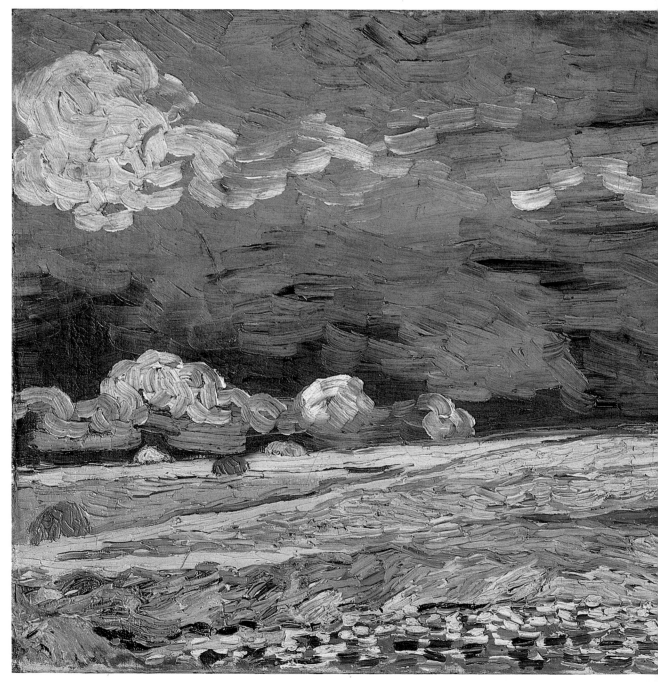

that seems best to echo van Gogh's evocation of the plain of Auvers. Writing to Theo and Jo on about 10 July, he referred to "three more big canvases" that he had completed since his return from Paris on Sunday 6 July. "[Two of them] are vast fields of wheat under troubled skies, and I did not need to go out of my way to try to express sadness and extreme loneliness. I hope you will see them soon—for I hope to bring them to you in Paris as soon as possible, since I almost think that these canvases will tell you what I cannot say in words, the health and restorative forces that I see in the country" (LT649).

The other large canvas can be identified as *Crows Over the Wheat Field* (cat. 85). In the obsessive concern with the dating, decoding, and symbolism of that picture, *Wheat Field Under Clouded Sky* is frequently overlooked. Yet with its fluency of handling, its immediacy of attack, and its supremely lucid execution, its emotive effect is more potent, more subtle, and more sublime. It is perhaps van Gogh's most haunting and elemental creation.

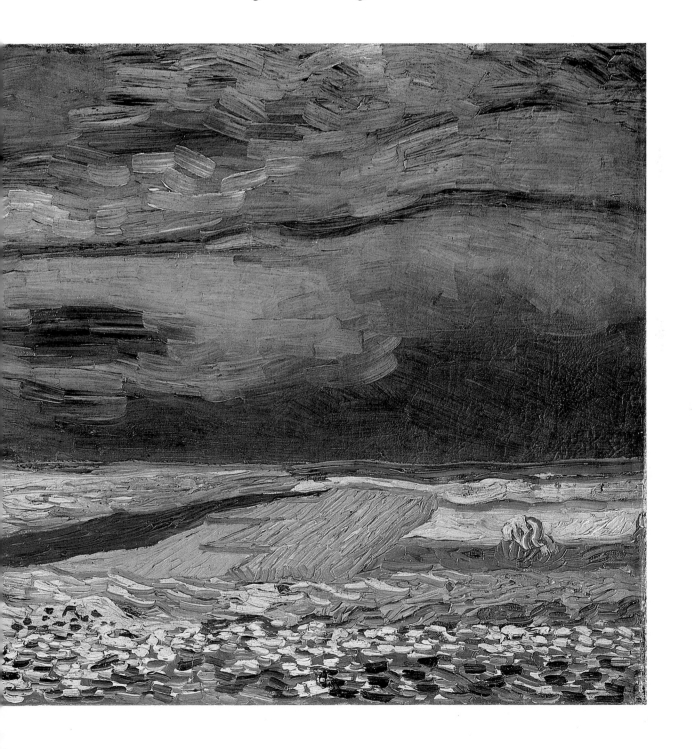

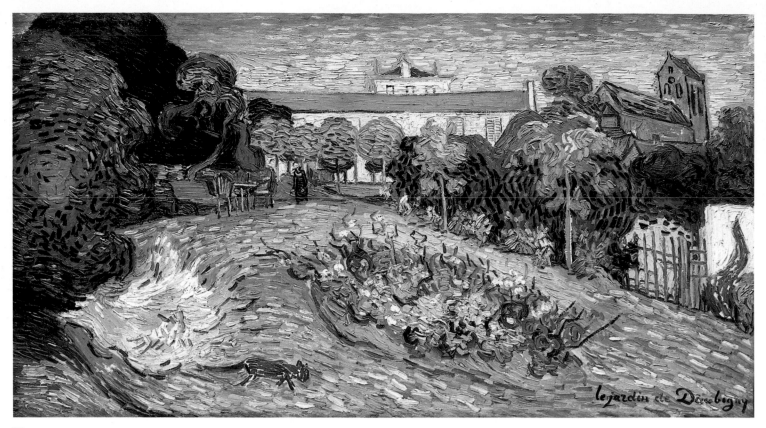

le jardin de Daubigny

84

84. Daubigny's Garden

Oil on canvas, 21¼ × 39¾ in. (54 × 101 cm.)
Inscribed, lower right: le jardin de Daubigny
Rudolf Staechelin Foundation, on extended loan
 to the Oeffentliche Kunstsammlung Basel

F777 H765 JH2105

Early in his stay in Auvers, van Gogh explained to Theo: "Some pictures are vaguely present in my mind; it will take time to get them clear, but that will come little by little" (LT637). By mid-June 1890 he had painted, on a linen towel twenty inches square, a first study of Daubigny's house and garden (fig. 67), and he planned to make "a more important canvas" of it (LT642).

The Barbizon painter Charles-François Daubigny moved to Auvers in 1861, building his own house and studio in the central part of the village, known as Les Vallées. His adoption of Auvers attracted other artists, among them Jean-Baptiste-Camille Corot (1796–1875) and Honoré Daumier (1808–1879). Pictorially, he put Auvers on the map. Just before his death he acquired another house, east of the village, near both the railroad station and the church, though he never actually lived there. But his widow did. "Mmes Daubigny and Daumier, they say, are still living here; at least I am sure that the former is," van Gogh wrote on 21 May (LT636).

Van Gogh's admiration for Daubigny's work was deep and lasting. It was natural that he should want to paint his house and garden, and that he should wish to meet and to talk with Daubigny's widow.

Having said on 17 June that he intended to paint the picture, he confirmed its completion in his letter of about 10 July. Describing two "big canvases" of wheat fields (cat. 83, 85), he continued: "Now the third canvas is Daubigny's garden, a

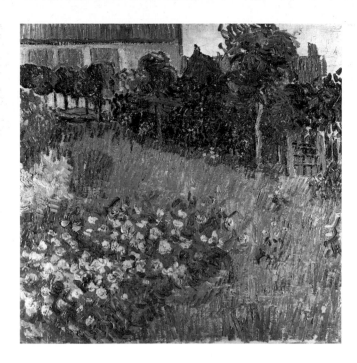

Fig. 67. *A Corner in Daubigny's Garden* (F765). Oil on linen, 20 x 20 in. (51 x 51 cm.). Rijksmuseum Vincent van Gogh (Vincent van Gogh Foundation), Amsterdam

picture I have been thinking about since I came here" (LT649). The present painting, from Basel, is surely the one he refers to.

It has all the signs of a "study done from nature," and the inscription, "le jardin de Daubigny," is in van Gogh's hand. Those who dispute the painting's authenticity vis-à-vis the second version (cat. 89) fail to distinguish between the nature and the function of each work. The second version is clearly the studio repetition, its brushstrokes more structured and consistently controlled. Both pictures have suffered from later repaintings and additions: in the Basel canvas, for instance, most of the sky is by another hand.

In each painting, van Gogh has reconstituted the motif. He has pulled the church of Auvers much closer to the long, low house than it is in reality (fig. 68), and he has made the villa behind the house, the Villa Ida, more visible above the roof line.

The figure shown walking in the garden is Madame Daubigny. She died soon after van Gogh, on 26 December 1890.

Fig. 68. View of Auvers, with Daubigny's house, the Villa Ida, and the Church of Auvers, c. 1936. Ueberwasser, *Le Jardin de Daubigny*, fig. 6

273

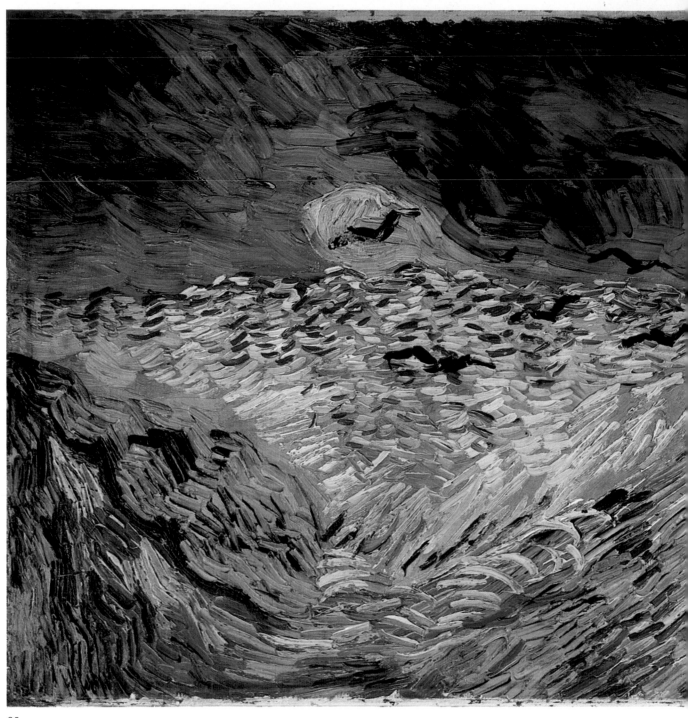

85

85. Crows Over the Wheat Field

Oil on canvas, 19⅞ × 39½ in. (50.5 × 100.5 cm.)
Unsigned
Rijksmuseum Vincent van Gogh (Vincent van Gogh Foundation),
 Amsterdam

F779 H809 JH2117

Crows Over the Wheat Field has attracted a great deal of critical commentary.
Interpretations of its symbolism and meaning have varied enormously. It has been

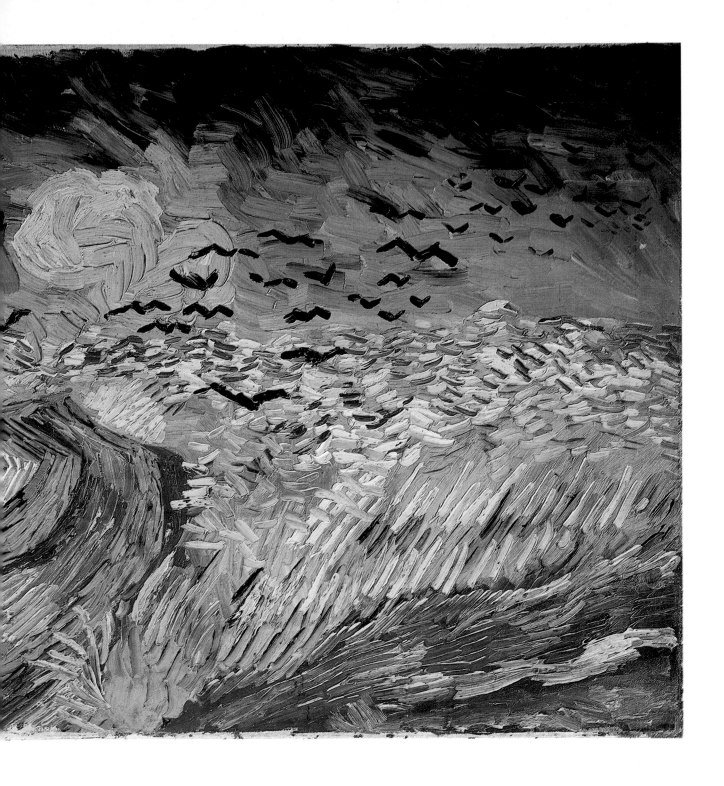

interpreted as Christian iconography, from Crucifixion to Last Judgment; as an image of cosmic chaos projected through van Gogh's inner torment; as a psychic graph of his imminent suicide. Many of these interpretations are linked to the assumption that it was van Gogh's last painting. But this has never been established.

In the passage from his letter of about 10 July 1890, already quoted in cat. 83, van Gogh refers to three "big canvases," two of which show "vast fields of wheat under troubled skies" (LT649). The third "big canvas" is *Daubigny's Garden*

(cat. 84), of double-square format. Surely the other two are also double squares.

Compare the sentence in van Gogh's last letter, of 23 July, where he writes of "two size 30 canvases representing vast fields of wheat after the rain" (LT651). Here van Gogh clearly indicates the canvas size, and the fields are seen "after the rain." The two paintings in question, the Pittsburgh *Wheat Fields* (cat. 73) and the Munich *Wheat Fields* (cat. 73, fig. 60), have skies that are by no means "troubled." The only Auvers paintings that show such skies are *Wheat Field Under Clouded Sky* (cat. 83) and *Crows Over the Wheat Field,* which must have been painted contemporaneously from 7 to 10 July.

This identification has been disputed. It is argued that the wheat in *Crows Over the Wheat Field* appears too ripe, too ready for harvesting, for the picture to have been painted as early as 10 July. However, the wheat could be a variety that matures earlier than mid-July. It is also argued that the picture does not show the "health and restorative forces" that van Gogh thought were expressed by the canvas (LT649). Yet is the image so tragic and sinister as some have claimed? Is it more disturbing than its pendant, *Wheat Field Under Clouded Sky*? Is the claustrophobia of a closeup view more disconcerting and alarming than vastness and infinity?

What has been perceived as the picture's brooding sense of menace can in fact be seen in a different light. On the one hand, each of the three paths ends abruptly. There is no exit from the field. And the crows appear to be flying toward the artist-spectator, intensifying the threat of trapped enclosure. On the other hand, the center path turns into the field; it is lost in turning; it does not end. And the crows, rather than flying toward the artist-spectator in a threatening manner, may in fact be flying in the opposite direction.

If one looks at the painting without imposing on it the sense of menace-filled tragedy that comes with the knowledge of hindsight, then the "restorative forces" that van Gogh speaks of as being expressed in the landscape can be felt. Indeed, the combination of ripening wheat seen under a stormy or troubled sky is one commonly found in the atmospheric landscapes of Georges Michel and other nineteenth-century French artists, as well as in the landscapes of seventeenth-century Dutch masters.

86. Sheaves of Wheat

Oil on canvas, 19⅞ × 39¾ in. (50.5 × 101 cm.)
Unsigned
Dallas Museum of Art. The Wendy and Emery Reves Collection
F771 H757 JH2125
Reproduced on pages 278–79

Van Gogh's return to the North meant that he would be painting the summer harvest later than he had become accustomed to in Provence. Instead of mid-June, harvesting took place after mid-July. He may have been reminded of harvesttime in Nuenen, where in August 1885 he made five drawings (F1319v, F1339–F1342) and one painting (F193) of standing sheaves of wheat. Two of these drawings in particular, *Landscape with Sheaves of Wheat and a Windmill* (fig. 69) and *Field with Sheaves and a Windmill* (F1340), show a diagonalized arrangement of sheaves that prefigures the present painting.

Van Gogh wrote of his Nuenen series, but he said nothing of this Auvers canvas. Probably one of his last pictures, it is a simplified study of light and shadow expressed in complementary contrasts of yellows and muted violets applied with controlled, graphiclike hatchings of the brush. The distant fields are realized in flatter areas of various greens.

Fig. 69. *Landscape with Sheaves of Wheat and a Windmill* (F1319v).
Black chalk, 17½ x 22¼ in. (44.5 x 56.5 cm.). Rijksmuseum
Vincent van Gogh (Vincent van Gogh Foundation), Amsterdam

87. Field with Haystacks

Oil on canvas, 19⅝ × 39½ in. (50 × 100 cm.)
Unsigned
Private collection
F809 H795 JH2098
Reproduced on pages 280–81

Of the thirteen double-square canvases that van Gogh painted from 17 June to 27 July 1890, five are not mentioned in the letters. These are *Thatched Cottages Against a Hill* (cat. 82), *Sheaves of Wheat* (cat. 86), *Roots and Tree Trunks* (cat. 88), *Landscape at Auvers in the Rain* (F811), and the present *Field with Haystacks*. In each canvas, van Gogh adapts his intricate color harmonies and expressively varied brushstrokes to the demands of the motif. If *Sheaves of Wheat* was painted predominantly in a series of uniformly hatched brushstrokes, with a late flickering of enthusiasm for color complementaries, *Field with Haystacks* is characterized by a more elaborate vocabulary. Among the more complex marks are the now familiar brick strokes that model the sky and the unusual horseshoe shapes that describe the vegetation. Horseshoe strokes similar to those seen here are used in the Vienna *Wheat Fields* (cat. 78), in the lower left. Less in evidence are the bounding contours, more often than not in Prussian blue, that van Gogh was in the habit of applying last to his Auvers canvases.

It was this contrast in surface articulation that so influenced the Fauves, not only Vlaminck (see cat. 70) but also André Derain and Henri Matisse. (Interestingly, this painting belonged to Matisse's dealer, Bernheim Jeune, before 1910.) Nonetheless, there are spatial axes that can be disentangled from the insistent surface marks. The two diagonally placed haystacks are seen against a distant horizon across the plain. But the line of the horizon becomes a sequence of displaced horizontals, higher at the left, lower at the right, reminiscent of some of Cézanne's still lifes. This may have been a pictorial device, to anchor more firmly the various elements of the composition. But it may also have represented reality, a part of the Auvers plain that not only sloped gently from left to right but also rose very slightly from foreground to background. The inherent instability of the haystacks can be compared with that of their counterparts in an Arles landscape of June 1888, *Haystacks in Provence* (F425). There, too, a potential pictorial collapse is cleverly averted by van Gogh's reconciliation of surface and depth.

The motif of haystacks standing on the plain of Auvers occurs also in the Whitworth drawing (cat. 77).

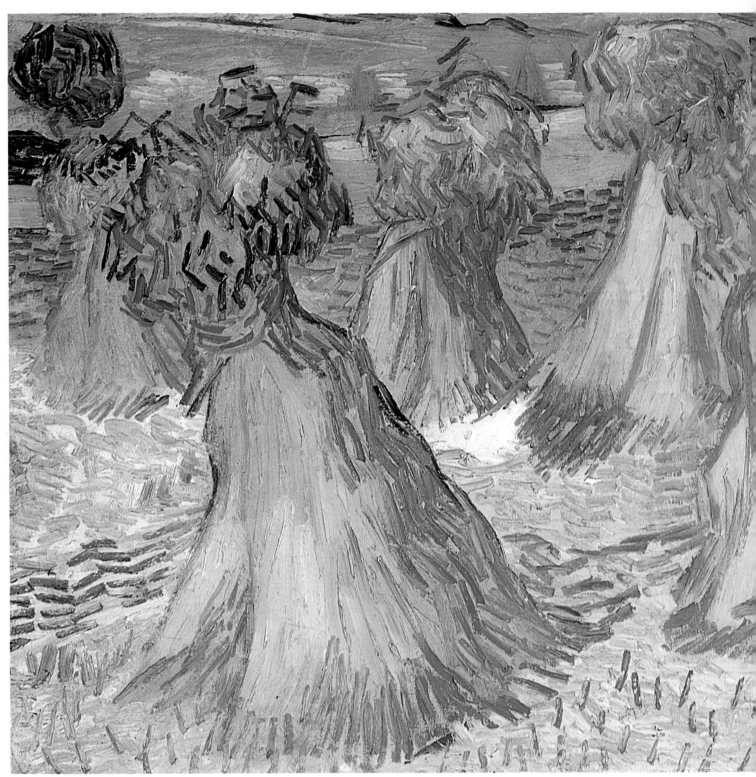

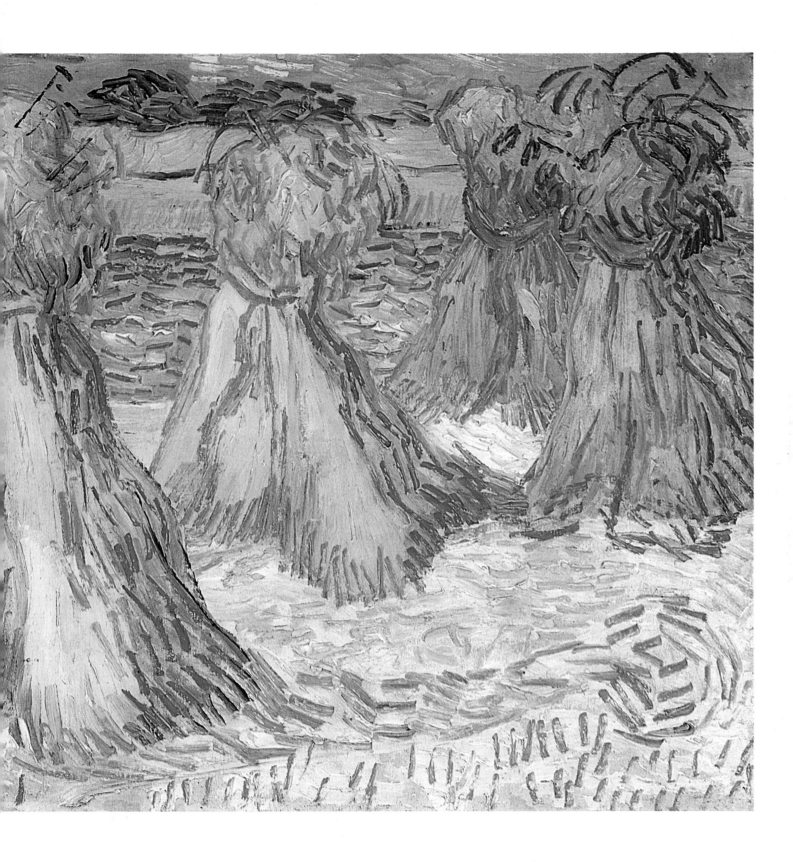

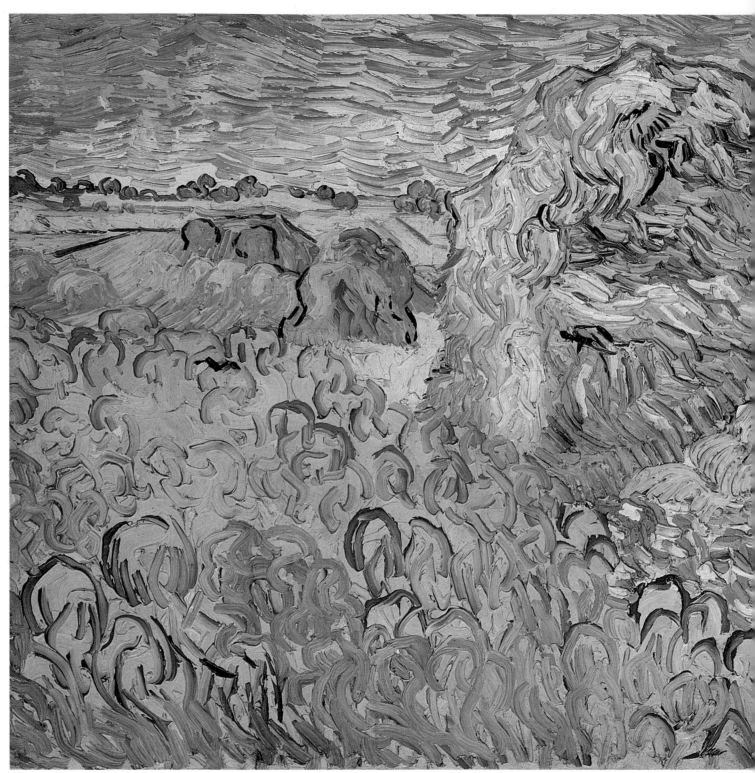

87

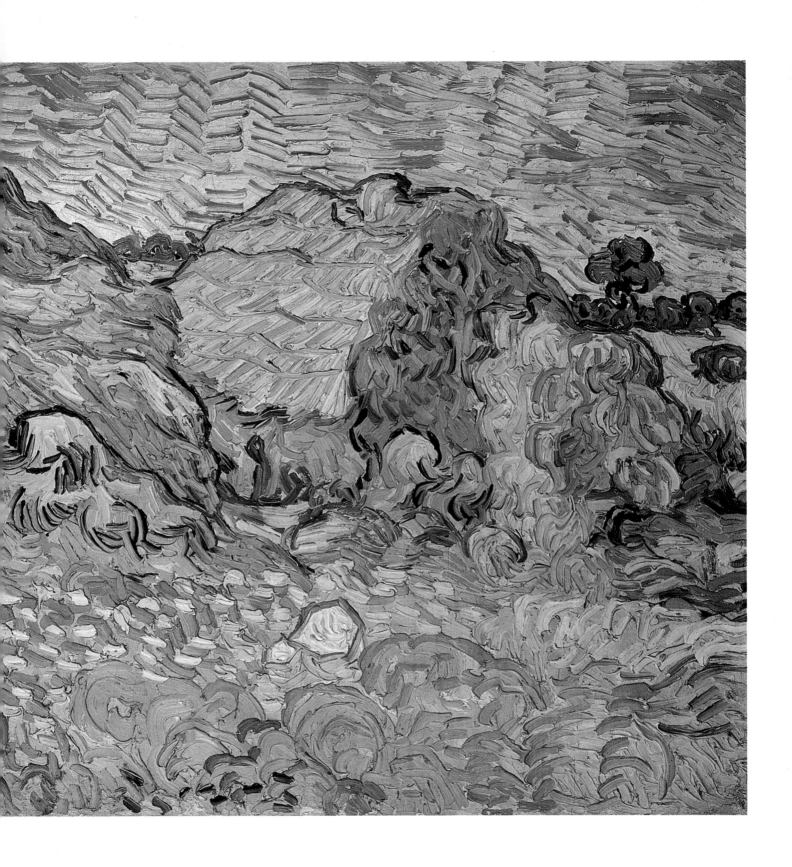

88. Roots and Tree Trunks

Oil on canvas, 19⅞ × 39½ in. (50.5 × 100.5 cm.)
Unsigned
Rijksmuseum Vincent van Gogh (Vincent van Gogh Foundation),
 Amsterdam

F816 H801 JH2113

Ambiguous, stylized, vitalistic, life-affirming, antinaturalistic yet palpably or-
ganic: a kind of prototype for an Art Nouveau frieze. No foreground, no element
on which the viewer can get his spatial bearings, no sky to differentiate back-
ground from foreground, no stabilizing horizontal. The roots and trunks are
vertical; the ground plane is almost vertical. The motif could be part of the steep

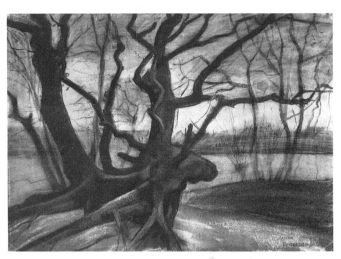

Fig. 70. *Study of a Tree* (F933r). Black and white chalks, pen and black ink, pencil, watercolor, 20 x 28 in. (51 x 71 cm.). Rijksmuseum Kröller-Müller, Otterlo

rise of the hillside, with the village below and the plain above, that characterizes the length of Auvers; van Gogh could have found it at almost any point. The image is passionately observed, yet objectively rendered; it belongs in the same category as the friezelike *Irises* (cat. 1) painted in Saint-Rémy.

Roots and Tree Trunks can be compared with a drawing of roots that van Gogh did in The Hague in April 1882 (fig. 70), but in the drawing there is no vertical thrust. The painting is almost a lexicon of van Gogh's Auvers style: flat, single-color areas contrast with areas of superimposed colors; the graphic brick-shape hatchings create a fluid surface rhythm; and the final, heavy contours of Prussian blue help bind together the strangely disparate forms. The colors—broken, mixed, and appropriately earthy—demonstrate van Gogh's conscious adoption of a Dutch palette to mark his return to the North.

89. Daubigny's Garden

Oil on canvas, 20⅞ × 40½ in. (53 × 103 cm.)
Unsigned
Hiroshima Museum of Art
F776 H758 JH2104

Van Gogh completed a small oil sketch of Daubigny's garden (cat. 84, fig. 67) by mid-June 1890, and a large study from nature, now in Basel (cat. 84), by about 10 July. He then needed a version for Theo, and one to present to the sitter—Madame Daubigny, who is shown in the large study from nature walking in her garden—as when he had made copies of the portraits of Trabuc and his wife in Saint-Rémy (see cat. 24). From 10 to 23 July he painted a second version in the studio, which he not only sketched in his last letter to Theo (fig. 71, reproduced on page 286) but

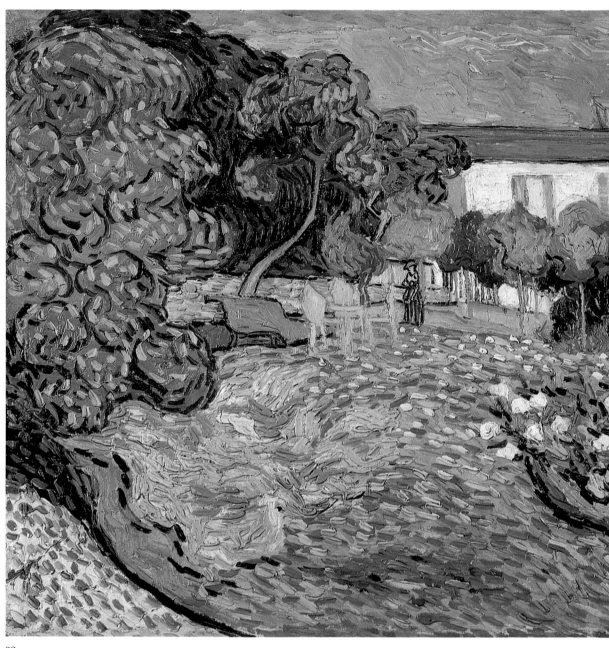

89

also described at some length: "Daubigny's garden, foreground of grass in green and pink. To the left a green and lilac bush and the stem of a plant with whitish leaves. In the middle a border of roses, to the right a wicket, a wall, and above the wall a hazel tree with violet foliage. Then a lilac hedge, a row of rounded yellow lime trees, the house itself in the background, pink, with a roof of bluish tiles. A bench and three chairs, a figure in black with a yellow hat and in the foreground a black cat. Sky pale green" (LT651).

Like the Basel version, the picture has not fared well with restorers. A cat has been painted out; an addition has been made to the sky; the picture has been retouched; and the paint surface has been flattened.

In spite of this, the painting remains beautifully composed, the final homage to Daubigny that van Gogh had considered since his arrival in Auvers (LT649). He wrote of it in his last letter: "It is one of my most purposeful canvases" (LT651).

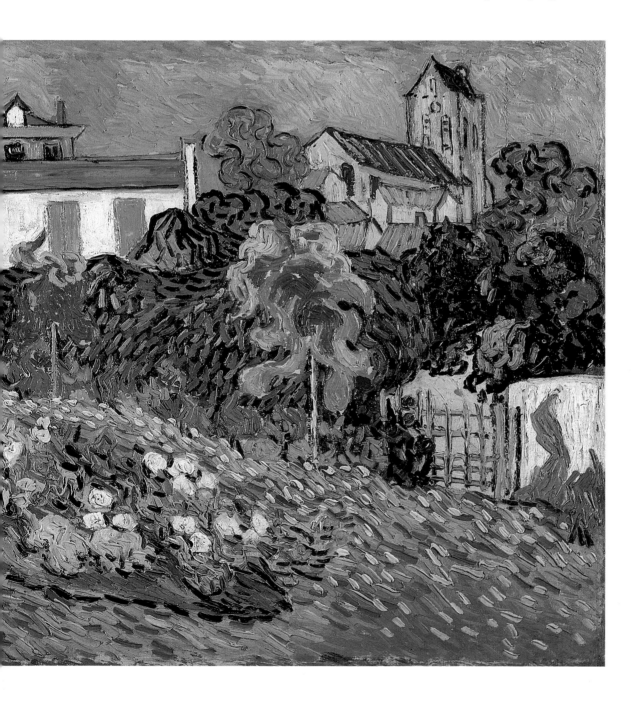

Overleaf: Figs. 71–74; sketches in LT651, Vincent van Gogh's last letter

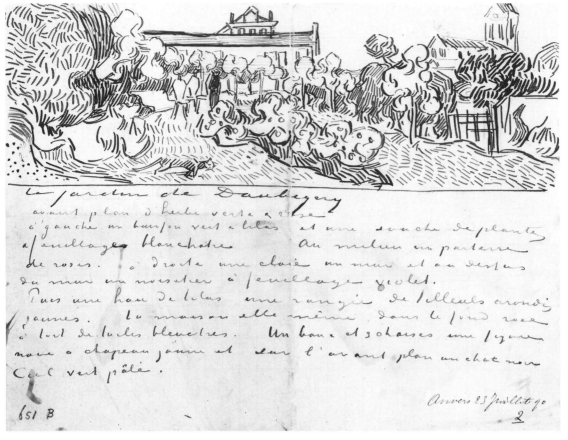

Fig. 71. Sketch of *Daubigny's Garden* (LT651/5; see cat. 89). Rijksmuseum
Vincent van Gogh (Vincent van Gogh Foundation), Amsterdam

Fig. 72. Sketch of *Thatched Cottages in Auvers* (LT651/7; see cat. 72).
Rijksmuseum Vincent van Gogh (Vincent van Gogh Foundation),
Amsterdam

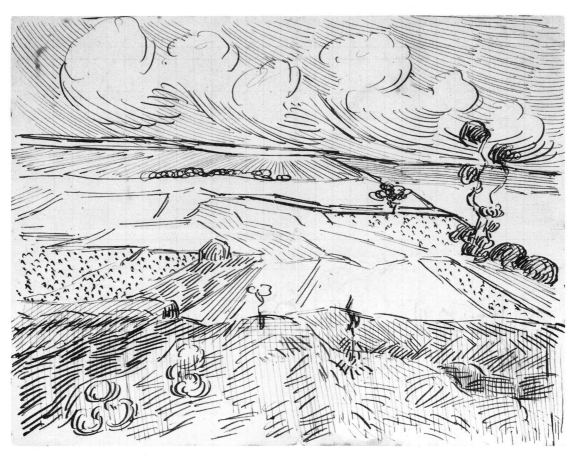

Fig. 73. Sketch of *Wheat Fields* (LT651/6; see cat. 73). Rijksmuseum
Vincent van Gogh (Vincent van Gogh Foundation), Amsterdam

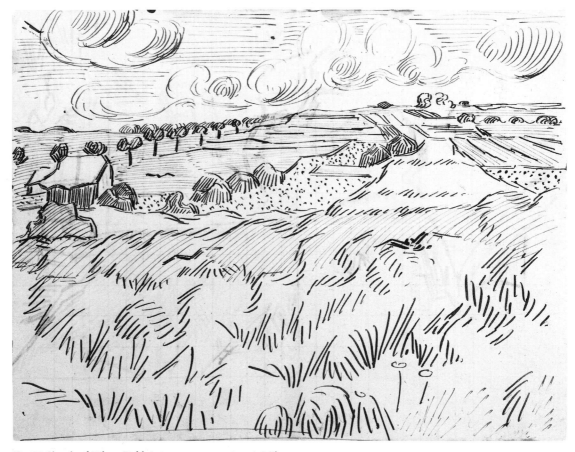

Fig. 74. Sketch of *Wheat Fields* (LT651/8; see cat. 73, fig. 60). Rijksmuseum
Vincent van Gogh (Vincent van Gogh Foundation),
Amsterdam

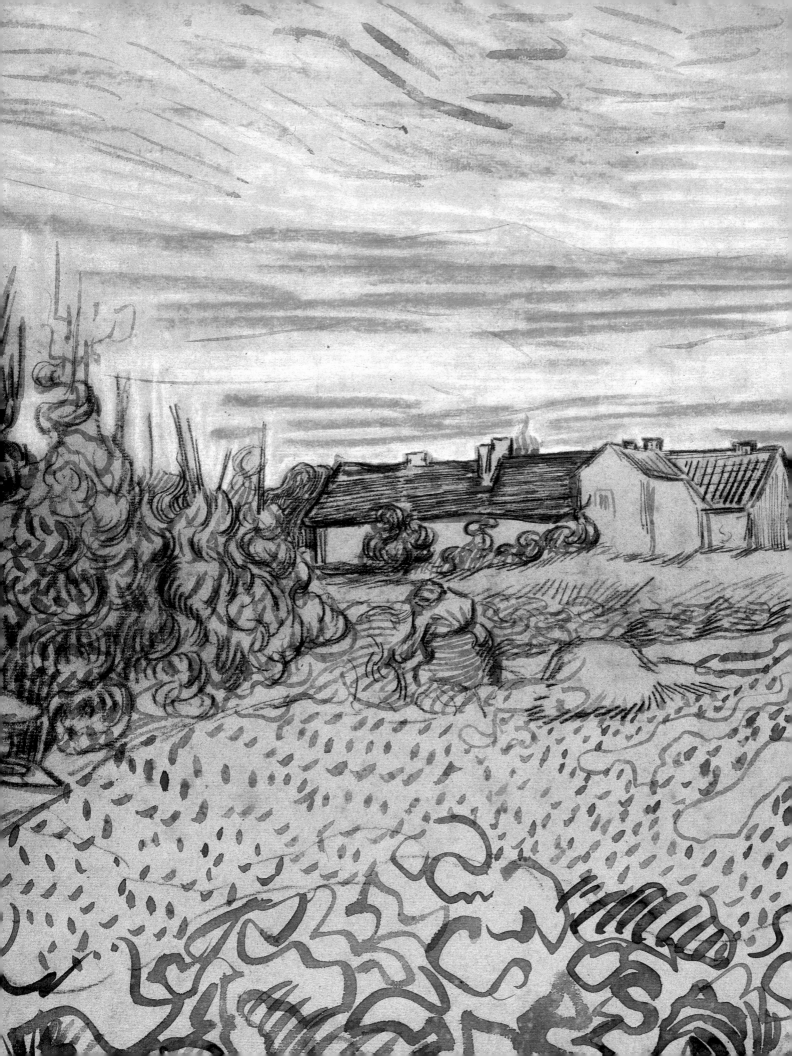

APPENDIX I
The Dating of van Gogh's Letters
from Saint-Rémy and Auvers

APPENDIX II
The Batches of Letters
Sent to Theo in Paris

APPENDIX III
"Les Isolés: Vincent van Gogh"
by G.-Albert Aurier

APPENDIX IV
Related Works

WORKS IN THE CATALOGUE

SELECTED BIBLIOGRAPHY

Farmhouse in a Field (cat. 76), detail

APPENDIX I: The Dating of van Gogh's Letters from Saint-Rémy and Auvers

Van Gogh's letters to his brother Theo (1857–1891) were preserved by Theo himself; ordered and edited first in 1914 by Theo's wife, Johanna van Gogh-Bonger (1862–1925); and enlarged and edited from 1952 on by their son, Dr. Vincent Willem van Gogh (1890–1978). Van Gogh's letters to Émile Bernard were published in 1911, and appeared in English translation in 1938 (see Selected Bibliography).

The problems of dating van Gogh's letters from Saint-Rémy and Auvers are much less difficult than those of dating the letters from Arles. While van Gogh himself dated none of them, their sequence and dating can often be more easily determined, thanks to the survival of many more of Theo's letters from this period than from the Arles period. Moreover, van Gogh wrote fewer letters from Saint-Rémy and Auvers; some eighty-six survive, as against some one hundred seventy from Arles. Only rarely did he write two letters on the same day (e.g., LT600 and LT603). And generally they were shorter than those he wrote from Arles.

For the past thirty years, Dr. Jan Hulsker has concerned himself with the ordering and dating of van Gogh's letters. In the Saint-Rémy and Auvers periods, he has made changes in the published order and suggested a date for each letter. In particular, Hulsker was the first to establish that LT614a, to J. J. Isaäcson, must date from Auvers; that LT648 must come between LT636 and LT637, and was written on 23 May 1890; and that LT652 is a draft that van Gogh carried about in his pocket for LT651, which he sent to Theo. Hulsker has also convincingly suggested that LT611 should be placed between LT612 and LT613, and that LT618 should follow LT615.

Disagreements with Hulsker's proposals are fewer and less radical than was the case with the letters from Arles. Some of the more significant ones are given below.

Because of the reference in W13 to the sale of Millet's *The Angelus* "yesterday," the letter can be dated to 2 July 1889. (The Millet sold, as part of the Secrétan sale, on 1 July.) In addition, LT597 to Theo and LT598 to his mother (sent with W13) also belong to 2 July. Hulsker gives a date bracket of 30 June–4 July.

Hulsker's proposed order of LT599–LT603–LT600 cannot be correct. The order must be LT599–LT600–LT603. The reference in LT603 to the "package" is to the batch of paintings that van Gogh had just announced in LT600 as sent, a fact further confirmed by the reference to "a big study of an orchard" that he had collected from Arles on 7 July, the day after writing LT599. The date of LT600 and LT603, both written the same day, is more open to doubt. There are, however, good reasons for dating van Gogh's first breakdown to about mid-July, rather than 8 or 9 July (see the later references in LT604 and W14).

T14 was written on 4 August 1889, and not 14 August: Theo began with a "3," deleted it with a vertical stroke, and then wrote "4."

LT601 can be securely dated to 22 August 1889 (Hulsker, "What Theo Really Thought of Vincent," p. 20). It seems much more probable that van Gogh's next letter, LT602, was written before the end of August, rather than on 3 and 4 September. The following letter, LT604, surely took more than two days to write (Hulsker dates it to 5 and 6 September). It could have been written over six days, from 31 August to 5 September; most probably, however, it was written over four days, from about 2 to 5 September.

LT610 is more likely to have been written a week after LT609, if only to allow for the completion of several landscapes. A date of 12 October 1889, rather than about 8 October, is proposed, and the same for B20.

LT615: The date penciled on the holograph, in Theo's hand, is 26 November. This date seems more probable than 18 or 20 November, which Hulsker has proposed, shortening as it does the tremendously long gap between this letter and the one that follows, LT618, of 7 December.

W18 was written before W17, and on the same day—23 December 1889—as LT619 (to his mother). In both, van Gogh talks of his breakdown in Arles as having occurred "exactly a year ago," and of painting specially for them a picture of women picking olives. When he wrote W17 on 4 January 1890, this picture had been sent to Paris the previous day.

LT622a: Hulsker places this letter between LT619 and LT620, and dates it to 30 or 31 December 1889. But van Gogh seems here to be referring to a week after his "bad attack" of 30 December; a date of about 5 January 1890 is therefore suggested.

LT628: Hulsker, having initially proposed a date of early April 1890, revised it to mid-March 1890 ("What Theo

Really Thought of Vincent," p. 20). Here, a date of 24 April is suggested: as van Gogh's reply to T32 of 23 April ("I am trying to answer you at once"), which LT629 is not.

W21 is more likely a draft written on 20 May 1890, van Gogh's first day in Auvers, than on 3 June 1890.

LT614a was written between LT648 and LT637, and not between LT639 and LT640; it should be dated 24–25 May 1890, rather than 3 June.

LT643 was probably written a day before LT642.

LT645 should be dated 26–27 June 1890, rather than 28–29 June. References to "the beginning of the month" and "a

few days sooner" suggest that the earlier date is more probable.

T39: Although dated 30 June by Theo, he in fact added an (unpublished) postscript on the morning of 1 July. Because of this, a date of 2 July 1890 is proposed for LT646.

LT647 is a short one-page letter that was clearly folded and carried about in van Gogh's pocket. Since it was not sent to Theo, it was perhaps a draft of a lost letter, possibly of about 15 July 1890.

LT652 (the draft for LT651) and LT651 itself are both more likely to have been written on 23 July 1890 than on 24 July.

LETTERS

LT Letter to his brother Theodorus (Theo)
W Letter to his sister Wilhelmina (Wil)
B Letter to Émile Bernard
T Letter from Theo

1889, Saint-Rémy							
		W14	19 September	LT622	4 January	*1890, Auvers-sur-Oise*	
		LT607	19 September	W17	4 January		
		LT608	28 September	LT622a	c. 5 January	LT635	20 May
T7	8 May	T18	4 October	T24	8 January	W21	20 May
T8	8 May	LT609	5 October	LT623	c. 10 January	LT636	21 May
LT591	c. 15 May	LT610	12 October	W19	20 January	LT648	23 May
T9	21 May	B20	12 October	T25	22 January	LT614a	24–25 May
LT592	22 May	LT612	c. 20 October	T26	29 January	LT637	25 May
LT593	c. 2 June	W15	c. 20 October	LT624	31 January	T35	2 June
LT594	c. 9 June	T19	22 October	T27	31 January	LT638	3 June
W12	16 June	LT611	23 October	LT623a	c. 1 February	LT639	4 June
T10	16 June	LT613	c. 2 November	LT625	2 February	W22	4 June
LT595	c. 18 June	T20	16 November	LT626b	c. 3 February	T36	5 June
LT596	25 June	LT614	17 November	T28	9 February	LT640	10 June
LT597	2 July	LT614b	20 November	LT626a	10 February	LT640a	12 June
LT598	2 July	B21	c. 22 November	LT626	c. 10 February	LT641a	13 June
W13	2 July	LT615	26 November	W20	c. 20 February	W23	13 June
T11	5 July	LT618	7 December	LT627	c. 20 February	LT641	14 June
LT599	6 July	T21	8 December	T29	19 March	T37	15 June
LT600	c. 14 July	LT616	9 or 10 December	T30	29 March	LT643	16 June
LT603	c. 14 July	W16	9 or 10 December	T31	29 March	LT642	17 June
T12	16 July	LT617	c. 15 December	T32	23 April	T38	23 June
T13	29 July	T22	22 December	LT628	24 April	LT644	24 June
T14	4 August	LT619	23 December	LT629	29 April	LT645	26–27 June
T15	16 August	W18	23 December	LT629a	29 April	T39	30 June–1 July
LT601	22 August			LT630	2 May	LT646	2 July
LT602	c. 30 August			T33	3 May	T40	5 July
LT602a	c. 30 August			LT632	3 May	LT647	c. 7 or 15 July
LT604	c. 2–5 September	*1890, Saint-Rémy*		LT631	4 May	LT649	c. 10 July
T16	5 September			T34	10 May	LT650	c. 11 July
LT605	6 September	LT620	1 January	LT633	11 or 12 May	T41	14 July
T17	18 September	LT621	3 January	LT634a	11 or 12 May	LT652	23 July
LT606	19 September	T23	3 January	LT634	13 May	LT651	23 July

APPENDIX II: The Batches of Paintings Sent to Theo in Paris

During the twelve months that van Gogh spent in Saint-Rémy, he sent seven batches of paintings to Theo in Paris. The letters that were exchanged between the two brothers about the works in each consignment provide insight into both van Gogh's evaluation of his own work and Theo's response to it.

In the fifteen months he spent in Arles, van Gogh had sent three batches of paintings to Theo. The first, sent in May 1888, comprised twenty-six canvases, mostly of orchards and bridges; the second, in mid-August, was made up of thirty-five canvases, mostly summer landscapes. Nothing else was dispatched until the end of his stay, when, in the beginning of May 1889, he sent his third and largest batch, probably about one hundred twenty-five paintings. He kept back some ten recent works which were not yet dry, planning to return to Arles to collect them later.

Theo's responses to the first two batches of May and August 1888 can be inferred only from van Gogh's letters, since none of Theo's letters from before October 1888 survive. There are indications of which canvases Theo had decided to frame, and references to the reactions of Camille Pissarro, whose opinions van Gogh valued greatly. But we know nothing of the responses of the artists Meijer de Haan and Émile Bernard, or the critics G.-Albert Aurier and J. J. Isaäcson, all of whom saw the work in October and November.

It is only from the period following the final batch from Arles, in May 1889, that we have more tangible evidence of a response. Theo, whose letters dating from this time are preserved, reported on the artists and critics who saw the work, and often noted those paintings that had been framed and those that had been hung, either at Tanguy's shop or in his own apartment. Visitors who saw the Arles canvases included Belgian, Dutch, French, and Norwegian artists; Octave Maus, secretary of Les XX in Brussels; and J. J. Isaäcson (T10, T12).

In Saint-Rémy, van Gogh's attitude about his consignments to Theo changed fundamentally. Instead of sending three batches in fifteen months, he sent seven in twelve. Six of these were dispatched to Paris from July 1889 to January 1890—one in July, two in September, two in December, and one in early January. The batches from Saint-Rémy included fewer paintings than those from Arles. Van Gogh generally aimed to send twelve canvases; in the six consignments, he sent fifty-nine. Then, as in Arles, he sent a large group at the end of his stay. This last consignment comprised some seventy paintings. Van Gogh said a great deal about these batches; so did Theo. And Theo's letters tell us much about the critical reactions of others. Now there is dialogue and critique, positive and responsive, that actually affected van Gogh's painting.

Batch One, sent about 15 July 1889

During his first two months at Saint-Rémy, van Gogh occasionally spoke of his intention to send paintings to Theo. He was deterred only by having to allow them to dry, and by having to return to Arles to collect his spring landscapes. But it was not until 7 July that he was able to go to Arles. He returned with some ten canvases. These he studied carefully for at least a week, and retouched slightly; he did not sign them. In one case, he made a studio replica (F512) of a "big study of an orchard" (F511) which had given him "great difficulty" (LT603). He also contemplated his quartet of May paintings of the asylum garden. He may have retouched them slightly, and he signed each one. It would also appear that he signed a painting of an olive orchard (F585), the only June canvas dry enough to send to Paris.

These spring landscapes from Arles and Saint-Rémy he listed in a letter to Theo of about 14 July (LT600):

"Tomorrow I shall send a roll of canvases by goods train. There are four, namely the following:
1. View of Arles—Orchards in Bloom [F516]
2. Ivy [F609]
3. Lilacs [F579]
4. Red Chestnuts in the Jardin des Plantes in Arles [F517] which will go with the ones you already have, such as the red [F495] and green [F475] Vineyard[s], the Garden[?], the Harvest [F412], the Starry Sky [F474]. I am putting in with them seven more studies which are dry, but which are more studies from nature than subjects for pictures. And it is always like that, you must make several before you can get a whole that has character. Now for the subjects of these seven studies: 'Irises' [F608]—'View of the Asylum at Saint-Rémy' [F734], size 30 canvases. 'Peach Trees in Bloom' (Arles) [F514], 'Meadows' (Arles) [F575], 'Olives' (Saint-Rémy) [F585?], 'Old Willows' (Arles) [F520], 'Orchard in Bloom' [F511?]."

Van Gogh's distinction between a "study" (*étude*) and a "picture" (*tableau*) is one that he always applied to his work. What is curious about his usage in this list is that of the four May garden paintings he categorizes "Ivy" and "Lilacs" as pictures and "Irises" and "View of the Asylum at Saint-Rémy" as studies. There are no obvious differences in facture or finish, all are size 30 canvases, and all are signed. Presumably, the differences he

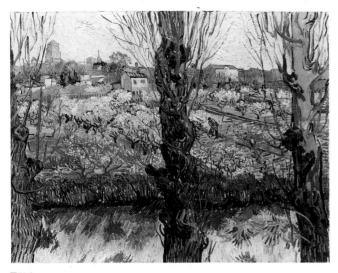

F516

F609

F579

F517

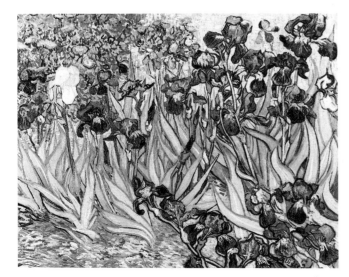

F608; cat. 1

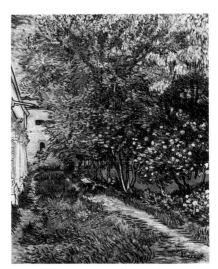

F734

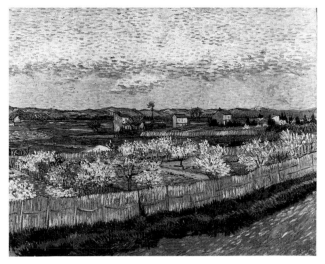

F514

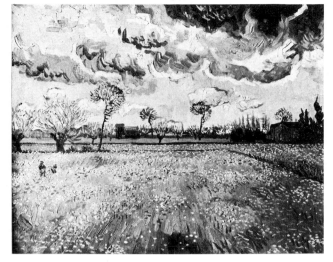

F575

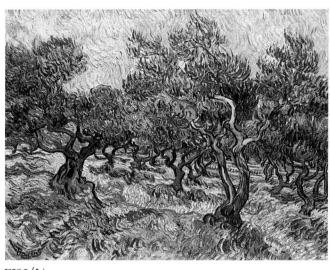

F585（?）

F520

F511（?）

saw were of a more subjective nature, or he applied criteria that he did not disclose to Theo.

The four pictures can be identified: F516, F609, F579, and F517; as can five of the seven studies: F608, F734, F514, F575, and F520. "Orchard in Bloom" must be the painting described in LT603 (written after LT600 but on the same day): "A big study of an orchard…(it is the same orchard you will find a variant of, but very vague, in the package)." The variant, F511, is in fact the first version, done from nature, and, like "Irises" and "View of the Asylum at Saint-Rémy," is a size 30 canvas. "Olives," too, is perhaps a size 30 canvas, which would identify it as F585 rather than F709, which is smaller.

Theo responded at length on 29 July: "I received in perfect condition your last consignment, which I find extremely beautiful.…In most of these canvases I find more clarity of expression and such a fine general effect. The *sous-bois* with trees covered in ivy [F609], the promenade at Arles [F517], and the fields with the gardens in spring [F516] are very beautiful. These and others too are now mounted on stretchers, from which we removed the canvases which were on them and which are now at Tanguy's. They make a very fine showing in the frames. As for Tanguy himself, he likes them very much too. In my opinion you choose such fine subjects for your pictures: those trees with their dense foliage full of freshness and bathed in sunlight [F516] are marvelously beautiful" (T13).

It is interesting that although Theo singled out three of the four pictures for praise (omitting only the "Lilacs") and said nothing of the seven studies, he later selected the study "Irises" for the September 1889 Salon des Indépendants.

Van Gogh, having suffered a serious breakdown in mid-July, was unable to pursue the discussion with Theo. However, on 22 August, writing for the first time after his breakdown, he commented, "I am pleased that you have got the package from here: the landscapes" (LT601). He said no more. Nonetheless, he must have noted Theo's

remarks, especially those on the *sous-bois* with ivy (F609) and the Arles orchard (F516); indeed, he and his brother would remember their exchanges on these paintings when they came to select work for the exhibition of Les XX, opening in Brussels in December 1889.

Van Gogh also noted Theo's arrangements with Tanguy (LT604). Having given up his bachelor apartment at 54 Rue Lepic on 15 July, Theo had rented a small room in Tanguy's shop to store his brother's canvases. It would now be easier to stretch and frame the ones that van Gogh preferred, and to let Tanguy take new works periodically, which he would then be able to show (T12). Clearly, the spring landscapes were quickly stretched and framed and put on view at Tanguy's before the end of July. In effect, this meant that van Gogh was given a one-man show in Paris, though small and informal, at the very time that Gauguin and Bernard and company were exhibiting at Volpini's café. In the longer term, it provided a continuously changing display of van Gogh's pictures in a shop that was much patronized.

Batch Two, sent 19 September 1889

When he sent his first batch of paintings in mid-July, van Gogh had written, "Now the next package, which will follow in a little while, will be made up mostly of wheat fields and olive orchards" (LT600). However, it was not until after mid-September that he put together another consignment.

Only one of these paintings was a recent work, a self-portrait against a light background (F627), completed by 4 September. "I have tried to make it simple. Show it to old Pissarro when you see him" (LT607). The other pictures he had painted during the summer. Some of them he may have retouched (LT604). He listed nine paintings:

"Moonrise (ricks) [F735]
Study of Fields [F581]
Study of Olives [F712]

Batch Two, 19 September 1889

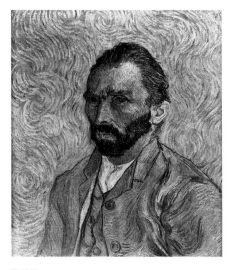

F627

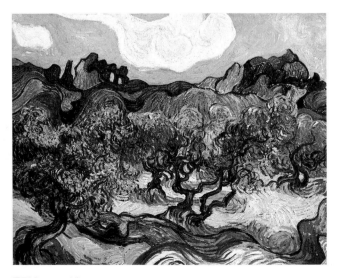

F712; cat. 13

296

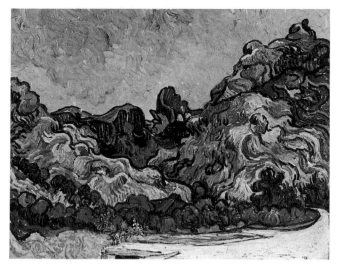

F622; cat. 20

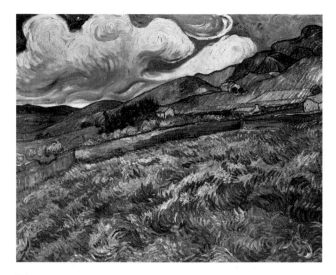

F611

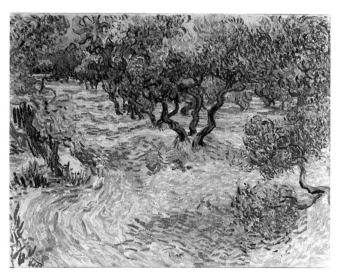

F715; cat. 12

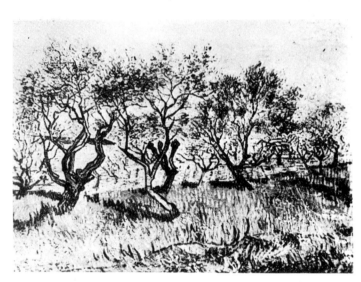

F512(?)

F744; cat. 21

Study of Night [F612]
The Mountain [F622]
Field of Green Wheat [F611]
Olives [F715]
Orchard in Bloom [F512?]
Entrance to a Quarry [F744]"

Van Gogh then provided one of his most complete exegeses of function, purpose, and style. First he made his customary distinction between those canvases he considered studies and those he considered pictures: "The first four canvases are studies without the effect of a whole that the others have." He then talked about two of the pictures in terms of their "effect of a whole." "I rather like the 'Entrance to a Quarry' [F744]—I was doing it when I felt this attack coming on—because to my mind the somber greens go well with the ocher tones; there is something sad in it which is healthy, and that is why it does not bore me. Perhaps that is true of the 'Mountain' [F622] too. They will tell me that mountains are not like that and that there are black outlines of a finger's width. But, after all, it seemed to me it expressed the passage in Rod's book—one of the very rare passages of his in which I found something good—about a desolate country of somber mountains, among which are some dark goatherds' huts where sunflowers are blooming."

He continued with his most revealing statement about what he was trying to achieve in three of the four studies. "The olive trees with a white cloud and a background of mountains [F712], as well as the moonrise [F735] and the night effect [F612], are exaggerations from the point of view of the arrangement; the lines are twisted as in old wood. The olive trees are more in character, as in the other study, and I tried to convey the time of day when you see green rose beetles and cicadas flying about in the heat."

And he concluded: "Altogether, I only find a *little* good in the field of wheat [F611], the mountain [F622], the orchard [F512?], the olives with the blue hills [F712], the [self-]portrait [F627], and the entrance to the quarry [F744], and the rest tells me *nothing*, because it lacks individual intention [*volonté personelle*] and feeling in the lines [*lignes senties*]. Where these lines are close and deliberate it begins to be a picture, even if it is exaggerated. That is a little what Gauguin and Bernard feel; they would not ask the correct shape of a tree at all, but they do insist that one can say if the shape is round or square—and honestly, they are right, exasperated as they are by certain people's photographic and empty perfection. They will not ask the correct color of the mountains, but will say: By God, the mountains were blue, were they? Then chuck on some blue and don't go telling me that it was a blue rather like this or that; it was blue, wasn't it? Good—make them blue and it's enough!"

The paintings in the second batch can all be identified, with the exception of the "Orchard in Bloom." Most likely, this is F512, a picture based on F511 and done from memory in early July. In the first batch, van Gogh signed all five of his Saint-Rémy canvases; in the second batch, he did not sign any. But he added "a study of flowers to the roll of canvases—nothing much, but after

all I do not want to tear it up" (LT607). Like "Orchard in Bloom," it has not been identified.

Although van Gogh mentioned eleven canvases, the self-portrait, the nine he listed, and the "study of flowers," in fact he held back three, adding them later to his next consignment. These were three of the four studies: "Moonrise" (F735), "Study of Fields" (F581), and "Study of Night" (F612).

Theo did not acknowledge the arrival of this batch until 4 October: "I have really waited too long to tell you that your last consignment arrived in good order. I like the wheat field [F611] and the mountains [F622] enormously; they are very beautiful in design. In the wheat field there is that unshakable something which nature has, even in her fiercest aspects. The orchard too [F512?] is extremely fine. Isaäcson, who has been writing for a Dutch paper recently, wants to write something about your work. He asked me to let him have certain pictures to keep at his home for a while, including the mountains and the wheat field" (T18).

Batch Three, sent 28 September 1889

On 19 September, van Gogh wrote, "The other canvases, the 'Reaper,' etc., are not dry" (LT607). He therefore allowed an additional nine days to pass before he sent them. And he explained, in his letter of 28 September (LT608), why he had held back three studies from batch two: "There are three studies missing in the package of canvases you already have, because the postage for the roll with these taken out was 3.50 fr. less. So I will send them at the next opportunity—or rather they are leaving today with other canvases—as follows:

Wheat Field [F719]	Study of Cypresses [F613]
Wheat Field and Cypresses [F717]	Reaper [F617]
ditto [F615]	ditto [F618]
Ivy [F746]	Olives [?]

then also the three above mentioned—
Poppies [F581]—Night Effect [F612]—Moonrise [F735]."

Van Gogh is briefer here, having said so much in his previous letter. Only one painting is called a study, the "Cypresses" (F613). He does not comment on the "Wheat Field" (F719), the horizontal "Ivy" (F746), or the "Olives" (which might have helped to identify the painting). And of the two pairs, each made up of the study from nature and the studio repetition, he refers only to the "Reaper": "Now as for the 'Reaper'—first I thought that the large-size duplicate [F618] that I am sending you was not bad—but afterward, when the days of mistral and rain came, I preferred the canvas done from nature [F617], which seemed rather strange to me. But no, when the weather is cold and sad, it is precisely that which makes me recall that furnace of summer over the white-hot wheat, so it is not so exaggerated after all."

Theo made no direct response to the paintings he received. Most remarkable, perhaps, is his silence about the "Reaper," a composition that van Gogh had described and enthused about so often. Instead, writing on 22 October, Theo tried to dissuade his brother from

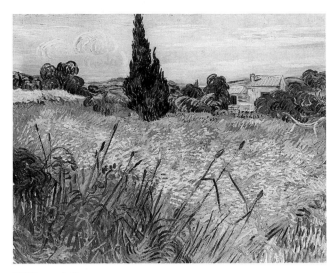

F719; cat. 10

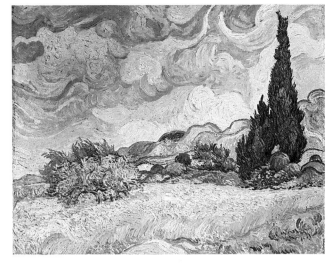

F717

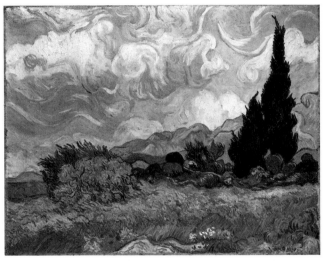

F615

F746

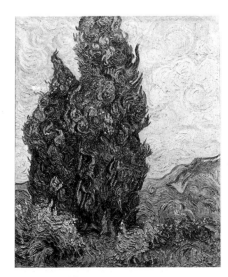

F613; cat. 15

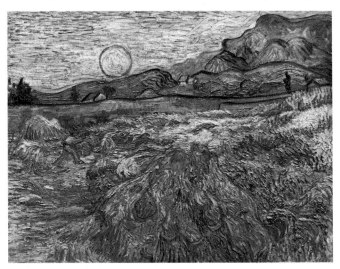

F617

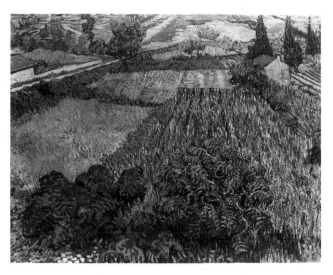

F618; cat. 27

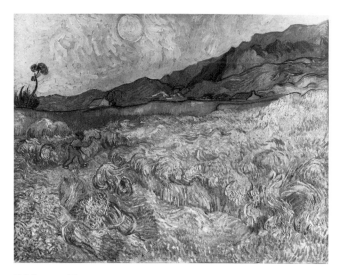

F581; cat. 9

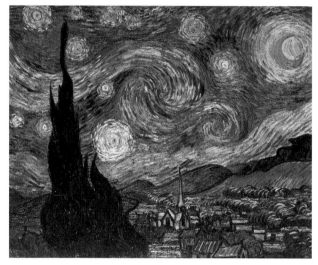

F612; cat. 14

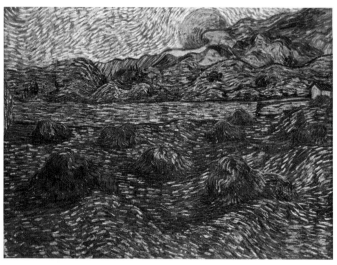

F735

following too far the path of arbitrary color and excessive linear stylization: "The exhibition of the Indépendants is over, and I've got your irises [F608] back. It seems to me that you are stronger when you paint true things like that, or like the stagecoach at Tarascon [F478a], or the head of a child [F440, F441, or F441a], or the vertical underbrush with ivy [F609]. The form is so well defined, and the whole is full of color. I understand quite well what it is which preoccupies you in your new canvases, like the village in the moonlight [F612], or the mountains [F712], but I think that the search for some style is prejudicial to the true sentiment of things." He also reported, "I have had quite a number of people calling on me to see your work. [Isaac] Israël's son, who is staying in Paris for some time; [Jan Pieter] Veth, a Dutchman who paints portraits, and who writes for the *Nieuwe Gids,* that periodical you may have heard about; and then [Théodore van] Rysselberghe, one of the Vingtistes of Brussels.

The last mentioned also saw everything there is at Tanguy's, and your pictures seem to interest him quite a lot" (T19).

Batch Four, sent 6 December 1889

Van Gogh announced in his letter of 28 September: "Soon I shall send you some smaller canvases with the four or five studies that I should like to give Mother and our sister. These studies are drying now; they are size 10 and 12 canvases, small copies of the 'Wheat Field and Cypress' [F743], 'Olives' [F711?], the 'Reaper' [F619], and the 'Bedroom' [F483], and a little self-portrait [F525]" (LT608). But it was not until 6 December that these "smaller canvases" and "studies" were dispatched to Theo. "Yesterday I sent off by post three packages, containing studies, which I hope will reach you safely.... Among the

studies you will find the following, which are for Mother and our sister: 'Olives' [F711?], 'Bedroom' [F483], 'Reaper' [F619], 'Ploughing' [F706?], 'Wheat Field with Cypress' [F743], 'Orchard in Bloom' [F714 or F716], 'Portrait' [F525]. The rest are especially studies of autumn, and I think that the best is the yellow mulberry tree against a bright blue sky [F637]—then the study of the house and the park, of which there are two variations. The studies, size 30 canvases, were not yet dry, and will follow later" (LT618).

Among the seven canvases for his mother and Wil, four can be identified with certainty: F483, F619, F743, and F525. Of the remaining three, "Olives" may be F711; "Orchard in Bloom" may be F714 or F716; and "a ploughed field, early morning effect," as van Gogh described it to Wil (W15), may be F706 (although F625, with the rising sun, shows more of an early morning effect).

Van Gogh himself gives little help in identifying the "smaller canvases" (LT608) or "studies of autumn" (LT618). The "mulberry tree" is clearly F637. The "study of the house and the park, of which there are two variations," raises problems. The two paintings cannot possibly be size 30 canvases, since van Gogh specifically mentioned that none were included in this batch: therefore, they are probably F642 and F730. The remaining "smaller canvases" have been identified as most likely from van Gogh's studies of autumn: F638, F625, F640, F731, F635, and F651. But there may have been more than six (e.g., F803 may also have been sent).

Sent on 6 December, the "three rolls of canvases" were received by Theo on 8 December. His response was brief: "Among the pictures there are some in which the harmony is sought in less glaring colors than you generally use; for all that there is a great deal of air in them" (T21).

Batch Four, 6 December 1889

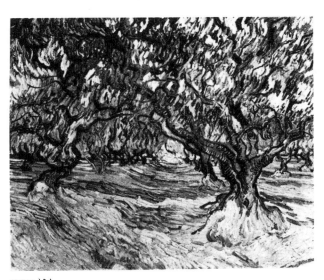

F711 (?)

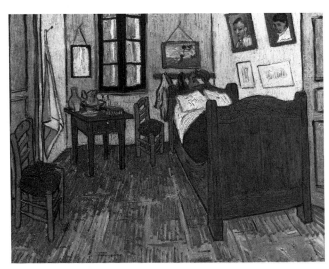

F483

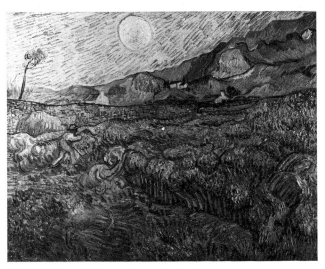

F619

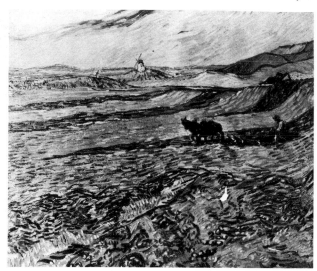

F706 (?)

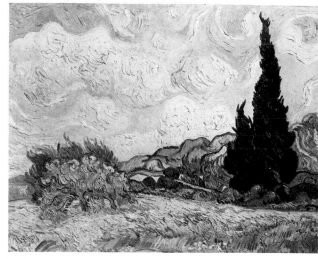

F743

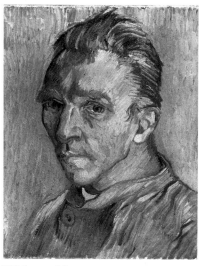

F525; cat. 25

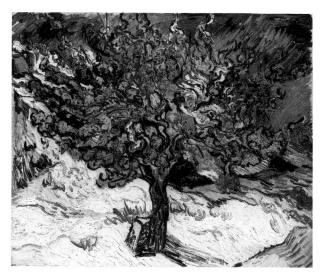

F637

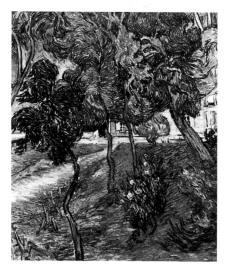

F642; cat. 31

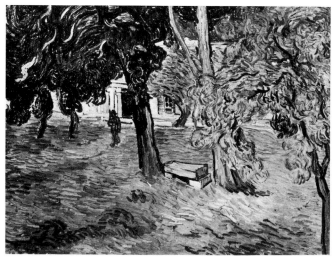

F730

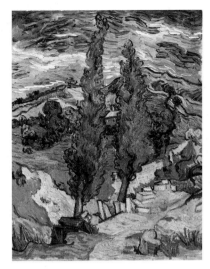

F638

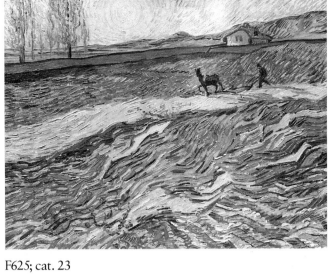

F625; cat. 23

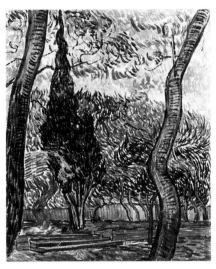

F640

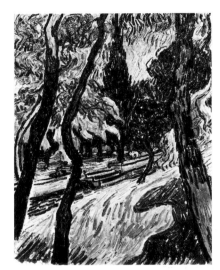

F731

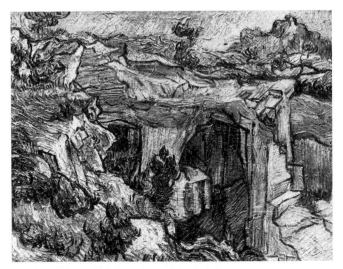

F635; cat. 35

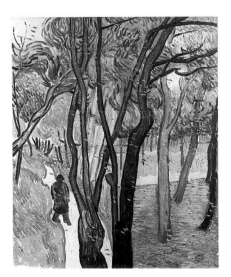

F651

This was the smallest of the batches, with a quite specific purpose: to allow Theo time to have "field of wheat at sunrise [F737]" framed for the exhibition of Les XX in Brussels. "You will get the 'Bedroom' [F482, F484] at the same time. I put in two drawings [F1545, F1552] as well. I am curious to know what you will say about the 'Wheat Field' [F737]; perhaps it needs to be looked at for some time. However, I hope you will write me soon whether it has arrived in good condition, if you find half an hour to spare next week" (LT617).

Theo's reply of 22 December helps clarify the contents of the batch: "I received the package containing your wheat field and the two bedrooms. I particularly like the last one, which is like a bouquet of flowers in its coloring. It has a very great intensity of color. The wheat field has perhaps more poetry in it; it is like a memory of something one has once seen. Tanguy is framing it at the moment, and on January 3 everything will go to Brussels" (T22).

Batch Six, sent 3 January 1890

In his letter of 7 December, sent with batch four, van Gogh had admitted that the studies of autumn, which he had held back because they were not yet dry, had given him "a lot of trouble." "Sometimes I think they are very ugly," he continued, "sometimes they seem good to me; perhaps you will have the same impression when you see them. There are a dozen of them, so it is more important than what I have just sent" (LT618).

On 9 or 10 December, he wrote to Wil: "I am working on twelve large canvases, especially olive orchards, one of which has a sky that is entirely pink, another one with a green and orange sky, and a third one with a big yellow sun. In addition, tall weather-beaten pine trees against a red evening sky" (W16).

His plan to send a dozen paintings to Theo was delayed by a week-long breakdown at the end of December. But on 3 January 1890, soon after his recovery, he sent off eleven canvases (LT621): "Today, I am sending off some canvases, as follows:

'Ploughed Field with Background of Mountains' [F641]—it is the same field as the reaper of last summer [F617] and can be a pendant to it; I think that one will set off the other.

'The Ravine' [F662]. It is the study done on a day of mistral—I had secured my easel with big stones. The picture of this [F661] is not dry: it has a closer drawing and there is more controlled passion and more color in it.

That can go with another study of mountains, summer effect, with a road in the foreground and a black cottage [F622].

'Women Picking Olives' [F655?]—I had intended this picture for Mother and sister, so that they should have something a little studied.

I still have a copy of it for you [F654?], and the study (more colored, with deeper tones) from nature [F656?].

'The Fields' [F721]. Fields of young wheat with background of lilac mountains and yellowish sky.

'Olive Trees' [F586]—sunset sky of orange and green (there is also a variant with figures here [F587]).

Ditto. Neutral effect [F708].

Ditto. Neutral effect [F707].

The big plane tree [F657]—the main street or boulevard of Saint-Rémy, study from nature—I have a copy [F658] which is perhaps more finished here.

Copy after Millet: 'The Diggers' [F648].

Ditto. 'La Veillée' [F647].

I must not forget 'Rain' [F650]."

These eleven paintings, all size 30 canvases, represent van Gogh's autumn campaign, begun in early October with the "Ploughed Field" (F641, which even at that time he had thought of as a pendant to the "Reaper," F617) and ending in December with "Women Picking Olives" (F655?). In his descriptions of the works, he maintains his distinction between studies from nature and studio repetitions, or pictures. Of the study and the picture of the "Ravine," he prefers the picture (F661), with its "closer drawing [*dessin plus serré*]," "more controlled passion," and "more color." Similarly, of the two versions of the "big plane trees" (the "Road Menders"), he shows a preference for the repetition (F658). Interestingly, he retained the two pictures, including them with the next consignment and sending Theo the two studies from nature.

In his letter, van Gogh gives detailed instructions to his brother about how his pictures should be properly viewed, and shows concern about their drying thoroughly: "Please don't look at them without putting them on stretchers and framing them in white; that is to say you must take down other canvases and mount these on the stretchers one by one—if you like—to get an idea of the effect. For the colorings absolutely need to be set off by the white frame for you to judge the whole. For instance, you can hardly see 'Rain' [F650] and the gray olive trees [F707 or F708] without the frame. That will somehow fill the gap left by the canvases gone to the Vingtistes—you must ask Tanguy to take down some other canvases and mount these on the stretchers so that they can dry all the way through" (LT621).

Theo received the batch on 7 January 1890. He found it "very remarkable." "One of the things I like most," he wrote, "is that 'Evening' after Millet ["La Veillée," F647]. Copied in such a way, it is no longer a copy. There is tone in it, and it is so full of air. It is really very successful. As for the other canvases, I very much like the one of those women clambering over the rocks [the "Ravine," F662], and the highway with the road menders [F657]. I think there is more atmosphere in these last works, more distance than in the preceding ones. Perhaps this is due to your not laying on your paint so thickly everywhere" (T24). The two landscapes singled out by Theo were later chosen by him to appear at the Salon des Indépendants, opening on 19 March.

Again referring to this consignment two weeks later, Theo remarked, "Do you know, when I saw your olive trees again, I admired them more and more; the one

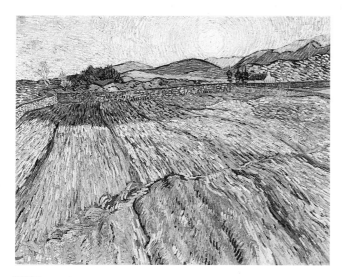

F737; cat. 30

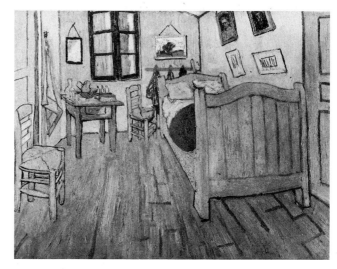

F482

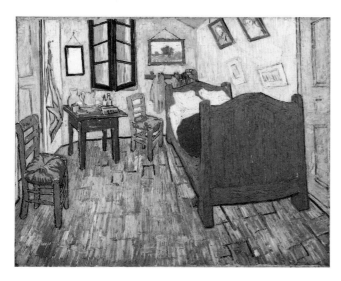

F484

F1545

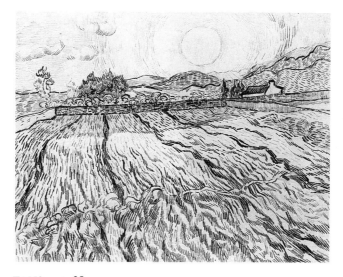

F1552; cat. 38

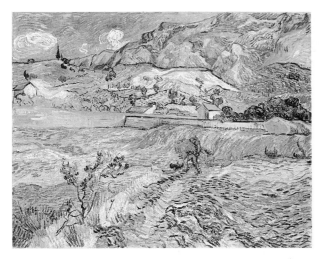

F641; cat. 28

F662

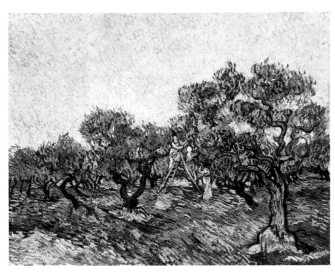

F655 (?)

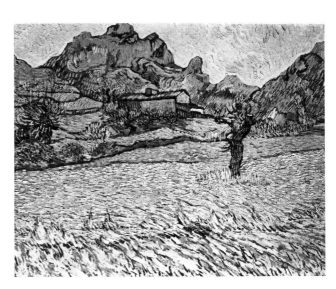

F721

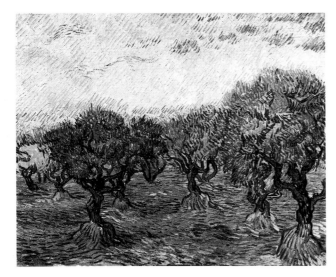

F586; cat. 41

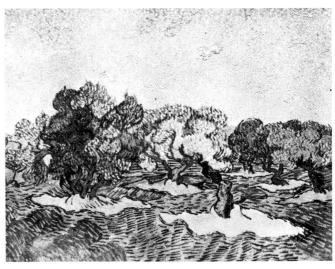

F708

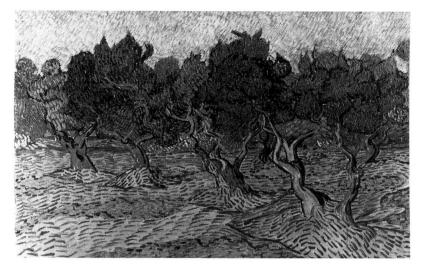

F707

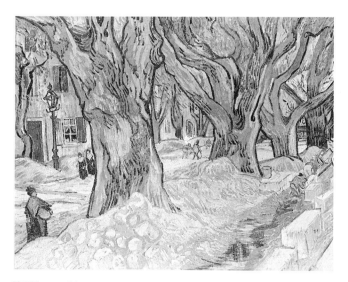

F657; cat. 44

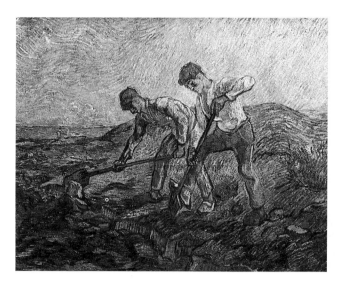

F648

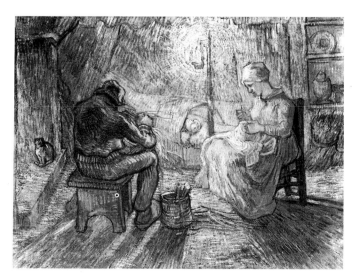

F647

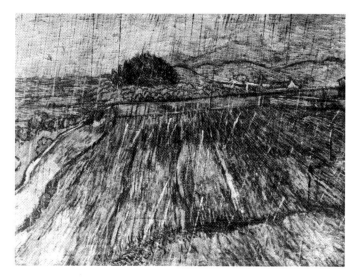

F650; cat. 29

with the sunset [F586] especially is superb. How you have worked since your last consignment; it is prodigious. I am anxious to see the other Millets" (T25). He also noted that the Provençal artist A.-M. Lauzet had seen them: "Lauzet came here again to see your new canvases, and after he had seen some pictures he exclaimed, 'This is the genuine character of Provence.' "

Batch Seven, sent 29 April 1890

Van Gogh said nothing to Theo about sending more paintings in January and February. Only after his long breakdown from 22 February to about 24 April did he gather together his remaining paintings for dispatch to Paris. He sent them on 29 April, as a sign of his recovery and as a birthday gift for Theo. "You will see that first of all there are canvases after Millet. As they are not intended for the public, perhaps you will eventually make presents of these to our sisters. But first you must keep what you like and as much as you want; it's yours absolutely....The rest of the canvases are meager; not having been able to work for two months, I am very much behind. You will find that the olives with the pink sky [F656] are the best, and the mountains [F710], I imagine; the first would go well as a pendant to those with the

yellow sky [F710?]. As for the portrait of the Arlésienne [F540 and F543], you know that I have promised a copy of it to our friend Gauguin, and you must send it to him. Then the Cypresses [F620] are for M. Aurier. I should have liked to do them again with a little less impasto, but I haven't time. They must get several washes with cold water, then a strong varnish when the impastos are thoroughly dry, then the blacks will not become dirty looking when the oil has evaporated" (LT629).

There must have been some seventy canvases in this last batch from Saint-Rémy. Only the eight that he and Theo mentioned plus the two retained from batch six [F661 and F658] are illustrated here.

Theo replied on 3 May: "Your consignment of pictures arrived...and there are very beautiful ones among them. The guard [F629] and the other fellow with his swollen face [F703] are extraordinary; the branch of almond blossoms [F671] shows that for these themes you have missed the season of trees in blossom....The copies after Millet are perhaps the best things you have done yet, and make me think that the day you begin making compositions of figures, we may look forward to great surprises....The canvas for Aurier [F620] is one of the finest you have done so far; it has the richness of a peacock's tail" (T33).

Batch Seven, 29 April 1890

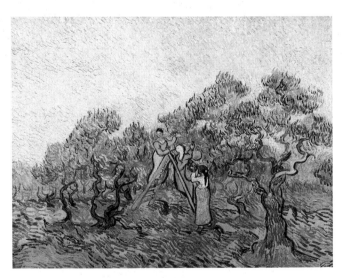

F656

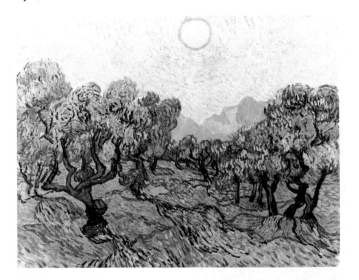

F710; cat. 40

308

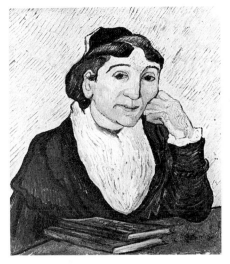

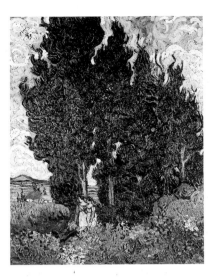

F540

F543; not illustrated

F620

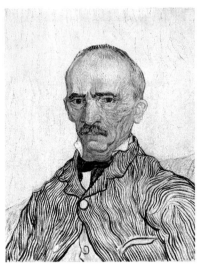

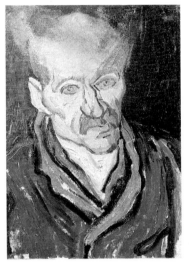

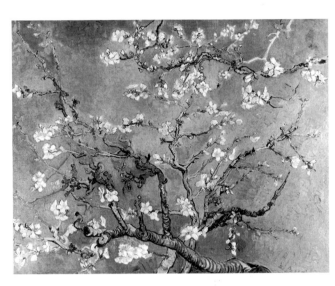

F629; cat. 24

F703

F671; cat. 49

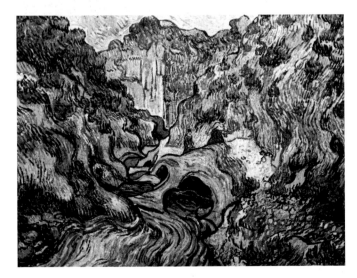

F661

F658; cat. 45

APPENDIX III: "Les Isolés: Vincent van Gogh" by G.-Albert Aurier*

G.-Albert Aurier (1865–1892), the Symbolist poet, art critic, and editor of the short-lived periodical *Le Moderniste* (April–September 1889), probably first heard of Vincent van Gogh when he was staying at Saint-Briac, in Brittany, in the summer of 1888. There he met Émile Bernard, who showed him several letters van Gogh had written to him that summer from Arles. In November of the same year, Aurier visited Theo van Gogh at his apartment in Paris, where, presumably, he saw van Gogh's work for the first time. Then, in the 13 April 1889 issue of *Le Moderniste*, he described, briefly, the paintings by van Gogh that he had seen at Tanguy's. "Here are canvases," he wrote, "tremendous in fire, intensity, sunshine." Aurier's friendship with Bernard continued, and Bernard encouraged Aurier to write about van Gogh. When, in January 1890, the first number of *Le Mercure de France* appeared, Aurier's "Les Isolés: Vincent van Gogh" was the feature article. It was apparently written without Theo's knowledge—and certainly without Vincent's. It was the only article on the work of van Gogh to be published during the artist's lifetime.

THE ISOLATED ONES

VINCENT VAN GOGH[1]

And so it was that, all at once, as soon as I returned to the base and muddy confusion of the dirty street and ugly real life,[2] in spite of myself, these bits of verse resounded in my memory:

> The intoxicating monotony
> Of metal, of marble and of water...
> And everything, even the color black
> Seemed polished, clear, iridescent
> Liquid enshrined its glory
> In the crystallized ray...
> And ponderous cataracts
> Like curtains of crystal
> Are suspended, dazzling
> Into walls of metal...[3]

Beneath skies that are now cut into the dazzling of sapphires and turquoises, now molded out of some unknown, infernal sulfurs, hot, pernicious, and blinding; beneath skies similar to rivers of blended metals and crystals, where, sometimes, incandescent torrid solar disks blaze out; beneath the unending and formidable shimmering of all possible lights; in the heavy, flaming, burning atmosphere, which seems to be exhaled by fantastic furnaces in which gold, diamonds, and singular gems are volatilized—it is a disquieting and disturbing display of a strange nature, at once truly true and quasi supernatural, of an excessive nature, where everything, beings and things, shadows and lights, forms and colors, rears up and rises in a raging desire to howl its own essential song, in the most intense and the most savagely shrill tone: there are trees, twisted like giants in battle, proclaiming with the gesture of their gnarled, menacing arms, and with the tragic soaring of their green manes, their indomitable power, the pride of their musculature, their sap warm like

LES ISOLÉS

VINCENT VAN GOGH

Et voilà que, tout à coup, dès la rentrée dans l'ignoble tohubohu boueux de la rue sale et de la laide vie réelle, éparpillées, chantèrent, malgré moi, ces bribes de vers en ma mémoire:

> L'enivrante monotonie
> Du métal, du marbre et de l'eau....
> Et tout, même la couleur noire,
> Semblait fourbi, clair, irisé;
> Le liquide enchâssait sa gloire
> Dans le rayon cristallisé....
> Et des cataractes pesantes
> Comme des rideaux de cristal
> Se suspendaient, éblouissantes,
> A des murailles de métal....

Sous des ciels, tantôt taillés dans l'éblouissement des saphirs ou des turquoises, tantôt pétris de je ne sais quels soufres infernaux, chauds, délétères et aveuglants; sous des ciels pareils à des coulées de métaux et de cristaux en fusion, où, parfois, s'étalent, irradiés, de torrides disques solaires; sous l'incessant et formidable ruissellement de toutes les lumières possibles; dans des atmosphères lourdes, flambantes, cuisantes, qui semblent s'exhaler de fantastiques fournaises où se volatiliseraient des ors et des diamants et des gemmes singulières—c'est l'étalement inquiétant, troubleur, d'une étrange nature, à la fois vraiment vraie et quasiment supranaturelle, d'une nature excessive où tout, êtres et choses, ombres et lumières, formes et couleurs, se cabre, se dresse en une volonté rageuse de hurler son essentielle et propre chanson, sur le timbre le plus intense, le plus farouchement suraigu; ce sont des arbres, tordus ainsi que des géants en bataille, proclamant du geste de leurs noueux bras qui menacent et du tragique envolement de leurs vertes crinières, leur

*Translated by Ronald Pickvance

blood, their eternal defiance of the hurricane, of lightning, of malevolent nature; there are cypresses shooting up their nightmarish silhouettes of blackened flames; mountains arching their backs like mammoths or rhinoceroses; white and pink and blond orchards, like the idealizing dreams of virgins; squatting houses, passionately contorted, as if they were beings who rejoice, suffer, and think; rocks, lands, undergrowths, lawns, gardens, rivers that one would have said were sculpted from unknown minerals, polished, reflecting, iridescent, magical; there are flaming landscapes like the effervescence of multicolored glazes in some diabolical crucible of the alchemist, foliage that one would say was antique bronze, new copper, spun glass; beds of flowers which are less flowers than the richest jewelry made from rubies, agates, onyxes, emeralds, corundums, chrysoberyls, amethysts, and chalcedonies:[4] there is the universal and mad and blinding coruscation of things; it is matter, it is nature frantically twisted, in paroxysm, raised to the extreme of exacerbation; it is form becoming nightmare, color becoming flames, lavas and precious stones, light setting fire to itself, life a burning fever.[5]

*
*　*

Such is, without exaggeration, even though one might well doubt it, the impression left upon the retina at the first sight of the strange, intense, and feverish works of Vincent van Gogh, this compatriot and not unworthy descendant of the old masters of Holland.

Oh! how far we are—is it not so?—from that beautiful, great, traditional art, very healthy and very well balanced, of the Low Countries! How far from Gerard Dou, Aelbert Cuyp, Terborch, Metsu, Pieter de Hooch, Vermeer, Van der Heyden and from their charming canvases, a little bourgeois, so patiently and caringly made, so phlegmatically overfinished, so scrupulously detailed! How far from the beautiful landscapes, so sober, so deliberate, so enveloped always in the soft and gray and indistinct vapors of Van der Heyden, Berchem, Van Ostade, Potter, Van Goyen, Ruysdael, Hobbema! How far from the slightly cold elegance of Wouwerman, from the eternal candle of Schalcken, from the timid myopia, the fine brushes, and the magnifying glass of good Pieter Slingeland![6] How far from the delicate and always slightly cloudy and misty colors of northern countries, and from the tirelessly finicky brushstrokes of these well-to-do artists, from down there and from former times,[7] who painted "in their manner," their spirit very calm, their feet warm, and their paunch full of beer, and how far from this art, very honest, very conscientious, very scrupulous, very protestant, very republican, very genially commonplace, of these incomparable old masters who had only one fault—if it were a fault for them—of all being fathers of families and burgomasters. . . .

And yet, make no mistake, Vincent van Gogh is not so much outside his race. He has submitted to those ineluctable, atavistic laws.[8] He is well and truly Dutch, of the sublime line of Frans Hals.

And first and foremost, like all his illustrious compatriots, he is a realist, a realist in all the force of that word.

puissance indomptable, l'orgueil de leur musculature, leur sève chaude comme du sang, leur éternel défi à l'ouragan, à la foudre, à la nature méchante; ce sont des cyprès dressant leurs cauchemardantes silhouettes de flammes, qui seraient noires; des montagnes arquant des dos de mammouths ou de rhinocéros; des vergers blancs et roses et blonds, comme d'idéaux rêves de vierges; des maisons accroupies, se contorsionnant passionément ainsi que des êtres qui jouissent, qui souffrent, qui pensent; des pierres, des terrains, des broussailles, des gazons, des jardins, des rivières qu'on dirait sculptés en d'inconnus minéraux, polis, miroitants, irisés, féeriques; ce sont de flamboyants paysages qui paraissent l'ébullition de multicolores émaux dans quelque diabolique creuset d'alchimiste, des frondaisons qu'on dirait de bronze antique, de cuivre neuf, de verre filé; des parterres de fleurs qui sont moins des fleurs que de richissimes joailleries faites de rubis, d'agates, d'onyx, d'émeraudes, de corindons, de chrysobérils, d'améthistes et de calcédoines; c'est l'universelle et folle et aveuglante coruscation des choses; c'est la matière, c'est la nature tout entière tordue frénétiquement, paroxysée, montée aux combles de l'exacerbation; c'est la forme devenant le cauchemar, la couleur devenant flammes, laves et pierreries, la lumière se faisant incendie, la vie, fièvre chaude.

*
*　*

Telle, et non point exagérée, bien qu'on puisse penser, l'impression que laisse en la rétine le premier regarder des œuvres étranges, intensives et fiévreuses de Vincent Van Gogh, ce compatriote et non indigne descendant des vieux maîtres de Hollande.

Oh! combien loin nous sommes—n'est-ce pas?—du beau grand art ancien, très sain et très pondéré, des Pays-Bas! Combien loin des Gérard Dow, des Albert Cuyp, des Terburg, des Metzu, des Peter de Hooghe, des Van der Meer, des Van der Heyden et de leurs toiles charmeuses, un peu bourgeoises, tant patiemment soignées, tant flegmatiquement léchées, tant scrupuleusement minutieuses! Combien loin des beaux paysages, si sobres, si pondérés, si enveloppés toujours de douces, et grises, et indécises vapeurs, des Van der Heyden, des Berghem, des Van Ostade, des Potter, des Van Goyen, des Ruysdaël, des Hobbema! Combien loin de l'un peu froide élégance des Wouwermans, de l'éternelle chandelle de Schalken, de la timide myopie, des fins pinceaux et de la loupe du bon Pierre Slingelandt! Combien loin des délicates couleurs toujours un peu nuageuses et brumeuses des Pays du Nord et des inlassables pignochements de ces bien portants artistes, de là-bas et d'autrefois, qui peignaient «dans leur poêle», l'esprit très-calme, les pieds chauds et la panse pleine de bière, et combien loin de cet art très honnête, très consciencieux, très scrupuleux, très protestant, très républicain, très génialement banal de ces incomparables vieux maîtres qui avaient le seul tort—si ce fut un tort pour eux—d'être tous pères de famille et bourgmestres!...

Et pourtant, qu'on ne s'y trompe pas, Vincent Van Gogh n'est point tant en dehors de sa race. Il a subi les inéluctables lois ataviques. Il est bien et dûment

Ars est homo, additus naturae, said Chancellor Bacon,[9] and M. Émile Zola has defined naturalism as "nature seen through a temperament."[10] Now, it is this "homo additus," this "through a temperament," it is this molding of the supposed objective, always one, into the subjectives, always many, that complicates the question and precludes the possibility of a totally irrefutable criterion of the degrees of sincerity of the artist. The critic is thus always fatally reduced in this resolve to more or less hypothetical, but always questionable, inductions. Nevertheless, I consider that, in the case of Vincent van Gogh, despite the sometimes baffling strangeness of his works, it is difficult, for one who wishes to be impartial or knows how to look, to deny or to contest the naïve truthfulness of his art, the ingenuousness of his vision. Independent, in effect, of this indefinable perfume of good faith and truly-seen that all his pictures give out, the choice of subjects, the constant relationship of excessive notes, the conscientious study of characters, the continual search for the essential sign of each thing, a thousand significant details affirm for us unimpeachably his profound and almost childlike sincerity, his great love of nature and of truth—of his truth, the truth for him.

This admitted, it is therefore permissible legitimately to deduce from the works of Vincent van Gogh themselves his temperament as a man, or rather as an artist—a deduction that it would be possible for me, if I so wished, to corroborate from biographical facts.[11] What characterizes his work as a whole is excess, excess of strength, excess of nervousness, violence in expression. In his categorical affirmation of the character of things, in his often fearless simplification of forms, in his insolence in challenging the sun face to face, in the vehement passion of his drawing and color, right down to the smallest particulars of his technique, a powerful figure reveals himself, a man, one who dares, very often brutal, and sometimes ingenuously delicate. And even more, this is revealed in the almost orgiastic excesses of everything he has painted: he is a fanatic, an enemy of bourgeois sobrieties and petty details, a kind of drunken giant, better suited to moving mountains than handling knickknacks, a brain in eruption, irresistibly pouring its lava into all the ravines of art, a terrible and maddened genius, often sublime, sometimes grotesque, always close to the pathological. Finally, and above all, he is a hyperaesthete with clear symptoms, perceiving with abnormal intensity, perhaps even painfully, the imperceptible and secret character of lines and forms but, even more, colors, lights, nuances invisible to healthy eyes, the magic iridescences of shadows.[12] And that is why the realism of this neurotic, and his sincerity and truth, are so different from the realism, the sincerity and truth of the great petits bourgeois of Holland, who were so physically healthy and so well balanced mentally, who were his ancestors and his masters.

*

* *

However, this respect for and this love of the reality of things are not enough, by themselves, to explain and characterize the profound, complex, and very special art of Vincent van Gogh. Without doubt, like all the painters of his race, he is very conscious of pigment, of its importance and beauty, but also, more often, he only considers

Hollandais, de la sublime lignée de Franz Halz.

Et d'abord, en effet, comme tous ses illustres compatriotes, c'est un réaliste, un réaliste dans toute la force du terme. Ars est homo, additus naturae à dit le chancelier Bacon, et M. Émile Zola à défini le naturalisme «la nature vue à travers un tempérament». Or, c'est cet «homo additus» c'est cet «à travers un tempérament», c'est ce moulage de l'objectif, toujours un, dans des subjectifs, toujours divers, qui compliquent la question, et suppriment la possibilité de tout irréfragable critérium des degrés de sincérité de l'artiste. Le critique en est donc fatalement réduit, pour cette détermination, à des inductions plus ou moins hypothétiques, mais toujours contestables. Néanmoins, j'estime que, dans le cas de Vincent Van Gogh, malgré la parfois déroutante étrangeté de ses œuvres, il est difficile, pour qui veut être impartial et pour qui sait regarder, de nier ou de contester la véracité naïve de son art, l'ingénuité de sa vision. Indépendamment, en effet, de cet indéfinissable parfum de bonne foi et de vraiment-vu qu'exhalent tous ses tableaux, le choix des sujets, le rapport constant des plus excessives notes, la conscience d'étude des caractères, la continuelle recherche du signe essentiel de chaque chose, mille significatifs détails nous affirment irrécusablement sa profonde et presqu'enfantine sincérité, son grand amour de la nature et du vrai—de son vrai, à lui.

Il nous est donc permis, ceci admis, de légitimement induire des œuvres même de Vincent Van Gogh, à son tempérament d'homme, ou plutôt d'artiste—induction qu'il me serait possible, si je le voulais, de corroborer par des faits biographiques. Ce qui particularise son œuvre entière, c'est l'excès, l'excès en la force, l'excès en la nervosité, la violence en l'expression. Dans sa catégorique affirmation du caractère des choses, dans sa souvent téméraire simplification des formes, dans son insolence à fixer le soleil face à face, dans la fougue véhémente de son dessin et de sa couleur, jusque dans les moindres particularités de sa technique, se révèle un puissant, un mâle, un ôseur, très souvent brutal et parfois ingénûment délicat. Et, de plus, cela se devine, aux outrances quasiment orgiaques de tout ce qu'il à peint, c'est un exalté, ennemi des sobriétés bourgeoises et des minuties, une sorte de géant ivre, plus apte à des remuements de montagnes qu'à manier de bibelots d'étagères, un cerveau en ébullition, déversant sa lave dans tous les ravins de l'art, irrésistiblement, un terrible et affolé génie, sublime souvent, grotesque quelquefois, toujours relevant presque de la pathologie. Enfin, et surtout, c'est un hyperesthésique, nettement symptomatisé, percevant avec des intensités anormales, peut-être même, douloureuses, les imperceptibles et secrets caractères des lignes et des formes, mais plus encore les couleurs, les lumières, les nuances invisibles aux prunelles saines, les magiques irisations des ombres. Et voilà pourquoi son réalisme, à lui, le névrosé, et voilà pourquoi sa sincérité et sa vérité sont si différents du réalisme, de la sincérité et de la vérité de ces grands petits bourgeois de Hollande, si sains de corps, eux, si bien équilibrés d'âme, qui furent ses ancêtres et ses maîtres.

*

* *

Au reste, ce respect et cet amour de la réalité des choses ne suffisent point, seuls, à expliquer et à caracté-

this bewitching pigment as a kind of marvelous language destined to translate the Idea. He is almost always a symbolist. Not, I am aware, a symbolist in the manner of the Italian Primitives, those mystics who felt the need to dematerialize their dreams, but a symbolist who feels the constant necessity to clothe his ideas in precise, ponderable, tangible forms, in intensely corporeal and material envelopes. In almost all his canvases, beneath this morphic envelope, beneath this very fleshly flesh, beneath this very material matter, there lies, for the spirit that knows how to see it there, a thought, an Idea, and this Idea, the essential substratum of the work, is, at the same time, its efficient and final cause. As for the brilliant and dazzling symphonies of color and lines, whatever their importance be for the painter, they are in his work only simple expressive *means,* simple *processes* of symbolization. Indeed, if one refuses to admit beneath this naturalist art the existence of idealist tendencies, a great part of the work that we are studying would remain largely incomprehensible. How would one explain, for example, the *Sower,* this august and disturbing sower, this rustic, with the brutally genial forehead, resembling sometimes and distantly the artist himself, whose silhouette, gesture, and labor have always obsessed Vincent van Gogh, and which he has painted and painted again so often, sometimes beneath the ruddy skies of sunset, sometimes in the golden dust of embrased noons,[13] if one does not wish to dream of the fixed idea that haunts his brain of the actual necessity of the coming of a man, a messiah, a sower of truth, who will regenerate our decadent and perhaps imbecilic industrialist society? And also this obsessive passion for the solar disk, which he loves to make glow in the embrasure of the skies, and, at the same time, for this other sun, this vegetal star, the sumptuous sunflower,[14] which he repeats tirelessly, like a monomaniac, how can one explain it if one refuses to admit his persistent preoccupation with some vague and glorious heliomythic allegory?

*
* *

Vincent van Gogh, in fact, is not only a great painter, enthusiast of his art, of his palette, and of nature, he is also a dreamer, a fanatical believer, a devourer of beautiful utopias, living on ideas and dreams.

For a long time, he has taken delight in imagining a renewal of art, possible through a displacement of civilization: an art of tropical regions;[15] peoples imperiously reclaiming works corresponding to the new inhabited places; artists finding themselves face to face with a nature hitherto unknown, formidably luminous, avowing at last the impotence of the old academic tricks, and dedicating themselves to seeking out, naïvely, the candid translation of all these new sensations!...Could not this have been he, the intense and fantastic colorist, grinder of golds and precious stones, the very painter, rather than Guillaumet, the insipid Fromentin, and the muddy Gérôme, worthy of these resplendent countries, of burning suns, and blinding colors?...[16]

Then, as a result of this conviction of the necessity to begin everything again in art, he had and for a long time he cherished the idea of inventing a very simple, popular, almost childlike painting, capable of touching the humble people without refinements and of being understood by

riser l'art profond, complexe, très-à-part, de Vincent Van Gogh. Sans doute, comme tous les peintres de sa race, il est très conscient de la matière, de son importance et de sa beauté, mais aussi, le plus souvent, cette enchanteresse matière, il ne la considère que comme une sorte de merveilleux langage destiné à traduire l'Idée. C'est, presque toujours, un symboliste. Non point, je le sais, un symboliste à la manière des primitifs italiens, ces mystiques qui éprouvaient à peine le besoin de désimmatérialiser leurs rêves, mais un symboliste sentant la continuelle nécessité de revêtir ses idées de formes précises, pondérables, tangibles, d'enveloppes intensément charnelles et matérielles. Dans presque toutes ses toiles, sous cette enveloppe morphique, sous cette chair très chair, sous cette matière très matière, gît, pour l'esprit qui sait l'y voir, une pensée, une Idée, et cette Idée, essentiel substratum de l'œuvre, en est, en même temps, la cause efficiente et finale. Quant aux brillantes et éclatantes symphonies de couleurs et de lignes, quelle que soit leur importance pour le peintre, elles ne sont dans son travail que de simples *moyens* expressifs, que de simples *procédés* de symbolisation. Si l'on refusait, en effet, d'admettre sous cet art naturaliste l'existence de ces tendances idéalistes, une grande part de l'œuvre que nous étudions demeurerait fort incompréhensible. Comment expliquerait-on, par exemple, *le Semeur,* cet auguste et troublant semeur, ce rustre au front brutement génial, ressemblant parfois et lointainement à l'artiste lui-même, dont la silhouette, le geste et le travail ont toujours obsédé Vincent Van Gogh, et qu'il peignit et repeignit si souvent, tantôt sous des ciels rubescents de couchant, tantôt dans la poudre d'or des midis embrasés, si l'on ne veut songer à cette idée fixe qui hante sa cervelle de l'actuelle nécessité de la venue d'un homme, d'un messie, semeur de vérité, qui regénèrerait la décrépitude de notre art et peut-être de notre imbécile et industrialiste société? Et aussi cette obsédante passion pour le disque solaire qu'il aime à faire rutiler dans l'embrasement de ses ciels et, en même temps, pour cet autre soleil, pour cet astre végétal, le somptueux tournesol, qu'il répète, sans se lasser, en monomane, comment l'expliquer si l'on refuse d'admettre sa persistante préoccupation de quelque vague et glorieuse allégorie héliomythique?

*
* *

Vincent Van Gogh, en effet, n'est pas seulement un grand peintre, enthousiaste de son art, de sa palette et de la nature, c'est encore un rêveur, un croyant exalté, un dévoreur de belles utopies, vivant d'idées et de songes.

Longtemps, il s'est complu à imaginer une rénovation d'art, possible par un déplacement de civilisation: un art des régions tropicales; les peuples réclamant impérieusement des œuvres correspondant aux nouveaux milieux habités; les peintres se trouvant face à face avec une nature jusqu'alors inconnue, formidablement lumineuse, s'avouant enfin l'impuissance des vieux trucs d'école, et se mettant à chercher, naïvement, la candide traduction de toutes ces neuves sensations!...N'eût-il pas été, en effet, lui, l'intense et fantastique coloriste broyeur d'ors et de pierreries, le très digne peintre, plutôt que les Guillaumet, que les fadasses Fromentin et que les boueux Gérôme, de ces pays des resplendissances, des fulgurants soleils et des couleurs qui aveuglent?...

the most naïve of the poor in spirit.[17] *La Berceuse,* this gigantic and genial *image d'Épinal* which he has repeated, with curious variations, several times, the portrait of the phlegmatic and indescribably jubilant *Employee of the Postal Services,* the *Drawbridge,* so crudely luminous, so exquisitely banal, the ingenuous *Young Girl with the Rose,* the *Zouave,* the *Provençal Woman*[18] indicate with the greatest clarity this tendency toward the simplification of art which one finds moreover, more or less, in all his work, and which seems to me neither so absurd nor so unworthy in these times of outrageous complexity, myopia, and inept analysis.

*

* *

All these theories, all these hopes of Vincent van Gogh, are they practical? Are they not vain and beautiful chimeras? Who knows? In any case, I cannot examine that here. It will suffice for me, in concluding, to characterize this unusual spirit, so far outside all banal paths, by saying some words on his technique.

The external and material aspect of his painting is completely at one with his artistic temperament. In all his works, the execution is vigorous, exalted, brutal, intense. His drawing, passionate, powerful, sometimes clumsy and somewhat heavy, exaggerates the character, simplifies, leaps over the detail like a master, like a conqueror, attains the magistral synthesis, sometimes, but not always, the grand style.

His color we know already. It is unbelievably dazzling. He is, as far as I know, the only painter who perceives the chromatism of things with this intensity, with this metallic, jewellike quality.[19] His researches into the coloration of shadows, into the influences of colors on colors, of full sunlight are of the most inquisitive.[20] He is not always able, however, to avoid certain disagreeable crudities, certain disharmonies, certain dissonances.... As for his facture itself, his procedures in coloring his canvas, they are, like all the rest of him, fiery, very powerful, and very nervous. His brush operates by enormous impasto touches of very pure colors, by curved trails broken by rectilinear strokes ... by accumulations, sometimes clumsy, of a very glowing masonry, and all this gives to some of his canvases the solid appearance of dazzling walls made of crystals and sun.

*

* *

This strong and true artist, a real thoroughbred, with the brutal hands of a giant, with the neuroses of a hysterical woman, with the soul of a visionary, so original and so apart from our pitiful art of today, will he know one day—anything is possible—the joys of rehabilitation, the repentant cajoleries of fashion? Perhaps. But, whatever happens, even if the world of fashion would come to pay for his canvases—which is hardly likely—the prices of the small infamies of M. Meissonier,[21] I do not think that much sincerity would enter into this belated admiration of the public at large. Vincent van Gogh is at once too simple and too subtle for the contemporary bourgeois spirit. He will never be fully understood except by his brothers, the

Puis, comme conséquence de cette conviction du besoin de tout recommencer en art, il eut et longtemps il caressa l'idée d'inventer une peinture très simple, populaire, quasiment enfantine, capable d'émouvoir les humbles qui ne raffinent point et d'être comprise par les plus naïfs des pauvres d'esprits. La *Berceuse,* cette gigantesque et géniale image d'Épinal, qu'il a répétée, avec de curieuses variantes, plusieurs fois, le portrait du flegmatique et indescriptiblement jubilant *Employé des postes,* le *Pont-levis,* si crûment lumineux et si exquisément banal, l'ingénue *Fillette à la rose, le Zouave, la Provençale,* indiquent, avec la plus grande netteté, cette tendance vers la simplification de l'art, qu'on retrouve d'ailleurs, plus ou moins, dans tout son œuvre et qui ne me paraît point si absurde ni si mésestimable en ces temps de complication à outrance, de myopie et de maladroite analyse.

*

* *

Toutes ces théories, toutes ces espérances de Vincent Van Gogh sont-elles pratiques? Ne sont-elles point de vaines et belles chimères? Qui le sait? En tous cas, je n'ai point à l'examiner ici. Il me suffira, pour terminer d'à peu près caractériser ce curieux esprit si en dehors de tous banaux sentiers, de dire quelques mots sur sa technique.

Le côté externe et matériel de sa peinture est en absolue corrélation avec son tempérament d'artiste. Dans toutes ses œuvres, l'exécution est vigoureuse, exaltée, brutale, intensive. Son dessin, rageur, puissant, souvent maladroit et quelque peu lourd, exagère le caractère, simplifie, saute en maître, en vainqueur, par dessus le détail, atteint la magistrale synthèse, le grand style quelquefois, mais non point toujours.

Sa couleur, nous la connaissons déjà. Elle est invraisemblablement éblouissante. Il est, que je sache, le seul peintre qui perçoive le chromatisme des choses avec cette intensité, avec cette qualité métallique, gemmique. Ses recherches de colorations d'ombres, d'influences de tons sur tons, de pleins ensoleillements sont des plus curieuses. Il ne sait pas toujours éviter, pourtant, certaines crudités désagréables, certaines inharmonies, certaines dissonances...Quant à sa facture proprement dite, à ses immédiats procédés d'enluminer la toile, ils sont, ainsi que tout le reste de ce qui est lui, fougueux, très puissants et très nerveux. Sa brosse opère par énormes empâtements de tons très purs, par trainées incurvées, rompues de touches rectilignes..., par entassements, parfois maladroits, d'une très rutilante maçonnerie, et tout cela donne à certaines de ses toiles l'apparence solide d'éblouissantes murailles faites de cristaux et de soleil.

*

* *

Ce robuste et vrai artiste, très de race, aux mains brutales de géant, aux nervosités de femme hystérique, à l'âme d'illuminé, si original et si à-part au milieu de notre piteux art d'aujourd'hui, connaîtra-t-il un jour—tout est possible—les joies de la réhabilitation, les cajoleries repenties de la vogue? Peut-être. Mais quoi qu'il arrive, quand bien même la mode viendrait de payer ses toiles—

true artists...by some happy ones among the simple people, the wholly simple people, who will, by chance, have escaped from the well-meaning teachings of public education!...

ce qui est peu probable—au prix des petites infamies de M. Meissonnier, je ne pense pas que beaucoup de sincérité puisse jamais entrer en cette tardive admiration du gros public. Vincent Van Gogh est, à la fois, trop simple et trop subtil pour l'esprit-bourgeois contemporain. Il ne sera jamais pleinement compris que de ses frères, les artistes très artistes...et des heureux du petit peuple, du tout petit peuple, qui auront, par hasard, échappé aux bienfaisants enseignements de la Laïque!...

NOTES

1. Aurier's article was published in the first number of *Le Mercure de France*, January 1890, pp. 24–29. A considerable part of it was reprinted in *L'Art Moderne*, Brussels, 19 January 1890, pp. 21–22. The entire article was reprinted in Aurier's *Oeuvres Posthumes*, Paris, 1893, pp. 257–65. There, also, van Gogh's letter to Aurier of February 1890 (LT626a) was published for the first time. Aurier's article was then ignored for almost half a century. It was reprinted—though not in its entirety—in *Van Gogh raconté par lui-même et par ses amis*, Geneva, 1947, pp. 59–70; and in Jean Leymarie, *Van Gogh*, Paris, 1951, pp. 75–77 (with some omissions). The first English translation, of selected parts only, was published in John Rewald, *Post-Impressionism: From van Gogh to Gauguin*, New York, 1956 (reprinted, 1978, pp. 342–43). Selected parts were also translated in Linda Nochlin, *Impressionism and Post-Impressionism, 1874-1904: Sources and Documents*, Englewood Cliffs, N.J., 1966, pp. 152–56; and in Bogomila Welsh-Ovcharov, *Van Gogh in Perspective*, Englewood Cliffs, N.J., 1974, pp. 55–57.

2. Aurier seems to imply here that he has just seen van Gogh's paintings for the first time, as if he were walking out of Tanguy's shop and entering the reality of the street, which he contrasts to the etherealized otherworld of van Gogh's art. But, in fact, Aurier had been familiar with van Gogh's work for at least a year, and had written of having seen it at Tanguy's in *Le Moderniste* of 13 April 1889.

3. Aurier's poem summarizes the main points of his article on the surfaces, textures, and colors of the paintings themselves. Welsh-Ovcharov, *Van Gogh in Perspective*, p. 55 n. 1, has pointed out that the poem is a pastiche of the "Rêve Parisien" from Baudelaire's *Les Fleurs du mal*.

4. Theo reported to his brother on 8 December 1889: "That friend of Bernard's named Aurier looked me up; you know, the one who came to see me once in the Rue Lepic. He is very interested in what you are doing, and he showed me a little paper which he edits, and in which he wrote about Tanguy's shop [i.e., *Le Moderniste* of 13 April 1889], on which occasion he mentioned your pictures" (T21). Aurier therefore must have seen the paintings van Gogh sent to Paris in late September 1889—that is, batches two and three, the summer landscapes of 1889, together with the *Self-Portrait* (F627). While each of Aurier's images is not necessarily tied to one specific painting, he must have had vividly in his mind such pictures as F608 (cat. 1), F712 (cat. 13), F613 (cat. 15), and F622 (cat. 20), as well as F579, F611, F617, and F717. The pictures of rivers and orchards must be of Arles; these Aurier could have seen either at Theo's or at Tanguy's.

5. Aurier's punctuation has been retained in this long opening sentence in order to convey the accumulating repetition of incantatory phrases.

6. An odd list of seventeenth-century Dutch artists, apparently haphazardly selected by Aurier. Not all of them would have been admired by van Gogh (e.g., Berchem and Slingeland). The most amazing omission is Rembrandt.

7. In the original French, "de là-bas et d'autrefois" might contain a disguised reference to Eugène Fromentin's *Maîtres d'autrefois Belgique-Hollande*, Paris, 1876.

8. The reference is to the positivist *Philosophie de l'Art* (1865) by Hippolyte Taine, published in Paris in 1865.

9. The Latin of Francis Bacon can be translated as "art depends upon men dedicated to nature."

10. Émile Zola actually wrote: "A work of art is a corner of nature seen through a temperament" ("Une œuvre d'art est un coin de la création vu à travers un tempérament").

11. Émile Bernard provided these biographical facts, which Aurier then declined to use.

12. The "secret character of lines and forms" is discussed by van Gogh himself in LT595, LT607, and LT613. It is unlikely that Aurier was aware of this.

13. Aurier appears to be referring to two paintings of the *Sower*, one of June 1888 (F422), the other of November 1888 (F450).

14. Van Gogh embellished on the symbol of the sunflower in his letter to Aurier: "Suppose that the two pictures of sunflowers that are now at the Vingtistes' exhibition have certain qualities of color, and that they also express an idea symbolizing 'gratitude'" (LT626a).

15. Rewald, *Post-Impressionism*, p. 358 n. 74, was the first to note that this passage is based on a letter that van Gogh and Gauguin had written to Émile Bernard from Arles in early November 1888 (B19a), and which Bernard later gave to Aurier. Van Gogh had written: "As for me, with my presentiment of a new world, I firmly believe in the possibility of an immense renaissance of art. Whoever believes in this new art will have the tropics for a home."

16. Aurier's references are to French artists who painted in North Africa: Gustave-Achille Guillaumet (1840–1887), Eugène Fromentin (1820–1876), and Jean-Léon Gérôme (1824–1904). Van Gogh himself often denigrated the paintings of Fromentin and Gérôme. He wrote to Bernard in early June 1888: "What I should like to find out is the effect of an intenser blue in the sky. Fromentin and Gérôme see the soil of the South as colorless, and a lot of people see it like that" (B6). It is said that Bernard showed Aurier van Gogh's letters of that summer when they met in Saint-Briac.

17. Compare van Gogh's references to such ideas in LT523 and LT592.

18. Aurier is referring to several paintings from Arles. *La Berceuse* exists in five versions (F504–F508); its *image d'Épinal* quality was stressed by van Gogh himself in LT592. The *Employee of the Postal Services* is probably the "jubilant" Roulin in three-quarter length (F432). The *Drawbridge* could be one of several pictures, but is most probably F570. The "ingenuous" *Young Girl with the Rose* is surely *La Mousmé* (F431). The *Zouave* is one of two paintings, F423 or F424. And Aurier's *Provençal Woman* must be *L'Arlésienne* (F488 or F489).

19. In his answer to Aurier's article van Gogh quoted this sentence and insisted that Adolphe Monticelli (1824–1886) had achieved these effects: "Be so kind as to go and see a certain bouquet by Monticelli at my brother's—a bouquet in white, forget-me-not blue and orange—then you will feel what I want to say" (LT626a).

20. Such preoccupations with color theory and practice were discussed in letters of summer 1888 to Bernard that were shown to Aurier in Saint-Briac (see note 16 above). See especially B6 of early June 1888.

21. In his answer to Aurier's article, van Gogh stoutly defended Jean-Louis-Ernest Meissonier (1815–1891): "I do not understand why *you* should speak of Meissonier's 'infamies.' It is possible that I have inherited from the excellent Mauve [Anton Mauve, 1838–1888] an absolutely unlimited admiration for Meissonier....What Mauve repeated so often was something like this: 'If one wants to paint colors, one should also be able to draw a chimney corner or an interior as Meissonier does'" (LT626a).

APPENDIX IV: Related Works

Works by Vincent van Gogh referred to in the present volume cited by their F number, the catalogue number assigned to them in the revised edition of J.-B. de la Faille, *The Works of Vincent van Gogh: His Paintings and Drawings,* Amsterdam–New York, 1970. The information provided in this Appendix was obtained from de la Faille and from Jan Hulsker, *The Complete van Gogh: Paintings, Drawings, Sketches,* Oxford–New York, 1980. When known, the dimensions, mediums, and present location of works have been updated. Titles have been brought into conformity with titles in the present volume.

F8. *Girl in White in the Woods*
Oil on canvas, 15¼ x 23¼ in. (39 x 59 cm.)
Rijksmuseum Kröller-Müller, Otterlo

F82. *The Potato Eaters*
Oil on canvas, 32¼ x 45 in. (82 x 114 cm.)
Rijksmuseum Vincent van Gogh (Vincent van Gogh Foundation), Amsterdam

F84. *The Old Church Tower at Nuenen*
Oil on canvas, 24¾ x 41 in. (63 x 79 cm.)
Rijksmuseum Vincent van Gogh (Vincent van Gogh Foundation), Amsterdam

F87. *The Cemetery at Nuenen in the Snow*
Canvas on pasteboard, 11¾ x 16½ in. (30 x 41.5 cm.)
Collection Stavros S. Niarchos

F193. *Sheaves of Wheat*
Oil on canvas, 15¾ x 11¾ in. (40 x 30 cm.)
Rijksmuseum Kröller-Müller, Otterlo

F305. *Entrance of Voyer-d'Argenson Park at Asnières*
Oil on canvas, 21½ x 26¼ in. (55 x 67 cm.)
Israel Museum, Jerusalem

F306. *Undergrowth*
Oil on canvas, 12½ x 18 in. (32 x 46 cm.)
Museum van Baaren, Utrecht

F307. *Undergrowth*
Oil on canvas, 18 x 15 in. (46 x 38 cm.)
Rijksmuseum Vincent van Gogh (Vincent van Gogh Foundation), Amsterdam

F308. *Undergrowth*
Oil on canvas, 18 x 15 in. (46 x 38 cm.)
Rijksmuseum Vincent van Gogh (Vincent van Gogh Foundation), Amsterdam

F309. *A Path in the Woods*
Oil on canvas, 18 x 15¼ in. (46 x 38.5 cm.)
Rijksmuseum Vincent van Gogh (Vincent van Gogh Foundation), Amsterdam

F309a. *Undergrowth*
Oil on canvas, 18 x 21¾ in. (46 x 55.5 cm.)
Rijksmuseum Vincent van Gogh (Vincent van Gogh Foundation), Amsterdam

F362. *Undergrowth with Flowers*
Oil on canvas, 19⅝ x 25⅝ in. (50 x 65 cm.)
Singer Memorial Museum, Laren (N. H.), The Netherlands

F371. *Japonaiserie: Flowering Plum Tree (after Hiroshige)*
Oil on canvas, 21¾ x 18 in. (55 x 46 cm.)
Rijksmuseum Vincent van Gogh (Vincent van Gogh Foundation), Amsterdam

F372. *Japonaiserie: The Bridge in the Rain (after Hiroshige)*
Oil on canvas, 28¾ x 21¼ in. (73 x 54 cm.)
Rijksmuseum Vincent van Gogh (Vincent van Gogh Foundation), Amsterdam

F391. *Snowy Landscape with Arles in the Background*
Oil on canvas, 19⅝ x 23⅝ in. (50 x 60 cm.)
Private collection

F392. *Blossoming Almond Branch in a Glass*
Oil on canvas, 9½ x 7½ in. (24 x 19 cm.)
Rijksmuseum Vincent van Gogh (Vincent van Gogh Foundation), Amsterdam

F393. *Blossoming Almond Branch in a Glass with a Book*
Oil on canvas, 9½ x 7½ in. (24 x 19 cm.)
Private collection, Switzerland

F407. *Path Through a Field with Willows*
Oil on canvas, 12¼ x 15¼ in. (31 x 38.5 cm.)
Present location unknown

F409. *View of Arles with Irises in the Foreground*
Oil on canvas, 21¼ x 25⅝ in. (54 x 65 cm.)
Rijksmuseum Vincent van Gogh (Vincent van Gogh Foundation), Amsterdam

F411. *Wheat Field*
Oil on canvas mounted on pasteboard, 21¼ x 25⅝ in. (54 x 65 cm.)
Rijksmuseum Vincent van Gogh (Vincent van Gogh Foundation), Amsterdam

F412. *Harvest at La Crau, with Montmajour in the Background*
Oil on canvas, 28½ x 36¼ in. (72.5 x 92 cm.)
Rijksmuseum Vincent van Gogh (Vincent van Gogh Foundation), Amsterdam

F420. *Street in Saintes-Maries-de-la-Mer*
Oil on canvas, 15 x 18⅛ in. (38 x 46 cm.)
Private collection

F422. *The Sower*
Oil on canvas, 25¼ x 31¾ in. (64 x 80.5 cm.)
Rijksmuseum Kröller-Müller, Otterlo

F425. *Haystacks in Provence*
Oil on canvas, 28¾ x 36⅝ in. (73 x 92.5 cm.)
Rijksmuseum Kröller-Müller, Otterlo

F432. *Portrait of Joseph Roulin*
Oil on canvas, 32 x 25¾ in. (81.2 x 65.3 cm.)
Museum of Fine Arts, Boston

F450. *The Sower*
Oil on burlap mounted on canvas, 28⅞ x 36¼ in. (73.5 x 92 cm.)
Foundation E. G. Bührle Collection, Zurich

F452. *Four Cut Sunflowers, One Upside Down*
Oil on canvas, 23⅝ x 39⅜ in. (60 x 100 cm.)
Rijksmuseum Kröller-Müller, Otterlo

F453. *Three Sunflowers in a Vase*
Oil on canvas, 28¾ x 22⅞ in. (73 x 58 cm.)
Private collection, Switzerland

F454. *Fourteen Sunflowers in a Vase*
Oil on canvas, 36⅝ x 28¾ in. (93 x 73 cm.)
The Trustees of the National Gallery, London

F455. *Twelve Sunflowers in a Vase*
Oil on canvas, 36¼ x 28¾ in. (92 x 72.5 cm.)
Philadelphia Museum of Art

F456. *Twelve Sunflowers in a Vase*
Oil on canvas, 35⅞ x 28 in. (91 x 71 cm.)
Bayerische Staatsgemäldesammlungen, Munich

F458. *Fourteen Sunflowers in a Vase*
Oil on canvas, 37⅜ x 28¾ in. (95 x 73 cm.)
Rijksmuseum Vincent van Gogh (Vincent van Gogh Foundation), Amsterdam

F459. *Five Sunflowers in a Vase*
Oil on canvas, 38⅝ x 27⅛ in. (98 x 69 cm.)
Destroyed; formerly in Yokohama

F462. *Portrait of Eugène Boch*
Oil on canvas, 23⅝ x 17¾ in. (60 x 45 cm.)
Musée d'Orsay, Paris

F463. *The Night Café*
Oil on canvas, 27½ x 35 in. (70 x 89 cm.)
Yale University Art Gallery, New Haven

F474. *Starry Night Over the Rhône*
Oil on canvas, 28½ x 36¼ in. (72.5 x 92 cm.)
Collection Mr. and Mrs. Robert Kahn-Sriber. Gift, reserving life interest, to the Musées Nationaux (Musée d'Orsay), Paris

F482. *Van Gogh's Bedroom*
Oil on canvas, 28⅜ x 35¼ in. (72 x 90 cm.)
Rijksmuseum Vincent van Gogh (Vincent van
 Gogh Foundation), Amsterdam

F483. *Van Gogh's Bedroom*
Oil on canvas, 22¼ x 29 in. (56.5 x 74 cm.)
Musée d'Orsay, Paris

F484. *Van Gogh's Bedroom*
Oil on canvas, 28¾ x 36¼ in. (73 x 92 cm.)
The Art Institute of Chicago

F485. *The Lovers: Poet's Garden IV*
Oil on canvas, 29½ x 36¼ in. (75 x 92 cm.)
Present location unknown

F486. *Les Alyscamps*
Oil on canvas, 28¾ x 36¼ in. (73 x 92 cm.)
Rijksmuseum Kröller-Müller, Otterlo

F487. *Les Alyscamps*
Oil on canvas, 28⅜ x 35⅞ in. (72 x 91 cm.)
Private collection

F488. *L'Arlésienne: Madame Ginoux*
Oil on canvas, 36 x 29 in. (91.4 x 73.7 cm.)
The Metropolitan Museum of Art, New York

F489. *L'Arlésienne: Madame Ginoux*
Oil on canvas, 36⅝ x 29⅛ in. (93 x 74 cm.)
Musée d'Orsay, Paris

F496. *Memory of the Garden at Etten*
Oil on canvas, 29 x 36⅜ in. (73.5 x 92.5 cm.)
The Hermitage Museum, Leningrad

F503. *Madame Augustine Roulin*
Oil on canvas, 21⅝ x 25⅝ in. (55 x 65 cm.)
Collection Oskar Reinhart, Winterthur,
 Switzerland

F504. *La Berceuse*
Oil on canvas, 36¼ x 28¾ in. (92 x 73 cm.)
Rijksmuseum Kröller-Müller, Otterlo

F511. *Orchard in Blossom*
Oil on canvas, 28¾ x 36¼ in. (72.5 x 92 cm.)
Rijksmuseum Vincent van Gogh (Vincent van
 Gogh Foundation), Amsterdam

F512. *Orchard in Blossom*
Oil on canvas, 28¼ x 36¼ in. (72 x 92 cm.)
Private collection

F513. *Orchard Bordered by Cypresses*
Oil on canvas, 25⅝ x 31⅞ in. (65 x 81 cm.)
Rijksmuseum Kröller-Müller, Otterlo

F514. *La Crau with Peach Trees in Bloom*
Oil on canvas, 25¾ x 32 in. (65.5 x 81.5 cm.)
Courtauld Institute Galleries, London

F515. *Orchard in Bloom*
Oil on canvas, 19⅞ x 25⅝ in. (50.5 x 65 cm.)
Rijksmuseum Vincent van Gogh (Vincent van
 Gogh Foundation), Amsterdam

F516. *View of Arles*
Oil on canvas, 28⅜ x 36¼ in. (72 x 92 cm.)
Bayerische Staatsgemäldesammlungen, Munich

F517. *Red Chestnuts in the Public Garden at Arles*
Oil on canvas, 28¾ x 36¼ in. (72.5 x 92 cm.)
Private collection, U.S.A.

F518. *Portrait of a Young Girl Against a Pink
 Background*
Oil on canvas, 20 x 19¼ in. (51 x 49 cm.)
Rijksmuseum Kröller-Müller, Otterlo

F520. *The Old Willows*
Oil on canvas, 21⅝ x 25⅝ in. (55 x 65 cm.)
Collection Stavros S. Niarchos

F540. *L'Arlésienne: Madame Ginoux Against a
 Cherry-Colored Background*
Oil on canvas, 23½ x 19¾ in. (60 x 50 cm.)
Galleria Nazionale d'Arte Moderna, Rome

F541. *L'Arlésienne: Madame Ginoux Against a
 Light Violet-Pink Background*
Oil on canvas, 25½ x 19¼ in. (65 x 49 cm.)
Rijksmuseum Kröller-Müller, Otterlo

F543. *L'Arlésienne: Madame Ginoux in a Light
 Dress Against a Cream-Colored Background
 with Flowers*
Oil on canvas, 26 x 21¼ in. (66 x 54 cm.)
Private collection

F554. *Orchard Bordered by Cypresses*
Oil on canvas, 12¾ x 15¾ in. (32.5 x 40 cm.)
Private collection

F565. *Farmhouse in Provence*
Oil on canvas, 18⅛ x 24 in. (46.1 x 60.9 cm.)
National Gallery of Art, Washington, D.C.

F568. *Les Alyscamps*
Oil on canvas, 36⅝ x 28⅜ in. (93 x 72 cm.)
Private collection, Lausanne

F569. *Les Alyscamps*
Oil on canvas, 36¼ x 29 in. (92 x 73.5 cm.)
Private collection

F575. *Landscape Under a Stormy Sky*
Oil on canvas, 23⅝ x 28¾ in. (60 x 73 cm.)
Private collection

F579. *Lilacs*
Oil on canvas, 28¾ x 36¼ in. (73 x 92 cm.)
The Hermitage Museum, Leningrad

F585. *Olive Orchard*
Oil on canvas, 28⅜ x 36¼ in. (72 x 92 cm.)
Rijksmuseum Kröller-Müller, Otterlo

F601. *Still Life: The Iris*
Paper mounted on canvas, 24¾ x 19 in.
 (62.5 x 48 cm.)
National Gallery of Canada, Ottawa

F609. *A Corner of the Asylum Garden*
Oil on canvas, 36¼ x 28⅜ in. (92 x 72 cm.)
Present location unknown

F610. *Death's-Head Moth*
Oil on canvas, 13 x 9½ in. (33 x 24 cm.)
Rijksmuseum Vincent van Gogh (Vincent van
 Gogh Foundation), Amsterdam

F611. *Mountainous Landscape Behind
 the Asylum*
Oil on canvas, 28 x 35 in. (70.5 x 88.5 cm.)
Ny Carlsberg Glyptotek, Copenhagen

F615. *Wheat Field with Cypresses*
Oil on canvas, 28¾ x 36¼ in. (72.5 x 91.5 cm.)
The Trustees of the National Gallery, London

F617. *The Reaper*
Oil on canvas, 28⅜ x 36¼ in. (72 x 92 cm.)
Rijksmuseum Kröller-Müller, Otterlo

F619. *Wheat Field with Reaper*
Oil on canvas, 23⅝ x 28¾ in. (59.5 x 73 cm.)
Museum Folkwang, Essen

F620. *Cypresses*
Oil on canvas, 36¼ x 28¾ in. (92 x 73 cm.)
Rijksmuseum Kröller-Müller, Otterlo

F621. *Cypresses*
Oil on canvas, 16½ x 10¼ in. (42 x 26 cm.)
Rijksmuseum Vincent van Gogh (Vincent van
 Gogh Foundation), Amsterdam

F627. *Self-Portrait*
Oil on canvas, 25⅝ x 21¼ in. (65 x 54 cm.)
Musée d'Orsay, Paris

F630. *Pietà (after Delacroix)*
Oil on canvas, 28¾ x 24 in. (73 x 60.5 cm.)
Rijksmuseum Vincent van Gogh (Vincent van
 Gogh Foundation), Amsterdam

F631. *Portrait of Madame Trabuc*
Oil on canvas mounted on panel, 25¼ x 19¼ in.
 (64 x 49 cm.)
Present location unknown

F632. *The Plough and the Harrow (after Millet)*
Oil on canvas, 28¼ x 36¼ in. (72 x 92 cm.)
Rijksmuseum Vincent van Gogh (Vincent van
 Gogh Foundation), Amsterdam

F633. *The Good Samaritan (after Delacroix)*
Oil on canvas, 28¾ x 23½ in. (73 x 60 cm.)
Rijksmuseum Kröller-Müller, Otterlo

F634. *Sheepshearers (after Millet)*
Oil on canvas, 17 x 11½ in. (43 x 29 cm.)
Rijksmuseum Vincent van Gogh (Vincent van
 Gogh Foundation), Amsterdam

F637. *The Mulberry Tree*
Oil on canvas, 21¼ x 25⅝ in. (54 x 65 cm.)
The Norton Simon Art Foundation, Pasadena

F638. *Poplars Against a Background
 of Mountains*
Oil on canvas, 24 x 18⅛ in. (61 x 45.5 cm.)
The Cleveland Museum of Art

F640. *The Park at the Asylum*
Oil on canvas, 25⅝ x 19¼ in. (64.5 x 49 cm.)
Private collection, Geneva

F644. *Husband at Sea (after Demont-Breton)*
Oil on canvas, 26 x 20⅛ in. (66 x 51 cm.)
Private collection, Philadelphia

F646. *The Hospital in Arles*
Oil on canvas, 29⅛ x 36¼ in. (74 x 92 cm.)
Oskar Reinhart Collection "Am Römerholz,"
 Winterthur, Switzerland

F647. *La Veillée (after Millet)*
Oil on canvas, 28½ x 36¼ in. (72.5 x 92 cm.)
Rijksmuseum Vincent van Gogh (Vincent van
 Gogh Foundation), Amsterdam

F648. *Men Digging (after Millet)*
Oil on canvas, 28¼ x 36¼ in. (72 x 92 cm.)
Stedelijk Museum, Amsterdam

F649. *Evening: The End of the Day (after Millet)*
Oil on canvas, 28¼ x 36¼ in. (72 x 92 cm.)
Private collection

F651. *The Walk: Falling Leaves*
Oil on canvas, 29 x 23¾ in. (73.5 x 60 cm.)
Rijksmuseum Vincent van Gogh (Vincent van Gogh Foundation), Amsterdam

F653. *Pine Trees with Figure in the Asylum Garden*
Oil on canvas, 22¾ x 17¾ in. (58 x 45 cm.)
Musée d'Orsay, Paris

F655. *Olive Pickers*
Oil on canvas, 23¾ x 35 in. (73 x 89 cm.)
Private collection

F656. *Olive Pickers*
Oil on canvas, 28¾ x 36¼ in. (73 x 92 cm.)
National Gallery of Art, Washington, D.C.

F659. *A Corner of the Asylum Garden*
Oil on canvas, 28⅜ x 35⅞ in. (71.5 x 90.5 cm.)
Rijksmuseum Vincent van Gogh (Vincent van Gogh Foundation), Amsterdam

F661. *The Ravine*
Oil on canvas, 28¼ x 36¼ in. (72 x 92 cm.)
Rijksmuseum Kröller-Müller, Otterlo

F662. *The Ravine*
Oil on canvas, 28¾ x 36¼ in. (73 x 92 cm.)
Museum of Fine Arts, Boston

F663. *Landscape with Olive Trees and Mountains in the Background*
Oil on canvas, 17¾ x 21¾ in. (45 x 55 cm.)
Present location unknown

F664. *White Mas Among the Olive Trees*
Oil on canvas, 27½ x 23½ in. (70 x 60 cm.)
Present location unknown

F669. *The Prison Courtyard (after Doré)*
Oil on canvas, 31½ x 25¼ in. (80 x 64 cm.)
Pushkin State Museum of Fine Arts, Moscow

F672. *The Asylum Garden*
Oil on canvas, 25½ x 32 in. (64.5 x 81 cm.)
The Trustees of the National Gallery, London

F673. *Huts: Memory of the North*
Oil on canvas, 18 x 17 in. (45.5 x 43 cm.)
Private collection, Switzerland

F677. *The Raising of Lazarus (after Rembrandt)*
Oil on canvas, 19 x 24¾ in. (48.5 x 63 cm.)
Rijksmuseum Vincent van Gogh (Vincent van Gogh Foundation), Amsterdam

F682. *Pink Roses in a Vase*
Oil on canvas, 36⅝ x 28⅜ in. (93 x 72 cm.)
Collection Walter H. Annenberg, Rancho Mirage, California

F689. *The Sower (after Millet)*
Oil on canvas, 25¼ x 21¾ in. (64 x 55 cm.)
Rijksmuseum Kröller-Müller, Otterlo

F695. *Women Digging in Field with Snow*
Oil on canvas, 19¾ x 25¼ in. (50 x 64 cm.)
Foundation E. G. Bührle Collection, Zurich

F703. *Portrait of a Patient at the Asylum*
Oil on canvas, 12⅝ x 9½ in. (32 x 23.5 cm.)
Rijksmuseum Vincent van Gogh (Vincent van Gogh Foundation), Amsterdam

F706. *Enclosed Wheat Field with Ploughman*
Oil on canvas, 21 x 26 in. (54 x 67 cm.)
Collection W. A. Coolidge, Cambridge, Mass.

F707. *Olive Orchard*
Oil on canvas, 28¾ x 36⅝ in. (73 x 92.5 cm.)
Rijksmuseum Vincent van Gogh (Vincent van Gogh Foundation), Amsterdam

F708. *Olive Orchard*
Oil on canvas, 29⅛ x 36¼ in. (73.5 x 91.5 cm.)
Collection Walter H. Annenberg, Rancho Mirage, California

F711. *Olive Orchard*
Oil on canvas, 21¼ x 25⅝ in. (53.5 x 64.5 cm.)
Private collection, Switzerland

F717. *Wheat Field with Cypresses*
Oil on canvas, 28¾ x 37 in. (73 x 93.5 cm.)
Private collection, Switzerland

F720. *The Enclosed Field*
Oil on canvas, 28¼ x 36¼ in. (72 x 92 cm.)
Rijksmuseum Kröller-Müller, Otterlo

F721. *Fields*
Oil on canvas, 28¾ x 36¼ in. (73 x 91.5 cm.)
Rijksmuseum Kröller-Müller, Otterlo

F730. *The Asylum Garden*
Oil on canvas, 19⅝ x 24¾ in. (50 x 63 cm.)
Private collection

F731. *Trees in the Asylum Garden*
Oil on canvas, 16½ x 12⅝ in. (42 x 32 cm.)
Private collection, Switzerland

F734. *The Asylum Garden*
Oil on canvas, 37⅜ x 29⅞ in. (95 x 75.5 cm.)
Rijksmuseum Kröller-Müller, Otterlo

F735. *Rising Moon: Haycocks*
Oil on canvas, 28⅜ x 36¼ in. (72 x 92 cm.)
Rijksmuseum Kröller-Müller, Otterlo

F746. *Undergrowth*
Oil on canvas, 29⅛ x 36¼ in. (74 x 92 cm.)
Rijksmuseum Vincent van Gogh (Vincent van Gogh Foundation), Amsterdam

F750. *Cottages with Thatched Roofs*
Oil on canvas, 23½ x 28¾ in. (60 x 73 cm.)
The Hermitage Museum, Leningrad

F751. *Flowering Chestnut Trees*
Oil on canvas, 27½ x 22¾ in. (70 x 58 cm.)
Present location unknown

F752. *Chestnut Tree in Flower*
Oil on canvas, 24¾ x 20 in. (63 x 50.5 cm.)
Rijksmuseum Kröller-Müller, Otterlo

F754. *Portrait of Dr. Gachet*
Oil on canvas, 26¾ x 22½ in. (68 x 57 cm.)
Musée d'Orsay, Paris

F755. *Dr. Gachet's Garden*
Oil on canvas, 28¾ x 20¼ in. (73 x 51.5 cm.)
Musée d'Orsay, Paris

F756. *Marguerite Gachet in the Garden*
Oil on canvas, 18 x 21¾ in. (46 x 55 cm.)
Musée d'Orsay, Paris

F757. *Pietà (after Delacroix)*
Oil on canvas, 16½ x 13½ in. (42 x 34 cm.)
The Vatican Museums, Vatican City

F758. *Cottages at Jorgus*
Oil on canvas, 13 x 16 in. (33 x 40.5 cm.)
Collection The Reader's Digest Association, Inc.

F760. *Landscape with Carriage and Train*
Oil on canvas, 28⅜ x 35⅜ in. (72 x 90 cm.)
Pushkin State Museum of Fine Arts, Moscow

F761. *Wheat Field*
Oil on canvas, 19⅝ x 25⅝ in. (50 x 65 cm.)
Private collection, Zurich

F765. *A Corner in Daubigny's Garden*
Oil on linen, 20 x 20 in. (51 x 51 cm.)
Rijksmuseum Vincent van Gogh (Vincent van Gogh Foundation), Amsterdam

F766. *The White House at Night*
Oil on canvas, 23⅝ x 28¾ in. (59.5 x 73 cm.)
Present location unknown

F767. *Ears of Wheat*
Oil on canvas, 25½ x 18½ in. (64.5 x 47 cm.)
Rijksmuseum Vincent van Gogh (Vincent van Gogh Foundation), Amsterdam

F768. *Portrait of Adeline Ravoux*
Oil on canvas, 26½ x 21¾ in. (67 x 55 cm.)
Private collection, Switzerland

F769. *Portrait of Adeline Ravoux*
Oil on canvas, 28¼ x 21 in. (71.5 x 53 cm.)
Private collection

F782. *Wheat Fields*
Oil on canvas, 29 x 36¼ in. (73.5 x 92 cm.)
Bayerische Staatsgemäldesammlungen, Munich

F788. *Peasant Woman Standing in the Wheat*
Oil on canvas, 26 x 17¾ in. (66 x 45 cm.)
National Gallery of Art, Washington, D.C.

F789. *The Church at Auvers*
Oil on canvas, 37 x 29¼ in. (94 x 74 cm.)
Musée d'Orsay, Paris

F790. *The Town Hall of Auvers on Bastille Day*
Oil on canvas, 28⅜ x 36⅝ in. (72 x 93 cm.)
Private collection

F792. *Cottages at Cordeville*
Oil on canvas, 28¼ x 35¾ in. (72 x 91 cm.)
Musée d'Orsay, Paris

F794. *The House of Père Eloi*
Oil on canvas, 20 x 22¾ in. (51 x 58 cm.)
Present location unknown

F797. *The Vessenots at Auvers*
Oil on canvas, 21¾ x 25½ in. (55 x 65 cm.)
Thyssen-Bornemisza Collection, Lugano-Castagnola, Switzerland

F806. *Farm near Auvers with Two Figures*
Oil on canvas, 15 x 17¾ in. (38 x 45 cm.)
Rijksmuseum Vincent van Gogh (Vincent van Gogh Foundation), Amsterdam

F811. *Landscape at Auvers in the Rain*
Oil on canvas, 19¾ x 39½ in. (50 x 100 cm.)
National Museum of Wales, Cardiff

F820. *Blossoming Chestnut Branches*
Oil on canvas, 28¼ x 35¾ in. (72 x 91 cm.)
Foundation E. G. Bührle Collection, Zurich

F821. *Branches of a White Flowering Acacia Tree*
Oil on canvas, 13 x 9½ in. (33 x 24.2 cm.)
Nationalmuseum, Stockholm

F902. *Vicarage Garden at Etten*
Pencil, black chalk, pen and ink, watercolor,
17½ x 22¼ in. (44.5 x 56.5 cm.)
Rijksmuseum Kröller-Müller, Otterlo

F930a. *Diggers in a Trench*
Pencil, pen and ink, heightened with white and
colors, 17 x 24¾ in. (43 x 63 cm.)
Nationalgalerie, East Berlin

F933r. *Study of a Tree*
Black and white chalks, pen and black ink,
pencil, watercolor, 20 x 28 in.
(51 x 71 cm.)
Rijksmuseum Kröller-Müller, Otterlo

F943. *Roofs Seen from the Artist's Attic Window*
Watercolor, heightened with white,
15¼ x 21¾ in. (39 x 55 cm.)
Private collection, Paris

F1037. *Potato Fields Behind the Dunes*
Brush and ink, heightened with white,
10¾ x 16½ in. (27.5 x 42 cm.)
Rijksmuseum Kröller-Müller, Otterlo

F1319v. *Landscape with Sheaves of Wheat
and a Windmill*
Black chalk, 17½ x 22¼ in. (44.5 x 56.5 cm.)
Rijksmuseum Vincent van Gogh (Vincent van
Gogh Foundation), Amsterdam

F1339. *Field with a Man Binding Sheaves*
Black chalk, 7¾ x 13 in. (20 x 33 cm.)
Rijksmuseum Vincent van Gogh (Vincent van
Gogh Foundation), Amsterdam

F1340. *Field with Sheaves and a Windmill*
Black chalk, stumped, slightly heightened with
white, 8¾ x 11½ in. (22.5 x 29.5 cm.)
Rijksmuseum Vincent van Gogh (Vincent van
Gogh Foundation), Amsterdam

F1341. *Field with One Sheaf: Windmill in the
Right Background*
Black chalk, stumped, 9¾ x 13½ in. (25 x 34 cm.)
Rijksmuseum Vincent van Gogh (Vincent van
Gogh Foundation), Amsterdam

F1342. *Sheaves: Windmill in the Right
Background*
Black chalk, stumped, 9¾ x 13½ in. (25 x 34 cm.)
Rijksmuseum Vincent van Gogh (Vincent van
Gogh Foundation), Amsterdam

F1420. *La Crau Seen from Montmajour*
Pencil, reed pen, quill pen, brown and black ink
on Whatman paper, 19¼ x 24 in. (49 x 61 cm.)
Rijksmuseum Vincent van Gogh (Vincent van
Gogh Foundation), Amsterdam

F1467. *The Courtyard of the Hospital at Arles*
Pencil, reed pen and brown ink on Ingres paper,
18 x 23¼ in. (45.5 x 59 cm.)
Rijksmuseum Vincent van Gogh (Vincent van
Gogh Foundation), Amsterdam

F1468. *View in the Park in Arles*
Chalk, pen, reed pen and ink on Whatman
paper, 19¼ x 24¼ in. (49 x 61.5 cm.)
The Art Institute of Chicago

F1478. *Farmhouse in Provence*
Pencil, reed pen and brown ink on wove paper,
15⅜ x 21⅛ in. (39 x 53.7 cm.)
Rijksprentenkabinet, Rijksmuseum,
Amsterdam

F1488. *Wheat Field with Sheaves*
Pencil, reed pen and brown ink, 9⅝ x 12⅝ in.
(24.5 x 32 cm.)
Staatliche Museen zu Berlin (German
Democratic Republic)

F1501. *Trees in the Garden of the Asylum*
Pencil, reed pen and ink, 18½ x 23⅝ in.
(47 x 60 cm.)
Rijksmuseum Vincent van Gogh (Vincent
van Gogh Foundation), Amsterdam

F1505. *A Corner of the Asylum Garden*
Charcoal, brush, pen and brown ink,
18 x 23¾ in. (45.5 x 60.5 cm.)
Rijksmuseum Kröller-Müller, Otterlo

F1522. *Tree with Ivy and a Stone Bench in the
Asylum Garden*
Pencil, reed pen and brown ink, 24½ x 18½ in.
(62 x 47 cm.)
Rijksmuseum Vincent van Gogh (Vincent van
Gogh Foundation), Amsterdam

F1523. *Death's-Head Moth*
Black chalk, pen and brown ink, washed,
6¼ x 10¼ in. (16 x 26 cm.)
Rijksmuseum Vincent van Gogh (Vincent van
Gogh Foundation), Amsterdam

F1525a. *Cypresses*
Black chalk, reed pen and ink, 12¼ x 9 in.
(31 x 23 cm.)
Rijksmuseum Kröller-Müller, Otterlo

F1526. *Oleanders in the Asylum Garden*
Watercolor, 24 x 18½ in. (61 x 47 cm.)
Present location unknown

F1527. *Flowers in the Asylum Garden*
Watercolor, 24½ x 18½ in. (62 x 47 cm.)
Rijksmuseum Kröller-Müller, Otterlo

F1531. *The Fountain in the Asylum Garden*
Black chalk, pen, reed pen and brown ink,
19½ x 18 in. (49.5 x 46 cm.)
Rijksmuseum Vincent van Gogh (Vincent van
Gogh Foundation), Amsterdam

F1533. *A Tree in the Asylum Garden, with a
Figure in the Background*
Black chalk, pencil, pen, brush with brown ink
and watercolor, 18½ x 24½ in. (47 x 62 cm.)
Rijksmuseum Vincent van Gogh (Vincent van
Gogh Foundation), Amsterdam

F1534. *A Tree in the Asylum Garden*
Black chalk, pencil, pen, brush with brown ink
and watercolor, 18¾ x 24¼ in. (47.5 x 61.5 cm.)
Present location unknown

F1536. *The Asylum Garden in Summer*
Watercolor, 18¼ x 24¼ in. (46.5 x 61.5 cm.)
Present location unknown

F1537. *Stone Bench in the Asylum Garden*
Black chalk, brush, watercolor, gouache,
14½ x 24 in. (37 x 61 cm.)
Rijksmuseum Vincent van Gogh (Vincent van
Gogh Foundation), Amsterdam

F1538. *Wheat Fields and Cypresses*
Black chalk, pen, reed pen and brown ink,
18½ x 24½ in. (47 x 62 cm.)
Rijksmuseum Vincent van Gogh (Vincent van
Gogh Foundation), Amsterdam

F1539r. *Landscape with Cypresses and Four
Figures*
Black chalk, 12½ x 9¼ in. (32 x 23.5 cm.)
Museum Folkwang, Essen

F1540. *The Starry Night*
Pen and ink, 18½ x 23¾ in. (47 x 62.5 cm.)
Destroyed; formerly Kunsthalle Bremen

F1541v. *View of Saint-Rémy*
Pencil, pen and ink, wash, 6½ x 11¾ in.
(16.5 x 30.1 cm.)
Rijksmuseum Vincent van Gogh (Vincent van
Gogh Foundation), Amsterdam

F1543. *Olive Trees in the Mountains*
Black chalk, brush and brown ink,
19¾ x 25½ in. (50 x 65 cm.)
Rijksmuseum Vincent van Gogh (Vincent van
Gogh Foundation), Amsterdam

F1544. *Olive Trees with the Alpilles in the
Background*
Pencil, pen, reed pen and ink, 18½ x 24½ in.
(47 x 62.5 cm.)
Nationalgalerie, East Berlin

F1545. *A Corner of the Asylum Garden*
Black chalk, pen, reed pen and ink,
18½ x 24 in. (47 x 61 cm.)
Private collection

F1546. *The Reaper*
Pen, reed pen and ink, 17¾ x 23 in. (45 x 58.5 cm.)
Nationalgalerie, East Berlin

F1547. *Wheat Field Behind the Asylum*
Pen, reed pen and brown ink, 18½ x 24½ in.
(47 x 62 cm.)
Rijksmuseum Vincent van Gogh (Vincent van
Gogh Foundation), Amsterdam

F1550. *Sower in the Rain*
Pencil and chalk, 9¼ x 12½ in. (23.5 x 31.5 cm.)
Museum Folkwang, Essen

F1551r. *Sower in the Rain*
Black chalk, 9½ x 10¾ in. (24 x 27.5 cm.)
Rijksmuseum Vincent van Gogh (Vincent van
Gogh Foundation), Amsterdam

F1552. *Enclosed Field with Rising Sun*
Black chalk, reed pen and ink, 18½ x 24½ in.
(47 x 62 cm.)
Staatliche Graphische Sammlung, Munich

F1555. *Olive Orchard*
Reed pen and brown ink, 19⅝ x 25⅝ in.
(50 x 65 cm.)
Rijksmuseum Vincent van Gogh (Vincent
van Gogh Foundation), Amsterdam

F1564. *Six Pines near the Enclosure Wall*
Pencil, 9¾ x 12¾ in. (25 x 32.5 cm.)
Collection D. de Wolff Peereboom, Bergen,
The Netherlands

F1577. *Garden with Stone Bench and the
Asylum in the Background*
Pencil, 7¾ x 11½ in. (19.5 x 29 cm.)
Rijksmuseum Vincent van Gogh (Vincent
van Gogh Foundation), Amsterdam

F1578. *Enclosure with Pine Trees*
Black chalk, stumped, 9¼ x 12 in.
(23.5 x 30.5 cm.)
Rijksmuseum Vincent van Gogh (Vincent
van Gogh Foundation), Amsterdam

F1579. *Trunks of Two Pine Trees*
Pencil, 11¾ x 8 in. (30 x 20.5 cm.)
Rijksmuseum Vincent van Gogh (Vincent
van Gogh Foundation), Amsterdam

F1581. *Pine Trees in the Asylum Garden*
Pencil, stumped, 11¾ x 7¾ in. (30 x 20 cm.)
Rijksmuseum Vincent van Gogh (Vincent
van Gogh Foundation), Amsterdam

F1582. *Path in the Pines*
Black chalk, stumped, 8 x 11¾ in. (20.5 x 30 cm.)
Rijksmuseum Vincent van Gogh (Vincent van
Gogh Foundation), Amsterdam

F1587r. *Carriage and Two Figures on the Road*
Black chalk, 11¼ x 9¼ in. (28.5 x 23.5 cm.)
Rijksmuseum Vincent van Gogh (Vincent van
Gogh Foundation), Amsterdam

F1589r. *Carriage with Two Figures on a Road*
Black chalk, 11¼ x 9¼ in. (28.5 x 23.5 cm.)
Rijksmuseum Vincent van Gogh (Vincent
van Gogh Foundation), Amsterdam

F1591v. *Landscape with Farms and Peasants*
Pencil, 9½ x 12⅝ in. (24 x 32 cm.)
Rijksmuseum Vincent van Gogh (Vincent
van Gogh Foundation), Amsterdam

F1593r. *Thatched Cottage with Cypresses
and Peasants*
Pencil, 12⅝ x 9½ in. (31.5 x 23.5 cm.)
Rijksmuseum Vincent van Gogh (Vincent
van Gogh Foundation), Amsterdam

F1595v. *Peasants at Table; Busts of Two Peasants*
Pencil, 9½ x 12⅝ in. (24 x 32 cm.)
Present location unknown

F1611. *Dead Leaf and Pod*
Black chalk, 9½ x 12⅝ in. (24 x 31.5 cm.)
Rijksmuseum Vincent van Gogh (Vincent van
Gogh Foundation), Amsterdam

F1623r. *Marguerite Gachet at the Piano*
Black chalk, 11¾ x 7½ in. (30 x 19 cm.)
Rijksmuseum Vincent van Gogh (Vincent
van Gogh Foundation), Amsterdam

F1627. *Wooded Shore of the Oise*
Pencil and black chalk, 9¼ x 12 in.
(23.5 x 30.5 cm.)

Rijksmuseum Vincent van Gogh (Vincent
van Gogh Foundation), Amsterdam

F1628. *Path in the Fields*
Pencil and black chalk, 9¼ x 12 in.
(23.5 x 30.5 cm.)
Rijksmuseum Vincent van Gogh (Vincent
van Gogh Foundation), Amsterdam

F1629. *Wooded Shore of the Oise*
Pencil and black chalk, 9¼ x 12 in.
(23.5 x 30.5 cm.)
Rijksmuseum Vincent van Gogh (Vincent
van Gogh Foundation), Amsterdam

F1637r. *Houses Among Trees*
Black and blue chalk, pen and violet ink,
9½ x 12¼ in. (24 x 31 cm.)
Rijksmuseum Vincent van Gogh (Vincent
van Gogh Foundation), Amsterdam

F1640v. *House and Chestnut Trees*
Black chalk, 17¾ x 21⅝ in. (45 x 54.5 cm.)
Rijksmuseum Vincent van Gogh (Vincent van
Gogh Foundation), Amsterdam

F1652r. *Figure Sketches*
Black chalk, 17 x 10½ in. (43.5 x 27 cm.)
Collection Mr. and Mrs. Harry M. Goldblatt,
New York

F1653. *The Farm of Père Eloi, in the Foreground
a Woman Working*
Pencil, pen and ink, 18½ x 24¼ in. (47 x 61.5 cm.)
Musée d'Orsay, Paris

WORKS IN THE CATALOGUE

The title of each work is followed by an F number in parentheses, which refers to the catalogue number assigned in the revised edition of J.-B. de la Faille, *The Works of Vincent van Gogh: His Paintings and Drawings,* Amsterdam – New York, 1970. In the column at the right are catalogue numbers.

SELECTED BIBLIOGRAPHY

Abbreviations used in this volume precede the listing of the relevant publication. The arrangement is by van Gogh, Saint-Rémy, and Auvers.

VAN GOGH

Catalogues Raisonnés

F Faille, J.-B. de la. *L'Oeuvre de Vincent van Gogh: Catalogue raisonné.* 4 vols. Paris–Brussels, 1928. Rev. ed. *The Works of Vincent van Gogh: His Paintings and Drawings.* New York, 1970.

H Faille, J.-B. de la. *Vincent van Gogh.* Translated by P. Montagu-Pollock. Paris–London–New York, 1939.

 Scherjon, W., and W. J. de Gruyter. *Vincent van Gogh's Great Period: Arles, Saint-Rémy and Auvers-sur-Oise.* Amsterdam, 1937.

JH Hulsker, J. *The Complete van Gogh: Paintings, Drawings, Sketches.* Oxford–New York, 1980.

Letters

The Complete Letters of Vincent van Gogh. 3 vols. Introduction by V. W. van Gogh. Preface and Memoir by J. van Gogh-Bonger. London–New York, [1958]. The author of the present volume has made emendations to the following letters: LT594, LT596, LT597, LT604, LT608, LT613, LT621, LT638, LT640a, LT642, LT643, T14, T20, T25, T32, T33, T38, W20, W22, W23.

 LT Letter to his brother Theodorus (Theo)
 W Letter to his sister Wilhelmina (Wil)
 B Letter to Émile Bernard
 T Letter from Theo

GAC Cooper, D. *Paul Gauguin: 45 Lettres à Vincent, Theo et Jo van Gogh: Collection Rijksmuseum Vincent van Gogh, Amsterdam.* 's Gravenhage, 1983.

Lord, D., ed. and trans. *Vincent van Gogh: Letters to Émile Bernard.* London–New York, 1938.

Letters of Vincent van Gogh, 1886–1890: A Facsimile Edition. Preface by J. Leymarie. Introduction by V. W. van Gogh. London, 1977.

Karagheusian, A. *Vincent van Gogh's Letters Written in French: Differences Between the Printed Versions and the Manuscripts.* New York, 1984.

General

Barnett, V. E. *The Guggenheim Museum: Justin K. Thannhauser Collection.* New York, 1978.

Cooper, D. *Drawings and Watercolours: A Selection of 32 Plates in Colour.* New York, 1955.

Coquiot, G. *Vincent van Gogh.* Paris, 1923.

Doiteau, V., and E. Leroy. *La Folie de Vincent van Gogh.* Preface by Paul Gachet *fils.* Paris, 1928.

Gachet, P. *Deux Amis des impressionnistes: Le docteur Gachet et Murer.* Paris, 1956.

Gachet, P., ed. *Lettres impressionnistes au Dr. Gachet et à Murer.* Paris, 1957.

Gachet, P., and G. Bazin. *Van Gogh et les peintres d'Auvers-sur-Oise.* Exhibition catalogue, Musée de l'Orangerie, Paris, 1954.

Hulsker, J., ed. *Van Gogh door Van Gogh: De brieven als commentaar op zijn werk.* Amsterdam, 1973.

Leroy, E. *Van Gogh à l'asile,* with *Du Démon de Van Gogh,* by F. J. Beer. Preface by Louis Piérard. Nice, 1945.

Liber Amicorum Karel G. Boon. Edited by D. de Hoop Scheffer, C. van Hasselt, and C. White. Amsterdam, 1974.

Løvgren, S. *The Genesis of Modernism: Seurat, Gauguin, Van Gogh and French Symbolism in the 1880's.* Stockholm, 1959.

Lubin, A. J. *Stranger on the Earth: A Psychological Biography of Vincent van Gogh.* New York, 1972.

Mauron, C. *Van Gogh: Études psychocritiques.* Paris, 1976.

Outhwaite, D. *The Auvers Period of Vincent van Gogh.* Master's thesis, London University, 1969.

Pickvance, R. *English Influences on Vincent van Gogh.* Exhibition catalogue, University Art Gallery, Nottingham, 1974.

Pollock, G., and F. Orton. *Vincent van Gogh: Artist of His Time.* Oxford–New York, 1978.

Reidemeister, L. *Auf den Spuren der Maler der Ile de France.* Berlin, 1963.

Rewald, J. *Post-Impressionism: From van Gogh to Gauguin.* 3rd rev. ed. New York–London, 1978.

Rijksmuseum Kröller-Müller. *A Detailed Catalogue with Full Documentation of 272 Works by Vincent van Gogh.* 4th ed. Otterlo, 1980.

Rijksmuseum Vincent van Gogh. *Japanese Prints Collected by Vincent van Gogh.* Introduction by W. van Gulik. Essay by F. Orton. Amsterdam, 1978.

Roskill, M. W. *Van Gogh, Gauguin and the Impressionist Circle.* New York, 1970.

Schapiro, M. *Vincent van Gogh*. New York, 1950.

Sheon, A. *Monticelli: His Contemporaries, His Influence*. Exhibition catalogue, Museum of Art, Carnegie Institute, Pittsburgh, 1978.

Tralbaut, M. *Vincent van Gogh*. New York, 1969.

Ueberwasser, W. *Le Jardin de Daubigny, das letzte Hauptwerk van Gogh's*. Basel, 1936.

Van Uitert, E. *Vincent van Gogh in Creative Competition: Four Essays from Simiolus*. Zutphen, The Netherlands, 1983.

Welsh-Ovcharov, B., ed. *Van Gogh in Perspective*. Englewood Cliffs, N.J., 1974.

———. *Vincent van Gogh: His Paris Period, 1886–88*. Utrecht–The Hague, 1976.

———. *Vincent van Gogh and the Birth of Cloisonism*. Exhibition catalogue, Art Gallery of Ontario, Toronto, 1981.

Articles

Aurier, G.-A. "Les Isolés: Vincent van Gogh," *Mercure de France* 1 (no. 1, January 1890), pp. 24–29. Reprinted in *Oeuvres Posthumes*, Paris, 1893, pp. 257–65.

Boime, A. "Van Gogh's *Starry Night*: A History of Matter and a Matter of History," *Arts Magazine* 59 (December 1984), pp. 86–103.

Carrié, A. "Les Souvenirs d'Adeline Ravoux sur le séjour de Vincent van Gogh à Auvers-sur-Oise," *Les Cahiers de van Gogh* (no. 1, 1956), pp. 7–17.

Chatelet, A. "Le Dernier Tableau de Van Gogh," *Société de l'Histoire de l'Art Français: Archives* 25 (1978), pp. 439–42.

Doiteau, V. "La Curieuse Figure du Dr. Gachet: Un ami et un amateur de la première heure de Cézanne, Renoir, Pissarro, Van Gogh," *Aesculape* (August 1923), pp. 169–73; (September 1923), pp. 211–16; (November 1923), pp. 250–54; (December 1923), pp. 278–83; (January 1924), pp. 7–11.

———. "Deux 'copains' de Van Gogh, inconnus, les frères Gaston et René Secrétan, Vincent, tel qu'ils l'ont vu," *Aesculape* (March 1957), pp. 38–62.

Gachet, P. [*fils*]. "Les Médecins de Théodore et de Vincent Van Gogh," *Aesculape* (March 1957), pp. 4–37.

Hentzen, A. "Der Garten Daubignys von Vincent van Gogh," *Zeitschrift für Kunstgeschichte* 4 (1935), pp. 325–33.

———. "Nochmals: Der Garten Daubignys von Vincent van Gogh," *Zeitschrift für Kunstgeschichte* 5 (1936), pp. 252–59.

Hulsker, J. "Vincent's Stay in the Hospitals at Arles and St.-Rémy: Unpublished Letters from the Reverend Mr. Salles and Doctor Peyron to Theo van Gogh," *Vincent* 1 (no. 2, 1971), pp. 24–44.

———. "Van Gogh's Threatened Life in St. Rémy and Auvers," *Vincent* 2 (no. 1, 1972), pp. 21–39.

———. "What Theo Really Thought of Vincent," *Vincent* 3 (no. 2, 1974), pp. 2–28. Unpublished letters by Theo van Gogh.

Korshak, Y. "Realism and Transcendent Imagery: Van Gogh's 'Crows over the Wheatfield,'" *Pantheon* 48 (1985), pp. 115–23.

Leroy, E. "L'Art et la folie de Vincent Van Gogh," *Journal des Practiciens* no. 29 (July 21, 1928), pp. 1558–63.

———. "La folie de Van Gogh," *Cahiers de Pratique Médico-Chirurgicale* no. 9 (November 15, 1928), pp. 3–11.

———. "A propos de l'exposition Van Gogh," *Notre Flandre* 6 (no. 4, 1958), pp. 122ff.

———. "La Provence à travers les lettres de Vincent Van Gogh," *La Revue des Pays d'Oc* (June 1932).

———. "Quelques paysages de Saint Rémy de Provence dans l'oeuvre de Vincent van Gogh," *Aesculape* (July 1957), pp. 3–21.

———. "A Saint Paul de Mausole, quelques hôtes célèbres au cours du XIXème siècle," *La Revue d'Arles* (June 1941), pp. 125–30.

———. "Le Séjour de Vincent Van Gogh à l'asile de Saint Rémy de Provence," *Aesculape* (May 1926), pp. 137–43; (June 1926), pp. 154–58; (July 1926), pp. 180–86.

———. "Van Gogh à l'asile," *Opéra: L'hebdomadaire du théâtre, du cinéma, des lettres et des arts* (no. 266, 1950), pp. 1–2; (no. 267, 1950), p. 2; (no. 268, 1950), p. 2; (no. 269, 1950), p. 2; (no. 270, 1950), p. 6; (no. 271, 1950), p. 6.

———. "Vincent Van Gogh au pays d'Arles," *La Revue d'Arles* no. 14 (October–November 1954), pp. 261–64.

Leroy, E., and V. Doiteau. "Van Gogh et le portrait du Dr. Rey," *Aesculape* (February 1939), pp. 42–47; (March 1939), pp. 50–55.

———. "Vincent Van Gogh et le drame de l'oreille coupée," *Aesculape* (July 1936), pp. 169–92.

Nordenfalk, C. "Van Gogh and Literature," *Journal of the Warburg and Courtauld Institutes* 10 (1947), pp. 132–47.

Pickvance, R. "The New de la Faille," *Burlington Magazine* 115 (March 1973), pp. 174–80.

Pollock, G. "Artists' Mythologies and Media Genius: Madness and Art History," *Screen* 21 (no. 3, 1980), pp. 57–96.

Rewald, J. "Gachet's Unknown Gems Emerge," *ARTnews* 51 (March 1952), pp. 16–18, 63–66.

———. "Theo van Gogh, Goupil and the Impressionists," *Gazette des Beaux-Arts*, ser. 6, 81 (January–February 1973), pp. 1–108.

———. "Van Gogh en Provence," *L'Amour de l'Art* 17 (October 1936), pp. 289–98.

———. "Van Gogh: The Artist and the Land," *ARTnews Annual* 19 (1950), pp. 64–73.

Roskill, M. "Van Gogh's Blue Cart and His Creative Process," *Oud Holland* 81 (no. 1, 1966), pp. 3–19.

Sheon, A. "Monticelli and van Gogh," *Apollo*, n.s. 85 (June 1967), pp. 444–48.

Soth, L. "Van Gogh's Agony," *Art Bulletin* 68 (June 1986), pp. 301–13.

Various nineteenth-century guidebooks were consulted in preparing this catalogue. Especially useful were those written by Adolphe Joanne, and those issued by Karl Baedeker, Publishers, Leipzig, and John Murray, Publisher, London.

SAINT-RÉMY-DE-PROVENCE

Bonnet, M. *Album d'iconographie Saint-Rémoise,* Saint-Rémy-de-Provence, 1977.

Clebert, J., and P. Richard. *La Provence de van Gogh.* Aix-en-Provence, 1981.

Darmesteter, M. "Impressions of Provence," *Littel's Living Age* 80 (no. 2530, December 24, 1892), pp. 813–24. Reprinted as "A Little Tour in Provence," in *The Fields of France,* by M. [Darmesteter] Duclaux, London, 1904.

Hare, A. *South-Eastern France.* London, 1890.

Leroy, E. *Saint-Paul-de-Mausole à Saint-Rémy-de-Provence. Notes historiques et touristiques.* Saint-Rémy-de-Provence, 1948.

AUVERS-SUR-OISE

Cazier, S. *Monographie communale d'Auvers-sur-Oise,* September 1899.

Demoy, E. *Auvers en 1900.* Paris, 1985.

Mataigne, H. *Histoire de la commune d'Auvers-sur-Oise.* Pontoise, 1901.

Trublot (Paul Alexis). "Auvers-sur-Oise," *Le Cri du Peuple.* August 15, 1887.